Impressionist Art

Volume I

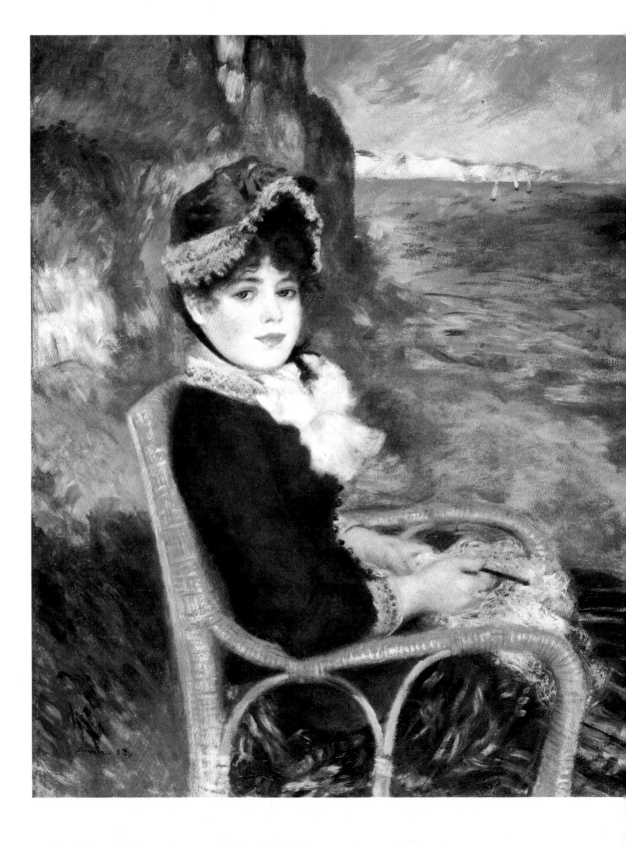

IMPRESSIONIST ART

1860–1920

Edited by Ingo F. Walther

Volume I

IMPRESSIONISM
IN FRANCE

by
Peter H. Feist

Benedikt Taschen

"To treat a subject for the colours and not for the subject itself,
that is what distinguishes the Impressionist from other painters."
GEORGES RIVIERE, 1877

Slipcase:
Edouard Manet
The Viennese: Portrait of Irma Brunner in
a Black Hat (detail), 1880
Paris, Musée du Louvre, Cabinet des Dessins
© Photo: R.M.N., Paris
cf. p. 213

Front cover:
Pierre-Auguste Renoir
The Theatre Box (detail), 1874
London, Courtauld Institute Galleries
cf. p. 128

Page 2:
Pierre-Auguste Renoir
By the Seashore, 1883
Au bord de la mer
Oil on canvas, 92 x 73 cm
New York, The Metropolitan Museum of Art

This book was printed on 100 % chlorine-free
bleached paper in accordance with the TCF standard.

© 1996 Benedikt Taschen Verlag GmbH
Hohenzollernring 53, D-50672 Köln
© 1992 for the reproductions: VG Bild-Kunst, Bonn,
and the estates of the artists
Edited and produced by
Ingo F. Walther, Alling, Munich
Editorial assistants: Antje Günther, Matthias Feldbaum
English translation: Michael Hulse

Printed in Germany
ISBN 3-8228-8643-2 (Hardback)
ISBN 3-8228-8558-4 (Paperback)
GB

Contents

Editor's Preface

On 15 April 1874 an exhibition featuring 30 artists opened in the Paris studio of Nadar the photographer. They had joined for the express purpose of presenting their work to the public as a group. It was the first group exhibition to be mounted without state intervention or the jurying process. And it was also the birth of Impressionism – an avant-garde event, a revolution that was to be of great significance for all the movements that followed, in Modernist art and after.

And the art that went on display was avant-garde and revolutionary too: landscapes, cityscapes and other subjects from everyday life, in light, luminous colours, full of atmosphere, the brushwork consisting merely of brief strokes and dabs. The paintings had partly been done *sur le motiv*, in the open. It was a protest against the dusty studio art of the time with its lofty historical and mythological subjects, its colours predominantly gloomy and earthy, its light chosen purely to suit the artist.

Impressionist painting has remained the most fascinating product of modern art – and the most popular, as has been shown in recent years by spectacularly successful exhibitions of Degas, Gauguin, van Gogh, Manet, Monet or Renoir. Their work fetches record prices. The critical literature on them fills libraries. And yet some aspects of Impressionism have not been sufficiently researched, while several of the painters and their works have remained unknown, or have been forgotten.

This study describes the history of Impressionism, and of Neo- and Post-Impressionism, in France; it also affords an overview of related artistic developments elsewhere in Europe and in North America.

Volume I deals with France. The book aims not only to deal with the illustrious names – Monet, Renoir, Manet, Pissarro, Sisley, Degas, Cézanne, Gauguin, van Gogh, Seurat, Signac – but also to present little-known artists who were important for Impressionism, among them Gustave Caillebotte, a significant painter whose work was not "discovered" till a century after his death. The monograph includes 17 of his paintings. Others included are Bracquemond, Cross, Forain, Gonzalès, Guillaumin, Lebourg, Lépine, Luce, Morisot, Raffaëlli and Vignon.

Volume II deals with painting elsewhere in Europe and in North America that was inspired by French Impressionism or evolved parallel to it. Though this art may not always be strictly Impressionist, it nonetheless owed a debt to the French artists even when their style was translated into a different national artistic idiom. Volume II also features a reference section including brief biographies, bibliographies and photographs of 236 artists, as well as numerous entries on other movements, critics, publications and locations.

Pierre-Auguste Renoir
Mademoiselle Romaine Lacaux, 1864
Oil on canvas, 81 x 65 cm
Cleveland (OH), Cleveland Museum of Art

1 Appraising Impressionism

Impressionist paintings are today among the most admired of all art-works. They are the pride of every public and private collection. As a rule they offer a visual feast, and possess a magic of their own that captivates the practised connoisseur and the less experienced art lover alike. Countless reproductions have made many Impressionist works familiar worldwide. And the flood of publications is growing continually, making available all the information we ever wanted to have on both the works and the artists.

Nevertheless, the debate on the aesthetic standing of Impressionist art and its place in art history is not over. Like any dispute over value judgements, it never will be. Nowadays, new questions are being raised concerning the forces that power historical developments in art, and the relations of Impressionism to other artistic movements. Many of these questions are being broached because art historians, for a good thirty years at least, have been charting a more complete and nuanced map of 19th-century art history.[1] For a long time it was widely thought that for decades only the Impressionists produced art that was of value and noteworthy as a gauge of the *Zeitgeist*; but this view must now be amended, even if eminent scholars of Impressionism such as John Rewald have been angrily condemning the recent revaluation of Salon art.[2]

There is a point to such anger as long as market considerations are in the foreground and conservative nostalgia takes precedence over careful aesthetic evaluation. But we must clear the way for a discriminating critical look at Impressionism and at the limits of Impressionist art's capacity to grasp and render the world artistically and to satisfy ever-changing aesthetic needs. Outstanding art moves and impresses us; but this should not obscure our realization that even the greatest masterpiece can never be "absolute", can never fulfil every conceivable expectation. Indeed, its impact may derive from a quality of emphatic one-sidedness.

The term "Impressionist" primarily describes a particular way of painting, drawing or working in graphics. There are comparable approaches in sculpture, literature and music. In relatively early days, when the Impressionist movement was still just one controversial strand in the art scene and at the same time a readily-surveyed aspect of recent art history (which younger artists were already critically rejecting), a young German art critic by the name of Richard Hamann wrote "Impression-

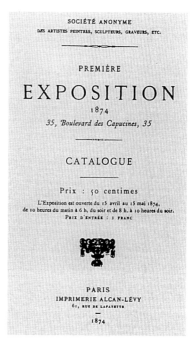

Catalogue of the first Impressionist exhibition, 1874

Claude Monet
Monceau Park, 1878
Le parc Monceau
Oil on canvas, 73 x 54 cm
Wildenstein 466
New York, The Metropolitan Museum of Art

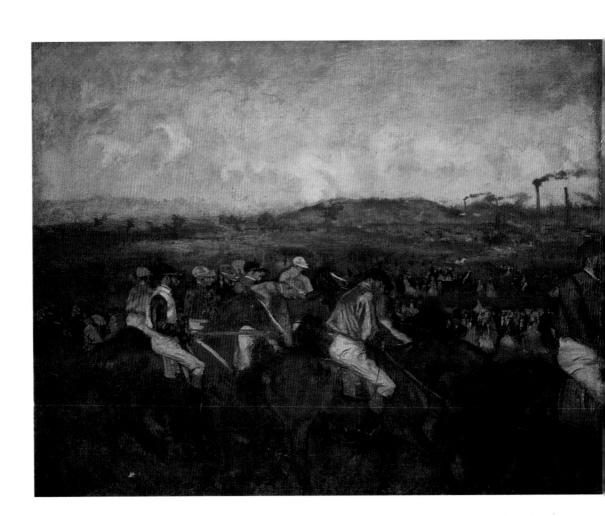

Edgar Degas
Gentlemen's Race. Before the Start, 1862
Course de gentlemen. Avant le départ
Oil on canvas, 48.5 x 61.5 cm
Lemoisne 101. Paris, Musée d'Orsay

ismus in Leben und Kunst" (1907).[3] Hamann saw the distinctive qualities of Impressionist principles as deriving from a contemporary feel for life itself, from kinds of sensibility and behaviour that could be encountered as much in everyday life, philosophy and science as in art. But another German art critic of about the same age, Werner Weisbach, who had been lecturing on Impressionist painting at the University of Berlin since 1904, took a different approach in the two volumes of his "Impressionismus: Ein Problem der Malerei in Antike und Neuzeit" (1910/11).[4] In linking Impressionist art to the aesthetics of antiquity, Weisbach was seeking to give the new art a respectable ancestry and to explain its principles as fundamentals that were always available to the art of painting. This approach has not been ignored, but scholars today prefer to see Impressionism as one particular artistic type of evolution unfolding alongside others in a historical, cultural and aesthetic situation that was unique. American and British art historians in particular – critics such as Robert L. Herbert, Albert Boime or Timothy J. Clark – stress the decisive part played by cultural and social circumstances in art history, rather than individual aesthetic or formal strategies on the part

of the artists themselves.[5] "The New Painting. Impressionism 1874–1886", edited by Charles S. Moffett, provides invaluable documentation of these interrelations.[6] Moffett's title comes from an 1876 essay by the critic Edmond Duranty, "to draw attention to the entire spectrum of the modern movement rather than restricting it to one or another ism."

Impressionism represents the grand finale of a particular way of appropriating the world through painting or drawing. This method, often termed realism, evolved in Europe in the dawn of the modern era. But Impressionism also established various features that were preconditions and characteristics of 20th-century art. For this reason, critics have tended to see Impressionism as either an end or a beginning – or both.

Most of the movement's principles reveal Impressionism to have been a summation of earlier views and intentions, a conclusion, a peak. What struck most contemporaries as rebellious modernity was in fact closely linked to tradition. Many people today respond to traditionalism of this kind, and with good reason, without being conservative in any narrower

Pierre-Auguste Renoir
Oarsmen at Chatou, 1879
Les canotiers à Chatou
Oil on canvas, 81 x 100 cm
Daulte 305
Washington, National Gallery of Art

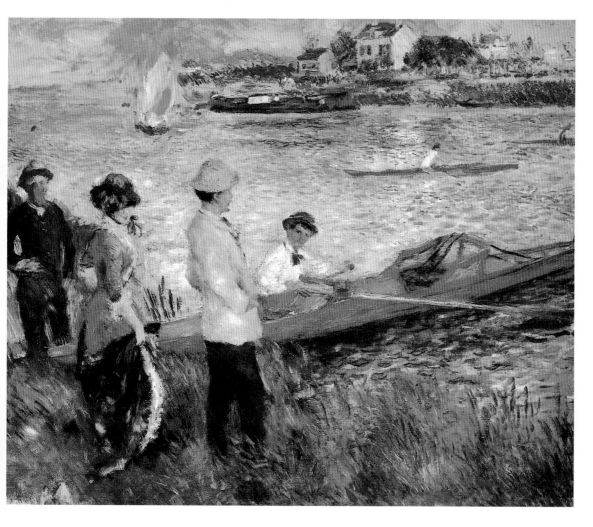

sense of the word. It was not until Post-Impressionism that a fundamental aesthetic upheaval and breakthrough occurred with the "end of scientific perspective" (Fritz Novotny)[7], when artists departed from an approach long taken for granted, the view that art should reproduce what was actually seen. Taken as a whole, though, Impressionism remains astoundingly contemporary: people today are still struck by the arresting specifics of the paintings. There can be no other explanation for the spectacular numbers that turn out to exhibitions of Impressionist art or for the continuing popularity of Impressionist works with collectors. But since one and the same painting – or "text", in modern analytic semiotics – can be "read" differently at different times by people with different interests, the present study will include a look at differing ways of reading, then and now.

The Impressionist style of painting first emerged as a definable, shared approach among a small group of young French artists, and it was these artists who were meant by the term – which was originally coined disparagingly. In any account of the movement, the work of Edouard Manet (1832–1883),[8] Edgar Degas (1834–1917),[9] Claude Monet (1840–1926),[10] Pierre-Auguste Renoir (1841–1919),[11] Camille Pissarro (1830–1903),[12] Alfred Sisley (1839–1899),[13] Frédéric Bazille (1841–1870)[14] and Berthe Morisot (1841–1895)[15] must occupy the central position.[16] These artists produced work over careers of varying lengths. Others who were also involved with the movement deserve more attention than they generally get, however – artists such as Armand Guillaumin (1841–1927),[17] Gustave Caillebotte (1848–1894)[18] or Eva Gonzalès (1849–1883).[19] The Post-Impressionist Paul Cézanne (1839–1906),[20] the key figure in the transition from 19th-century to 20th-century art, occupies a special position of his own.

The history of Impressionism would not be complete without the distinctive work of the Neo-Impressionists Georges Seurat (1859–1891),[21] Paul Signac (1863–1935)[22] and their fellows,[23] or of the Post-Impressionists Paul Gauguin (1848–1903),[24] Vincent van Gogh (1853–1890)[25] and Henri de Toulouse-Lautrec (1864–1901).[26] A delightful late afterglow of Impressionism came with the *intimisme* of Pierre Bonnard (1867–1947)[27] and Edouard Vuillard (1868–1940).[28]

But the history of Impressionism is not merely a French one. It is European, indeed global, as was demonstrated in 1990 by authors from around the world in "Impressionismus: Eine internationale Kunstbewegung 1860–1920", edited by the American art critic Norma Broude.[29] Impressionism did not derive from French preconditions and circumstances alone, nor would its rapid international spread be explicable if comparable tendencies had not already existed elsewhere.

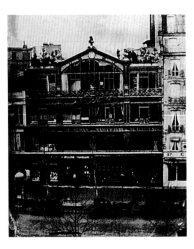

Photographer Gaspard-Félix Tournachon Nadar's house at Boulevard des Capucines 35. The first Impressionist exhibition of 1874 was held in his studio.

Pierre-Auguste Renoir
The Walk, 1870
La promenade
Oil on canvas, 80 x 64 cm
Daulte 55. Private collection

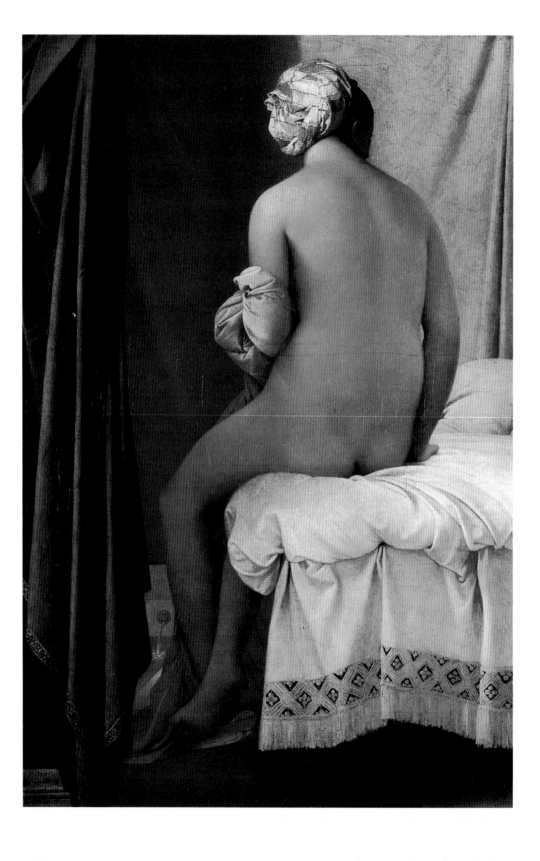

2 The Prehistory of Impressionism

We shall be examining the Impressionist conception of art and its roots in greater detail presently, but first it is useful to take a look at what went before. To do so will explain why Impressionism, though its origins were not only French, first emerged in France. France offered the best soil in which the movement could grow and achieve form and energy. Since the late 17th century, the political and artistic status quo had meant – to put it simply – that some of the most important decisions concerning the future course of European art were made in Paris. If French absolutism under Louis XIV, the *roi soleil*, had made France a model to be followed, the French Revolution of 1789 in turn brought worldwide class upheavals in its train. The evolution of middle-class society in the 19th century – including the evolution of that society's arts – advanced a little earlier and more consistently in France than in other countries. Despite the fact that England's production levels and capital resources had made it the "workshop of the world", in the visual arts – across the entire spectrum of exhibitions, dealers and the creation of taste – the 19th-century capital was Paris. The genesis and dissemination of Impressionism required the lifestyle and cultural climate of Paris.

Throughout the arts, particularly in the modern era, we can observe divergent artistic ideas and the resultant approaches to creative work co-existing. This is what we might term stylistic polyphony. In part it derives from the fact that arists of different generations are at work at the same time. When they are young they are shaped by their various situations, and subsequently remain true to the views they then formed or else adapt them in ways that differ from their coevals. The diversity is also caused by the fact that society (and, within society, groupings and levels that may be radically at odds) makes – or indeed insists on – various requirements of art. These requirements ensure that artworks are made for various purposes and to satisfy a variety of interests (and at the same time attempt to oust or obstruct work conceived along contrary lines).

Three strands in French painting in the first two thirds of the 19th century that were of particular significance for the subsequent emergence of Impressionism should be emphasized. To some extent they followed upon each other, and to some extent they overlapped chronologically. Of course we should not forget the attitudes and approaches from which the initially small group of Impressionists set themselves apart, at a criti-

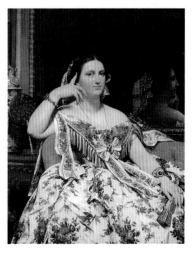

Jean Auguste Dominique Ingres
Portrait of Madame Inès Moitessier, 1856
Portrait de Madame Inès Moitessier
Oil on canvas, 120 x 92.1 cm
London, National Gallery

Jean Auguste Dominique Ingres
The Bather of Valpinçon, 1808
La baigneuse de Valpinçon
Oil on canvas, 146 x 97.5 cm
Paris, Musée du Louvre

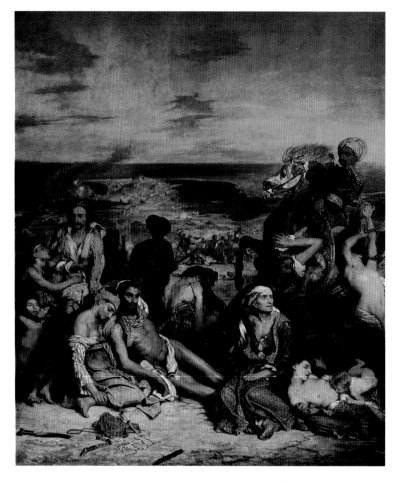

Eugène Delacroix
The Massacre on Chios, 1824
Le massacre de Scio
Oil on canvas, 417 x 354 cm
Robaut-Chesneau 91. Paris, Musée du Louvre

cal distance. This is complex territory, since the distinctions and polarities are not always clearly defined; there was shared ground too, and reciprocal influences.

The weightiest tradition was that of Classicism, involving a valuing of ancient Greek and Roman art and their exemplary qualities above all else. Classicism recognised the authority of the formal idiom and choice of subjects of great art of the past – and implied the imitation of that art. Those who espoused it shared the conviction that works of art should be beautiful, noble and instructive. They believed there were definite criteria for beauty and rules governing the way it should be created. The classical view placed the idea above reality. The artist, in this view, was inspired with an idea of perfection, and his task was to correct the chance imperfections of given reality by means of his style and shaping skills. The study of exemplary works of antiquity, and obedience to formal rules, took precedence over the study of Nature.

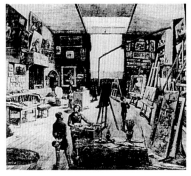

Delacroix' studio in Paris, Rue Notre-Dame-de-Lorette

It is true that Classicism served the French Revolution, and subsequently, with shifts of emphasis, the *Style Empire* of Napoleon. But it remains true, nonetheless, that Classicism, with its tendency to immunize

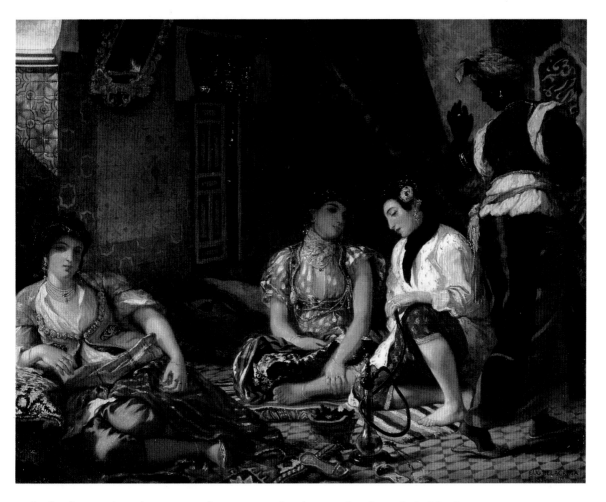

Eugène Delacroix
The Women of Algiers, 1834
Femmes d'Alger dans leur appartement
Oil on canvas, 180 x 229 cm
Robaut-Chesneau 482. Paris, Musée du Louvre

societal values against change, was the aptest mode of expression for those with a conservative interest in preserving the social status quo. In terms of the politics of the arts, Classicism was represented by the Academy and by its art college, the Ecole des Beaux-Arts.[30] The foremost Classical painter was Jean Auguste Dominique Ingres (1780–1867),[31] whose patriarchal authority was still making itself felt when the Impressionists first made an attempt to put their views on art before the public. Though these views were diametrically opposed to Classicism in every important respect, some of the younger painters did have a regard for certain qualities in the work of Ingres, and were later to rethink the basic principles of Classicism.

Ingres was a draughtsman of the first rank. He had an absolutely sure hand in drawing a line, and specifically in drawing the outlines of figures – which Classicism saw as the crux in formulating and conveying an idea. The compositional disposition of figures had to be harmonious and clear, as in a relief, and constitute a unified and well-ordered whole. Calmness and leisureliness inform the figures' gestures and poses. A good example is Ingres' first lifesize nude, *The Bather of Valpinçon* (p. 14), so

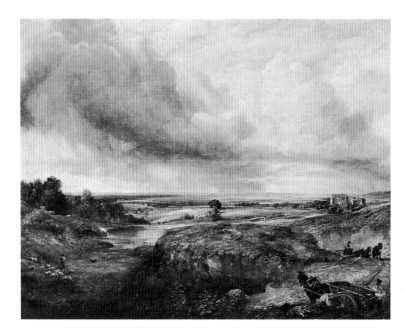

called after the man who commissioned it. This fine painting's simple, tranquil mood made an impression on those who came after, not least for its careful observation of the gentle play of light upon the woman's body. Ingres primarily worked in the mode that the doctrines of Classicism rated highest, histories – showing mythological or historical scenes, events from the Bible or the lives of the saints, or perhaps the histories of the kings of France. But he was also fond of the "oriental" subject matter that was particularly the domain of the Romantics – scenes of harem life, for instance.

Moreover, Ingres was a first-rate portraitist, as we can see in the psychologically persuasive *Portrait of Madame Inès Moitessier* (p. 15), which also conveys an opulent sense of the sitter's wealth. The artist worked on this portrait for twelve years, till, at the age of sixty-six, he finally felt satisfied. Ingres influenced the course along which art evolved not only through his own work but also through his teaching, in Paris and at the Académie Française department in Rome, where all who won the coveted Prize of Rome furthered their own training before accepting chairs in Paris and preaching the doctrines of a late Classicism that was in steady decline.

For decades, Ingres' very antithesis seemed to be Eugène Delacroix (1798–1863).[32] A painter of true genius, Delacroix was one of the most temperamental artists in the history of European art. To him, colour and not the line was the all-important formal means – and so the Classicists at the Académie Française barred him election to their hallowed ranks no fewer than seven times before he finally joined in 1857. From the very start, Delacroix startled the public and the critics alike with his fully-toned, sensuous use of colour, his passionate and highly personal interpretations of his material, and his eccentric choices of new subjects. He

Richard Parkes Bonington
Water Basin at Versailles, c. 1826
Le parterre d'eau à Versailles
Oil on canvas, 43 x 54 cm
Paris, Musée du Louvre

felt that not only the dramatic and tragic events of antiquity but also those of his own times merited a place in art.

The prime early example of this is his large-scale painting *The Massacre on Chios* (p. 16). In 1822, the Greek inhabitants of the island of Chios had mounted a rebellion against their Turkish overlords, whereupon twenty thousand of them had been butchered. Many western Europeans felt deeply involved in the Greek struggle for liberty. In his picture, Delacroix has grouped his figures relief-style as in a classical composition, but the rich modelling of the colours harks back to Peter Paul Rubens (1577–1640). Ingres, by contrast, forebade his pupils to study the great Baroque master. The painter Antoine-Jean Gros (1771–1835) shared Ingres' tastes and, horrified by Delacroix's painting, dubbed it "the massacre of painting". From a Classicist point of view, it hardly helped that Delacroix had lightened and loosened the colours of the landscape background shortly before the exhibition opened; he had seen *The Hay Wain* (p. 20) by the English painter John Constable (1776– 1837)[33] – the painting that presently won the exhibition Gold Medal. *The Hay Wain* came as a revelation to Delacroix, encouraging him to be more responsive to light and colour values, and to record his impressions with greater spontaneity. It was no accident that his eye lit upon that painting.

English Antecedents

Since the 18th century, English painters and those who bought their work had displayed a particular interest in landscape – which the doc-

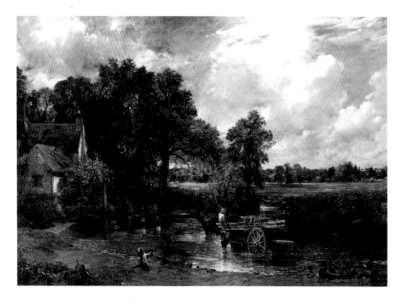

John Constable
The Hay Wain, 1821
Oil on canvas, 130.2 x 185.4 cm
London, National Gallery

trines of Classicism rated low. Owing to the distinctive evolution of English society and the nation's economy, England had originated a fundamentally new approach to landscape: the landscape garden.[34] From the third quarter of the 18th century on, the principles of the English garden were assiduously imported by continental clients and artists of modern taste – as were the numerous other economic, technical, practical and intellectual advances the Industrial Revolution had brought. England was especially blessed with gifted artists, in watercolour and oils, who gave their attention almost exclusively to native or foreign landscapes (including townscapes, harbour scenes and seascapes). The distinctive landscape atmospheres and moods established by different kinds of weather or light offered an important aesthetic attraction in this kind of work; the precision with which they were recorded decided its value as art. The public and the buyers wanted the pictures to make the same impression on them, if at all possible, as the landscape itself might make.

From the 1820s on, three painters in particular introduced significant innovations which the Impressionists were later to draw upon: J. M. W. Turner (1775–1851),[35] Constable, and Richard Parkes Bonington (1801–1828).[36] Turner took his bearings in part from the 17th-century Dutch seascape tradition and from dramatic 18th-century shipwreck scenes which we can consider an early stage in Romantic art. While Romanticism in general was to leave the Impressionists fairly unmoved, Turner's leaning towards a profoundly meditative, historical-cum-philosophical approach to pictorial content offered a variant of Romantic art that remained important. His idiosyncratic version of the Romantic view of Nature included a unique eye for the expressive atmospherics of light and colour phenomena.

In fact, Turner concentrated so intensely on these effects that the late paintings of sunlight seen breaking through haze or mist could often

J. M. W. Turner
Cathedral Church, Lincoln, 1795
Watercolour over crayon, 45 x 35 cm
London, British Museum

J. M. W. Turner
Yacht Approaching the Coast, c. 1838–1840
Oil on canvas, 102 x 142 cm
London, The Tate Gallery

J. M. W. Turner
Rain, Steam and Speed – The Great Western
Railway, 1844
Oil on canvas, 91 x 122 cm
London, National Gallery

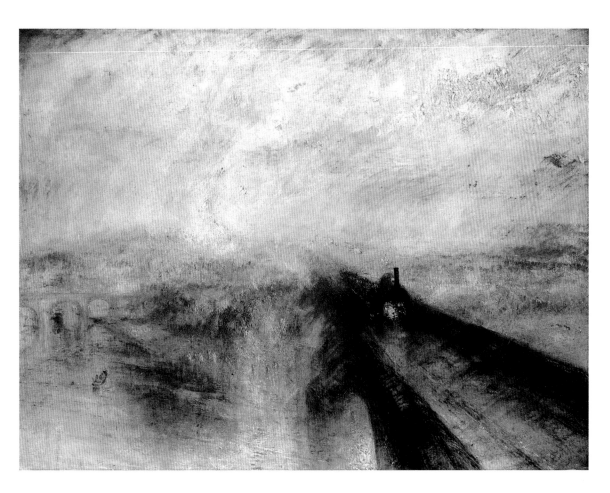

Charles-François Daubigny
The Pool at Gylieu, 1853
L'étang de Gylieu
Oil on canvas, 62.2 x 99.7 cm
Cincinnati, Cincinnati Art Museum

John Constable
Elm Trees in Old Hall Park, East Bergholt, 1817
Pencil on paper, 59.2 x 49.4 cm
London, Victoria and Albert Museum

become almost non-representational, abstract constructs of loose, amorphous whirls and smears of colour (p. 21). The visionary, supra-real character of such works was matched by their titles; in other paintings (and again in their detailed, descriptive titles) Turner was aiming at a quality of reportage (one thinks of his famous experience of a storm on shipboard, for instance), or else displayed his alertness to the latest technology of his times. One of the latter works is *Rain, Steam and Speed – The Great Western Railway* (p. 21). Since their invention there, steam railways had been revolutionizing the transport of freight and people in England; the same was true in other countries too from the 1830s on. A new era of communications had dawned. Trains raced along their tracks at speeds that had previously been impossible, smoking and steaming, crossing viaducts, cutting through country that used to be peaceful and idyllic. The experience was a new one, and many – such as Wordsworth – were shocked. Painters tended to be fascinated by the railways as subjects for art. The picture Turner painted when he was almost seventy uses superlative composition and technique to express the spatial sovereignty and speedy thrust of the new technology, both its audacity and its danger. To many contemporaries, paintings such as this – which shares the visionary use of colour and form so characteristic of Turner's mature and late work – could often seem the incomprehensible extravagance of a madman.

The earlier innovations of a Constable were certainly more accessible. This painter, by no means universally esteemed in England during his lifetime, almost exclusively painted the landscape and villages of his home, Suffolk, and the outlying areas of London (p. 18). While his work was in many respects a continuation of 17th-century Dutch art, Constable did take a significant step forward in the core sensuousness of art taken from life, by recording the colour impressions that his subjects made upon him in meticulous nuances, though with a sketcher's disregard for exact detail; above all, he introduced brighter light. Simple

Théodore Rousseau
Clump of Oaks, Apremont, 1852
Groupe de chênes, Apremont
Oil on canvas, 63.5 x 99.5 cm
Paris, Musée du Louvre

motifs, things accessible to everyone, were being more highly valued by the aesthetics of the time, and in his choice of undramatic subjects Constable was squarely in line with this key development in 19th-century art. In France too, where Constable's work became familiar from the 1820s on, younger artists were astounded and delighted to see how freshly and with what subtle nuances a green, say, might be painted.

Bonington, who died young, lived mainly in Paris. His art represented the earliest English component in the prehistory of Impressionism, in terms of a broad influence on taste. Principally a watercolourist and lithographer, he was one of a loose association of English and French artists. Their landscapes and townscapes, as well as their historical genre scenes (i.e. everyday life in times past), were popular with a largely middle-class clientele on both sides of the Channel. Bonington's work, in the tradition of English watercolour art which in the same period produced John Sell Cotman and John Varley, was prized for its light touch and spontaneity, and also for its brightness: *Water Basin at Versailles* (p. 19) is a fine example. It is an art that involves the observer more closely and directly in the individual experience of the artist and the specifics of a particular visual experience. Bonington was encouraging the public to value a personal viewpoint, the effects of colour made possible by seemingly unimportant objects or unexpected juxtapositions of objects, and the idiosyncratic qualities of a personal signature. As early as 1824, the conveying of an optical illusion was seen by Parisians as the "English method".[37]

Gros and Corot were struck by Richard Parkes Bonington's work, and Delacroix was already his friend when in 1818 he saw John Constable's *Hay Wain*. Delacroix saw Bonington, and possibly Turner, Constable and others, when he travelled to London in 1825 in order to study English innovations more closely. It was the English influence on Delacroix's art in particular that made his paintings so interesting to the Impressionists.

Art and Reality

In subject matter and approach, Delacroix had much in common with the Romantic school that was being established in his day; but differences in their ideas of what art was, as well as in the quality of work produced, prompted him to keep his distance. The solitary genius declined to be associated with a movement that achieved rapid success and popularity. The Romantics painted historical and literary scenes full of effects and moving touches; their picturesque landscapes and imaginary folklore subjects were done in smooth colours with fine-pointed brushes.[38] The Impressionists were having none of this. Only the history and genre painter Ernest Meissonier (1815–1891) achieved a higher level, in his hyper-precise and often small-format pictures, which were soon fetching exorbitant prices (p. 27).

Another broad, predominant current in 19th-century art was steadily gaining ground, though widely differing emphases were placed within the movement. The only word we have to describe this current is the rather tired word "realism".[39] Realist painters trusted the evidence of their own eyes and aimed to open a window on the world; given this aim, it was easy to link epistemological, ethical, social or political factors. For the realists, there was no doubt that what could be seen was real. The visible world was the given reality, and works of art were supposed to present a copy of it, a copy that was "true to Nature". The fidelity that produced verisimilitude had to be learnt, and achieving it required hard work in every individual case. And seeing itself, though a universal human capacity, called for practice if finer skill were to be acquired. Draughtsmen and painters found that in working on their art they developed new ways of seeing: the images they made of Nature taught them to look at Nature in new ways.

For the evolution of realism, the landscape and genre painters of the Barbizon School were of the greatest importance.[40] The use of the term "school" alluded to the museum terminology for grouping older works of art linked by regional origin – though the word had of course also been used in other senses by then (the "Romantic school"). In point of fact it was only in retrospect, in 1890 for the first time, that critics and art dealers referred to a Barbizon School. At times they also spoke of the "generation of 1830". In the 1830s, younger artists tended with ever greater frequency to do their studies from Nature in the woods near the palace of Fontainebleau, some sixty kilometres south-east of Paris. There lay the village of Barbizon.

It was gently undulating country, with boggy hollows, gnarled oaks and curious rocky outcrops: landscape spartan but various, and of that identifiably northern character that supplied the early 19th century with aesthetic and emotional values to be used as a counterbalance to "classical" Italy. As early as 1800, the landscape painter Pierre-Henri de Valenciennes (1750–1819), a member of the Paris Academy of Art, had published a textbook in which he contrasted faithful "landscape portraiture" with "historical [or] pastoral landscapes" that tended to be liter-

"The Angelus". Postcard after Millet's painting (right), 1905

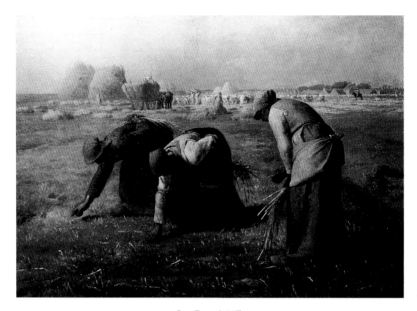

Jean-François Millet
Gleaners, 1857
Les glaneuses
Oil on canvas, 83.5 x 111 cm
Paris, Musée d'Orsay

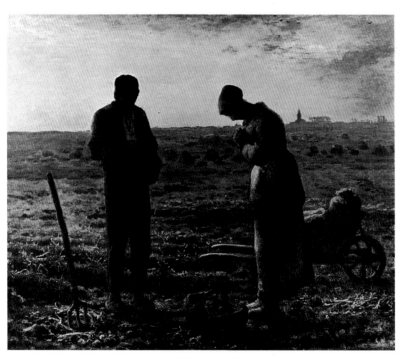

Jean-François Millet
The Angelus, c. 1859/60
L'angélus
Oil on canvas, 55.5 x 66 cm
Paris, Musée d'Orsay

Gustave Courbet
Girls on the Bank of the Seine, 1857
Les demoiselles des bords de la Seine
Oil on canvas, 173.5 x 206.5 cm
Fernier 203. Paris, Musée du Petit Palais

ary in conception and were largely imaginary. In making the contrast he took 17th-century Dutch and Flemish art as the model to be followed, rather than Italian art or the work of the French classical artist Nicolas Poussin (1593–1665).

Observing Nature closely inevitably drew the attention of painters to shifting conditions of light and their relevance to colour. An interest in these matters was almost universal in Europe in that period. We have already seen that English artists made a contribution of particular significance. In the decades that followed, though, a new landscape art came into being in the woods at Fontainebleau, at Barbizon, and in a small number of other places. Taking simple motifs, and emphasizing fidelity to the appearance of things, this new realistic landscape art was to exert a far-reaching influence on the history of art, partly because the artists working (often together) in these places were extremely gifted, but mainly because of the proximity to Paris, which was further consolidating its position as the art capital of Europe.

If young French artists took to the Fontainebleau woods, it was partly because of their dissatisfaction with political and social conditions under the July Monarchy that followed the revolution of July 1830. The regime of Louis Philippe, known as the bourgeois monarch, was corrupt. Many an artist felt that "back to Nature" was the better, more sensible alternative. By 1857, Jules-Antoine Castagnary (1830–1888), the critic, felt that the revival of landscape art reflected the fact that society, dissatisfied with itself, was seeking out the tranquillity of the forests and fields.[41] This retreat from the principal arena of modern social conflict was accompanied by the fight against the Academy's classical doctrine of art. For the Academy, realistic landscape art remained the lowest aesthetic denominator, so to speak; the same applied to scenes of everyday life featuring ordinary people – and in particular the peasants, farmers,

Ernest Meissonier
The Reader, 1857
Le liseur blanc
Oil on canvas, 21.5 x 15.5 cm
Paris, Musée d'Orsay

labourers and herdsmen living around Barbizon. In art they could only be the *petit genre* – or, as it came to be called, genre painting. Human fellow-feeling or compassion with the socially underprivileged might well play a part in the artist's choice of subject; if it did so, however, it would merely be seen as expressing traditional curiosity, and the product would be dismissively labelled "picturesque".

The core of the Barbizon school consisted of Théodore Rousseau (1812–1867) and his friend Jules Dupré (1811–1889), Charles-François Daubigny (1817–1878), the Spanish painter Narcisse Diaz de la Peña (1807–1876), the animal painter Constant Troyon (1810–1865) and the presiding elder spirit, Camille Corot (1796–1875).[42] There was also Jean-François Millet (1814–1875),[43] who arrived at Barbizon with his rather curious companion Charles Jacque (1813–1894) as late as 1847. Rousseau's clumps of trees, craggy rocks in forest clearings and extensive river landscapes viewed in gentle, muted light have a serious emotional charge, verging on piety, in such works as the 1852 *Clump of Oaks, Apremont* (p. 23). Daubigny loved plains, fields seen in bright light, and, above all, pond water (p. 22) and the tranquil banks of the Seine and the Oise, which he painted from his boat, Le Botin, from 1856 onwards.

Corot had visited the woods at Fontainebleau as early as 1822 to paint studies. He then spent three years in Italy, brightening his palette and taking a calm, essentially middle-class and private look at the great historical buildings of the country. After his return to France, he regularly went to the villages and small towns near the Fontainebleau woods to paint. He used a silvery shimmer to endow the trees and houses with an understated magic – a magic that steadily cast its spell on fellow-artists and connoisseurs of art throughout Europe (pp. 29 and 30).

Millet met the Rousseau group in the period after 1846, and at Barbizon in 1849 he finally found the most eloquent backdrop for his scenes of decent hard work and the life of poor farmers and labourers. Figures and compositions such as the *Gleaners* or the couple at prayer in *The Angelus* (p. 25) presented a passionately held socio-philosophical aesthetic in a pointed, almost confrontational manner; as time went by, they

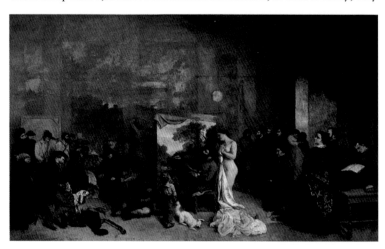

Gustave Courbet
The Artist's Studio, 1854/55
L'atelier du peintre
Oil on canvas, 359 x 598 cm
Fernier 165. Paris, Musée d'Orsay

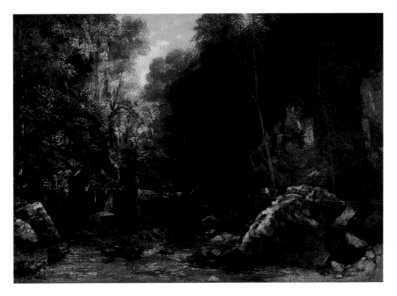

came to be seen worldwide as models for an agrarian art with ethical roots in the soil of home.

In many respects, Millet's approach to art overlapped with that of Gustave Courbet (1819–1877).[44] His was the most invigorating contribution to the evolution of 19th-century realism in painting, and it also had the most far-reaching consequences. Courbet's personality and his preferred range of subjects were rooted in the farming lower classes and in the craggy, wooded landscape of his home parts on the fringes of the Jura mountains. Later, however, he also turned to the coast of Normandy (p. 31) and (unlike the Barbizon painters) to certain aspects of city life in Paris, seen in *Girls on the Bank of the Seine* (p. 26). He was a pugnacious man, with strong republican convictions, and a vehement advocate not only of his own views on art but also of their social and political implications: for him, art was ultimately political in function. Through his own work, he definitively made realism a central concept in artistic debate, and for a lengthy period he established the term as the description of a particular style. Although Courbet himself did not always abide by the precept, he asserted that only the reality seen by the artist could be the point of departure, and evaluative criterion, for a work of realist art. For this reason he excluded historical, mythological and religious art – indeed all art of purely imaginary origin – from his definition of realist art.

Courbet's paintings are milestones in the history of 19th-century art, thanks to his core artistic vision, the physical power of his heavy, earthy paint (substantially applied, at times with a spatula) and the provocative, plebeian force that informs many of the figures in his works. His most important paintings include the immense *Burial at Ornans* (1849/59; Paris, Musée d'Orsay); *The Stone Breakers* (1849; formerly Dresden, Gemäldegalerie, but lost in the War); the rather enigmatic programmatic

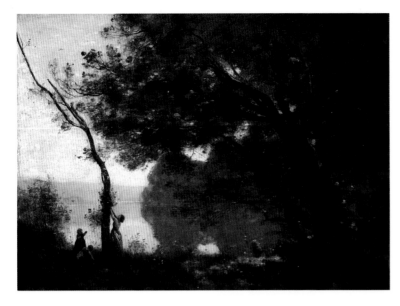

Camille Corot
Memory of Mortefontaine, 1864
Souvenir de Mortefontaine
Oil on canvas, 65 x 89 cm
Robaut 1559. Paris, Musée du Louvre

picture *The Artist's Studio* (p. 27); *Girls on the Bank of the Seine* (or, to be exact, whores); various versions of *The Wave* (about 1870); and his paintings of the French Channel coast, such as *The Cliff at Etretat after the Storm* (p. 31). Courbet's work fascinated many younger artists, and differing views of art were necessarily defined in relation to his.

Art in Paris around 1860

The influence of these artists on the Paris art scene at the beginning of the 1860s varied. Aesthetic positions of every description, as well as shares in the art public's attention and respect and in the market, had to be competed for and constantly reasserted. The conditions that prevailed in the art world,[45] reflecting conditions in general and the frequent shifts in various social and political groupings' power and interests, were not normally favourable to those who espoused reality, Nature and light.

In France, the economic and social structures of capitalism evolved rapidly and forcefully. The Second Empire – created in 1852 when Napoleon's nephew Charles Louis Napoléon Bonaparte (1808–1873), who had been elected President of the French republic in 1848, proclaimed himself Emperor Napoleon III of France – sought to create the best possible political atmosphere for capitalism. Development of the means of production and the overall acceleration of industrialization affected life profoundly. In Paris, the most striking change was in the city's urban structure, brought about by the Prefect of the Seine Département, Georges Haussmann (1809–1891). In terms of foreign policy, Napoleon III hoped to augment French power and global influence, with a competitive eye on the position of Britain.

Emperor Napoleon III, Charles Louis Napoleon Bonaparte (1808–1873). Photo: Disdéri

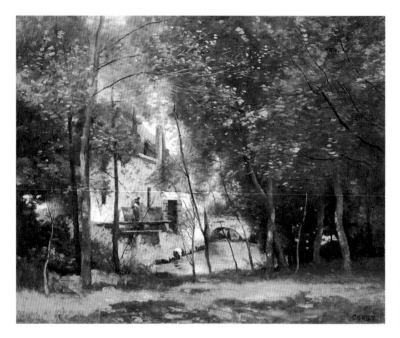

Camille Corot
The Mill at Saint-Nicolas-les-Arras, 1874
Le moulin de Saint-Nicolas-les-Arras
Oil on canvas, 65.5 x 81 cm
Robaut 2184. Paris, Musée d'Orsay

In 1855, to enhance the standing of France and the French economy, a World Fair was held in Paris, the second of its kind following the success of the Great Exhibition in London in 1851.[46] At the Paris fair, the programme included a large-scale art exhibition, with the aim of consolidating the international significance of French art, the market for that art, and the status of Paris as an art centre and an arbiter of taste and style. From then on, the great world fairs – the next were again in London (1862) and Paris (1867) – were also events in the ongoing history of art; and that first French *Exposition universelle* in 1855 was an art event in a number of ways.

Over five thousand paintings, as well as sculptures and other works, afforded the visitor a comparative overview of contemporary European art. In the French section, the two rivals Ingres and Delacroix were juxtaposed. The panel of assessors, dominated by Academy classicists and historicists, accepted only a very few works by Corot, the other Barbizon painters, and particularly Millet; as for Courbet, he was so seriously underrepresented that he decided to put his work on show independently, near the exhibition centre. This was by no means usual; it was also a costly, risky business. The traditional approach was for artists to make a major new work, or a small selection of works, accessible to public view in their own studios.[47] Courbet, however, had a pavilion built especially for his own work, and called the show quite simply: "Realism. Gustave Courbet".

The centrepiece of the show was *The Artist's Studio*, a huge programmatic painting. It is a complex work. Its iconography is multivalent, and the aesthetic programme advanced in it has been variously interpreted and evaluated; to this day, it remains one of the most debated 19th-

The cliffs at Etretat. Photograph, c. 1910

century pictures. Neither the impenetrable full title – *The Artist's Studio, a Real Allegory, Covering a Period of Seven Years in My Artistic Work* – nor the explanatory accounts Courbet offered a number of friends makes an unambiguous interpretation feasible. In the present context it is of particular importance that in this painting Courbet – who generally preferred to advance his concept of realism in connection with figural work – shows the artist (who quite clearly bears his own features) at work on a landscape. In doing so, he is emphasizing the significance of landscape art for realism, and he is assigning to Nature (as an aesthetic category) a central place in his aesthetic programme – which in turn was a component of an overall utopian view of culture and society. "To paint out in Nature, amongst natural people, in a natural way" – as the German painter Wilhelm Leibl (1844–1900) put it[48] a quarter of a century later – became a fundamental article of faith for realist artists everywhere. In Courbet's picture, the natural people are those seen taking the first look at the new landscape being painted: the model, an ordinary woman presented in natural nakedness, and a child, bearing the hopes of the future.

Gustave Courbet
The Cliff at Etretat after the Storm, 1870
La falaise d'Etretat après l'orage
Oil on canvas, 133 x 162 cm
Fernier 745. Paris, Musée d'Orsay

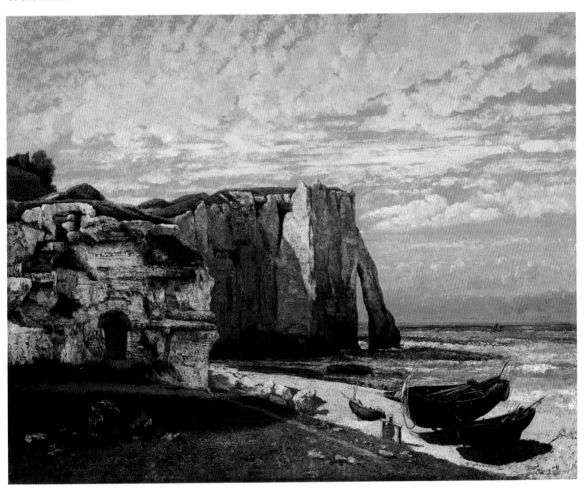

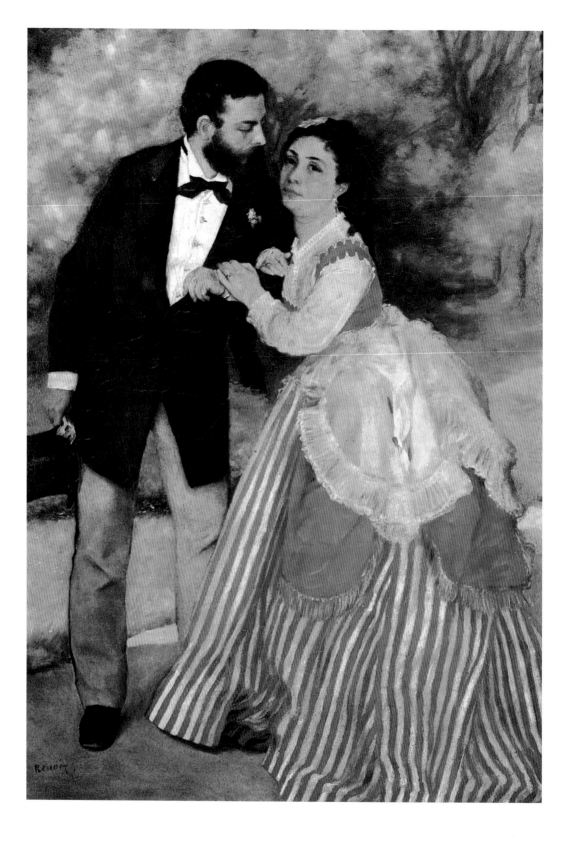

3 A New Generation

The World Fair and the Courbet exhibition naturally attracted the attention of the artists who were later to be the Impressionists, or at least those who were old enough to take an interest. Over the next few years, all of them were to embark on a life in art; they met and established their own creeds as artists.

Pissarro was the eldest. Subsequently the most unwavering of them all in his advocacy of the original principles of Impressionism, he was also the only one to show work at every one of their group exhibitions. He was the son of pious Jewish parents who had moved from southern France to the West Indies. There Camille was born at Charlotte-Amalie on Saint-Thomas, an island in the Antilles, then a Danish colony. His father intended the lad to go into business too, and sent him to school in the Paris suburb of Passy from 1842 to 1847, where Camille drew from Nature and visited museums. Back on Saint-Thomas, he became the friend of Fritz Melbye, a Danish painter, and in 1852 together with him he fled his father's business world to lead an artist's life in Caracas. Pissarro senior finally acceded to his son's professional wishes, and in 1855 sent him to receive proper training in Paris, where he was supported by another branch of the family. Pissarro did not embark on serious art study, though, preferring to make occasional use of the facilities of the Académie Suisse on the Quai des Orfèvres, from about 1859 on. Charles Suisse had himself modelled for artists, and now earned a living by putting a studio and nude models at the disposal of artists for a modest fee. No tuition was offered; but painters who proposed to do figural work needed to study the nude in various positions, and hiring models for one's own use was expensive, so a fair number of artists did make use of Suisse's facilities. By doing so they also met other artists and benefitted from advice. At the Académie Suisse, Pissarro presently met Monet, Guillaumin and Cézanne.

He painted landscapes at a number of villages outside Paris, preferring the banks of the Seine, Marne and Oise. In his style he followed Corot, whose work he had admired at the 1855 World Fair and with whom he had sought personal contact. Courbet influenced him too, in his coloration. In 1859 he submitted work to the Salon for the first time, and was accepted. In the early 1860s he moved in with Julie Vellay, the daughter of a wine-grower in Burgundy who was working as a maid for his par-

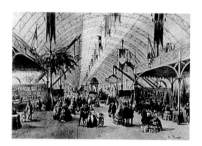

The Machine Hall at the World Fair, Paris, 1855. Lithograph

Pierre-Auguste Renoir
Alfred Sisley and his Wife, 1868
Les fiancés
Oil on canvas, 105 x 75 cm
Daulte 34. Cologne, Wallraf-Richartz-Museum

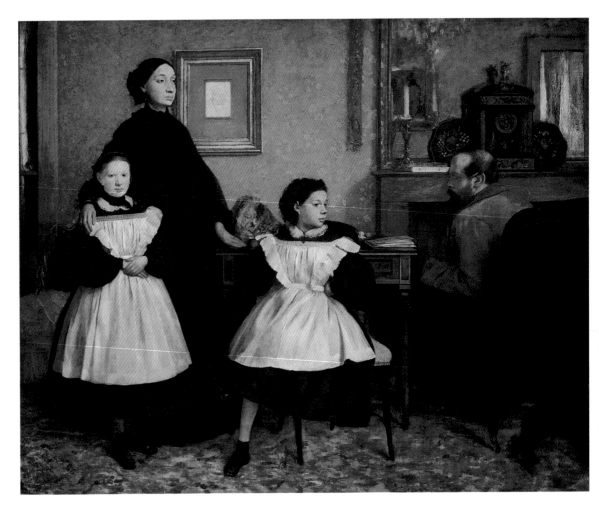

Edgar Degas
The Bellelli Family, 1858–1860
La famille Bellelli
Oil on canvas, 200 x 250 cm
Lemoisne 79. Paris, Musée d'Orsay

The beach at Trouville. Lithograph by Adolphe
Maugendre, 1867

ents. Their first son, Lucien, who was to become a talented graphic artist
as well as a painter in his own right, was born in 1863. Pissarro and Julie
married in 1871, by which time three of their eight children had already
been born. It was a large family, and for a long time they lived in de-
cidedly modest circumstances.

Manet's beginnings as an artist were altogether different. He came of
a well-to-do family, its menfolk civil servants and army officers. He went
to a good school, and grew up in cultivated *haute bourgeoisie* surround-
ings. His father was opposed initially to Manet's wish to become a
painter, but then from 1850 to 1856 he was permitted to study under
Thomas Couture (1815–1879)[49] at the Ecole des Beaux-Arts. The latter
was a gifted neo-Renaissance painter; though himself a business-minded
"reluctant *bourgeois*" (Pierre Vaisse),[50] he held society in moral disdain.
Manet was to retain a certain respect for his teacher his whole life long,
although in his own art he struck out in quite different directions, but he
suffered under Couture's method of instruction, which called for an im-
personal sense of the ideal, while Couture's poisonous attacks on Dela-

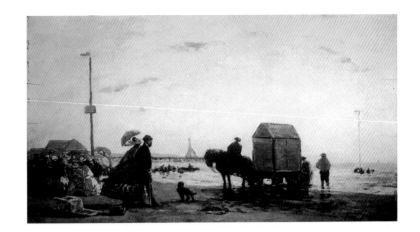

Eugène-Louis Boudin
Beach Scene, Trouville, 1863
La plage à Trouville
Oil on panel, 25.4 x 45.8 cm
New York, The Metropolitan Museum of Art

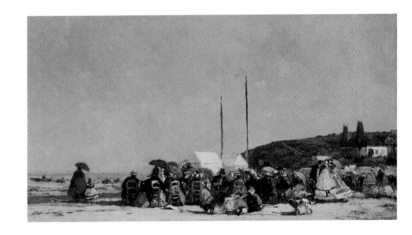

Eugène-Louis Boudin
Beach Scene, Trouville, 1864
La plage à Trouville
Oil on panel, 26 x 48 cm
Schmit 258. Paris, Musée d'Orsay

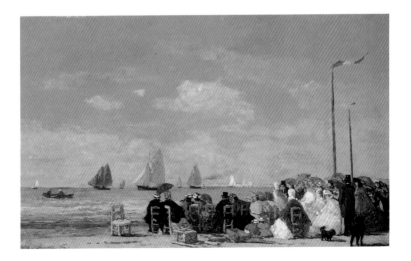

Eugène-Louis Boudin
Beach Scene, Trouville, 1863
La plage à Trouville
Oil on panel, 34.9 x 57.8 cm
Schmit 274
Washington, National Gallery of Art,
Mr. and Mrs. Paul Mellon Collection

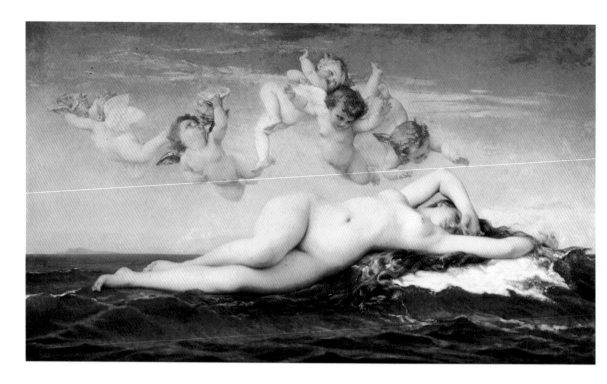

Alexandre Cabanel
The Birth of Venus, 1863
La naissance de Vénus
Oil on canvas, 130 x 225 cm
Paris, Musée d'Orsay

Edouard Manet
Le déjeuner sur l'herbe (study), 1862/63
Watercolour, pencil, pen and ink,
37 x 46.8 cm
Rouart/Wildenstein II,306
Oxford, The Visitors of the Ashmolean Museum

croix, Rousseau or Courbet repelled him. The artificial light in the studio and the equally artificial poses of the models only made matters worse. "I paint what I see, and not what others choose to see", was Manet's response to academic doctrine; and his emphasis on the legitimacy of a subjective viewpoint was as important as the stress he placed on looking rather than acquiring conventions and rules. Still, from today's perspective what links Manet to Couture (who is seen as representing eclecticism or historicism) is his high regard for the humanist legacy of figural painting with a moral message, and the use of visual quotations from the art of the past. When Manet had completed his studies he moved into a studio of his own, and visited the great museums of Holland, Germany and Italy. In 1852 his son by a Dutch piano teacher, Suzanne Leenhoff, had been born; Manet and Leenhoff married in 1863, when his father's death left Manet financially independent and indeed affluent. For public purposes, the son, Léon-Edouard Leenhoff, who often served as a model for Manet, was described as Suzanne's little brother and the artist's godson.

In his early paintings, Manet applied the paint with a thick, even pastose richness, using dark backgrounds and compositional components that recalled Dutch and, above all, Spanish art of the 17th century. A "Spanish" approach became fashionable among realistic and historical painters alike, its influence consolidated by Napoleon III's Empress, Eugénie, who was a Spanish countess and did much to promote the music, dance and dress fashions of Spain.

There was a recognisably Spanish flavour to the *Absinth Drinker*

(1858; Copenhagen, Ny Carlsberg Glyptotek) which Manet submitted to the Salon in 1859 (his first submission) and which was turned down by the jury over Delacroix's vote in favour. Couture reprimanded his former student for making a character from the twilit fringes of society the subject of a full-figure, almost life-size portrait. "Is one really to paint such repugnant subjects? My dear friend, you yourself are the absinth drinker. You are the one who has lost his hold on morality."[51] Before Impressionism had properly begun, in other words, the coming aesthetic debate on individual rebellion, the use of pictorial conventions for material hitherto considered inappropriate, and the interconnections of aesthetic with moral (and ultimately socio-political) values had already been sketched in.

Manet had hit upon a procedure that was to characterize much of his subsequent work: by adapting available visual figures and their expressive values to contemporary reality he was able to experiment with the productive contrasts and incompatibilities that became apparent. He made copies of 16th- and 17th-century art in order to master its strategies and roamed Paris, which was in a state of rapid change, prob-

Edouard Manet
Le déjeuner sur l'herbe, 1863
Oil on canvas, 208 x 264.5 cm
Rouart/Wildenstein I,67. Paris, Musée d'Orsay

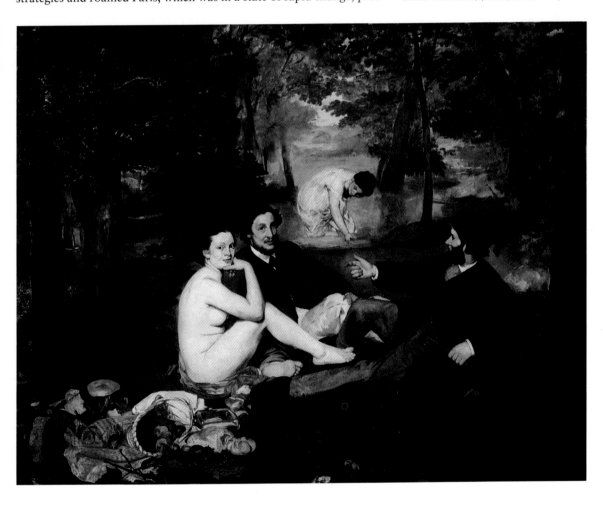

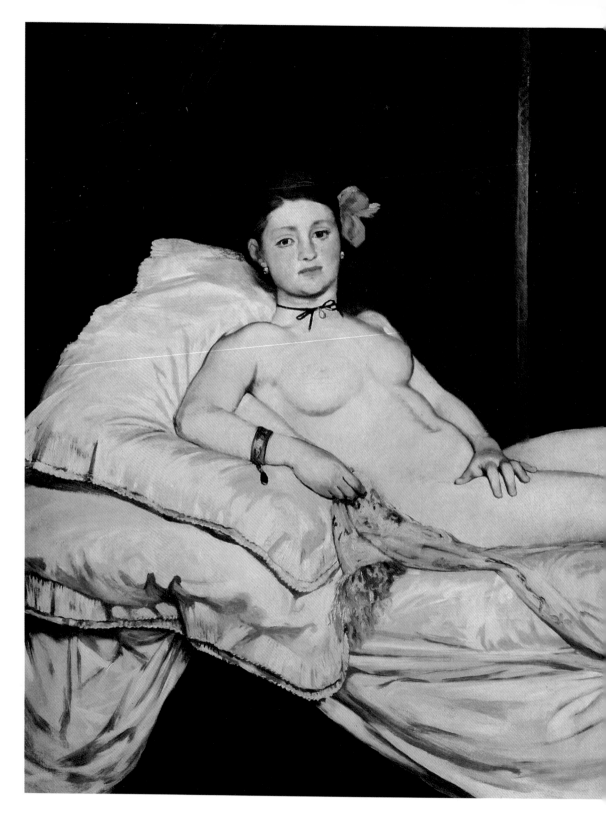

Edouard Manet
Olympia, 1863
Oil on canvas,
130.5 x 190 cm
Rouart/Wildenstein I,69
Paris, Musée d'Orsay

ing the city's subtlest secrets. He became a flâneur – that new type of man about town later so profoundly analysed by Walter Benjamin. The flâneur accepts the workings of chance. Himself moving in his own irregular way, he is the observer of a world in constant flux. He is attentive but remains uninvolved at heart. He is unprejudiced and does not leap to judgemental conclusions. Antonin Proust (1832–1905), Manet's former schoolmate and his lifelong friend, later (with the benefit of culturally enriched hindsight) left an account of their strolls as flâneurs as the 1860s arrived. Along the boulevards, he reported, Manet would draw in his notebook "nothing at all: a profile, a hat – in a word, a fleeting impression". He saw white-clad demolition workers seen in a cloud of white dust against a white wall as "the symphony in white that Théophile Gautier refers to".[52] Gautier (1811–1872), the poet and novelist, was also an art critic, an influential man with government contacts. And *Symphony in White* (cf. Volume Two, p. 573) was the innovative title the American painter James Abbott McNeill Whistler (1834–1903), an acquaintance of Manet's, gave to a portrait of a girl which attracted attention in Paris in 1863.

Manet made his debut appearance in the Salon in 1861 with a painting that was still Spanish in style but which found favour and indeed was given an honourable mention (the lowest distinction available). His portrait of the Spanish dancer *Lola de Valence* (p. 47) was of a similar kind. Her costume, painted in bold, solid colours, doubtless constituted the main attraction of the task for the artist. In March 1863 he held his first solo exhibition at Louis Martinet's gallery on the Boulevard des Italiens. One picture that drew on his flâneur observations, *Music at the Tuileries* (p. 43), met with a poor response. At that time, with the imperial palace of the Tuileries still intact, society people would flock to the gardens to see and be seen. A military band (not in Manet's painting) would be playing and people would meet there to talk, among them Manet himself, who often went there after lunch at Tortoni's, with his new friend the poet Charles Baudelaire (1821–1867),[53] spent the afternoons drawing, and later showed his studies to friends – artists, writers and critics alert to his work – back at Tortoni's. This was also the period when Manet and Degas became friends.

Parts of *Music at the Tuileries* are sketchily painted or indeed left unfinished. The crowd of people is only partly resolved into isolated groups engaged in conversation. There are neither a central focus in the composition nor any main figures. The cropping of figures at the edges – the figure cropped at left is Manet himself, seen behind his equally stylish fellow-painter Albert de Balleroy (1828–1873) – emphasizes that what we are seeing is a slice of life. It was an approach that flew in the face of established ideas of unity. Garden chairs and a parasol are given prominent positions in the foreground. The picture is bright, but no light source can be identified. The paint is applied everywhere with equal vigour and generosity, though the definition of shapes does slacken from the left of the canvas to the right. People in the art scene would recognise some of those portrayed in the picture: the man standing somewhat to

Claude Monet
Le déjeuner sur l'herbe (study), 1865
Oil on canvas, 130 x 181 cm
Wildenstein 62
Moscow, Pushkin Museum of Fine Art

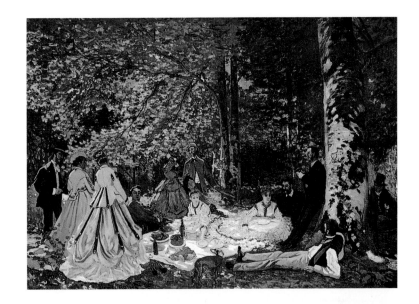

Claude Monet
Le déjeuner sur l'herbe (centre section), 1865
Oil on canvas, 248 x 217 cm
Wildenstein 63B
Paris, Musée d'Orsay

Left:
Claude Monet
The Walkers (Bazille and Camille), 1865
Les promeneurs (Bazille et Camille)
Oil on canvas, 93 x 69 cm
Wildenstein 61
Washington, National Gallery of Art,
Ailsa Mellon Bruce Collection

Claude Monet
Le déjeuner sur l'herbe (left section), 1865
Oil on canvas, 418 x 150 cm
Wildenstein 63A. Paris, Musée d'Orsay

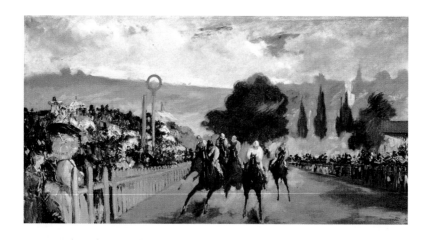

Edouard Manet
The Races at Longchamp, c. 1865–1867
Courses à Longchamp
Oil on canvas, 43.9 x 84.5 cm
Rouart/Wildenstein I,98
Chicago, The Art Institute of Chicago

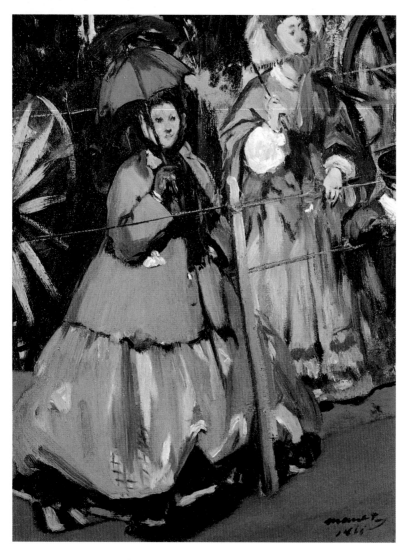

Edouard Manet
At Longchamp Racecourse, 1864
Champ de courses à Longchamp
Oil on canvas, 42.2 x 32.1 cm
Rouart/Wildenstein I,95
Cincinnati, Cincinnati Art Museum

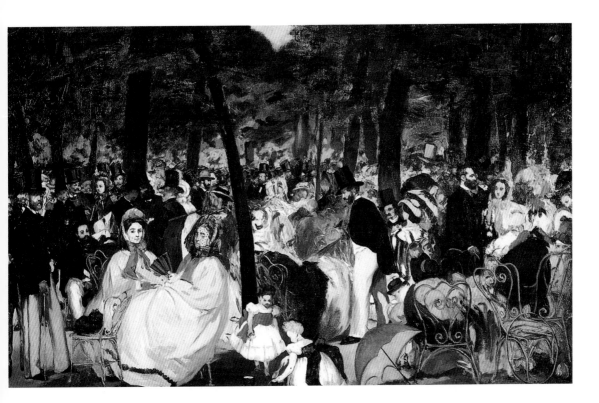

the right of centre is Manet's brother Eugène (1833–1892), and the man sitting behind him, in front of a tree, is the composer Jacques Offenbach (1819–1880), who had just scored his first great hit with "Orphée aux enfers" (1858), a delicious spoof on classicism and the Second Empire. The group behind the two seated ladies at left includes Baudelaire and Gautier, whose opinions Manet valued, and a third person who has not been definitely identified but may be the Franco-Irish art patron Baron Isidore Taylor (1789–1879), one of the finest connoisseurs of Spanish art. *Music at the Tuileries*, which apparently remained unsold till 1882, resembles Courbet's *The Artist's Studio* in offering a programmatic view of a young artist's identification with a specific socio-cultural situation. In its compositional approach it opened up one of the various routes subsequently to be followed by the Impressionists.

Degas was close to Manet in terms of their social status, education and attitude to art. He was more of a figure painter than Manet, and took only a very occasional interest in landscapes. The natural light of open spaces was not for him; he preferred artificial light. As a result, some art historians have difficulty fitting him (and Manet) into a more narrowly conceived definition of Impressionism; but the fact is that he was a dedicated driving force behind the movement. It would not be possible to describe the new, Impressionist approach to art and reality in its full complexity without reference to Degas.

He was born into a well-to-do upper middle-class family with aristocratic connections; till 1873 he spelt his name in its original way, de Gas.

Edouard Manet
Music at the Tuileries, 1862
La musique aux Tuileries
Oil on canvas, 76.2 x 118.1 cm
Rouart/Wildenstein I,51
London, National Gallery

Edouard Manet
Horse Race, 1864
Course de chevaux
Lithograph, 36.5 x 51 cm

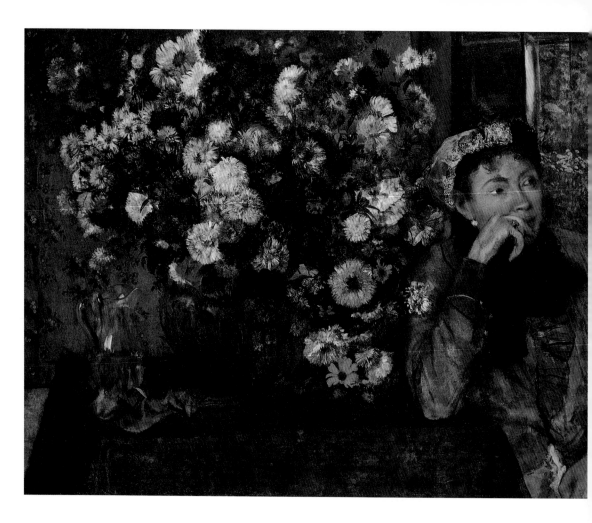

Edgar Degas
Woman with Chrysanthemums, 1865
Femme aux chrysanthèmes
Oil on canvas, 73.7 x 92.7 cm
Lemoisne 125
New York, The Metropolitan Museum of Art

His grandmother was Italian, his mother a Creole – that is, a French-woman born in America, in New Orleans (a French possession till 1803). He was educated to a high standard at the Lycée Louis-le-Grand, and while he was still at school his father, who was interested in art, allowed him to set up a studio at home. After briefly reading law, from 1853 on he studied under various artists, including Louis Lamothe, a pupil of Ingres, and for a short time was at the Ecole des Beaux-Arts. His guiding light was not Delacroix but the master draughtsman Ingres. He studied the art of the old masters closely in museums and on several visits to Italy. Where Manet rediscovered the attitudes of figures in older art in his contemporaries, however, Degas took the opposite approach, introducing a more modern and relaxed note into the figures in his history paintings.

Making copies of old masters in Italy, Degas was already outlining a programme of Impressionist representation of contemporary life in his diary. Unpublished till 1921, these entries, begun in 1859, included a list of subjects that he considered it important to study: musicians with

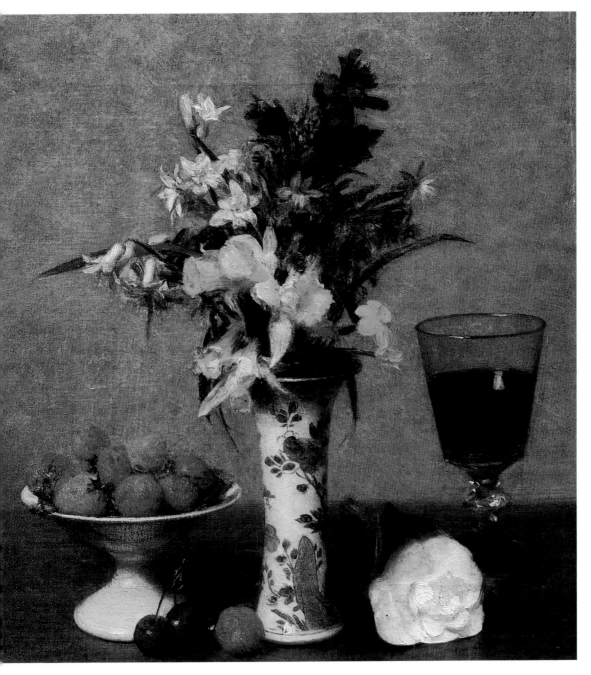

Henri Fantin-Latour
Still Life with Flowers and Fruit, 1865
Nature morte aux fleurs et fruits
Oil on canvas, 64 x 57 cm
Fantin-Latour 276 bis
Paris, Musée d'Orsay

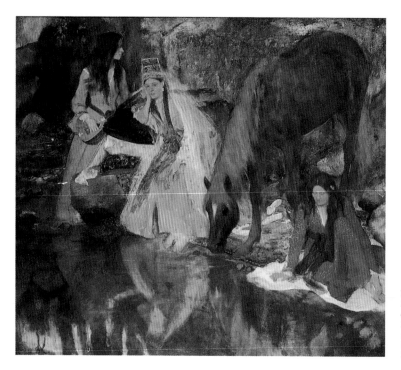

Edgar Degas
Mlle Eugénie Fiocre in the Ballet "La Source",
c. 1867/68
*Mlle Eugénie Fiocre à propos du ballet de
«La source»*
Oil on canvas, 130 x 145 cm
Lemoisne 146. New York, The Brooklyn Museum

various instruments, the smoke from cigarettes and from locomotives or steamships, "mourning" (a series using every kind of black), or "dancers of whom one can see only their bare legs, caught in mid-movement, or having their hair dressed; countless impressions; cafés in the evening with gas lamps turned up brighter or lower, the light reflected by mirrors..."[54] All of these motifs were to occur either in his own work or in that of others.

The subject of mourning was in Degas's mind when he painted the Bellellis in mourning in Florence in the late 1850s. *The Bellelli Family* (p. 34) is the earliest Impressionist masterpiece. Baron Gennaro Bellelli was an opponent of the Bourbons and a revolutionary of 1848, exiled from his Neapolitan home. The painting shows him with his wife Laura, the artist's aunt and daughter of the late Don Ilario de Gas, a banker in Naples; it also includes the couple's daughters. At twenty-four, Degas was already in full command of the portraitist's art. His interest was in the psychological state his subjects were in; compositionally, he opted (as he was to do so often in the future) for an arrangement that was all the more striking for being unfamiliar. At left we see the baroness, composed and dignified – although her hand makes a hard, nervous impression on the tabletop. Her daughter Giovanna's hands are clasped modestly before her as in Hans Holbein's *Anne of Cleves,* which Degas had copied in the Louvre just a short while previously. Solemnity is avoided, though, by the more relaxed position of her feet. As we look further to the right, the dignified front put up by this lifesize group becomes less persuasive. Giulietta, seated in the middle and occupying the most prominent posi-

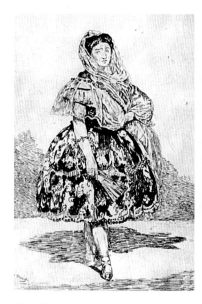

Edouard Manet
Lola de Valence, 1863
Etching and aquatint, 23.5 x 16.1 cm

tion in the painting, has a slightly coquettish air; she has drawn one leg up under her, so that it even looks as if she were one-legged. Degas's figures in later work often convey this impression. The girl is facing to the right, where her father, assigned a surprisingly minor role in the layout, is seen with his back to us, offering a shoulder and a profile half in shadow. He has been jammed in among furniture and a medley of interesting and colourful objects on the mantelpiece, where the interplay of real and mirror images provides a teasing conundrum.

At that date, marginalizing the father and head of the family in this way was the height of unconventionality. It was also unusual to undermine the seriousness of a family portrait by using relaxed poses. Degas was subverting the conventions. His group portrait has become a simple everyday scene. Though the people's gestures may suggest that they are indeed a family, belonging together, they are not looking at each other: their gazes go in different directions, their facial expressions are cool, and contact between them and us is thus minimalized. This casual coolness was to be a hallmark or leitmotiv throughout the figural work of Degas and the other Impressionists. Through it, the artists were articulating their responses to a prevailing mood of social austerity. They preferred

Edouard Manet
Lola de Valence, 1862 (to post-1867)
Oil on canvas, 123 x 92 cm
Rouart/Wildenstein I,53. Paris, Musée d'Orsay

Edouard Manet
The Fifer, 1866
Le fifre
Oil on canvas, 161 x 97 cm
Rouart/Wildenstein I,113. Paris, Musée d'Orsay

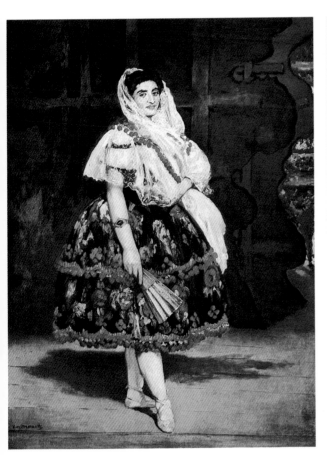

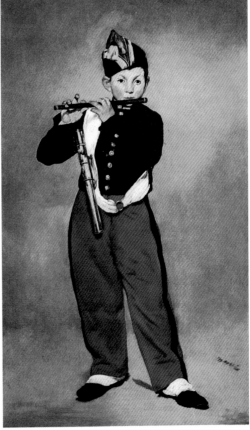

to show things as they truly saw them, and would not veil the facts by superimposing a sham emotional demonstrativeness. In the Bellelli picture, the inanimate objects in the room, the weighty tokens of wealth, furthermore have an oppressive presence. For instance, Degas has placed a hard gold picture frame right by the mother's head: it is a subtle and subtly disquieting effect, giving the picture-within-a-picture, a mere red chalk drawing on the wall, almost greater significance than a main character in the portrait. Degas worked on the painting over a lengthy period, not completing it till after his return to Paris in 1860; he kept it in his own possession till his death. It plainly had family as well as aesthetic meaning for him – and he had no financial need to sell it.

He made his first Salon submission in 1865. It was one of the five history paintings he did in all, but at the same time he had hit upon a modern subject that was to hold his interest for thirty years – horse racing. In 1861 he had gone to the races at Mesnil-Hubert with the Valpinçons, family friends, and in 1862 he continued his observations at Longchamp, a track laid out near Paris in 1854, where the first *Grand Prix* was being run that year. Both racing and its use as a subject for art had been imported from England over the past thirty years as a pastime for the aristocracy. In England, Théodore Géricault (1791–1824), one of the pre-eminent French Romantic artists of the early 19th century, had painted horses at the gallop in 1821, showing them in a way that had been accepted as correct since antiquity, with all four legs outstretched off the ground. In Degas's time, though, people had begun to wonder whether horses really did have all four legs simultaneously in the air. It was the photographer Eadweard Muybridge who supplied final proof in his motion studies done between 1872 and 1877 (p.71).[55] At first Degas

Right:
Claude Monet
Women in the Garden, 1866
Femmes au jardin
Oil on canvas, 255 x 205 cm
Wildenstein 67. Paris, Musée d'Orsay

Edouard Manet
Reading, 1865–1873
La lecture
Oil on canvas, 60.5 x 73.5 cm
Rouart/Wildenstein I,136
Paris, Musée d'Orsay

Edouard Manet
Repose. Portrait of Berthe Morisot, 1870
Le repos. Portrait de Berthe Morisot
Oil on canvas, 147.8 x 111 cm
Rouart/Wildenstein I,158
Providence (RI), Museum of Art,
Rhode Island School of Design

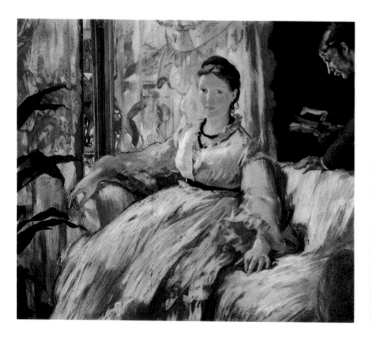

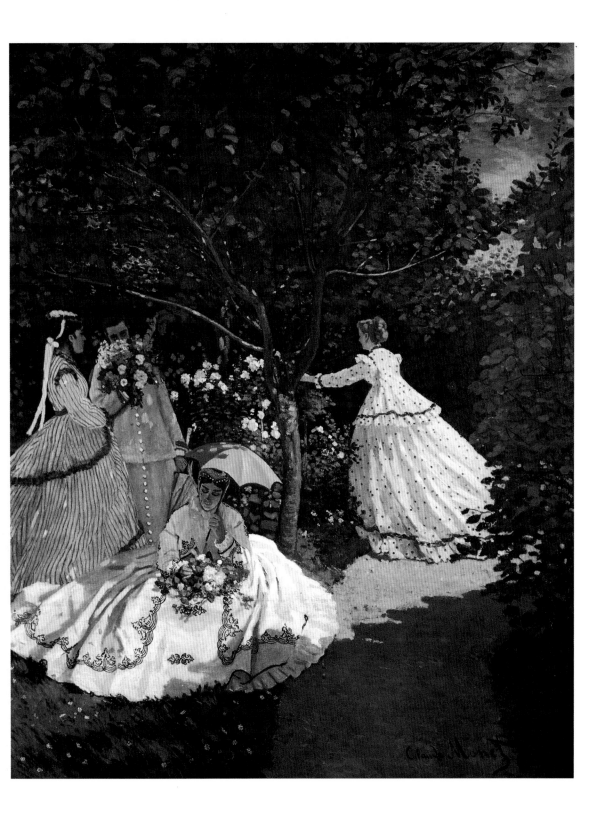

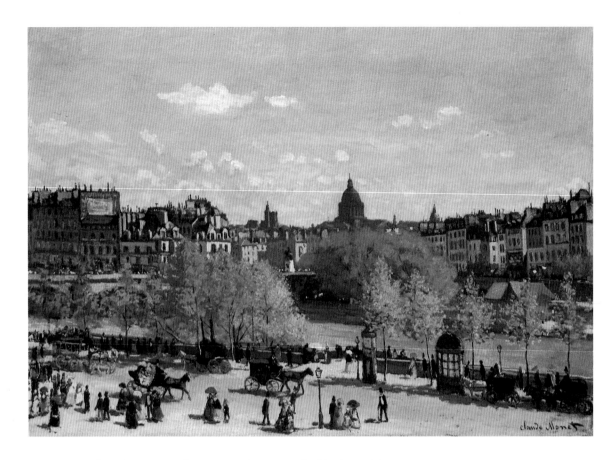

was interested in the process of getting ready to start; he liked watching the horses and riders in various states of tension and relaxation; and he was interested in racetrack society, from ladies in carriages to the jockeys in their colourful shirts. His paintings (cf. p. 10) used a restless patterning of colour patches and combined a precision rendering of positions with sketchy brushwork – especially for the background, where smoking factory chimneys or a glimpse of a railway train suggested the proximity of a modern city. Degas cropped his figures brusquely as if to emphasize that the picture could convey no more than a spatial and temporal section of a larger scene and continuing motion.

Monet, six years Degas's junior and ten years Pissarro's, had not yet found his way as an artist at this point. The eldest son of a Parisian shopkeeper who had moved to Le Havre for business reasons when Monet was five, he had to overcome financial and family obstacles in making art his life. At school his caricatures earned him fame and even a modest income, which he used in 1859 to pay for studies in Paris when his application for a state grant was turned down. He was confirmed in his wish to study art by an aunt who was an amateur artist, and above all by Eugène Boudin (1824–1898), a landscape painter who worked in Le Havre and along the coast of Normandy and whom Monet had met the year before.[56]

Claude Monet
Quai du Louvre, 1867
Oil on canvas, 65 x 93 cm
Wildenstein 83
The Hague, Haags Gemeentemuseum

Right:
Claude Monet
The Garden of the Infanta, 1867
Le jardin de l'infante
Oil on canvas, 91 x 62 cm
Wildenstein 85
Oberlin (OH), Allen Memorial Art Museum

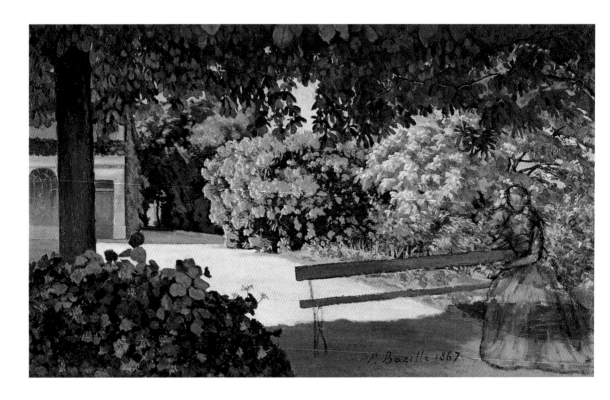

Frédéric Bazille
The Terrace at Méric (Oleander), 1867
Terrasse à Méric (Les lauriers-roses)
Oil on canvas, 56 x 98 cm
Daulte 26. Cincinnati, Cincinnati Art Museum

Boudin, the son of a Honfleur sailor, spent most of his life in seaside towns and concentrated on painting landscapes by the sea, everyday coastal scenes. The tradition he was following was primarily an English one; though Boudin did not paint ships at sea. Rendering precisely observed slices of Nature, and in particular the changing colour values of things seen in the open, sufficed for him aesthetically. Little by little the public began to respond to his work. The pictures he painted over the years in his loose, sketchy way did not, strictly speaking, possess any central subjects. Even his market or beach scenes present an extensive panorama of colour and economically deployed line accentuation. The atmosphere is bright, moist and highly sensitively registered (p. 35). Corot in old age was inevitably delighted; for his "meteorological beauties" he dubbed Boudin the "king of the skies". At first Monet, then young, was repelled; but work together on the spot opened his eyes and convinced him that (as Boudin put it) "one must be extraordinarily stubborn in abiding by the *impression primitive*".[57] Much later, Monet was to say: "If I became a painter it was thanks to Boudin."[58]

Monet had been intended for conventional Parisian academic training. Instead he merely frequented the Académie Suisse, meeting Pissarro and others there. The military service he had to see through in Algeria interrupted his studies for a few months; but then a severe bout of typhoid fever brought Monet home. Returned, he resumed work with Boudin and with the Dutch painter Johan Barthold Jongkind (1819–1891), who specialized in beach scenes. He even subsequently referred to Jongkind

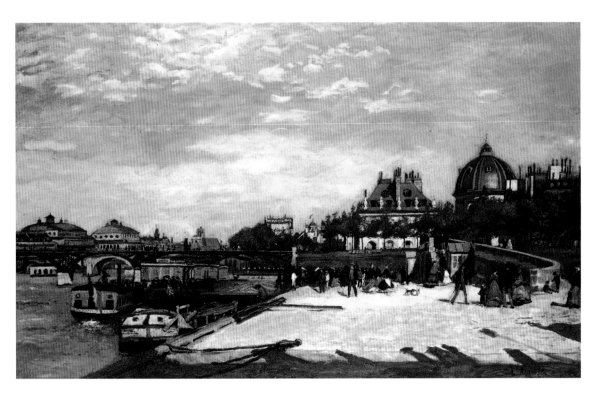

as his "true teacher".[59] Monet's aunt bought him out of service (which had lasted seven years in all) and he now turned to more serious study at the College of Fine Art in Paris and particularly in the private studio of the Swiss professor Charles Gleyre (1806–1874).[60] The studio could accommodate several dozen students for a whole day's life drawing or painting at a time; and twice a week, unpaid, Gleyre would make corrections and offer his thematic or compositional recommendations. At one time, Gleyre himself had practised his skills at the Académie Suisse and learnt watercolour techniques under Bonington, before developing his own classic-cum-Romantic eclecticism. Fidelity to the real appearance of things left him indifferent, as did "non-ideal" genre and landscape painting. What he was out to teach his students was an appreciation of lofty subjects, style and ideal beauty. His personal modesty, his long experience of poverty and humiliatingly dependent circumstances, and his assertive republicanism prompted respect among his students, even among those who rebelled against his views on art. These latter included Monet: realistic still lifes he did at this period have survived. They also included Bazille, Sisley and Renoir. The four became friends.

Bazille was the son of a wealthy wine-producer and notary in Montpellier. His circumstances were quite different from Monet's. Since 1862 he had been studying in Paris: medicine, but mainly painting under Gleyre.

Sisley was the son of an English merchant living in Paris, and remained a British citizen. He spent four years in London training for a business

The Pont Neuf, Paris. Photograph, 1855

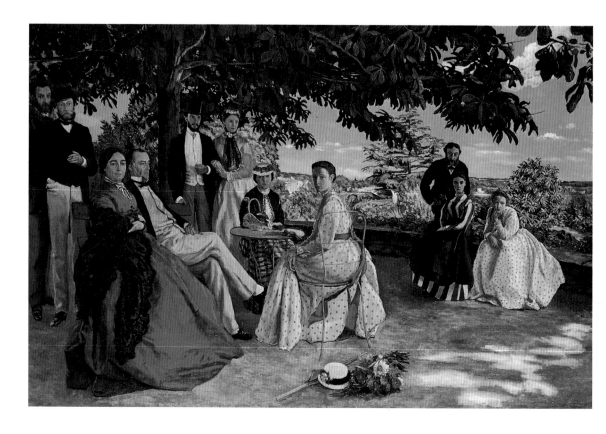

Frédéric Bazille
Family Reunion, 1867
Réunion de famille
Oil on canvas, 152 x 230 cm
Daulte 29. Paris, Musée d'Orsay

career, but art was already the greater attraction. In October 1862 he entered Gleyre's studio, and thus a life as the somewhat less successful fellow-traveller or indeed imitator of his friend Monet.

Renoir had a little more professional experience than his companions. His family – his father was a tailor in Limoges – had moved to Paris when the boy was four. The young Renoir's artistic gift was initially put to use in a china pottery where he worked as an apprentice, spending his lunch breaks drawing in the Louvre nearby. When the manufacturer bought a machine that printed rococo motifs onto china plates, Renoir lost his job. He earned a living painting blinds, then church drapery for overseas missionaries. By April 1862 he had saved enough to enter the Ecole des Beaux-Arts and to work at Gleyre's studio.

That year, a southern Frenchman named Cézanne was at the Académie Suisse, as he had been the previous year. He was an idiosyncratic, vehement man, though his self-confidence was unsteady; he was trying (in vain) to prepare for the Ecole's entrance exam. His father was something of a tyrant, who had risen from being a hatter to joint proprietor of a bank and was insisting, at least initially, that the youth who would one day inherit study law. But Cézanne's imaginative school-friend Emile Zola (1840–1902), now living in Paris and destined to become the foremost French writer of the late 19th century, had played a particularly influential part in confirming Cézanne's artistic leanings.[61] At that time,

On the terrace. Photograph, c. 1870

the only common ground between Cézanne's art and what was to be Impressionism was the rejection of prescriptive aesthetic rules; but Pissarro became his friend, as did Armand Guillaumin, a poor railway worker who painted in his spare time and had been at the Académie Suisse since 1861.

It was at this time that Renoir met Henri Fantin-Latour (1836–1904),[62] a friend of Manet and Whistler who liked painting poetic floral still lifes (p. 45). In 1861, together with the copper engraver Félix Bracquemond (1833–1914),[63] a friend of Degas, Fantin-Latour placed two young amateurs, Edma and Berthe Morisot, with Corot, who was to teach them landscape painting. Thus by the early sixties all of the links had been forged that were in time to create the Impressionist community.

Developments were stimulated from 1863 on by spectacular events on the Paris art scene, and particularly at the Salon.

The Salon and Rejection

We have already had occasion to refer to the Salon, and shall be doing so again. The history of Impressionism cannot in fact be grasped without reference to it.[64] In terms both of an overall aesthetic evolution and of the

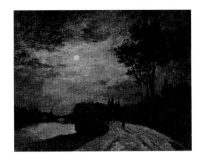

Pierre-Isidore Bureau
Moonlight at L'Isle-Adam, 1867
Clair de lune sur les bords de l'Oise à L'Isle-Adam
Oil on canvas, 33 x 41 cm
Paris, Musée d'Orsay

Frédéric Bazille
Portrait of Pierre-Auguste Renoir, 1867
Portrait de Pierre-Auguste Renoir
Oil on canvas, 62.2 x 50.8 cm
Daulte 22. Algiers, Musée des Beaux-Arts

Frédéric Bazille
Self-Portrait with Palette, 1865
Autoportrait à la palette
Oil on canvas, 108.5 x 72.6 cm
Daulte 10
Chicago, The Art Institute of Chicago

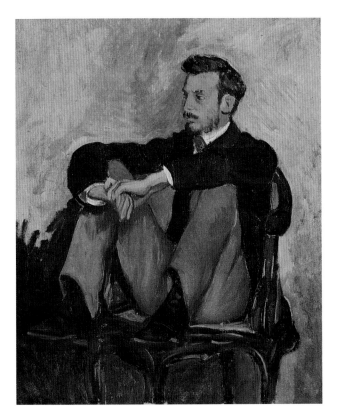

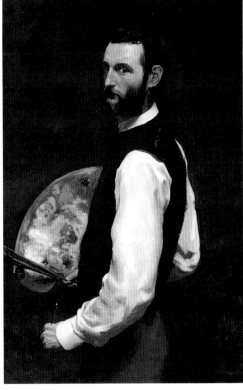

lives of individual artists, the ways that artworks and the "clients" are brought together are invariably of germane importance. In the course of time, these processes have varied. In the 19th century, public exhibitions were finally established as the crucial, indispensable means of putting the producers and consumers of art in touch. Social, economic and cultural evolution had produced a situation in which art was mainly made by independent people who were neither the servants of princes nor the slaves of guild guidelines. As independent artists, they made their living by selling on the art market to clients who might be anybody at all.

This was the rule, despite exceptions such as employment of artists by colleges, the direct commissioning of works, or the fact that an occasional artist might have inherited enough money not to need to sell his work. An increasingly important intermediate role was played by art dealers, too, whose ongoing commercial gallery shows made contact possible. From 1862 to 1865, for instance, Louis Martinet gave permanent space at his gallery to the Société Nationale des Beaux-Arts under the chairmanship of Gautier. This group included Corot, Daubigny and Manet, among others. Martinet's major rival, Francis Petit, made space available to the Cercle de l'Union Artistique at his Rue Choiseul gallery. Martinet also published a magazine, the *Courrier artistique*, to publicize the work he handled. At a later date, the linking of exhibitions and periodical publications was to become a regular feature of the art and media market.

For the artists, finding exhibition space was absolutely vital to survival. Their efforts to do so became a driving force in art history. Impressionism occupies a key position in the history of galleries and exhibitions; indeed, that history would be scarcely comprehensible were it not for the Impressionists' struggle to circumvent rejection.

In France, the Paris Salon was the exhibition space *par excellence*. The country had long been centralized both in political and in cultural terms, and aesthetic criteria were laid down in the capital. The political and cultural clout of France, and the achievements of French artists, had made the Paris art scene a major centre of international weight ever since the 17th century. Since 1673 there had been regular exhibitions by members of the Royal Academy of Art. These exhibitions were known as the Salon after the great hall at the Louvre where they were held. Following the 1789 revolution, non-members of the Academy were permitted to exhibit in the show as well, as of 1791. In 1848, another year of revolution, the exhibition was mounted without the intervention of a selection committee, for the first time – with the result that a full 5,180 works were put on display. From 1855 to 1863 the Salon was held every other year; after that it became what it had sometimes been already, an annual event. A panel selected the works. Till 1863, this committee consisted of members of the Académie des Beaux-Arts, itself a division of the Institut de France, the premier instrument of state arts policy. From 1864 on, three quarters of the committee members were elected by artists who had already been awarded a medal of distinction and could therefore exhibit without submitting to the selection panel (*hors concours*).

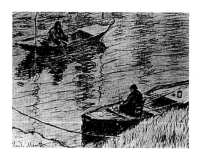

Claude Monet
Angling in the Seine at Pontoise, 1882
Black crayon on card, 25.6 x 34.4 cm
Cambridge (MA), Fogg Art Museum,
Harvard University

Claude Monet
The Beach at Sainte-Adresse, 1867
La plage de Sainte-Adresse
Oil on canvas, 75.8 x 102.5 cm
Wildenstein 92
Chicago, The Art Institute of Chicago

Claude Monet
The Regatta at Sainte-Adresse, 1867
Les régates à Sainte-Adresse
Oil on canvas, 75 x 101 cm
Wildenstein 91
New York, The Metropolitan Museum of Art

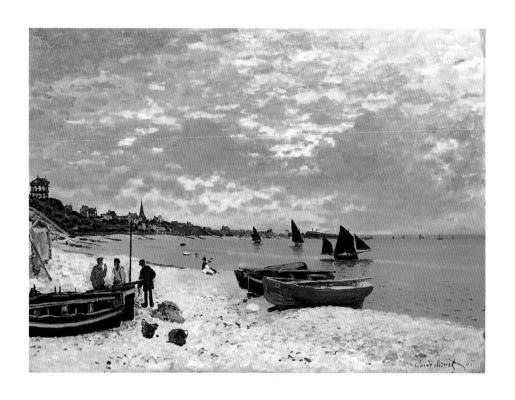

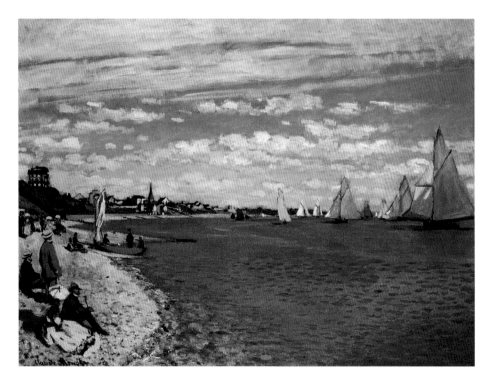

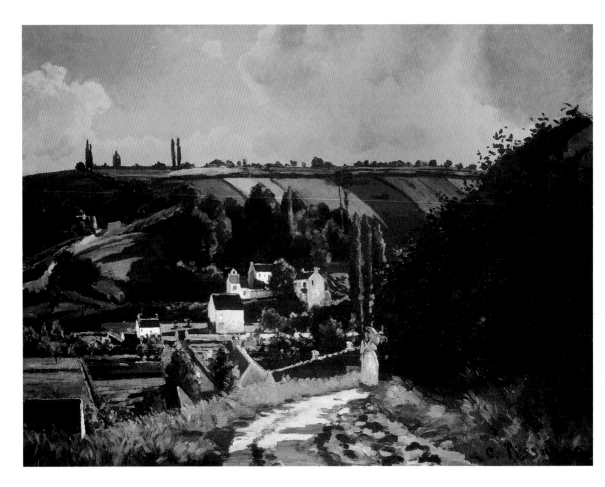

Camille Pissarro
Jallais Hill, Pontoise, 1867
La Côte du Jallais, Pontoise
Oil on canvas, 89 x 116 cm
Pissarro/Venturi 55
New York, The Metropolitan Museum of Art

And in 1869 *all* the artists who had ever exhibited at the Salon became eligible to elect two thirds of the committee.

In 1881 the government devolved its control of art's public access to the artists themselves, and from that date on the Société des Artistes Français, consisting of artists who had already exhibited at the Salon, chose the panel. In other words, the presiding forces in French art were always recruited via the Salon. Its role in the dissemination of art can be readily grasped from the statistics. In 1863 alone, over 4,000 works were rejected. In 1874 a total of 3,657 works were exhibited. In 1876 the number of paintings alone was 2,500. In 1880, 2,586 artists exhibited a range of work that included 3,957 paintings and some 2,000 drawings. The works were hung right up to the ceilings, and there was little hope that visitors to the Salon would be invariably equal to the strain on their concentration. Many a small or unspectacular picture would inevitably be overlooked. Even so, the Salon was intended to provide information on the art officially considered worthy of respect and purchase. In 1875, no fewer than 51,509 copies of the Salon catalogue were sold – which suggests that the number of actual visitors must have been considerably greater.

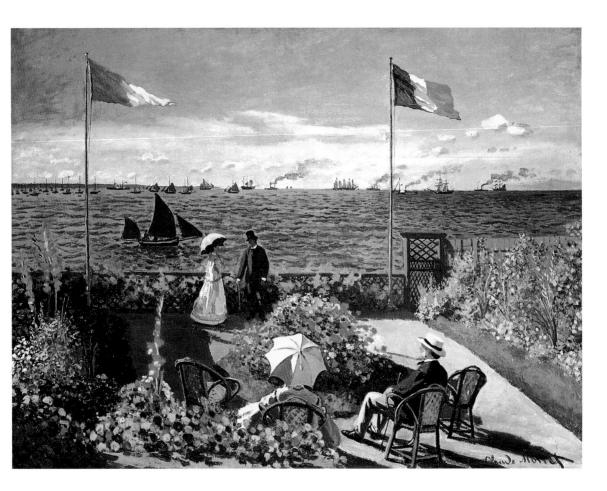

Claude Monet
Terrace at Sainte-Adresse, 1867
Terrasse à Sainte-Adresse
Oil on canvas, 98 x 130 cm
Wildenstein 95
New York, The Metropolitan Museum of Art

The Salon was a constant target of attack by artists. It was cursed; it was disdained out of pride, or eschewed out of despair, by artists who felt the works were not properly exhibited. Nevertheless, the great French jamboree of art – which also attracted foreign submissions – remained crucial to artists for the time being. If they were to secure a place in the scene, and establish new aesthetic approaches, they had to crack the Salon.

Art criticism in the daily and weekly press, and in the art journals (sometimes distinctly short-lived), dealt at particular length with the Salon. There were also pamphlets, broadsheets and cartoons. Artists were compelled to woo the critics and to organize their own promotion. And still the fact remained that most of the public preferred not to make up their own minds and simply relied on the committee's expert opinion, while a painting that carried the mark of rejection on its stretcher would only rarely find a buyer.

Attempts were repeatedly made to put art before the public in other ways. Commercial art galleries were soon to become the most important alternative. As this process took its course, artists competing with each other were also involved in the competition among dealers, and found

their careers depended on the outcome of those competitions. As we have seen, since the late 18th century artists had tended to open their studios for a day or so in order to show one or more new works; but for an unknown beginner occupying some shabbby garret, this was hardly a viable solution to the problem. And Courbet's maverick pavilion of 1855, the first large-scale solo show on a freelance basis, was not a financial success.

The committee that selected the 1863 Salon was especially difficult to please. Of over 5,000 works submitted by about 3,000 artists, they rejected about 4,000. The resulting discontent among artists and in the press was so great that Napoleon III visited the Palais de l'Industrie to view the exhibition himself. He consulted the committee chairman, Comte Alfred-Emilien de Nieuwerkerke (1811–1892), a sculptor and Director General of National Museums, who in 1855 had commented on Millet's work: "This is the painting of democrats, of people who don't change their linen, who want to deceive men of the world. It is an art which displeases and disgusts me."[65] The emperor decided that the artists should have the option of putting their rejected works on public show elsewhere in the exhibition building.

This liberal gesture, which gave offence to Napoleon III's academic art politicians, was part of his manoeuvring to combat unpopularity: once an adherent of the ideas of the utopian socialist Claude-Henry Comte de Saint-Simon (1766–1825), the emperor was now suffering from a signal lack of success. Turbulent social events – and not least property speculation during the redevelopment of Paris – had left many people feeling insecure, and had exacerbated political tensions. In 1863, only the Republican opposition candidates were returned to the Chamber of Deputies in Paris. To show largesse in the arts was a safe but effective way of soothing public feeling.

Napoleon III's own notion of good art was illustrated when he promptly bought *The Birth of Venus* (p. 36) by Alexandre Cabanel (1823–1889) for 40,000 francs for his personal collection. Though the classicizing title gave the work Salon respectability, the woman's seductive pose was "titillatingly ambivalent" (Werner Hofmann)[66] in a way typical of the "female nudes then invading the exhibition halls" (Max Osborn).[67] Classical and rococo traditions were co-present in this fairly cool, brightly coloured, smoothly painted work, and it proved so successful that Cabanel painted numerous versions of it. That same year he was made a member of the Academy and a professor at the Ecole des Beaux-Arts.

Of course the Salon also featured fairly true-to-life genre and history paintings. There were also works by Courbet, who had just been engaging in joint landscape work with Corot, and Millet – though a provocative Courbet showing drunken priests was even turned down for the Salon des Refusés, on political-cum-ethical grounds. There were works in the Salon des Refusés that had been rejected not for thematic reasons but because of their style or quality. Among these were paintings by Cézanne, Fantin-Latour, Guillaumin, Jongkind, Pissarro, Whistler, and

The 1855 Salon in the Palace of Industry

Frédéric Bazille
View of the Village of Castelnau-le-Lez, 1868
Vue de village Castelnau-le-Lez
Oil on canvas, 51 x 35 cm
Daulte 36. Montpellier, Musée Fabre

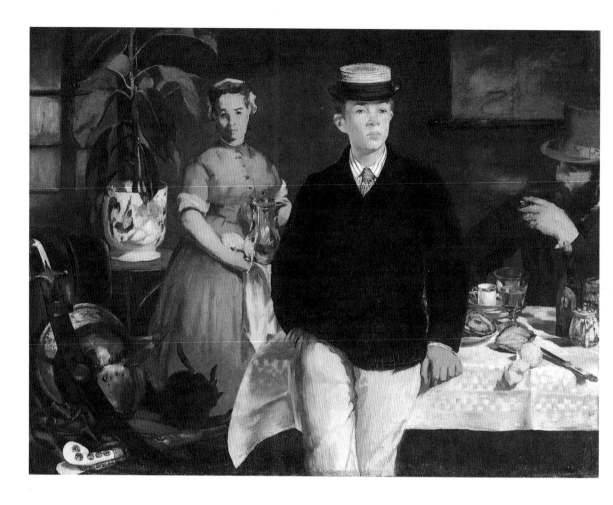

particularly Manet. The latter's *Le déjeuner sur l'herbe* (p. 37) – originally titled *Bathing* – was a *succès de scandale*, and twenty-three years later Zola immortalized the debate it provoked, the scorn and derision, in his novel *The Masterpiece* (1886), a fictionalized history of the Impressionist movement.[68]

The verisimilitude of Manet's painting was not, of course, flawless. We see two fully dressed Paris bohemians out on a summer's day (Manet's models were his brother Gustave and Ferdinand Leenhoff, who became his brother-in-law that same year). They are reclining on the grass in a woodland clearing by a pond or stream where their two women companions have been bathing. One of them (Victorine Meurent, who was modelling for Manet at the time) is sitting naked with the men, who are deep in talk. Her discarded clothing is beside her, by the luncheon basket, and she is gazing evenly out of the canvas and straight into our eyes. The figures, and especially the still life objects in the foreground, are lovingly detailed, and the natural surroundings are landscaped in with a generous hand. There are distinct areas of brightness, even though no specific light source or even an interplay of sun and shade is definable.

Edouard Manet
Luncheon in the Studio, 1868
Le déjeuner dans l'atelier
Oil on canvas, 118 x 153.9 cm
Rouart/Wildenstein I,135
Munich, Bayerische Staatsgemäldesammlungen,
Neue Pinakothek

Right:
Edouard Manet
The Balcony, c. 1868/69
Le balcon
Oil on canvas, 170 x 124.5 cm
Rouart/Wildenstein I,134
Paris, Musée d'Orsay

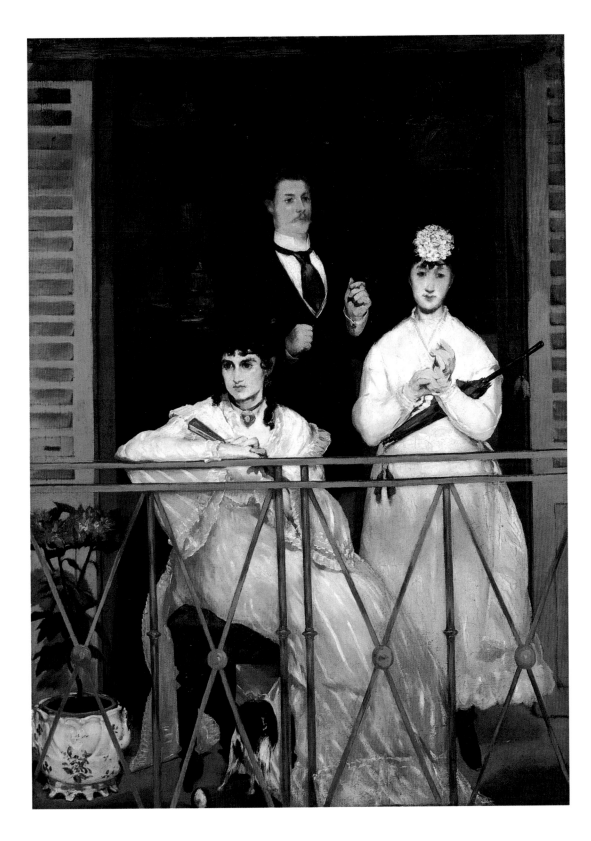

The subject of the picture threw many of those who saw it. Almost everyone was familiar with the masterpiece of the Venetian High Renaissance which hung in the Louvre and to which Manet was alluding in order (as he supposedly observed to Proust) "to make it new in a transparent atmosphere"[69] – Giorgione's *Country Concert* (possibly completed by Titian). In that work, we see two dressed gentlemen and two naked women sitting in the open by a fountain, playing music. Manet's contemporaries were perfectly ready to enjoy poetic eroticism in the garb of a distant age (or in the pseudo-ancient look Cabanel gave it); but if the setting was the Bois de Boulogne or Argenteuil in modern times, they were outraged by the indecency of it.

Manet was in fact aiming to rediscover the noble bearing of a cultured tradition in his contemporaries. To this end he also incorporated in his composition the physical gestures of reclining river gods in an engraving done by Marcantonio Raimondi from a drawing by Raphael. This fell on stony ground at the time. And later, indeed, art historians of a Modernist persuasion accused Manet of lacking compositional imagination of his own. As many have remarked, the picture lacks unity – in spatial, gestural and colour terms. From our present point of view, this very fact is eloquent of Manet's forward-looking modernity; and the inconsistencies in the work as a whole, the cracks that the artist has not papered over, the painting's montage and quotation quality, accurately convey the state of culture in his own era. It is a stock-taking, coolly assessing work, free of moralizing. The artist's own gaze is as even as naked Victorine's. The relationship between the gentlemen (possibly artists) and their lady friends (perhaps models) is one of inequality; it is economic and pragmatic in character rather than emotional. The people's gazes do not meet, and the classic, formulaic gesture of the man reclining on the right evokes no response in the woman, who makes a sovereign, isolated impression.

The scandal prompted by the Salon des Refusés – an experiment which the government declined to repeat – merely served to accelerate artistic evolution and stimulate debate. Manet's painting, and those he had previously shown at Martinet's, brought younger artists flocking to him. In their admiring eyes he was a confident force for the new. It was not till 1866, though, that Monet, Pissarro and Cézanne personally met Manet.

Establishing a Position

Seven years lay between the Salon des Refusés and the trauma of the Franco-Prussian War, which brought France defeat, the end of imperial rule, and the experience of the Paris Commune. For the artists we are concerned with, they were seven years of quest, and of alternating success and failure. The period ended with the establishment of a common artistic personality and of Impressionism as a joint movement. Most of the artists submitted regularly to the Salon (now held annually). As a rule

Edouard Manet
The Execution of Emperor Maximilian, 1868
L'exécution de l'Empereur Maximilien
Lithograph, 33.3 x 43.3 cm

Edouard Manet
The Execution of Emperor Maximilian (four fragments), 1867
L'exécution de l'Empereur Maximilien
Oil on canvas, 19 x 16, 99 x 59, 89 x 30 and 35 x 26 cm
Rouart/Wildenstein I,126
London, National Gallery

Edouard Manet
The Execution of Emperor Maximilian, 1868
L'exécution de l'Empereur Maximilien
Oil on canvas, 252 x 305 cm
Rouart/Wildenstein I,127
Mannheim, Kunsthalle Mannheim

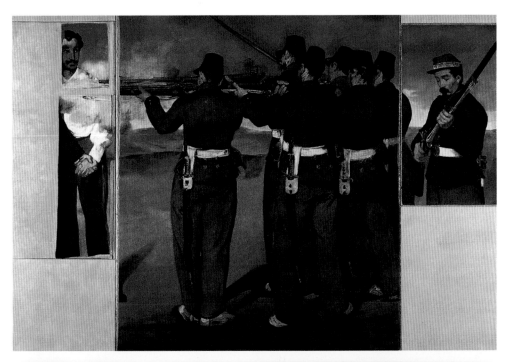

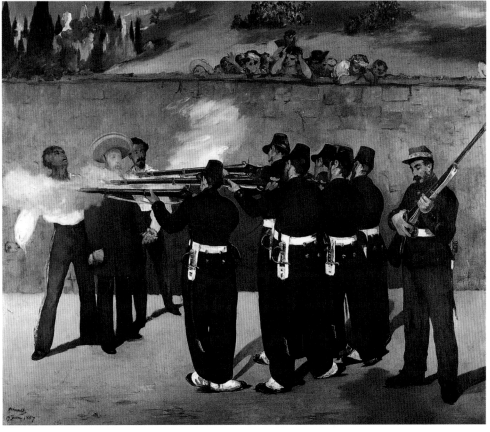

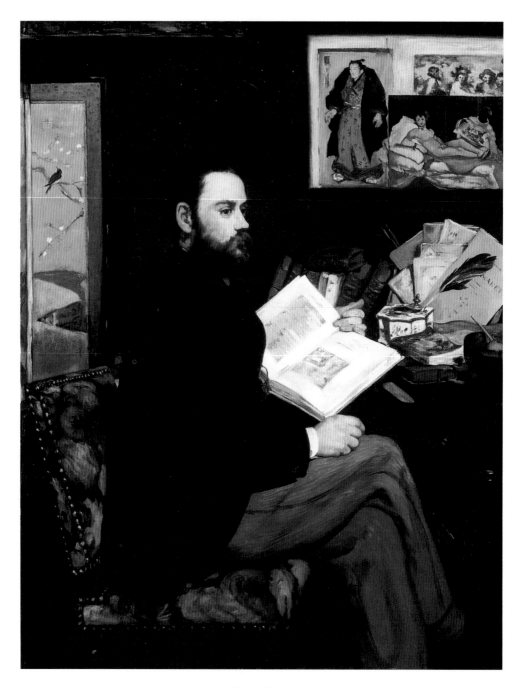

Edouard Manet
Portrait of Emile Zola, 1868
Portrait d'Emile Zola
Oil on canvas, 146.5 x 114 cm
Rouart/Wildenstein I,128
Paris, Musée d'Orsay

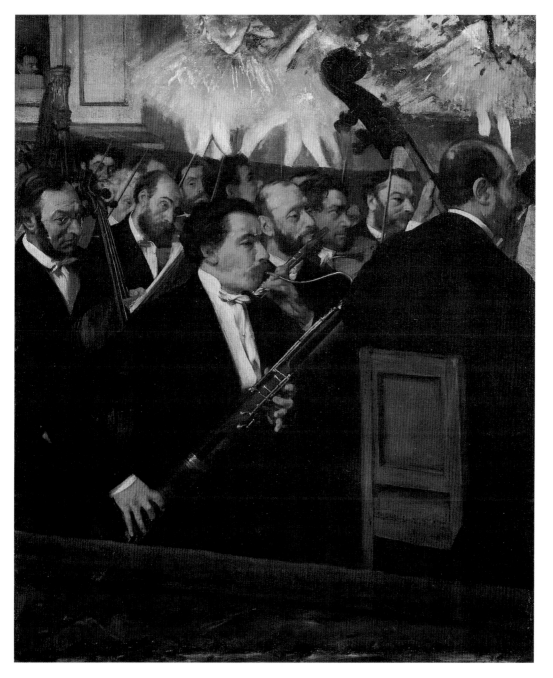

Edgar Degas
The Opera Orchestra, c. 1868/69
L'orchestre de l'Opéra
Oil on canvas, 56.5 x 46.2 cm
Lemoisne 186
Paris, Musée d'Orsay

Stanislas Lépine
Banks of the Seine, 1869
Bords de la Seine
Oil on canvas, 30 x 58.5 cm
Paris, Musée d'Orsay

they were accepted at their first try, as were Renoir and Morisot in 1864, Monet and Degas in 1865, Bazille and Sisley in 1866, Gonzalès in 1870. At times they also had work rejected subsequently. Cézanne's work was too uncompromising ever to find favour with the selection panel. The sifting of Salon art was particularly thorough in 1867, when a further World Fair held in Paris prompted the thought of an independent group show, paid for by the group; but the idea was abandoned, not least for lack of funds – though Manet did have a pavilion built for a solo show during the Fair, as did Courbet once again.

The painters were tireless in their search for motifs, new ideas and stimuli, contacts and friendships. Some worked together for periods. They debated their aesthetics, among themselves and with critics; of the latter, Zola was to be of particular importance for them. From 1866 on he was vigorous on their behalf, contributing criticism of their art to a shortlived periodical called "L'Evénement". For those who had no money behind them, the financial situation could often be very difficult, and at times they lived in penury. Bazille gave Monet occasional support. Pictures had to be sold at giveaway prices if there was a chance of a sale at all. It did not make matters easier if wives and children had to be supported: Pissarro and Manet had families, and Monet and Sisley followed them in 1866.

In aesthetic terms, the problems facing the group lay in certain definable areas. They all wanted to take up the realism practised by Courbet and the Barbizon school and take it further, adapting it as they went. For this continuation of the line, Zola used the term "naturalism" from 1865 on; it had been coined two years earlier by the Republican art critic Castagnary, a friend of Courbet's.[70] For Zola, the Renaissance metaphor of a painting as a window through which reality could be seen still applied. Similarly, he saw the picture or even the artist as a screen or window pane on which phenomena that originated in reality could be seen. However, Zola importantly added that every artist was an individual medium in his own right, clouding or refashioning the phenomena in his own peculiar way or breaking them up prismatically, as it were. This, in fact, is how the artist transforms what is given into a work of art. In

Right:
Armand Guillaumin
A Path in the Snow, 1869
Chemin de creux, effet de neige
Oil on canvas, 66 x 55 cm
Serret/Fabiani 5. Paris, Musée d'Orsay

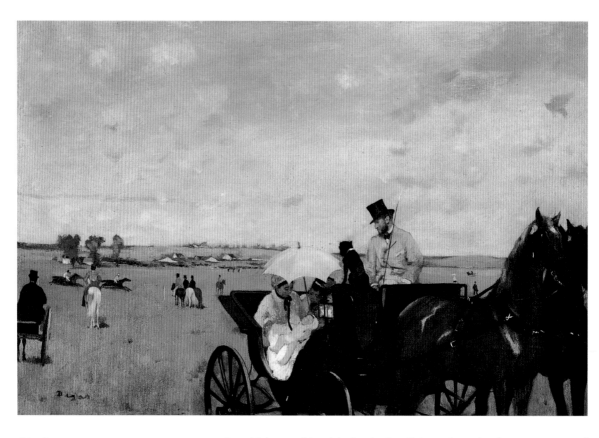

Edgar Degas
A Carriage at the Races, c. 1869–1872
Aux courses en province (La voiture aux courses)
Oil on canvas, 36.5 x 55.9 cm
Lemoisne 281. Boston, Museum of Fine Arts

1867, Zola put this with classic simplicity: "A work of art is a corner of creation seen through a temperament."[71]

Plural objective reality was taken as a valid given. This meant that the artists were debarred from pursuing preconceived ideals – say, in the representation of human figures. Partly for oppositional political reasons, the realists, for their part, had hitherto preferred to portray people from the lower classes or fringes of society. Renoir and Monet, wanting Salon space and portrait commissions, were divided between the undaunted quest for truth and conformity to prevailing aesthetic ideals or social norms.

For most of the artists, following realism or naturalism meant going into the country to paint in outlying villages or on the coast of Normandy – where the optical qualities of light and atmospherics that fascinated them, and the colour values, could be studied even better than in the forests or beside rivers. When their master, Gleyre, closed his school in 1864 for reasons of old age, Monet, Renoir, Bazille and Sisley took to systematic forays into the country. In 1863 they had already gone to the Fontainebleau woods; Renoir met Diaz, who advised him to paint lighter, and Pissarro and Morisot met Corot. In 1864, Monet and Bazille worked at Honfleur, on the coast, where they met Boudin and Jongkind. Manet too began to take an interest in harbour scenes and ships at sea (*The Departure of the Folkestone Boat*, p. 77).

As well as landscape and light, what particularly interested the new artists was modern life. They were forever identifying subjects of striking contemporaneity, and establishing their right to a place in art; increasingly, though, a new way of seeing and representing motifs came to occupy the foreground of their attention. They set out to convey movement and flux. Life in the new cities was marked by an accelerated tempo and the loosening of old ties and hierarchies, and they wanted to get these changes into their work. The artist became an observer, alert but uninvolved, recording interesting but randomly selected moments in a process he simply happened to be witnessing, from a standpoint occupied by chance rather than design.

More than the rest, Manet liked painting scenes of current affairs. A major one is *The Execution of Emperor Maximilian* (p. 65).[72] Chasing imperial expansion, France had sent a military force to Mexico in 1863, and the young Austrian Archduke Maximilian had accepted the Mexican throne. When American pressure obliged the French to withdraw their troops, Napoleon III's protégé was left to fend for himself, and was presently executed with two of his generals, on 19 June 1867, at Queré-

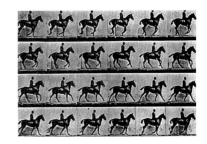

Motion study: canter. Documentary photographs by Eadweard Muybridge, c. 1878

Edgar Degas
Race Horses in Front of the Stands, c. 1869
Le défilé (Chevaux de courses, devant les tribunes)
Thinned oil on paper on canvas, 46 x 61 cm
Lemoisne 262. Paris, Musée d'Orsay

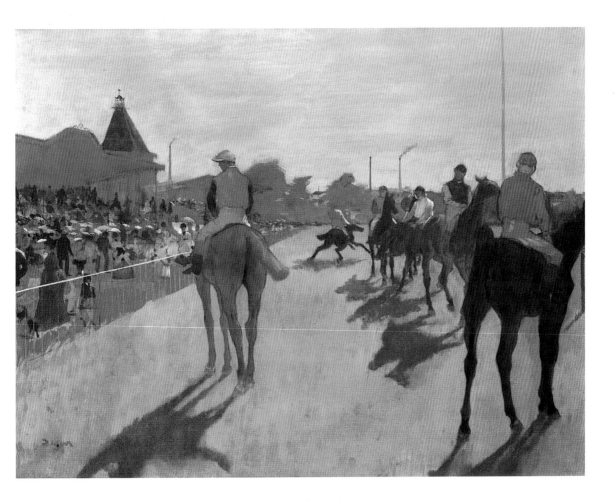

La Grenouillère

taro. Manet, drawing on news reports and press pictures, set about re-creating the event, which had been a humiliating blow to Napoleon III's ambitions. He put the firing squad in French uniform – partly because he was working from model soldiers an officer friend lent him. Four versions of the painting and a lithograph (p. 64) resulted; distribution of the latter was banned for political reasons, as was exhibition of the first, small version of the painting at Manet's World Fair pavilion. The final version, now in Mannheim, was painted in early 1868. Manet has done the lifesize figures in bold colours, making the uniforms into an almost decorative pattern. What we see is the working of a faceless military machine – which does not fit actual events in Mexico. The gun barrels are the dominant compositional horizontal; they do not in fact point in correct perspective at the victims. A remarkable, dispassionately neutral calm broods upon the scene. Though Manet was doubtless attempting a personal response to events, his own creed of impersonality proved an obstruction.

He had already painted a *View of the World Fair* (Oslo, National

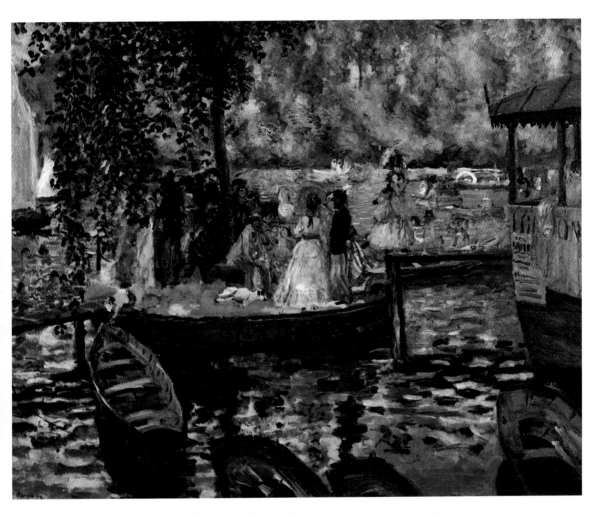

Claude Monet
La Grenouillère, 1869
Oil on canvas, 74.6 x 99.7 cm
Wildenstein 134
New York, The Metropolitan Museum of Art

Pierre-Auguste Renoir
La Grenouillère, 1869
Oil on canvas, 66 x 81 cm
Stockholm, Nationalmuseum

Gallery) in which a number of solo figures and groupings appeared on a rise near the Fair, seeming curiously unrelated to each other. And as early as 1864/65 he had engaged in friendly competition with Degas to paint the races and the ladies in the crowd (p. 42). Manet's method was to render the overall impression with a sketchy use of patchy colourwork, rather than trying to detail the bearing of figures. In his last racecourse picture (p. 42), the horses are galloping straight towards us – which has the optical effect of arresting movement entirely.

Following the scandal of Le déjeuner sur l'herbe, Manet prompted an even more violent controversy with Olympia (pp. 38/39), painted the same year and shown at the Salon in 1865. The lifesize nude quotes Titian's famed Venus of Urbino in the Uffizi, Florence, which Manet had copied in 1865. Manet well knew that in painting portraits of Venus, Titian would be portraying a lover of the prince who commissioned the picture. Manet's contemporaries were well aware of this too; but they could not accept the translation of a Renaissance goddess into a woman who was plainly a highly-paid Paris prostitute and who paraded her lofty

name as defiantly as her nakedness. In Manet's conception of the picture, a gap yawned wide between the Titianesque mood and drapes, the "Romantic" black servant and the cat, and, on the other hand, the astringently contemporary coolness of the woman, reclining with a certain angular coarseness and giving us a calculating, businesslike look. Manet's contemporaries were affronted.

Of course the look on the woman's face was Manet's doing more than his model Victorine's. He used light colours and no warm shadows. The painting was so flat that Courbet dismissively compared it with a playing card. The vivid personality and verisimilitude present in *Olympia* produced an immediacy and truthfulness that were shocking right across Napoleon III's Second Empire, regardless of individual ideological persuasions. Manet was aware that he had produced something of significance. His whole life long he kept the painting in his own possession. When his widow, needing money, proposed selling it to an American in 1888, Monet collected funds – primarily from artists – to ensure that a work rightly regarded as a milestone in modern French art could be acquired for the Louvre. (In 1890, it is true, the *Olympia* was initially only accepted into the contemporary art collection of the Palais Luxembourg.)

Manet demonstratively placed a small study for the painting behind his sitter in his portrait of Zola, who was doing so much on his behalf in essays and a pamphlet (p. 66).[73] The pamphlet can be seen to the right on the writer's desk. Zola himself makes a well-groomed rather than bohemian impression. The portrait also includes other programmatic material important to Manet: a reproduction of a painting by Diego Velázquez (1599–1660), whose work Manet admired more than ever following his visit to Spain in 1865, and Japanese artworks – a painted screen, and a coloured woodcut.

Japanese art and crafts, and "Japonaiserie", were then newly in fashion throughout western Europe.[74] In part this was an extension of the 18th-century "Chinoiserie", which had linked the aesthetic interest of things exotic to an enlightened admiration for the wisdom and philosophy of the Far East (and also of Islam and the Near East). The Japanese vogue represented an active, historicizing interest in older or remoter art forms that could be used for one's own rethinking; and its influence continued to be potent into the 20th century. Long closed off to the outside world, Japan had been "opened" to the USA and Europe since 1854. Two years later, the Parisian etcher Bracquemond, who partly exhibited with the Impressionists, discovered and bought a volume of woodcuts by Hokusai (1760–1849; see left). He was impressed by the realistic precision and compositional ease of the art in which Hokusai, a late figure in an urban-cum-folk strain in Japanese painting, recorded his observations of everyday life. One of those infected by Bracquemond's enthusiasm was Whistler, who exhibited a portrait of a young woman in Japanese costume at the 1865 Salon. The picture hit the taste of the time: since 1862 a Paris store known as "La Porte Chinoise" had been doing brisk trade in oriental goods, and the London

Katsushika Hokusai: The Waterfall at Ono,
c. 1823–1830. Coloured woodcut, 37.2 x 25.2 cm

Frédéric Bazille
Bathers (Summer Scene), 1869
Scène d'été
Oil on canvas, 158 x 159 cm
Daulte 44
Cambridge (MA), Fogg Art Museum,
Harvard University

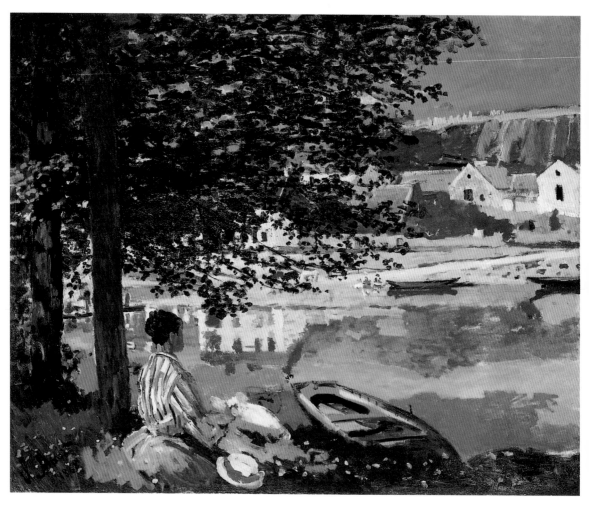

Claude Monet
The River, Bennecourt, 1868
Au bord de l'eau, Bennecourt
Oil on canvas, 81.5 x 100.7 cm
Wildenstein 110
Chicago, The Art Institute of Chicago

World Fair of that year had featured a broad selection of Japanese crafts. The trend was confirmed at the Paris World Fair in 1867.

Initially, Manet was not altogether impressed by the Japanese talent for adopting unusual perspectives, cropping in striking ways, and evoking the fleeting moment. Instead, what interested him was the decorative potential of generously, sweepingly outlined individual figures, seen against barely spatial, almost monochrome backgrounds – as can be seen from his *Fifer* in National Guard uniform (p. 47). This was a commonplace enough motif; however, it was rendered here in a demanding format, and predictably enough, the Salon committee of 1866 turned it down.

At the close of the decade Manet painted a number of masterpieces. *Reading* (p. 48), a small genre portrait of Manet's wife and their son Léon, is of particular note for its place in the evolution of the artist's style. In this private work, Manet gave himself full rein to pursue all the nuances of white he could see. The true subject of this "interior open-air picture", claims Denis Rouart, Manet's grand-nephew and author of the

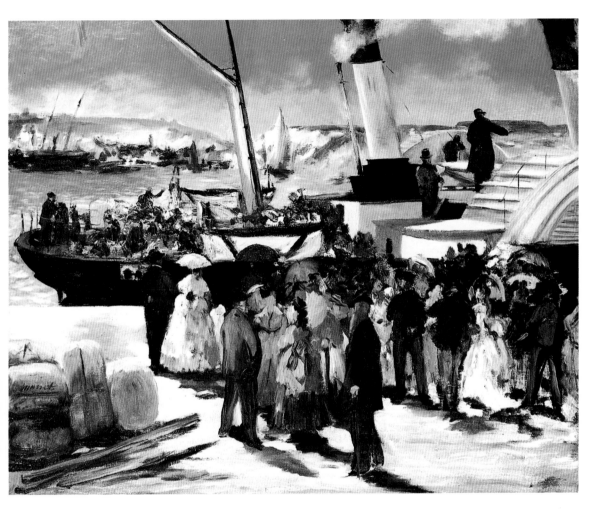

most recent *catalogue raisonné* of his works, is "the finely modulated play of the light".[75]

Delicacy of touch, a relish for whites, as well as a real respect for the sitter, are also apparent in *Repose* (p. 48), a full-figure portrait of the young painter Berthe Morisot, whom Manet met in 1868. Reclining on the settee, she seems at once relaxed and tense, somewhat distanced yet attracted to the artist and something of a siren. She may have a stylish look in our eyes; contemporary cartoonists dismissed her as vulgar.

Manet's conception of the visual image was most plainly evidenced in two large pictures that were both shown in the 1869 Salon. In *Luncheon in the Studio* (p. 62), the main figure is Léon. Only the still life of old weapons, the props of the history painter, suggests that this might be a studio scene. A second still life is on the table: the painter is demonstrating his capacity for conveying the sensuous qualities of things in paint. There is no action in the picture, no talk, not even eye contact; in fact, there seems no explanation for the scene we are offered, and this is what creates its peculiarly unsettling air. In essence, it is not a scene at all. In

Edouard Manet
The Departure of the Folkestone Boat, 1869
Le départ du bateau de Folkestone
Oil on canvas, 59 x 71 cm
Rouart/Wildenstein I,147
Philadelphia (PA), Philadelphia Museum of Art

defiance of custom, Manet was not out to tell a tale at all. He was simply painting.

The Balcony (p. 63) has an even greater quietness, a greater ceremony of presence, and a more exacting use of spatial values. It was the first occasion that Berthe Morisot sat as a model; beside her is the violinist Fanny Claus, their friend the landscape artist Antoine Guillemet, and, barely visible in the background, Léon. A painting by Francisco de Goya (1746–1828), which Manet may have been familiar with from a copy in a Paris collection, conceivably influenced the arrangement, though Manet, surprisingly, had a low opinion of Goya. The uncommunicative isolation of the figures is striking; their expressionlessness and apparent lack of emotion confounded Manet's contemporaries. Almost a century later, in 1949/50, the Belgian Surrealist René Magritte (1898–1967) painted a version of the picture (Ghent, Musée des Beaux-Arts) in which he substituted coffins for the people, thus highlighting the lifeless effect. For Manet, the structural issues at stake were worth considerable attention, however, and he placed special emphasis on the strongly coloured shutters and the balcony rail that separates us from the group in the picture.

In the later 1860s, Manet became the most highly regarded of the artists, writers and aficionados who met with some regularity, usually on Friday evenings, at the Café Guerbois, 11 rue des Batignolles (now 19 avenue de Clichy). Manet, whose flat and studio were in the street, was now seen as the leader of the new school, widely dubbed the Batignolles School. In 1864, in his *Hommage à Delacroix* (Paris, Musée d'Orsay), Fantin-Latour had portrayed a group of ten artists, including Manet, with a portrait of Delacroix, whom they all revered. Now it was Manet's turn to be at the centre of attention. *A Studio in the Batignolles Quarter* (p. 81) shows Manet at work. The studio space accommodates objects of classical and Japanese art, the two traditions he was stressing. Manet is being respectfully watched by (from left to right) the German painter Otto Scholderer (1834–1902), who had arrived in Paris in 1868; Renoir; sculptor, poet and art critic Zacharie Astruc (1835–1907); Zola; his friend Edmond Maître; and Bazille and Monet.

Degas, who was particularly close to Manet in artistic terms, did not go out of his way to keep company with the other artists, whom he met about 1865 at the Café Guerbois. From 1865 to 1870 he submitted to the Salon every year, and had work accepted; thereafter he never submitted again. He worked hard at psychologically precise, realistic portraits, observing light and colour very closely, but his interest in new compositional approaches and subjects that would convey a specifically modern spirit was even greater. *Woman with Chrysanthemums* (p. 44), which probably depicts one Madame Hertel of whom we know nothing more, may well be the earliest example of so radical a displacement of a portrait sitter from the centre of a composition.[76] But then, is this picture of a woman somewhat absently, nervously putting her hand to her lips and gazing sideways at some person or thing unknown actually or primarily a portrait? It seems far more of a lavish floral still life. Our picture

Laundresses in Paris, c. 1870

Edgar Degas
Woman Ironing, c. 1869
La repasseuse
Oil on canvas, 92.5 x 74 cm
Lemoisne 216
Munich, Bayerische Staatsgemäldesammlungen,
Neue Pinakothek

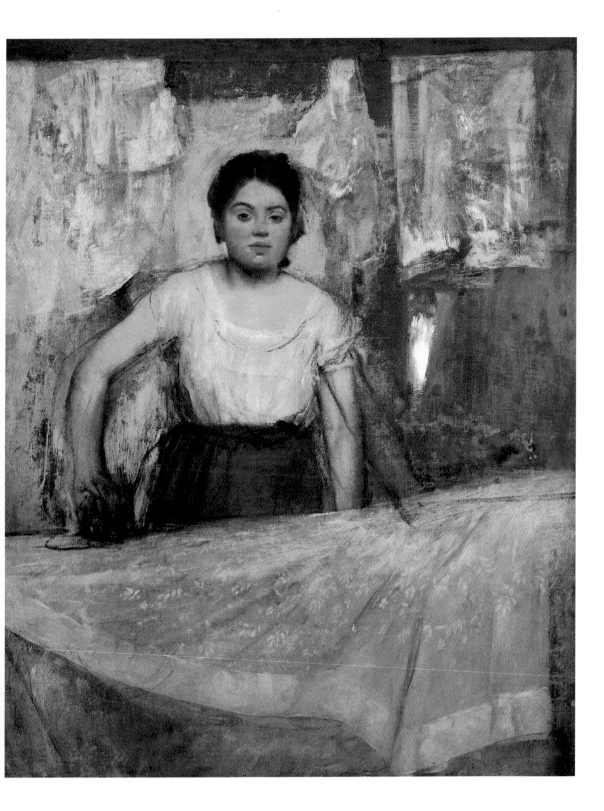

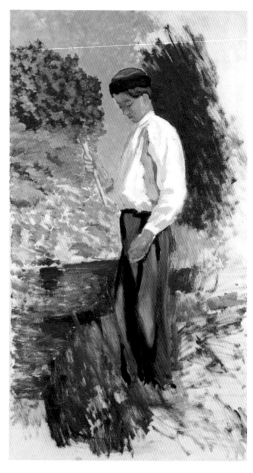

Frédéric Bazille
After the Bath, 1870
Sortie de bain
Oil on canvas, 41 x 30 cm
Daulte 49. Private collection

Frédéric Bazille
Louis Auriol Fishing, 1870
Louis Auriol pêchant à la ligne
Oil on canvas, 103 x 55 cm
Daulte 58. Private collection

categories may need to be flexible. The subjects in Degas's works – person or plant, glove or water jug – are on a par with each other, as they are in Manet's works too. In every portrait he painted, Degas opted for a different pose. It almost invariably recorded a fleeting moment, showing the subject feeling restless or uncertain about his or her relations with the world outside or with his or her own real self. The novel approach of these portraits probably influenced Manet in portraits such as that of Zola (p. 66).

Following his Salon debut with a history painting, Degas exhibited a racetrack scene there in the following year, 1866. At the same time he entered fully into the thematic world that was to be the hallmark of his art: theatre, dance and music. The world of entertainment, and the lifestyle of the affluent city classes, provided him with the perfect pretext to concentrate on the conscious act of seeing, of unbiassed observation. In the 1868 Salon he exhibited a painting of Eugénie Fiocre in a scene from the ballet "La Source", premièred in 1866 (p. 46). Compared with Degas's later dance scenes, this one makes a placid impression, like an illustration to a fairy tale. Of greater importance is *The Opera Orchestra* (p. 67), which is in some respects a work of striking novelty. Degas portrayed the

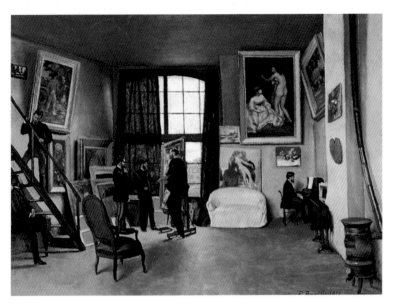

Frédéric Bazille
The Artist's Studio, Rue de la Condamine, 1870
L'atelier de Bazille, rue de la Condamine
Oil on canvas, 98 x 128.5 cm
Daulte 48. Paris, Musée d'Orsay

Henri Fantin-Latour
A Studio in the Batignolles Quarter, 1870
Un atelier aux Batignolles
Oil on canvas, 204 x 273.5 cm
Fantin-Latour 409. Paris, Musée d'Orsay

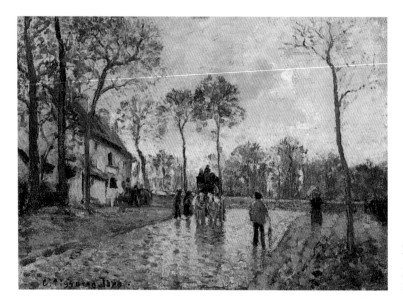

Camille Pissarro
The Mailcoach at Louveciennes, 1870
La diligence à Louveciennes
Oil on canvas, 25.5 x 35.7 cm
Pissarro/Venturi 80. Paris, Musée d'Orsay

musicians – among them the bassoon player Désiré Dihau, a friend to whom he gave the finished painting – as seen from the front row of the stalls, complete with croppings dictated by chance. The point of view that he chose also meant presenting the ballerinas on stage as no more than a disorderly tangle of legs and colourful tutus, minus their heads. This picture contained the seeds of a lifetime's work on related subjects.

Degas only rarely ventured beyond his own social sphere, but at this period he also first broached a theme that was later to engage him a number of times, albeit less fully than it interested others: women ironing. From 1865 on, the women who toiled at their ironing in the basic, steamy, hothouse rooms of the laundries featured regularly in Salon paintings.[77] Zola famously took one of them as a main character, Gervaise in his 1877 novel "L'Assommoir". As early as 1867, in his novel of artistic life, "Manette Salomon", Edmond de Goncourt took ironers and dancers as the two women's professions that (as he put it in his diary) "offer an artist the most appealing models of contemporary femininity".[78] The literary and artistic attractiveness of laundry women lay partly in the fact that they were widely perceived as loose-living, since their miserable pay forced many of them into prostitution. Not that this is apparent in Degas's earliest studies, which in 1869 resulted in an unfinished lifesize painting, *Woman Ironing* (p. 79). It is a delicate, arresting portrait of an unknown woman seen in a fragrantly sketched setting of whites, greys and pale pinks.

At this time, as a number of portraits show, Degas was fascinated by Yves Morisot (who became Madame Gobillard in 1867). She was the elder sister of Berthe, who had attracted Manet's attention. Berthe Morisot was the daughter of a top-ranking civil servant and the great-niece of the eminent rococo painter Jean-Honoré Fragonard (1732–1806). With her other sister, Edma (who abandoned painting when she married in

Emile-Auguste Carolus-Duran
Lady with Glove
(Madame Pauline Carolus-Duran), 1869
La dame au gant (Mme Pauline Carolus-Duran)
Oil on canvas, 228 x 164 cm
Paris, Musée d'Orsay

Right:
Camille Pissarro
The Road from Versailles at Louveciennes, 1870
La route de Versailles à Louveciennes
Oil on canvas, 100 x 81 cm
Pissarro/Venturi 96
Zurich, E.G. Bührle Collection

Alfred Sisley
First Snow at Louveciennes, c. 1870/71
Premières neiges à Louveciennes
Oil on canvas, 54 x 73 cm
Daulte 18. Boston, Museum of Fine Arts

1869), she had taken private tuition, mainly from Corot, and from 1864 on she regularly exhibited landscapes at the Salon. A double portrait (p. 88) shows her mother reading and her sister Edma on a settee, listening or thinking; the picture was not merely reminiscent of Manet's approach (cf. p. 48) but was in fact so heavily reworked by him (she now regarded Manet as her teacher) that she withdrew it from the 1870 Salon, where it had been accepted – no longer feeling sure of it. For a young woman at that time it was not easy to balance the willingness to learn with self-confidence, liking for a man with professional self-esteem, in a society dominated by men. Furthermore, Manet was also giving a good

Alfred Sisley
Saint-Martin Canal in Paris, 1870
Le canal Saint-Martin à Paris
Oil on canvas, 54.5 x 73 cm
Daulte 17. Winterthur, Oskar Reinhart Collection

Paul Cézanne
The Railway Cutting, c. 1870
La tranchée
Oil on canvas, 80 x 129 cm
Venturi 50
Munich, Bayerische Staatsgemäldesammlungen,
Neue Pinakothek

deal of attention to another student, Eva Gonzalès, and submitted a large
and rather stiff portrait of her (1870; London, National Gallery) to the
same Salon.

Bazille too, the well-off medical student, who was spending more and
more of his time painting, was combining a new approach to figural
work with energetic attention to colour values in the open. In the few
years still left to him before his early death, he could still seem rather
unassured, yet at the same time his new aesthetic was evolving in
astonishingly bold and versatile ways. On two occasions, four years
apart, he tackled open-air portraiture, doing a young woman dressed in
light colours, with a view of the village of Castelnau-le-Lez rising upon
a gentle slope in the background. The 1868 painting (p. 61) was ex-
hibited at the Salon the following year.

Between these two solo portraits came his most ambitious work, the
large *Family Reunion* (p. 54), which was taken by the Salon in 1868. It
shows Bazille's parents and relations on the terrace at Méric (cf. p. 52),
their country residence near Castelnau in the Lez valley. The picture
conveys a sense of family and of social status, a particular lifestyle, and
a fresh response to Nature and light; in painting it, Bazille was also out
to convince his family of his ability as an artist. This "masterpiece of the
bourgeoisie" (François Daulte)[79] would repay sociological study. The
postures of the figures alone speak volumes. They are coolly presented
in a silence innocent of event. None of them is looking at the others. The

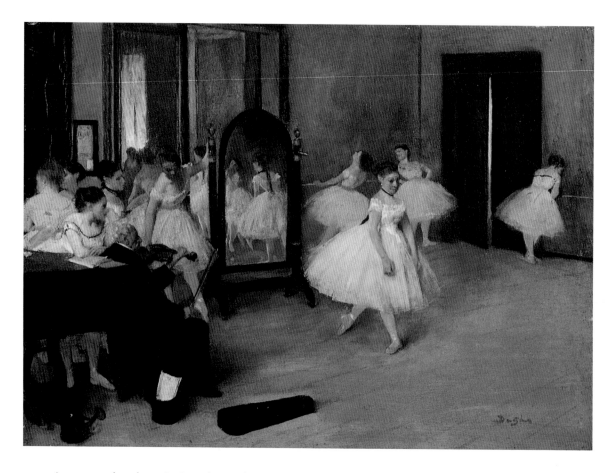

scene is not one that the artist has observed unnoticed; rather, the artist (and so we too) and the subjects are taking a calm, even, assessing look at each other, from a careful distance.

The little picture Bazille painted of himself with his Batignolles artist friends a short time later (p. 81) is rather different. He had shared his studio with Monet and Renoir (and did a portrait of the latter: p. 55). He had also given them financial support in other ways. Then in 1868 he moved to a new studio not far from the Café Guerbois. We see him in the studio, showing a new work to Manet (who painted Bazille, the tall figure by the easel, himself) and Monet; his good friend Maître is playing the piano; on the stairs, probably Zola and either Renoir or Sisley are talking. It is a scene of friendship, artistic work, and intellectual give and take: animated, easy-going, and without apparent hierarchical ranking.

The previous summer at Méric, Bazille had painted one of his most striking works, one that gained acceptance by the 1870 Salon. *Bathers* (p. 75) shows a number of youths in a grove of birches, fooling about and bathing in a pool. There is an occasional clumsiness in the rendering of the bodies, the foreshortening of perspective, and the painting of the water. The lighting of the figures is uneven, and they do not seem to be lit by the same sources as the setting. (This issue was to preoccupy Renoir

Edgar Degas
The Dancing Class, c. 1872
La classe de danse
Oil on panel, 19.7 x 27 cm
Lemoisne 297
New York, The Metropolitan Museum of Art,
H.O. Havemeyer Collection

Right:
Edgar Degas
Musicians in the Orchestra, 1870/71
Musiciens à l'orchestre
Oil on canvas, 69 x 49 cm
Lemoisne 295
Frankfurt am Main, Städelsches Kunstinstitut
und Städtische Galerie

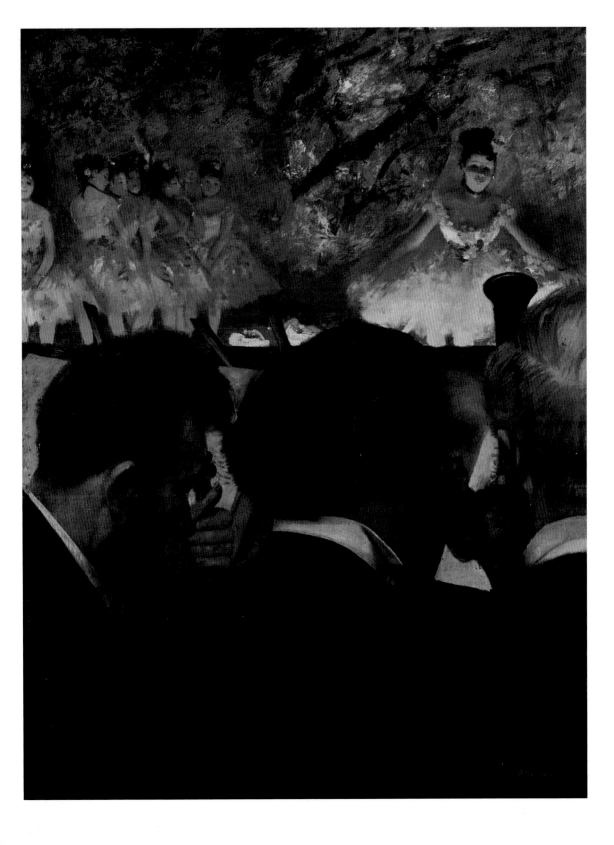

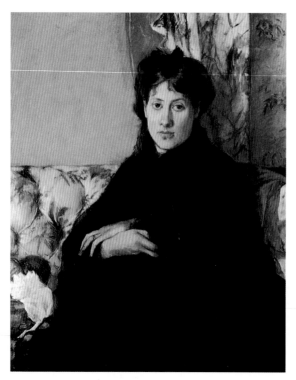

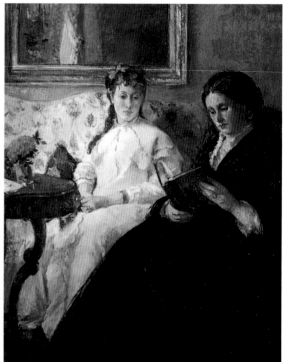

Berthe Morisot
Portrait of Madame Pontillon, 1871
Portrait de Madame Pontillon
Pastel on paper, 81.3 x 64.1 cm
Bataille/Wildenstein 419
Paris, Musée du Louvre, Cabinet des Dessins

Berthe Morisot
The Mother and Sister of the Artist (Reading),
c. 1869/70
*Portrait de Mme Morisot et de sa
fille Mme Pontillon (La lecture)*
Oil on canvas, 101 x 81.8 cm
Bataille/Wildenstein 20
Washington, National Gallery of Art,
Chester Dale Collection

Berthe Morisot in her Paris studio

and Monet some years later.) But what is arresting in this picture by a man still in his twenties is its view of life and of man, and its determination (which perhaps owed something to Manet) to rediscover the figurative values of the old masters in modern everyday life: the man leaning against the tree at left resembles a St. Sebastian (say, by Antonello da Messina), the reclining youth an ancient river deity. And the helpfulness of the man at right may recall Christ helping the damned up out of purgatory.

Pissarro, and particularly Sisley, concentrated on landscapes, including atmospheric scenes of street life in small towns or life on the Paris waterways. They met regularly, and worked together with Monet and Renoir. In 1866, 1868 and 1870 Sisley exhibited at the Salon, but in 1867 and 1869 he was turned down. Sisley's work (pp. 84 and 96–99) showed his interest in the colour impressions of trees and buildings and particularly in the shifting play of light and cloud on a landscape.

In 1866, Pissarro settled at Pontoise with his family, then moved to Louveciennes in 1869; but he had an apartment in Paris too, and sometimes used it as a base when he went to the Café Guerbois evenings. On several occasions he joined Monet to work on the same view. The motifs he chose and his treatment of them show how systematically he was working on presenting spatial depth while retaining a firm structure in the visual surface, and how carefully he aimed to record gradations of colour under the influence of changing light. Apart from 1867, he was regularly accepted by the Salon, though he sold little as a result. Only

one unimportant dealer took an interest in his work. In 1868, together with Guillaumin, he tried to make a little money painting shop signs and doing other work of a similar kind.

He had more experience as a painter, compared with Monet, Renoir or Sisley, and in consequence his pictures possessed a greater maturity (pp. 58, 82, 83). His colours became visibly brighter, though Pissarro also had a penchant for muted shades beneath an overcast sky. He was particularly adept at nuancing shades of green and using the modulations to suggest depth without impairing the unity of impact. In the main he chose and handled his subjects so that the linear and the physical, plastic qualities would abet the marriage of spatiality and surface structure. Straight roads, often lined with trees, plunging into the depths at an angle and inscribing a dynamic sense of movement into a tranquil landscape, as well as *routes tournantes* twisting a gentle way through undulating country, are characteristic features in his work. The colouring and construction create a sense of structural interaction that looks almost Cubist – with hindsight. This quality, which was even more strikingly present in the work of his sometime follower Cézanne, has led to a higher valuation now being placed on Pissarro's work than was once the case.[80]

Renoir's aims were broader in scope, though his aesthetics were less secure than Pissarro's. Trying to carve out a place for himself in the Paris art scene, and at the same time having to sell pictures to make a living, he was not always clear in his own mind about the direction he was moving in. He was close to his Café Guerbois associates, particularly to

Berthe Morisot
On the Balcony, c. 1871/72
Sur le balcon
Oil on canvas, 60 x 50 cm
Bataille/Wildenstein 24. Private collection

Berthe Morisot
The Cradle, 1873
Le berceau
Oil on canvas, 56 x 46 cm
Bataille/Wildenstein 25
Paris, Musée d'Orsay

Bazille and Monet. In his application of paint he at first had a heavier touch than Manet, for instance, tending more to the manner of Courbet, who gave him personal advice and encouragement in 1865. About 1866 he began to lighten his palette, to dispense with underpainting in darker shades, and to study light in the open closely. To this end, in 1865 and 1866, with his painter friend Jules Le Cœur, he repeatedly went to Marlotte in the Fontainebleau woods or took long boat rides on the Seine with Sisley and Bazille. In spring 1867 he painted Paris city scenes with Monet. His view of the recently built *Pont des Arts* (p. 53), which spans the Seine between the Louvre and the Academy of Fine Arts, is a broad, panoramically structured scene that includes the bustle at a steamer landing stage and a lively interplay of light, shadow and clouds of various colours.

His main artistic aim became apparent in numerous genre portraits of his girl-friend, Lisa Tréhot, the daughter of a post office clerk. One life-size open-air portrait of her, exhibited at the 1868 Salon and now in the Folkwang Museum, Essen, had what Zacharie Astruc called a compelling "rightness of effects, finesse of colour shading, unity and purity of impression".[81] The bright light and transparent shadows found particular favour. The critic Théophile Thoré (1824–1869), who advocated *art social* under the pseudonym Wilhelm Bürger, found them "so naturally and exactly observed that people will think the whole thing wrong since they are used to imagining Nature in conventional colours".[82] The double portrait of Sisley and his newly wed wife Marie Lescouzec (p. 32) which Renoir painted a year after the picture of Lise is a winningly persuasive presentation of real feeling, made all the more attractive by the brilliant colourfulness of the dress; in this picture, though, the couple are not seen in uniform exterior light.

In summer 1869, Renoir changed his ways of painting, indeed of viewing his subjects, when he and Monet spent time on leisure-time pursuits of the Parisians. La Grenouillère was a bathing and boating lake with a bar and restaurant, on the island of Croissy in the Seine at Bougival. It was "widely known as a popular place for middle-class Parisian men to meet ladies of the *demi-monde*".[83] There were dealers who wanted paintings on this kind of subject,[84] so Renoir and Monet set about painting them – though the pictures they produced lacked sufficient precise detail and did not have the required anecdotal flavour. Their paintings (pp. 72, 73) were more like studies towards further works: they registered what they saw in compositions that were open-ended at the sides and seemed almost to shake and pitch as much as the boats and jetties. They painted rapidly and vigorously, in a way well suited to the bustle of people noisily enjoying themselves and to the shifting lights and colours on the agitated surface of the water. That favourite word in artistic debates at the Café Guerbois and in the Fontainebleau woods, "impression", was the very term for what the two artists were trying to capture. In their Grenouillère pictures they established something that had yet to wait five years for its name: Impressionism.

Monet was the most consistent of all the artists then questing in similar

The bank of the Seine at Argenteuil, with the new bridge in the background. Postcard, c. 1900

Claude Monet
Riverside Path at Argenteuil, 1872
La promenade d'Argenteuil
Oil on canvas, 50.4 x 65.2 cm
Wildenstein 223
Washington, National Gallery of Art

Claude Monet
The Harbour at Argenteuil, 1872
Le bassin d'Argenteuil
Oil on canvas, 60 x 80.5 cm
Wildenstein 225. Paris, Musée d'Orsay

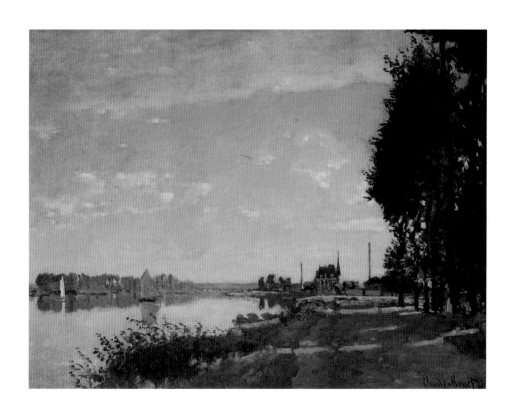

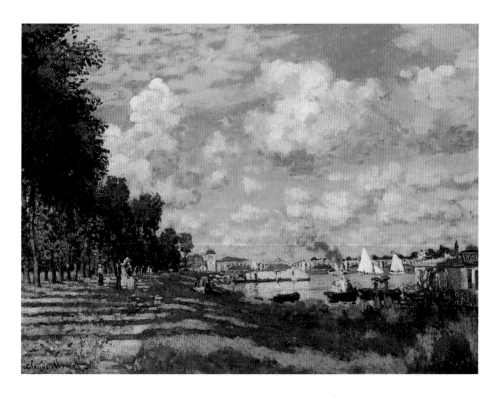

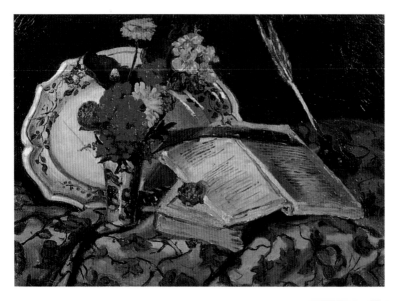

directions through similar experiments. His life was a hard one, particularly so when he married in defiance of his family and had a wife to look after. He and Camille Doncieux had had a first son in 1867; they married in 1870. To succeed with female portraits such as he was then painting, he would have had to paint them more like *Lady with Glove* (p. 82), say – with a casual coquettishness yet an inscrutable modesty of gesture. This brilliantly painted work took a prize at the 1869 Salon. The young artist Charles Durand, known as Carolus-Duran (1837–1917), had painted his young wife. A dazzling career as a portrait painter lay before him.

Monet was interested in the problems posed by groups of several figures in the open. He wanted to outdo Manet's *Le déjeuner sur l'herbe* (p. 37) both in terms of consistent *plein-airisme* and indeed in format: in

Pierre-Auguste Renoir
Madame Monet Reading "Le Figaro", 1872
Madame Monet lisant «Le Figaro»
Oil on canvas, 54 x 72 cm
Lisbon, Fundação Calouste Gulbenkian Museu

the late summer of 1865, at Chailly in the Fontainebleau woods, he painted his own picture of the same title, a group of twelve on a huge canvas measuring over four and a half by six metres and requiring a special and complicated easel. His wife, Camille, and various painter friends, among them Bazille and, at the centre, Courbet, modelled. Needless to say, Monet painted preliminary studies; the generous swathes of colour, often contrasting violently and varying greatly in brightness, have an almost Fauvist look to them. Though Monet continued work that winter in his Paris studio, however, the painting remained unfinished. He was unable to submit it to the 1866 Salon; later, rolled up, it spoiled, and all that remains now are a few impressive fragments (pp. 40, 41). Fortunately a study to which the date 1866 was subsequently added, in which some of the dresses are different colours and Courbet is not yet present, has survived to show what the composition was to look like as a whole.

Other comparable but less ambitious paintings, such as *Women in the Garden* (p. 49), painted in summer 1866, were completed. Monet did them at his new home closer to Paris, at Ville-d'Avray; Bazille paid for the materials; and the Salon committee, particularly hard to please in

World Fair year 1867, rejected them. When Monet looked at Paris, he saw visitors from all over the world, with potential purchasers among them, and doubtless with them in mind he painted a number of views from the windows of the Louvre (pp. 50, 51). All of them attest his admiration for the French capital's bustling energy, diversity and pride. That summer he visited his parents on the coast of Normandy and pressed on with what he had learnt from Boudin and Jongkind. He experimented with various points of view, and contrasted the fishermen's walks with the holidaymakers' promenades. In one painting in particular, *Terrace at Sainte-Adresse* (p. 59), he essayed a presentation of middle-class holiday behaviour amidst luscious flower beds and atmospheric beauty, in a light far brighter than in the woods near Paris. Monet's relish for powerful colours, and his numerous modern motifs, compensated for the lack of imagination or tension in the composition.

Over the next few years he overcame his compositional weakness. In his beautiful *The River, Bennecourt* (p. 76), the Grenouillère pictures (p. 72), and his Trouville beach scenes, his new attitude to Nature, a greater sense of dramatic tension in the visual image, and a stronger and more spontaneous use of colour were all happily forged into a new unity. Monet's eye for the beauties of this world, and his evident desire to pass on to viewers and buyers the pleasure he took in it, notably recorded his remarkable fundamental approach to life and art as an artist who said a big yes to life, despite constant hardship which placed him in frequent financial dependence on Bazille or the scarcely better-off Renoir. It was not his current circumstances but his vision of a better, more harmonious state that lay at the heart of Monet's art. At the same time, he insisted on painting only what he saw and felt himself, and abiding entirely by the imperatives of momentary appearances.

Impressionism

By the late 1860s, though no one could have distinguished the fact at the time, everything that was shortly to constitute Impressionism was already present in powerful early form. It is not easy to define Impressionism, though. It was the art of a small group of fairly young artist friends who spent a great deal of time in each other's company; but this is a purely external feature. The aesthetic aims and approaches of the group by no means invariably dovetailed. Friendship, and mutual strategies to secure positions in the art world, linked them to artists whose styles were not Impressionist at all. Every individual trait in the style had its roots and antecedents in pre-Impressionist art, and parallels in non-Impressionist art.

To paint in an Impressionist way meant representing a seen, given reality as it appeared to the eye. Everyday reality was foregrounded, particularly that of the artist's own social class, especially if it was engaging and attractive. Leisure activities made preferable subjects to

The Ile de la Cité, Paris

Berthe Morisot
View of Paris from the Trocadéro, 1872
Vue de Paris des hauteurs du Trocadéro
Oil on canvas, 45 x 81 cm
Bataille/Wildenstein 23
Santa Barbara (CA), The Santa Barbara
Museum of Art

Edouard Manet
The Railway, Gare Saint-Lazare, c. 1872/73
Le chemin de fer, Gare Saint-Lazare
Oil on canvas, 92.7 x 114.3 cm
Rouart/Wildenstein I,207
Washington, National Gallery of Art

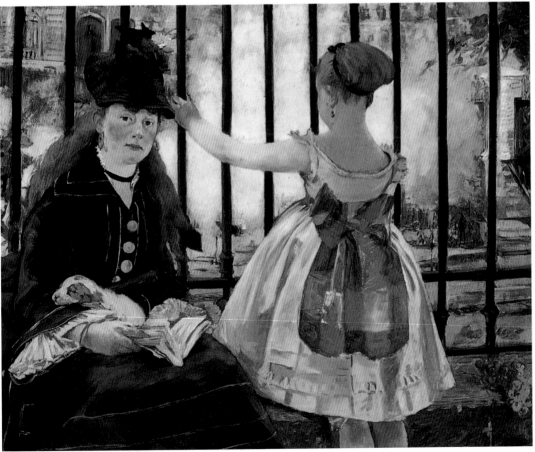

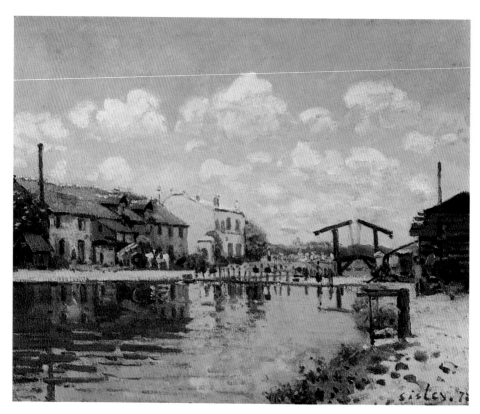

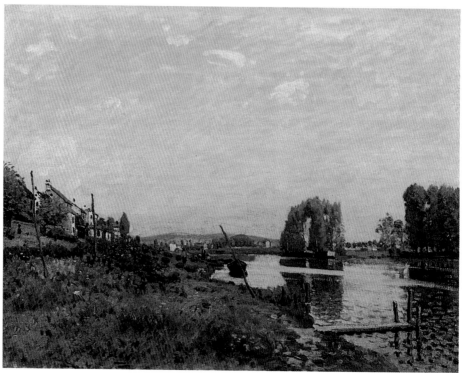

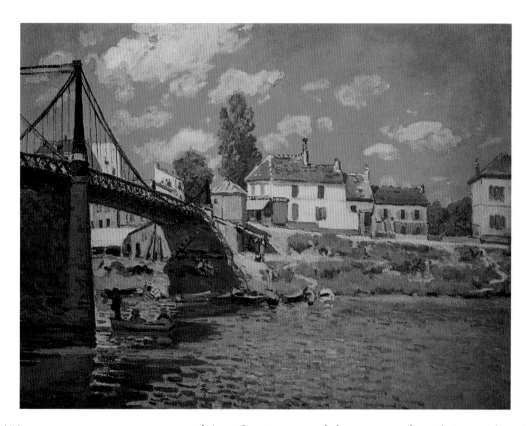

Alfred Sisley
The Bridge at Villeneuve-la-Garenne, 1872
Le pont de Villeneuve-la-Garenne
Oil on canvas, 49.5 x 65.5 cm
Daulte 37
New York, The Metropolitan Museum of Art

Left:
Alfred Sisley
The Saint-Martin Canal, 1872
Le canal Saint-Martin
Oil on canvas, 38 x 46.5 cm
Daulte 35. Paris, Musée d'Orsay

Alfred Sisley
The Island of Saint-Denis, 1872
L'Ile Saint-Denis
Oil on canvas, 50.5 x 65 cm
Daulte 47. Paris, Musée d'Orsay

worktime. Country, sea and sky were seen from their appealing sides. These were not unusual motifs by any means, and matched public taste well enough to mean sales. The Impressionists were particularly interested in dynamic aspects of the real, in anything that spoke of speedy flux. Indeed, the sense of change and movement was crucial – including the change and movement of light and colour. The Impressionists viewed the world exclusively through their own eyes as painters, and insisted that they were ahead of their contemporaries in terms of correct seeing. They were for more light and brighter colours; and the fact is that they really did grasp earlier or more emphatically than others what effect colour contrasts in a painting have, how the colour of a thing changes according to its surroundings and the conditions of light, and that shadows are of different colours. They also realised that a stronger or brighter impact can be achieved by a colour if dabs of various un-mixed colours are applied adjacently on a canvas, mixing optically only when they are registered by the onlooker's eye. Experiments aimed at a new way of seeing struck them as germane, a vital legitimation of artistic endeavour; and for this reason they occasionally declared that it was of no importance what subjects happened to be painted.

Impressionism was important in art history for three reasons. The first was that, in terms both of colour and of the cropping of sections of reality, the truth of a picture was relative because it depended on the person who did the seeing and painting and applied only at a specific

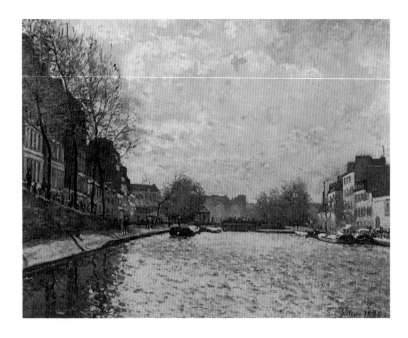

Alfred Sisley
The Saint-Martin Canal in Paris, 1870
Vue du canal Saint-Martin, Paris
Oil on canvas, 50 x 65 cm
Daulte 16. Paris, Musée d'Orsay

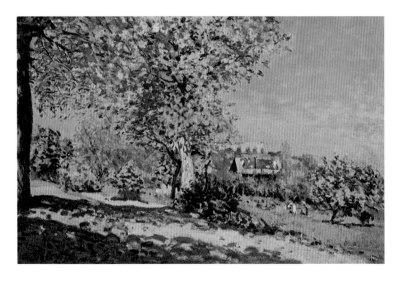

Alfred Sisley
Landscape at Louveciennes, 1873
Paysage à Louveciennes
Oil on canvas, 54 x 81 cm
Daulte 49
Tokyo, National Museum of Western Art

moment in specific circumstances. This idea was underlined by the openness of pictorial form in Impressionist art: the image was an excerpted section of space and time, to be recorded in rapid sketches.

The second reason was that the relativity of the image, and its open form, prompted those who looked at them to look and feel for themselves in new ways, and in so doing to complete the visual image and message. The individual picture was no longer an authoritative, incontestably valid source of instruction – though of course the artists had a natural interest in having their own ways of seeing and painting accepted by as many people as possible as correct and persuasive.

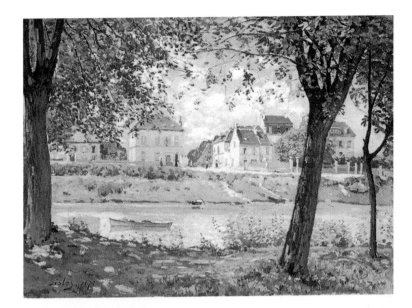

Alfred Sisley
Villeneuve-la-Garenne on the River Seine, 1872
Villeneuve-la-Garenne sur Seine
Oil on canvas, 59 x 80.5 cm
Daulte 40. St. Petersburg, Hermitage

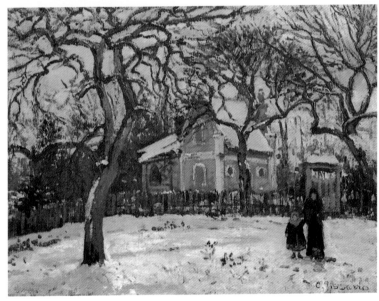

Camille Pissarro
Chestnut Trees at Louveciennes, c. 1872
Châtaigniers à Louveciennes
Oil on canvas, 41 x 54 cm
Pissarro/Venturi 146
Paris, Musée d'Orsay

The third reason why Impressionism was important was that, regardless of the representational value of the pictures, the act of painting as a pleasurable venture in itself, and the artwork as its enduring record, became established as intellectual values in their own right. This autonomy of creativity enabled the doctrine of *l'art pour l'art*, long in the offing, to gain ground. The view that an artist painted because he happened to want to and had the skill became widespread: the entire meaning and cultural significance of a picture might now consist solely in the fact that it was a picture rather than anything else.

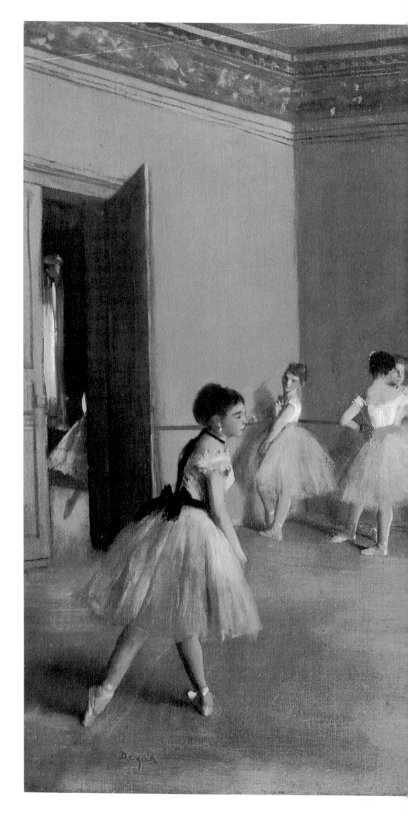

Edgar Degas
Dance Studio of the Opera, Rue Le Peletier, 1872
Le foyer de la danse à l'Opéra, rue Le Peletier
Oil on canvas, 32 x 46 cm
Lemoisne 298. Paris, Musée d'Orsay

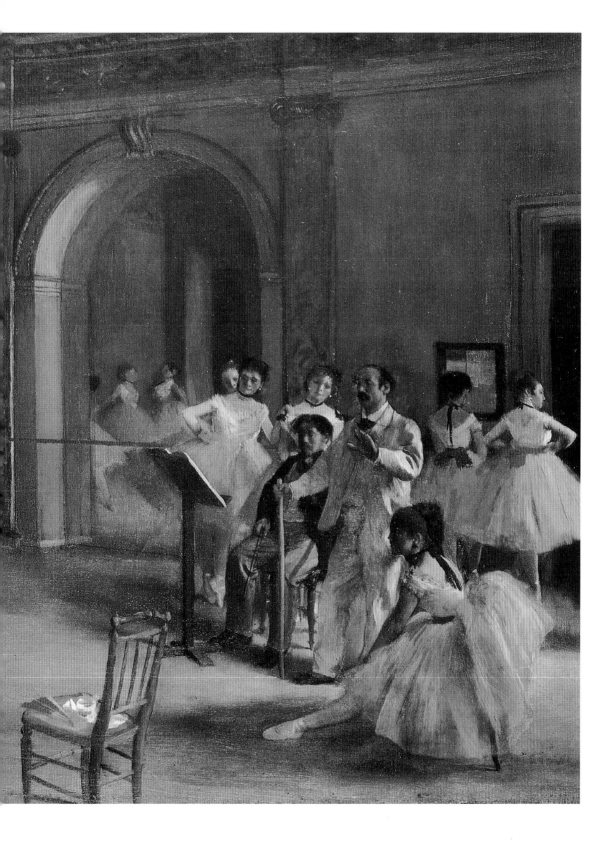

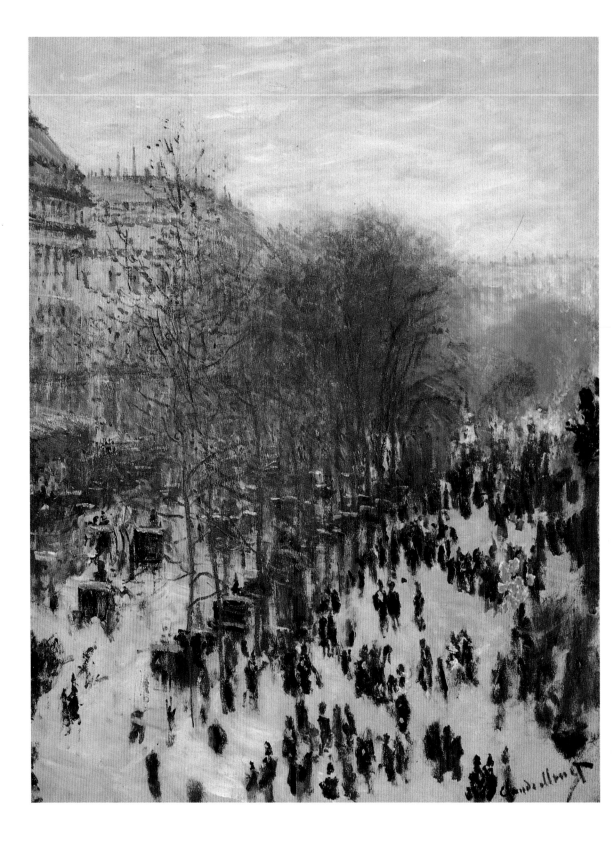

4 Getting there

For the small group of artists aged between thirty and forty, with their new ideas of Nature and art, the chances were good that they would establish their position with a growing proportion of the critics, the public, and art institutions, as the Barbizon painters had done some years before. "The landscape of France," it was said, "looks more like Corot's pictures with every year that passes" – and the witticism aptly reflected the influence the Barbizon artists had had on ways of seeing. But profound political changes were to deflect the normal course of aesthetic evolution.

War and Dispersal

In summer 1870, in a manner that was characteristic of the 19th century, France went to war with Prussia and certain other German states. France emerged defeated. Napoleon III capitulated at Sedan on 2 September and was taken prisoner by the Prussians; and two days later his opponents at home in Paris proclaimed France a republic. Bismarck's Prussia continued the war till the ceasefire of 28 January 1871 and the peace of 10 May. Under the Treaty of Frankfurt France surrendered Alsace and most of Lorraine to the new German Empire, which had been proclaimed on 18 January at the Palace of Versailles (of all places). The unstable fledgling republic of France was rocked by the Commune: in Paris, surrounded by German troops, a central committee of the lower classes established a more or less socialist commune of a kind familiar from precedent, from March to May. French troops put down this Commune (which had attracted the support of various artists, including Courbet) in a week of bloody and cruel fighting in May 1871.

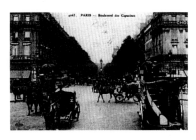

Boulevard des Capucines, Paris

The artists with whom we are concerned were affected by these events in various ways. Bazille enlisted in the Zouaves and was killed in a skirmish at Beaune-la-Rolande on 28 November 1870. Renoir too joined the army, but served in southern France, far from the front. He fell ill, received his discharge, and returned to Commune Paris, where Guillaumin and others were too. Manet, a Republican of firm conviction, joined the National Guard in Paris after the fall of the monarchy. Like Bracque-

Claude Monet
The Boulevard des Capucines, 1873
Le Boulevard des Capucines
Oil on canvas, 79.4 x 59 cm
Wildenstein 293
Kansas City (MO), Nelson-Atkins Museum of Art

Paul Cézanne
A Modern Olympia, c. 1873
Une moderne Olympia
Oil on canvas, 46 x 55.5 cm
Venturi 225. Paris, Musée d'Orsay

mond, Carolus-Duran, Tissot and the delicate late classicist Pierre Puvis de Chavannes (1824–1898), who was subsequently to play an important part in Post-Impressionism, he was under the command of Meissonier. Manet observed the misery in besieged Paris, and the defeat of the Communards, attentively, and was deeply shocked and moved. Degas, by no means a Republican, also served in the National Guard; like the others, he never actually saw active service. All of them still had enough free time to continue painting, drawing and frequenting the Café Guerbois. Morisot was living in Paris, and withdrew to the country, like Degas, only during the months of the Commune. Sisley had British nationality and was thus not directly affected by the war and its upheavals; he remained at Louveciennes, but the economic decline resulting from the war, and his father's death, made him a poor man. Pissarro, a Danish citizen and thus a foreigner too, left Louveciennes (which was not far

from the theatre of war) and fled via Britanny to London. His house was looted, by the French and especially the Germans. Hundreds of paintings which he had left behind were destroyed.

Monet spent the summer of 1870 on the coast again and, no friend of the Empire, avoided military service by going to London too, where he met Pissarro and Daubigny. The latter introduced him to the Parisian art dealer Paul Durand-Ruel (1833–1922), whose gallery in Rue de la Paix (and since 1870 in Rue Laffitte) had helped establish the Barbizon painters and was now acquiring a second house in London, in New Bond Street. There, Durand-Ruel now placed a number of works by Monet and Pissarro on show. Both found themselves with an opportunity to view various English paintings more closely, and Constable's landscapes in particular confirmed them in their views. Returning to France in 1871,

Paul Cézanne
Le déjeuner sur l'herbe, c. 1873–1875
Oil on canvas, 20.8 x 27 cm
Venturi 238. Paris, Musée de l'Orangerie

Monet stopped in Holland for his first visit of any duration, to see the museums and study new motifs. In 1869 Cézanne had begun an affair with Hortense Fiquet, a bookbinder's assistant and part-time model; after the outbreak of war he found her lodgings at L'Estaque near Marseilles, where he secretly visited her from Aix-en-Provence and painted. It was imperative that his strict and narrow-minded father, who disapproved of his son's art, know nothing of Hortense, since he might otherwise discontinue the 150 francs monthly allowance to Paul.

Manet was the only one whose art evidenced the traces of those turbulent times. Drawings and graphics which he did not dare publish recorded the defeat of the Commune, through motifs similar to those in *The Execution of Emperor Maximilian*. We know that Manet, as well as Degas, was profoundly affected by the butchery in Paris; a letter written to Berthe Morisot by her mother provides eloquent evidence.[85]

Camille Pissarro
Orchard in Blossom, Louveciennes, 1872
Verger en fleurs, Louveciennes
Oil on canvas, 45 x 55 cm
Pissarro/Venturi 153
Washington, National Gallery of Art,
Ailsa Mellon Bruce Collection

The temporary émigrés tried hard to extend their repertoire of motifs. Monet painted views of London and of Dutch canals and houses. In Pissarro's case it is striking that his interest in viewing unfamiliar sights went hand in hand with the continuity of a personal way of seeing. What he chose to paint in London suburbs was not unlike the village scenery of Louveciennes and environs, right down to the lanes leading to the distance and the gentle light.

The art of Cézanne, on the other hand, underwent a radical transformation during this period. Hitherto, all he had really had in common with the others had been ambition, an urge for innovation, and a rebellion against academic norms. In a letter of 1866 he had declared, "I shall have to decide to paint only in the open from now on"; initially, however, the deed did not follow upon the word. Both thematically and formally, Cézanne's art was more lacking in unity than that of his fellows. Unlike Monet, he poured his violent shifts of mood and response, and indeed his sexual obsessions, into his choices of subjects and the ways he rendered them. Self-taught, he struggled with difficulties in figural work and perspective spatiality. But he was also prone to give his temperament full rein, laying total and provocative claims to subjectivity.

Cézanne's paintings covered a broad range of subjects. One showed his father frontally, sitting on an armchair as on a throne and reading a newspaper. Originally the paper was the anti-imperial "Siècle"; but Cézanne overpainted its title, substituting "L'Evénement", the short-lived journal where Zola had published his first impassioned defence of Manet and other innovative artists in April and May 1866. These essays were

Camille Pissarro
The Four Seasons: Spring, 1872
Les quatre saisons: Le printemps
Oil on canvas, 55 x 130 cm
Pissarro/Venturi 183. Private collection

Camille Pissarro
The Four Seasons: Summer, 1872
Les quatre saisons: L'été
Oil on canvas, 55 x 130 cm
Pissarro/Venturi 184. Private collection

Camille Pissarro
The Four Seasons: Autumn, 1872
Les quatre saisons: L'automne
Oil on canvas, 55 x 130 cm
Pissarro/Venturi 185. Private collection

Camille Pissarro
The Four Seasons: Winter, 1872
Les quatre saisons: L'hiver
Oil on canvas, 55 x 130 cm
Pissarro/Venturi 186. Private collection

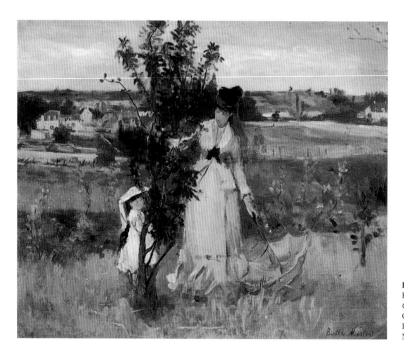

collected in pamphlet form as "My Salon" - and dedicated to his friend Cézanne (though there was no article on Cézanne's art in the colection).[86] Though Zola's views on art were unlikely to sway Cézanne *père*, Paul's visual allusion was meant as an argument: he wanted his father, who was grudgingly paying the allowance to his son, to register the fact that the art public were taking note of Paul Cézanne the artist. In 1870 and 1871, at Aix and L'Estaque, Cézanne (as he later related) decided, following an

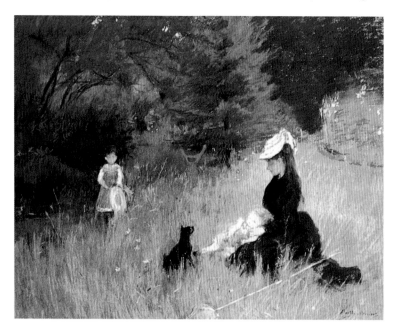

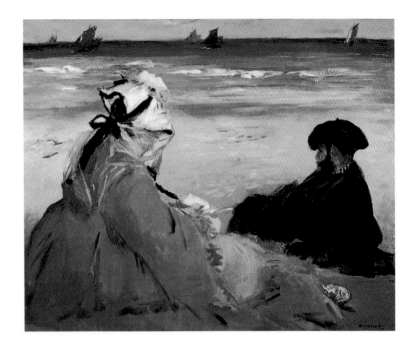

inner upheaval that he did not describe, to abide absolutely by Nature in his future art.[87]

Cézanne painted the landscape of his home parts, beneath the mighty Mont Sainte-Victoire, a mountain heady with ancient legend. He registered the incursions of modern life into the eternal face of Nature in works such as *The Railway Cutting* (p. 85). His aim was to experience and understand Nature by looking at it with appropriate humility and

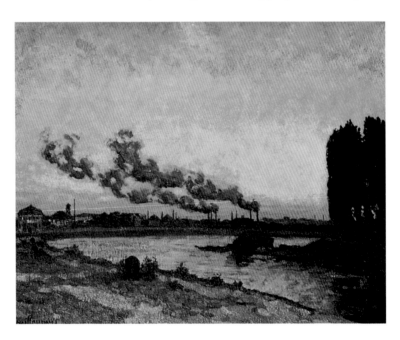

Edouard Manet
The Masked Ball at the Opera, c. 1873/74
Le bal masqué à l'Opéra
Oil on canvas, 59 x 72.5 cm
Rouart/Wildenstein I, 216
Washington, National Gallery of Art

attention. If he was out to create a photographic reproduction, though, he was nonetheless approaching Nature with his own ideas in mind, and looking in a way that his own views had delimited. Forms were simplified, and he worked sketchily, in powerful pastose colours, painting brightly. Henceforward, objectivity and interpretation were to be balanced in his work, a certain reticence together with a passionate involvement of his own self in the subject. He could never be entirely an Impressionist; but from 1871 on his art did have a fundamentally Impressionist tenor.

The Barrier of Mistrust

In the years that followed, the artists continued to work hard in the style they had struck out in. They were now certain of their ideas, and their efforts were directed at a more systematic solution of the structural prob-

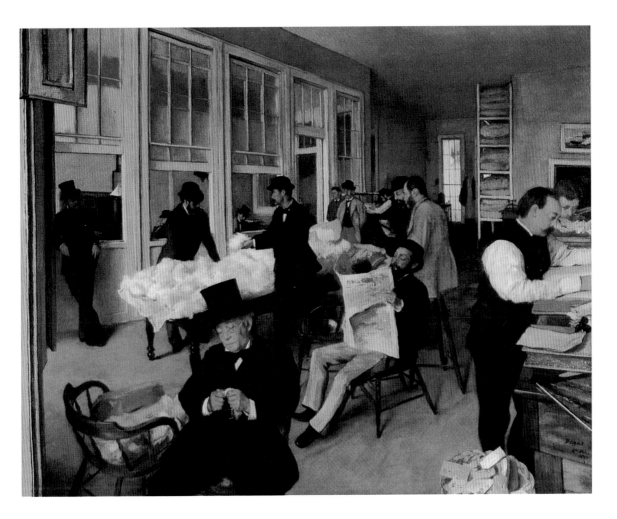

Edgar Degas
The Cotton Exchange at New Orleans
(Portraits in an Office), 1873
*Le bureau de coton à La Nouvelle-Orléans
(Portraits dans un bureau)*
Oil on canvas, 73 x 92 cm
Lemoisne 320. Pau, Musée des Beaux-Arts

lems they encountered during their work. Arts policy during the Second Empire had impeded their progress, and some of them had been politically opposed to the old regime too, so they now expected that greater recognition and better sales would come their way. But in this they were to be sorely disappointed.

The new republic was an insecure thing. Despite the reparations payments exacted by Germany, economic recovery was surprisingly prompt; but one of the first economic slumps of global proportions stifled this recovery in 1873. Power structures had by no means been clarified: President Adolphe Thiers was followed in office by Marshal Patrice MacMahon in 1873, with Victor Duc de Broglie as head of government. These two men aimed to restore a parliamentary monarchy under the old Bourbon dynasty; but the monarchists were divided, and there were adherents of imperial Bonapartism still to be reckoned with. In 1875, albeit by a majority of only one, a Republic constitution was adopted by the National Assembly that was to remain in force till 1940.

What matters for our present purposes is that the state of profound

Claude Monet
Red Poppies at Argenteuil, 1873
Les coquelicots à Argenteuil
Oil on canvas, 50 x 65 cm
Wildenstein 274. Paris, Musée d'Orsay

social shock that followed the Paris Commune produced an intellectual climate in which innovation or aesthetic revolution were viewed with fear, distrust or even loathing. For a considerable time to come, a cliché view of the Impressionists insisted on seeing them as "Communists", regardless of whether the painter in question happened to have sympathized with the Communards or not. For the first post-war Salon, in 1872, the jury was once again elected by artists who had been awarded a Salon distinction. In 1873 Paul Alexis (1847–1901), a friend of Zola and Cézanne and a regular at the Café Guerbois, wrote in a newspaper article that there were quite a few artists who, for this reason, longed for the Empire only recently so despised and vilified, and for the days of the Comte de Nieuwerkerke.[88]

On the other hand, a socio-cultural development continued that has remained important in art to this day. Art dealers were becoming more and more significant. The public fell into various unrelated sectors; there were only loose links between aesthetic positions, tastes or artistic preferences, and social status, worl-views, or political attitudes and interests; so the artists began to stress that the response of the expert was all

that mattered to them. Understandably enough, however, they still hoped to capture a wider and wider public.

At first, for the Impressionists, one dealer was of paramount importance: Durand-Ruel. He gave them confidence, despite the fact that even decades later he still preferred the Barbizon painters, who were more to his personal taste. As a dealer, he gambled that his clientele's aesthetic requirements would continue to develop. When the new movement finally got off to its proper start, his part was considerable. In January 1872 he bought everything he could lay his hands on in Manet's studio, and then works by almost all the other artists of the new Batignolles school. In 1873 he published a lavish three-volume sales catalogue with an introduction by the writer Armand Silvestre (1837–1901), who was intimate with the artists of the Café Guerbois. This catalogue, titled "Recueil d'estampes", featured 300 reproductions of works in Durand-Ruel's keeping. There were over twenty pictures each by Delacroix, Corot, Millet and Rousseau; seven each by Courbet and Manet; and a smaller number of works by Pissarro, Monet, Sisley and Degas. Durand-Ruel had also already bought work by Renoir and offered it for sale in

Claude Monet
Impression: Sunrise, 1873
Impression, soleil levant
Oil on canvas, 48 x 63 cm
Wildenstein 263. Paris, Musée Marmottan

Edgar Degas
The Dance Class, 1874
La classe de danse
Oil on canvas, 85 x 75 cm
Lemoisne 341. Paris, Musée d'Orsay

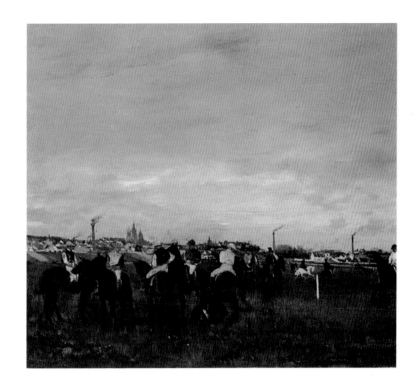

Edgar Degas
The Races. Before the Start, before 1873
Le champ de courses. Avant le départ
Oil on canvas, 26.5 x 35 cm
Washington, National Gallery of Art

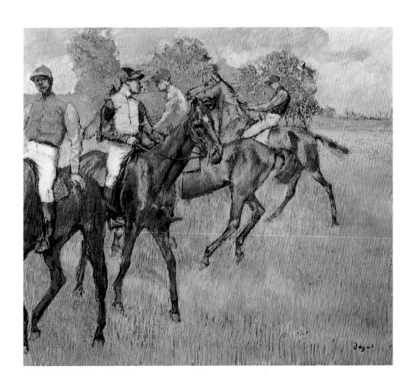

Edgar Degas
Race Horses, c. 1873
Chevaux de courses
Pastel, 57.5 x 65.4 cm
Lemoisne 755
Cleveland, The Cleveland Museum of Art

Camille Pissarro
Hoarfrost, 1873
Gelée blanche
Oil on canvas, 65 x 93 cm
Pissarro/Venturi 203
Paris, Musée d'Orsay

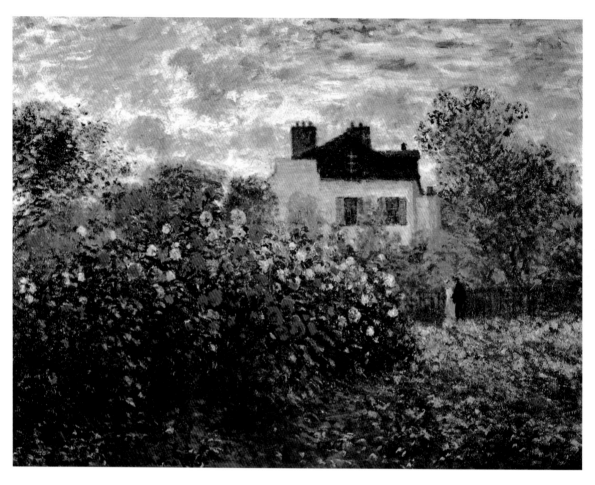

Claude Monet
Monet's Garden at Argenteuil, 1873
Le jardin de Monet à Argenteuil
Oil on canvas, 61 x 82 cm
Wildenstein 286. Private collection

his London rooms. In the following year, though, the financial effects of the slump forced him temporarily to suspend the purchase of paintings that provided him no return in the short term.

In the debates on the best market strategy, Manet was one of those who considered that the real decisions on public stature were taken at the Salon. In 1873 he had a certain success there with his stylish portrait of Berthe Morisot (p. 48), painted three years earlier. Other paintings from that same productive year show that he was not only trying to extend his ideas of modern subject matter but also aiming at a brighter, more fluid and open manner of painting. *The Masked Ball at the Opera* (p. 110) is suggestive of his ironic delight in the behaviour of the gentlemen in tails and top hats, providing him with an opportunity to shine at black, and the gaiety of the colourful girls. The top edge of the painting emphasizes the cropped nature of this sectional view. The work was bought by the Impressionists' first generous collector and patron, the wealthy opera singer Jean-Baptiste Faure (1830–1914). He also bought *The Railway, Gare Saint-Lazare* (p. 95), begun in 1872, shown

Claude Monet
The Luncheon, 1873
Le déjeuner; panneau décoratif
Oil on canvas, 160 x 201 cm
Wildenstein 285. Paris, Musée d'Orsay

at the Salon in 1874, and in reality a genre portrait of Manet's model Victorine and the daughter of his friend Alphonse Hirsch, in whose Paris garden near the station the picture was painted. The true subject is the exclusion of women from the new dynamics of modern life. In the summer of 1873, Manet was energetically tackling the problems posed by figures in the open. He painted in Paris, in the garden of his successful painter friend Alfred Stevens; or on holiday at Berck-sur-Mer on the coast, producing works such as *On the Beach* (p. 109).

Degas, free of the need to sell pictures in order to live, pursued his interest in people, their characters and temperaments, their faces and body language. The way they behaved struck him as remarkably eloquent of the conditions they led their lives in. He painted uncommissioned portraits or had his acquaintances present situations that conveyed typical behaviour. Crowds at racetracks (pp. 70, 71) and the lean, diminutive jockeys on their delicate, nervy horses (p. 115) supplied him with open-air motifs. He was relatively unconcerned with the play of sunlight; but he was all the more drawn to the curious colour effects

Paul Cézanne
View of Auvers, c. 1874
Auvers, vue panoramique
Oil on canvas, 65.2 x 81.3 cm
Venturi 150
Chicago, The Art Institute of Chicago

produced by cool, incisive gaslight. Gas was increasingly being used for lighting in theatres, restaurants and other public places, as well as homes. And ballet became the main focus of Degas's artistic interest, an inexhaustible source of interesting postures and movements.

Yet Degas rarely drew, much less painted, directly from a model. Rather, he used and developed his gift for exact observation, for memorizing details and then, in the studio, freeing what he had seen and resolving it in a composition. Degas's approach contrasted greatly with that of the open air painters; he was against their spontaneity, in fact. He insisted on the artist's right to transform and clarify what he has seen in a visual form of his own making. What appealed to him most in observed reality was the chance element, things that might appear meaningless at first. For him as a sceptical observer free of illusions, messages consisted primarily in permitting the individual to act with neither meaning nor result. There were no overall, lucid, causal contexts. Today, given the further development of given reality and of art, Degas may well strike us as especially "modern" on account of this sceptical pessimism.

In *Musicians in the Orchestra* (p. 87) he went in even closer to the heads of the orchestra musicians than in his earlier approach to the subject (p. 67). The spatial and colourist ensemble, with the dancers' limbs and faces lit strangely by the limelight from below, emphasizes unclarity or polarities.

From 1872 on, Degas devoted most of his attention to ballerinas practising under their master (pp. 100/101) or rehearsing on stage, where occasionally gentlemen would be looking on and would afterwards express a wish to take one of the girls home with them (p. 129). These scenes provided Degas with an opportunity to record the beauty of dance steps and the sheer effort that went into them, but also the bored weariness of ballerinas killing time as they waited to go on, stretching or scratching. He studied the girls' lean bodies; they tended to come from the poorer classes. Positioning their feet delicately had become second nature with them. Degas clearly perceived the contrast between their fairylike grace and their wretched social circumstances. He could see that ballet meant speedy, formalized movement, solo but especially in groups,

Paul Cézanne
Six Women Bathing, c. 1874/75
Baigneuses
Oil on canvas, 38 x 46 cm
Venturi 265
New York, The Metropolitan Museum of Art

Edgar Degas
Four Studies of a 14-year-old Dancer, 1879
Pencil on paper, 48 x 30 cm
Paris, Musée du Louvre, Cabinet des Dessins

Edouard Manet
The Monet Family in the Garden, 1874
La famille Monet au jardin
Oil on canvas, 61 x 99.7 cm
Rouart/Wildenstein I, 227
New York, The Metropolitan Museum of Art

Berthe Morisot
Chasing Butterflies, 1874
La chasse aux papillons
Oil on canvas, 46 x 56 cm
Bataille/Wildenstein 36
Paris, Musée d'Orsay

across an extensive, empty space. He devised ever new compositions in order to establish the greatest possible motion and spatiality in a fixed, immobile, flat scene.

The approaches taken in Japanese woodcuts prompted Degas to try out a degree of asymmetry hitherto unknown in European art. He juxtaposed crowded figures and vacant spaces, cropped figures or overlaid them with objects that happened to be standing around, and generally heightened the sense of chance at work. This seeming chaos, though, was networked with barely perceptible linear interrelations and parallel repetitions in the figures and the architectural backgrounds, and the visual structure was cemented by consonances and counterpoints of colour. The sizes of his pictures varied, gradually increasing; his approach as draughtsman and as painter evolved from a miniaturist, old-master delicacy to a more generous, relaxed largesse.

The circumscribed but artistically striking world of ballet and dance theatre afforded Degas an aesthetically structured model for relations and behavioural patterns in a society that indulged in such luxuries. There, as he put it, he found "the movements of the ancient Greeks united in one place",[89] but he also found an internally inconsistent union of art, work and business, and an unemotional manufacture of feeling. Author Joris-Karl Huysmans (1848–1907) presently wrote that "Degas [...] unremittingly dethroned the mercenary girl rendered stupid by her mechanical strutting and monotonous leaps..."[90] It is primarily the attractive colours of the pictures that tell us how susceptible Degas was to the magic of theatre. But his view of his own role as sceptical observer compelled him to strip away the magic from these idols of the entertainment world, of a social stratum hungry for pleasures.

Degas had an acute eye for everyday behaviour presented in a psychologically precise way, and for the critical moments in life that are expressed in mutual silence. *The Cotton Exchange at New Orleans* (p. 111) was kin thematically and stylistically to a fairly familiar kind of genre realism; for that reason, it was the first Degas to be acquired by a French museum, and for a long time indeed the only one. Degas's uncle Michel Musson – the elderly gentleman checking the product quality in the foreground – ran a cotton exchange in America, and Degas had gladly used this found subject, with its various autonomous and unrelated components, when he visited New Orleans. For pictures such as this, Degas at times used a photo he had himself taken as a starting point instead of preliminary studies;[91] this was the origin of Impressionist Realism in the representation of social reality. Degas himself, it is true, was not consistent in pursuing this line further, although he encouraged others to do so.

For financial reasons, Renoir inevitably needed sales and success more than Degas did. His attempt to lighten his palette and loosen his formal idiom was apparent not only in city scenes and landscapes but also in his small private portrait, *Madame Monet Reading "Le Figaro"* (p. 93). It would seem he surprised her at home in Argenteuil, lying on the sofa reading the paper; without troubling to adopt any more formal pose, she is gazing calmly at the artist (and at us) with her fine, dark eyes. This was

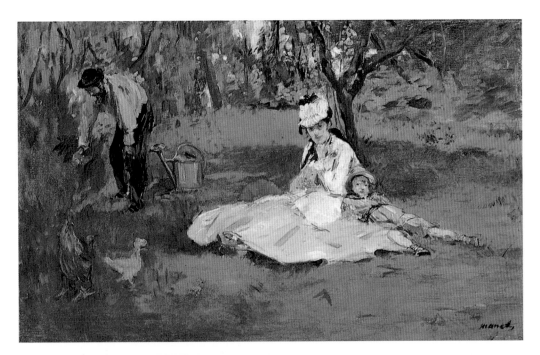

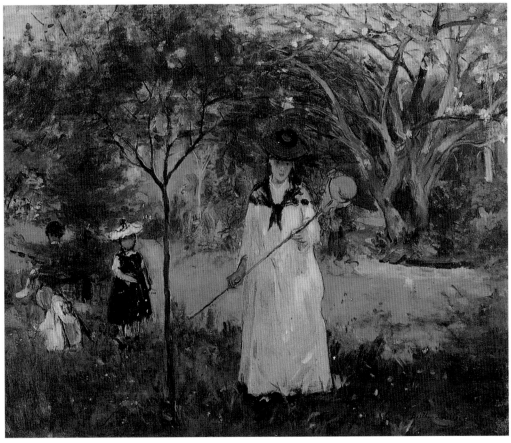

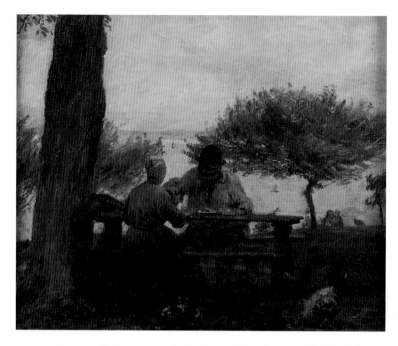

a natural, unstudied scene precisely observed; and it was filled with light, a thing of fragrance, sketchily done in thin paint. It was an *hommage*, tenderly done, without the sarcasm that was usually evident in Degas.

In Pissarro's case we see the maturity and assurance of a copious output. Living at Pontoise, in hilly country among vegetable growers, where industrialization was still in its infancy, he had all the motifs he needed

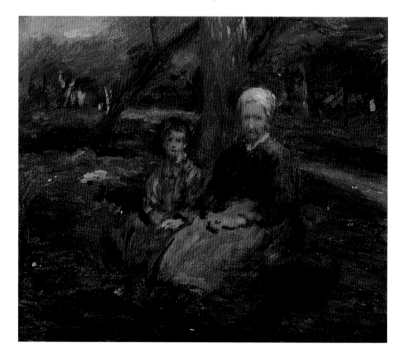

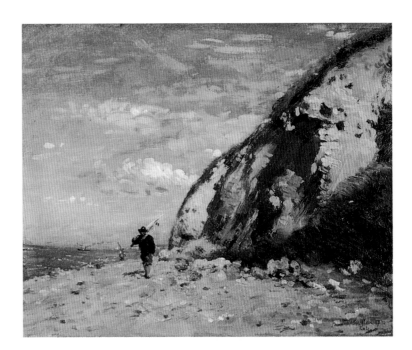

for his notions of artistic subjects and formal strategies. Nature cultivated by human toil and thus made accessible to the emotions, the tensions and harmonies of the terrain with its natural vegetation and man-made buildings and artefacts – these were sufficient to keep his responses on the alert and his eye registering constructively and noting formal solidities. The world recorded in his paintings is a tranquil, peaceful place and a makeweight to the hectic, profiteering reality that was in many ways becoming uglier elsewhere.

Edouard Béliard (1835–1902), of whose art we know next to nothing (p. 155), painted with Pissarro, as did Guillaumin, who worked night shifts in order to paint by day. From Pissarro he took the structure and composition of street views with figures (p. 154) and the creation of spatial depth by the use of twisted lanes. But he also had a somewhat romantically coloured view of modern industry of his own. In one work (p. 109) we see smoke billowing from factory chimneys in the Paris suburb of Ivry, like triumphant banners fluttering against a ruddy golden evening sky: is this some new impression, a positive view of technological progress and French economic power, or is it a warning against the destruction of the natural environment and of a fine riverscape? If Pissarro himself occasionally painted a new alcohol factory in Pontoise, for instance, it seemed he saw a certain dignity in a place of work and felt it was not at odds with the landscape, even if he was not entirely happy about it.[92]

For Pissarro, the most important contact was his genuinely productive work with Cézanne. The latter had settled in Pontoise in late 1872 to receive guidance from his mentor. Pissarro introduced him to the paint and art dealer Julien "Père" Tanguy (1825–1894), who had fought with

the Communards and now supplied Cézanne with paints and canvases in exchange for paintings (which initially he could not sell). It was similarly intellectual affinity that took Cézanne in early 1873 to Auvers, a village not many kilometres from Pontoise, where Dr. Paul Gachet (1828–1909), who had his practice in a working-class district of Paris but did not live there, put lodging, a studio and an etching printing press at his disposal, as well as buying occasional pictures. Gachet was a homoeopathic doctor, a freethinker and socialist who had been an army doctor during the Commune. He was interested in modern art, dabbled in painting himself, and frequented the Café Guerbois. For years he had been a friend of Pissarro and Guillaumin.

Near to Pissarro, and indeed often painting the same motif (though not at the same time), Cézanne adopted an Impressionist way of painting. And he in turn evidently strengthened Pissarro's desire for a constructivist visual structure and a sense of spatial depth achieved purely by gradation of colour values without changes in the planar qualities of the picture. His vehemence of old, and his oddly strained relations with Manet, whose well-groomed elegance and respect for the Salon repelled him, issued in his parodic paraphrase of Manet's controversial nude – *A Modern Olympia* (p. 104). Gachet bought it. His little *Le déjeuner sur l'herbe* (p. 105), on the other hand, with its crowd of sketchy figures and the verticals of trees and spire, is closer to Pissarro's work. The same is true of the crystalline patterning of *View of Auvers* (p. 120). These were contributions to the overall evolution of Impressionism, no doubt, and justify the view "that Pissarro and Cézanne, between 1870 and 1880, jointly laid the foundations of modern art"[93] – that is, of the view that pictorial values are autonomous, a view that gained ground from the late 19th century on.

For the moment, though, the main line of the new art was dictated by the quest for a new articulation of impressions and sensations conveyed by the flux of natural phenomena. To be precise, it was a matter of finding ways to express a positive, primarily hedonistic revelling in the natural and cultivated world, a setting with which humanity was conceived and shown to be in harmony. This was Pissarro's intention. Others such as Morisot (p. 95), Guillaumin or Sisley (pp. 96–99), partly under Manet's influence, placed a greater emphasis on city life in their work, or took people out in the open as their central subjects rather than as an excuse for landscapes.

Delight in the beauty of Nature accompanied a desire to juxtapose pure and contrasting colours, such as red and green or blue and yellow. Contrasts of this kind produced decorative effects that led Monet in particular to paint a great profusion of floral and blossom scenes. Glinting water on the Seine or one of its tributaries, beneath a blue sky studded with white clouds, and with a few cheerful sailing boats on the waves, prompted a more generous, relaxed, pastose application of paint.

For his resplendent large painting *The Luncheon* (p. 119), which he exhibited in 1876 under the telling title *Decorative Mural*, Monet hit upon a characteristic visual idea. Into a flower garden scene, where the

The Hermitage near Pontoise. Postcard c. 1890

Camille Pissarro
A Cowherd at Pontoise, 1874
Gardeuse de vache sur la route du Chou, Pontoise
Oil on canvas, 55 x 92 cm
Pissarro/Venturi 260
New York, The Metropolitan Museum of Art

Camille Pissarro
The Hermitage at Pontoise, 1874
Un coin de l'Ermitage à Pontoise
Oil on canvas, 61 x 81 cm
Pissarro/Venturi 262
Winterthur, Oskar Reinhart Collection

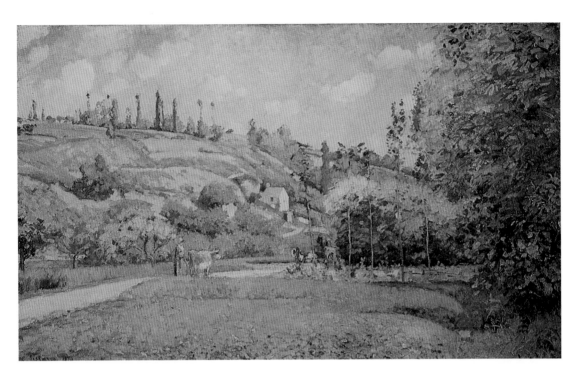

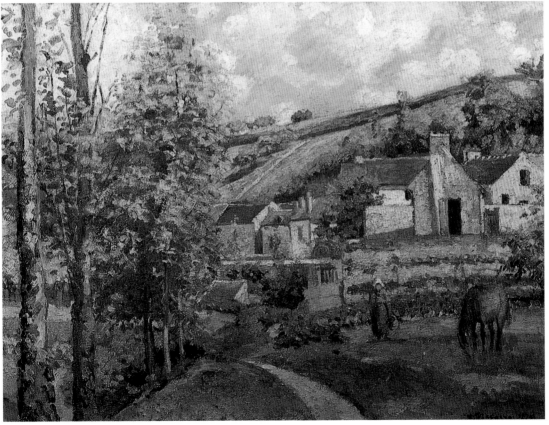

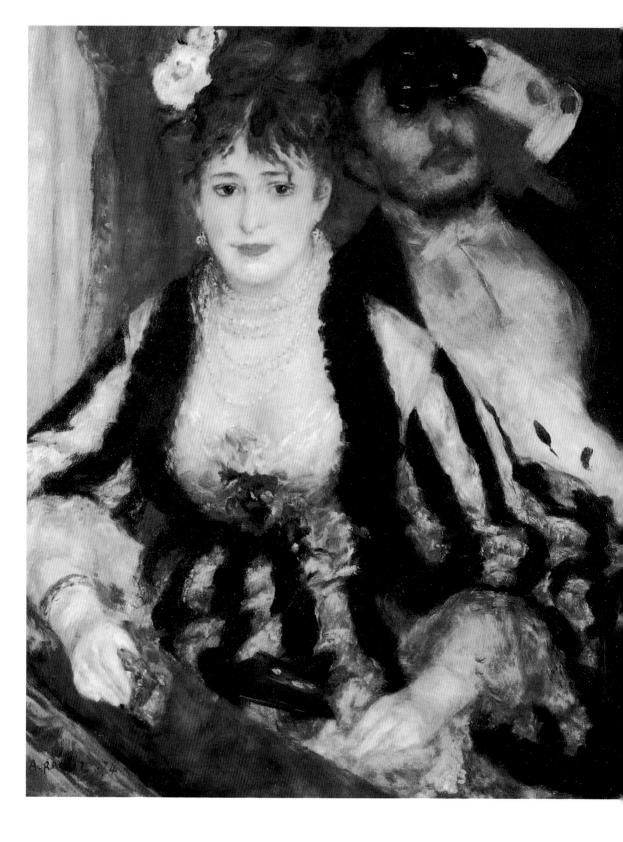

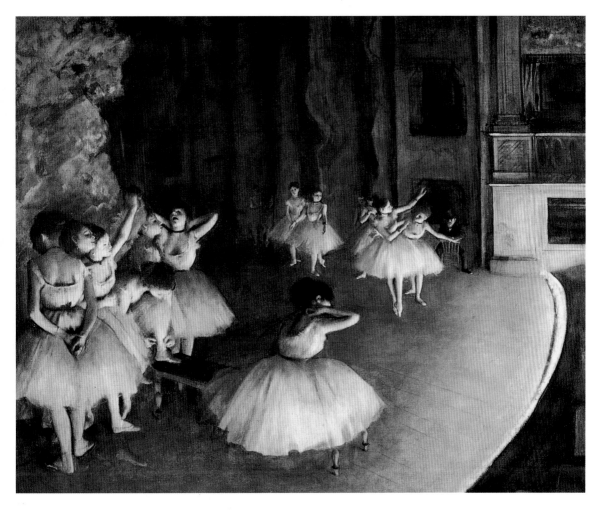

Edgar Degas
Rehearsal of a Ballet on Stage, 1874
Répétition d'un ballet sur la scène (Salle de danse)
Oil on canvas, 65 x 81 cm
Lemoisne 340. Paris, Musée d'Orsay

Left:
Pierre-Auguste Renoir
The Theatre Box, 1874
La loge
Oil on canvas, 80 x 63.5 cm
Daulte 116
London, Courtauld Institute Galleries

interplay of sunlight and blue shadows is dominant, he introduced the human cast (his family) primarily through the objects they had left behind, via a kind of still life. In this way he was able to take as his true subject a situation that in fact already lay in the past. The angled view of the abandoned table and seat, and the overlaying of the figures glimpsed in the background, suggest that the person viewing the scene has only just happened upon it; and this motif of departure constitutes an experiment with motion and with a dimension that is strictly speaking inaccessible to painting, the dimension of time. Degas was not the only one to find painting the passing of time become a central issue. It was to be a problem for Impressionism in general, and indeed subsequently for all of Modernism.

Movement, and the presence of crowds indistinguishable as individuals, as well as the atmospheric appeal of a winter's day at carnival time, prompted Monet to paint two pictures of the *Boulevard des Capucines* (p. 102). Monet clearly had an intuitive sense of the essence of modern city life. He was also a master of the sensuous effect that derives from

Marcellin Desboutin
Portrait of Jean-Baptiste Faure, 1874
Portrait de Jean-Baptiste Faure
Oil on canvas, 40.8 x 32.7 cm
New York, Wheelock Whitney and Company

Edgar Degas
At the Beach, 1876
Bains de mer
Thinned oil on paper on canvas, 46 x 81 cm
Lemoisne 406. London, National Gallery

this diagonal view downward and into a deep perspective. The canvas is meshed with short brushstrokes, some thin and abrupt, others thick and pastose, in fairly light shades. We almost imagine we can hear the sounds of carriages, horses' hooves, and people walking and talking. It is a record of reality in a state of busy flux.

Around 1800, Paris already had a population of about 550,000. By 1850 it was a million, but by 1870 the figure had climbed to almost 1.9 million. In those two decades, the formative years for the Impressionists, the city's population increased annually about six times as fast as it had done in the first third of the century. In his novel "The Spoils", written from 1869 to 1871, Zola described the ruthless land speculation when the new boulevards were being laid out, when "the old Paris was being ploughed under, the quarter of rebellions and barricades" (from 1789 to 1848) – the very term Haussmann had himself used.[94] But he also described a new, positive feeling towards the changed city: "The two lovers had a genuine passion for the new Paris... their eyes gazed affectionately on the vast, broad, grey ribbons of pavements with their benches, columns papered with colourful posters, scrawny trees. That bright track, growing ever narrower till it reached a rectangle of vacancy at the far horizon... the crowds of people pouring by, and the sound of their footfall and voices, gradually filled the two of them with unqualified and unmixed joy, with a sense of the excellence of street life."[95]

And then in 1873, on one of his visits to home parts at Le Havre, Monet painted a picture (which he later inscribed with the earlier date of 1872) of the old harbour. Hastily sketched in strong blue-green, violet,

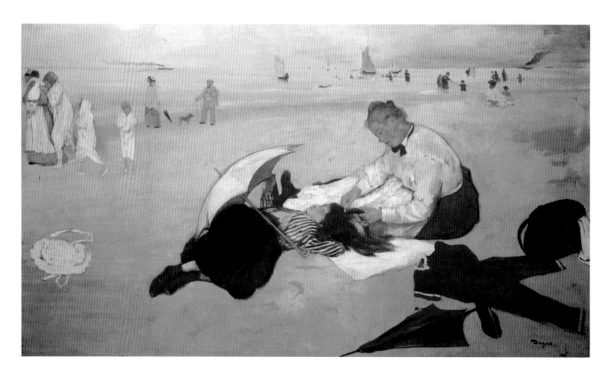

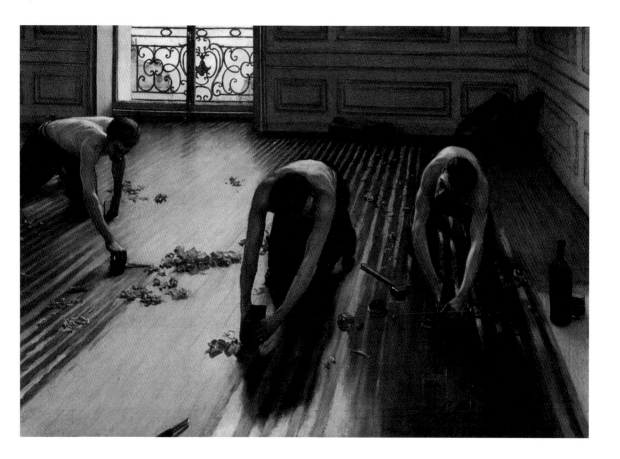

grey and reddish orange, it shows shipping, wharfs and dockland factories veiled in morning haze. It is an unromantic sunrise, effectively structured in obedience to the golden section (p. 113). When a title was needed in a hurry for the catalogue of the exhibition we shall presently be discussing, Monet supposedly suggested simply *Impression*, and the catalogue editor, Renoir's brother Edouard, added an explanatory *Sunrise*. The artist was not to know that in this way – via dismissive criticism which seized upon the first word – he had given the entire movement its name, and had made the painting itself a key, pivotal work in the history of modern art.

Gustave Caillebotte
The Floor Strippers, 1875
Les raboteurs de parquet
Oil on canvas, 102 x 146.5 cm
Berhaut 28. Paris, Musée d'Orsay

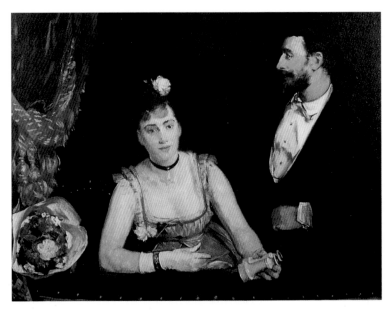

Eva Gonzalès
A Box at the Théâtre des Italiens, c. 1874
Une loge aux Italiens
Oil on canvas, 98 x 130 cm
Paris, Musée d'Orsay

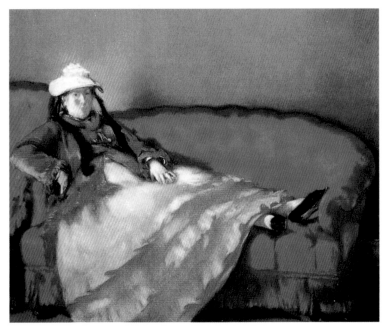

Edouard Manet
Madame Manet on a Divan, 1874
Mme Manet sur un divan
Pastel on paper on canvas, 65 x 61 cm
Rouart/Wildenstein II,3
Paris, Musée du Louvre, Cabinet des Dessins

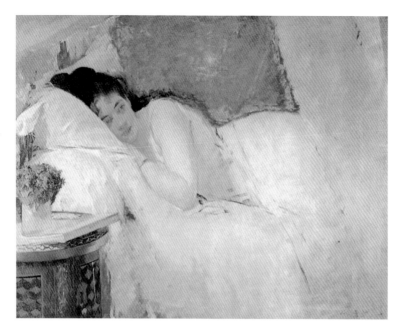

Eva Gonzalès
Morning Awakening, 1876
Le réveil
Oil on canvas, 81.5 x 100 cm
Bremen, Kunsthalle Bremen

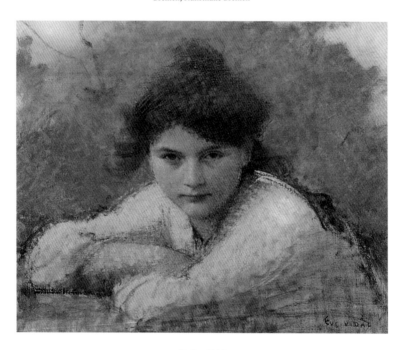

Eugène Vidal
Girl Resting on her Arms
Jeune fille accoudée
Oil on canvas, 47 x 59 cm
Private collection

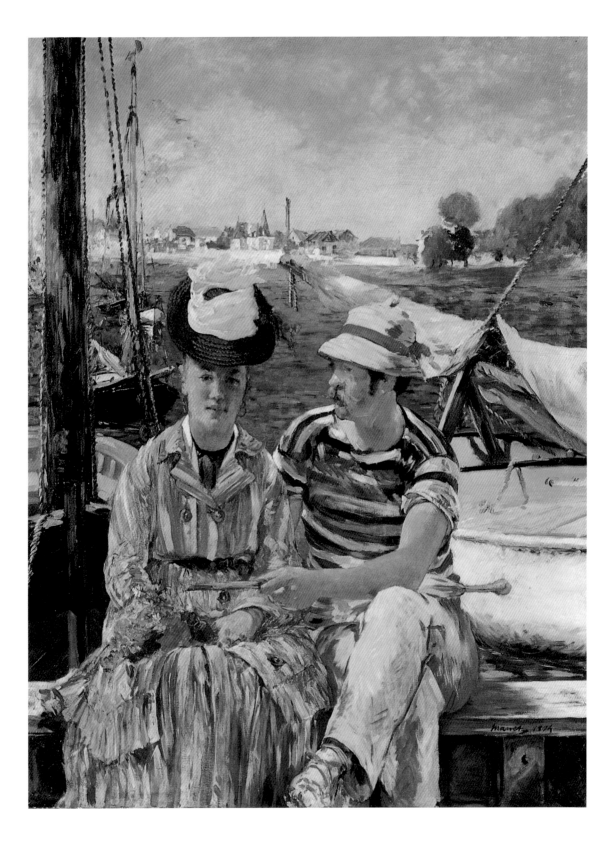

5 A Group Show and a Name

Only a few of our artists submitted paintings to the 1873 Salon. Of these few, only Manet and Morisot were successful. The Salon des Refusés was repeated that year; but the more important development was that the thought of making one's way independently of the Salon was gaining substantial ground. Durand-Ruel's interest, and his catalogue, fed the hope that dealers would establish the new art. Monet, for example, had had a good year in 1872. Durand-Ruel had bought at least 29 pictures from him, and there were other buyers too, bringing his total income to 12,000 francs. Monet now employed a gardener to tend the flower beds he painted, and he no longer needed to starve his appetite for good food and drink.[96]

"We thank M. Manet for introducing a touch of humour into this rather dismal Salon." Cartoon by Bertall in "L'Illustration", 29 May 1875

The economic crisis of 1873 muted the artists' hopes, despite the fact that good prices were still being paid for paintings in early 1874. In the latter half of 1873 they returned in heated debates to the old idea of an independent exhibitors' association. Certain artists such as Manet and critics such as Théodore Duret (1838–1927), who had started to advocate the new art, still considered the struggle for a place in the Salon to be the crux. Others, among them the politically left-wing critic Castagnary, argued the case for autonomous shows that bypassed the jury system. Renoir drew upon his experience working for the crafts trade when they discussed organizational and financial issues. Pissarro made enquiries into the statutes of a bakers' co-operative in Pontoise. These statutes ultimately served as a model for those of the new co-operative, the Société anonyme des artistes (or, as it was given on the cover of the first exhibition catalogue, the Société anonyme des artistes-peintres, sculpteurs, graveurs, etc.). The society was constituted on 27 December 1873, registered with the relevant authorities, and announced to the public in "La Chronique des Arts et de la Curiosité" of 17 January 1874.

Every member had to pay at least 60 francs a year. This fee earned the right to exhibit two works, the hanging of which would be decided by lot. Ten per cent of sales proceeds were to be returned to the co-operative's capital. The group busily sought further members to strengthen the financial base, and even placed advertisements using the names of artists who in the event declined to join. Names that were recognised by the Salon and valued by the public were particularly welcome, to consolidate the co-operative's credibility. This was a quite new strategy for bringing

Edouard Manet
Argenteuil, 1874
Oil on canvas, 148.9 x 115 cm
Rouart/Wildenstein I,221
Tournai, Musée des Beaux-Arts

art to the public's attention. There was no joint programme in writing, nor was there ever to be one. Degas suggested calling the group "La Capucine" (nasturtium) – from the seven or eight exhibition rooms at 35 Boulevard des Capucines – but the proposal was not adopted. The exhibition space belonged to Félix Tournachon called Nadar (1820–1910), the highly-regarded photographer, who had recently transferred his business to other premises. It is not altogether clear whether he gave the group the use of the rooms gratis or for a fee of 2,020 francs; since he himself was in financial straits, the latter is the likelier alternative.

On 15 April 1874, a fortnight before the official Salon opened, the Société's exhibition opened for a month, from 10 a.m. to 6 p.m. as well as 8 till 10 p.m. Admission cost one franc, as it did to the Salon, and the inaccurate catalogue half that amount. Thirty-one artists exhibited, and the catalogue ran to 165 entries, some of them multiple. Contrary to the Société's statutes, all of the artists exhibited more works than they had paid to exhibit. The show was well attended, by about 3,500 people in all, and earned a slight profit, at least on first inspection; at the end of the year, however, every member would have had to pay in 184.50 francs to cover debts and restock the co-operative's capital; and so, on 17 December 1874, the thirteen members present at a general meeting agreed to wind up the Société. It had not been a successful form of organization. Its fame in the history of art was assured, though. And in the short term it confirmed the artistic resolve and persistence of the most important artists.[97]

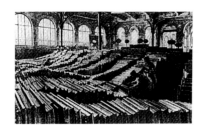

The paintings rejected by the Salon jury in 1863 were deposited in the Palace of Industry

Half of the Société artists (sixteen) did not repeat the experiment. Apart from Monet's old father-figure Boudin, and a delicate follower of Corot, landscape painter Stanislas Lépine (1835–1892), whose paintings (pp. 68, 202) had long since found an audience, these were all artists who, despite subsequent Salon exhibition, were to earn no places of any significance in the story of art; and, above all, they did not paint in an Impressionist way. Among them were Antoine Attendu (1845–1905), a painter of still lifes; landscape painters Louis Latouche (1829–1884), Auguste de Molins (1821–1890), Mulot-Durivage (1838–1944) and Léopold Robert; and the enamel painter Alfred Meyer (1832–1904). Astruc, the painter and sculptor, poet and art critic, had a good dozen works in the show, mainly watercolours, several of them dealing with the fashion in orientalism (p. 92). Gustave Colin (1828–1910), whose subjects followed the Spanish vogue, had been consigned to the Salon des Refusés along with Manet in 1863, and had been praised by Zola for his lighting effects. The show included sculpture by the aged Auguste Louis Marie Ottin (1811–1890), who exhibited there because he was an inveterate anti-establishmentarian. In the days of the Commune he had been on the committee of the Paris Artists' Association led by Courbet. Another aged painter, the realistic genre artist Adolphe-Félix Cals (1810–1880), a working-class Parisian now living in Honfleur and associated with Boudin (pp. 124, 125), also had progressive views on politics and art.[98] He remained loyal to the exhibition venture.

Certain painters and graphic artists took part for reasons of personal

Claude Monet
The Road Bridge at Argenteuil, 1874
Le pont routier, Argenteuil
Oil on canvas, 60 x 79.7 cm
Wildenstein 312
Washington, National Gallery of Art

Claude Monet
The Bridge at Argenteuil, 1874
Le pont d'Argenteuil
Oil on canvas, 60 x 80 cm
Wildenstein 311. Paris, Musée d'Orsay

Edouard Manet
Boating, 1874
En bateau
Oil on canvas, 97.2 x 130.2 cm
Rouart/Wildenstein I,223
New York, The Metropolitan Museum of Art

loyalty. One of those recruited by Degas was Giuseppe De Nittis, a successful Italian who happened to be vexed at official art and his dealer, Goupil, at the time. When his Salon success returned, he no longer saw any point in participating in an obscure venture. The versatile genre and landscape painter, etcher and sculptor Vicomte Ludovic-Napoléon Lepic (1839–1889), whose portrait Degas painted more than once, stayed with the group for the second exhibition, as did Béliard, the Pontoise landscape artist, whom his friend Pissarro had won over.

In 1874, the painters who were to remain the essential core of the exhibition group put characteristic works in the show, works typical of the new art's approach. Some of these are today considered major Impressionist works, such as dance and racecourse scenes (pp. 70, 86, 114) and women ironing by Degas. Monet had landscapes (p. 112) and street scenes (p. 102), as well as the famous *Impression: Sunrise* (p. 113). Morisot had some of her finest early works (pp. 88, 89, 108), paintings light in touch that show a relaxed yet attentive, meaningful quality in human conduct. Her first teacher, the old Joseph Guichard, found fault with her pictures for their light transparence; he told her that oil was unsuitable for kinds of work best done in watercolour; and he felt she would be ruining what she had hitherto accomplished, the respect she had earned, if she exhibited in Société company. Like Sisley, Pissarro was not represented by his strongest work (pp. 116/117); and Cézanne prompted widespread indignation with *A Modern Olympia*. Guillaumin and Degas's old school friend Henri Rouart (1833–1912), an engineer and talented amateur artist who played a leading part in the co-operative and exhibited his work (on which too little research has yet been done)[99] in the later Impressionist exhibitions too, also exhibited landscapes. Among Renoir's work in the show was *The Theatre Box* (p. 128), done in opulently nuanced colours, a freshly felt homage to female beauty. Doubtless

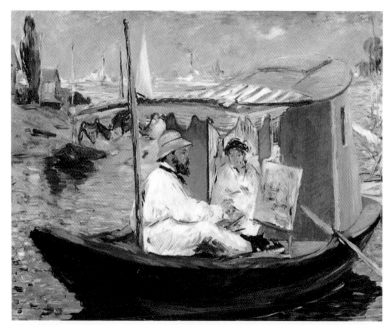

Edouard Manet
Claude Monet and his Wife in his Studio Boat, 1874
Claude Monet et sa femme dans son studio flottant
Oil on canvas, 82.5 x 100.5 cm
Rouart/Wildenstein I,210
Munich, Bayerische Staatsgemäldesammlungen,
Neue Pinakothek

Claude Monet
The Studio Boat, 1874
Le bateau-atelier
Oil on canvas, 50 x 64 cm
Wildenstein 323
Otterlo, Rijksmuseum Kröller-Müller

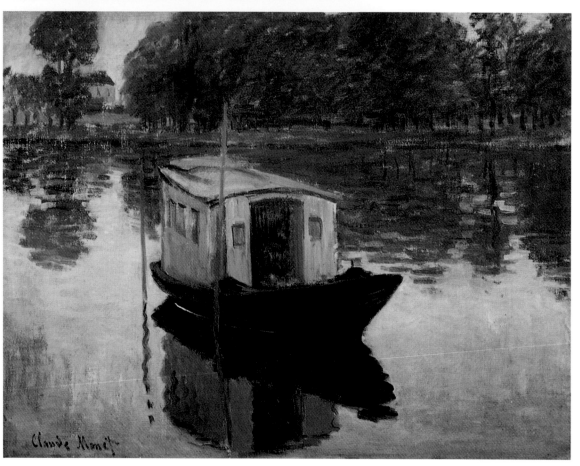

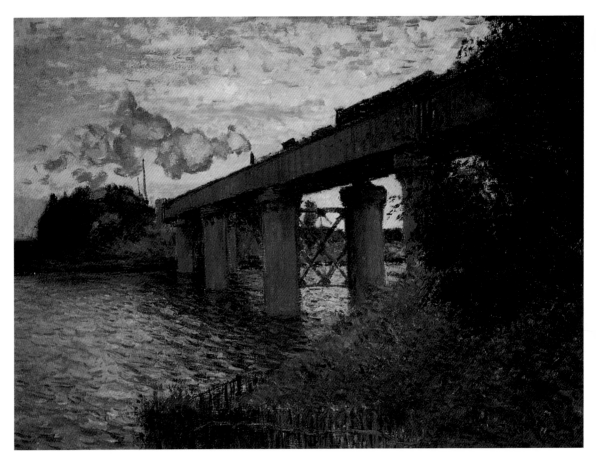

Claude Monet
The Railway Bridge, Argenteuil, 1873
Le pont du chemin de fer, Argenteuil
Oil on canvas, 54 x 71 cm
Wildenstein 319. Paris, Musée d'Orsay

Renoir was glad to be paid 425 francs for this painting by Père Martin, a paint and picture dealer; Renoir urgently needed the money to pay rent arrears. By way of comparison, a curious little picture by Academy member Jean-Léon Gérôme (1824–1904) was extremely successful at the Salon and earned Goupil the dealer 45,000 francs.

The exhibition on the Boulevard des Capucines was noted to some extent by the critics, especially in left-wing or opposition, republican publications.[100] Most of the conservative press preferred not to give a platform to the opponents of official arts policy. Naturally the significant stylistic differences amongst the exhibitors were remarked on, but the greatest amount of attention was given to the new aesthetics, be it in praise or damnation. Silvestre, who had written on them the previous year in Durand-Ruel's catalogue, used the political term "revoltés" of them in the republican "L'Opinion Nationale" (22 April). A week later, in the widely read conservative "La Presse" (29 April), Emile Cardon seized upon this and went on to deride the artists as a "School of the impression". The famous Salon des Refusés (did he mean 1863 or 1873?) had been a veritable Louvre in comparison, he declared.

The term "Impressionists" was first used four days earlier (25 April 1874) in the heading of an article in the satirical magazine "Le Charivari".

The Railway Bridge over the Seine at Asnières,
before 1900

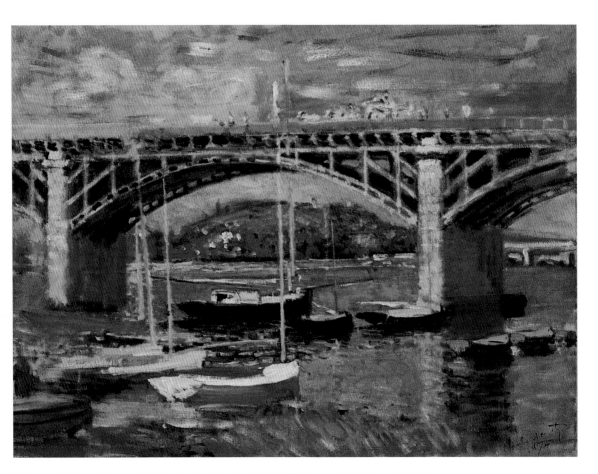

The great Honoré Daumier (1808–1879) had published lithographs in the magazine till he went blind in 1872. Now it was the elderly copper engraver, genre painter and popular playwright Louis Leroy (1812–1885) who scoffed at the exhibition. He claimed to have visited the show with a pupil of Ingres who, confronted with Monet's *Impression: Sunrise* and still more his *Boulevard des Capucines* and the work of Cézanne, had regularly gone out of his mind. Crying, "Eheu, I am an impression on legs, the avenging palette knife", he did a (barbaric!) Indian dance, Leroy reported. Of greater weight than the squib that earned Leroy his immortality was Castagnary's approving critique in "Le Siècle" four days later (29 April). Castagnary singled out as "Impressionists" (in the heading, too) Pissarro, Monet, Sisley, Renoir, Degas and Morisot, carefully differentiating their individual styles. For him, they were Impressionists "in the sense that they do not reproduce a landscape but rather convey the sensation produced by the landscape". This, he said, was the reason why the word "landscape" was replaced by the word "impression" in titles.

The term, which remains "in itself imprecise" (Rewald), has been repeatedly challenged or newly defined, but it has stuck. It is a label of convenience, a useful and flexible convention that has long since become indispensable, like most terms that describe movements or styles in art.

Claude Monet
The Bridge at Argenteuil, 1874
Le pont d'Argenteuil
Oil on canvas, 60 x 81.3 cm
Wildenstein 313
Munich, Bayerische Staatsgemäldesammlungen,
Neue Pinakothek

Alfred Sisley
The Regatta at Molesey, 1874
Les régates à Molesey
Oil on canvas, 66 x 91.5 cm
Daulte 126. Paris, Musée d'Orsay

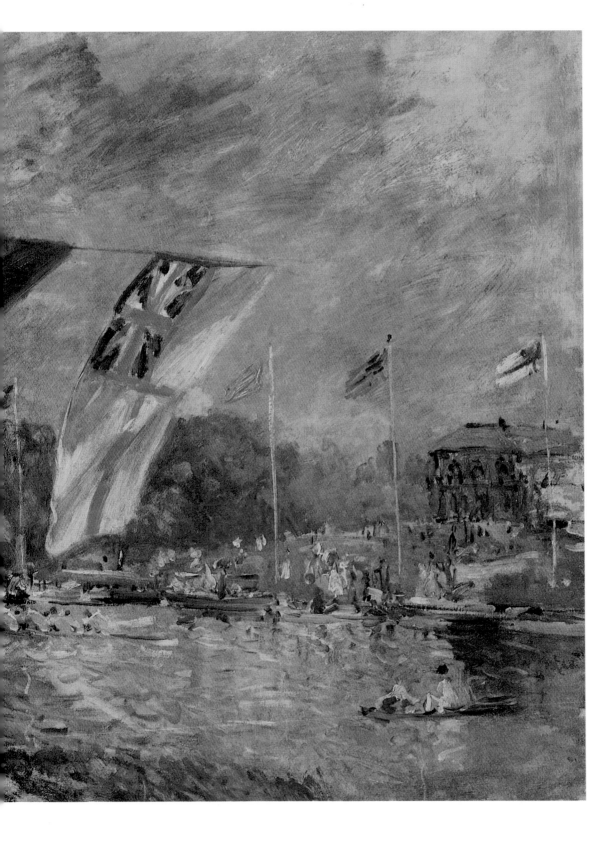

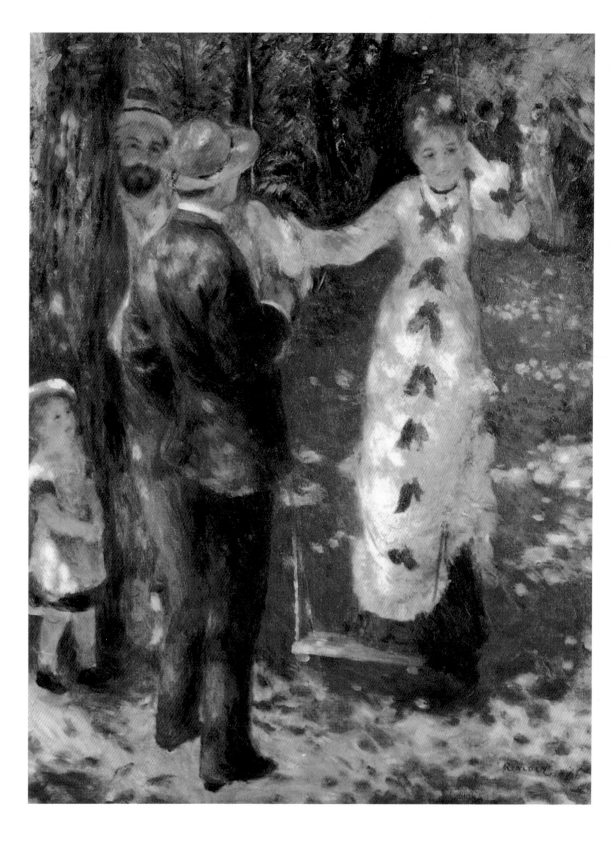

6 From Self-Confidence to Doubt

The core of the shortlived Société, most of them in their mid-thirties, had reason to feel satisfied with the attention they had attracted. They would not be deflected from their ideas by dismissive criticism. And indeed they found that Manet was coming closer to their own position, although in terms of exhibition strategy he agreed to differ. Zealously they went to work, and were impressively productive; though, generally speaking, their financial position deteriorated. The debates concerning approaches that were likeliest to succeed did not cease; and the Impressionists were not spared the problems all artistic groups have had to face in modern times, negotiating compromises between individuality, competitiveness and a group spirit.

Evolving a New Style

Following their show in Nadar's rooms, the Impressionists continued to paint energetically in the style they had adopted, and in the next few years they explored all the possibilities of their approach. Their attention centred on the colours of objects in open-air light, and ways of conveying those colours by juxtaposing dabs (*taches*) of paint as unmixed and bright as possible. The artists definitively parted company with the idea that there was a value distinction to be drawn between completed paintings and sketches. Indeed, they considered the sketch more truthful and better because of its spontaneous freshness. From later comments we know they wanted the painter to be "only an eye", to do nothing but see, and not to think. They neither wished to be constrained by rules nor did they care for contextual and evaluative processes that concerned their subjects as parts of a reality beyond the painting.

This conception of the meaning of what an artist does was of course not universally shared among them, nor did it remain uninfluenced by other considerations of the didactic functions of art. The realisation that the quality of a work of art was independent of its subject – articulated in the 1860s and defiantly asserted against academic hierarchical views of subject matter – by no means implied that artists were not free to make a selection of specific themes and motifs. And in fact Impressionism did

Pierre-Auguste Renoir
Lise with a Parasol, 1867
Lise à l'ombrelle dans la forêt
Pen and ink on paper
Whereabouts unknown

Pierre-Auguste Renoir
The Swing, 1876
La balançoire
Oil on canvas, 92 x 73 cm
Daulte 202. Paris, Musée d'Orsay

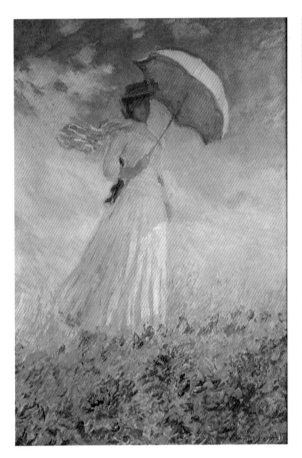

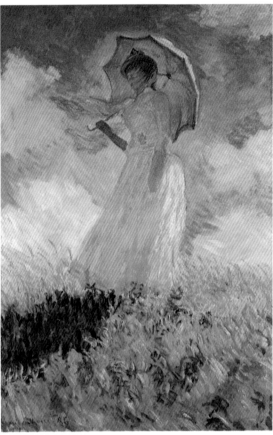

Claude Monet
Lady with Parasol (facing right), 1886
La femme à l'ombrelle (vers la droite)
Oil on canvas, 131 x 88 cm
Wildenstein 1076. Paris, Musée d'Orsay

Claude Monet
Lady with Parasol (facing left), 1886
La femme à l'ombrelle (vers la gauche)
Oil on canvas, 131 x 88 cm
Wildenstein 1077. Paris, Musée d'Orsay

Right:
Claude Monet
The Walk. Lady with Parasol, 1875
La promenade. La femme à l'ombrelle
Oil on canvas, 100 x 81 cm
Wildenstein 381
Washington, National Gallery of Art,
Mr. and Mrs. Paul Mellon Collection

have an iconography of its own. The artists naturally knew that for most people the subjects of artworks are a vital part of the whole, and affect their accessibility and saleability. It is all the more remarkable, then, that they made so few concessions on fundamentals.

Pissarro persisted in painting the same unprepossessing views of Pontoise and the vicinity: the Hermitage, the Côte des Bœufs, or the track that led through Le Chou, on the banks of the Oise, to Auvers (p. 174). On a number of occasions he stayed for some time with his painter friend Ludovic Piette (1826–1877) at his farm, Montfoucault, near Melleray, in the quite different landscape of the Mayenne. Piette did a small gouache portrait of Pissarro that gives a vivid sense of how the latter worked: gazing with attentive concentration, his whole body tensed, he is standing in the open at an easel shaded by a small parasol. Piette, who was to die shortly, painted in a manner similar to Pissarro's, but with a more meticulous attention to detail and without Pissarro's structural energy. Pissarro recruited him for the third Impressionist exhibition.

Cézanne and Guillaumin regularly consulted Pissarro for his advice. Their approach was closer to his insistence on constructing a picture out of colour, linear, and plastic or spatial components. Cézanne would depart radically from this line from time to time, painting imaginary figural

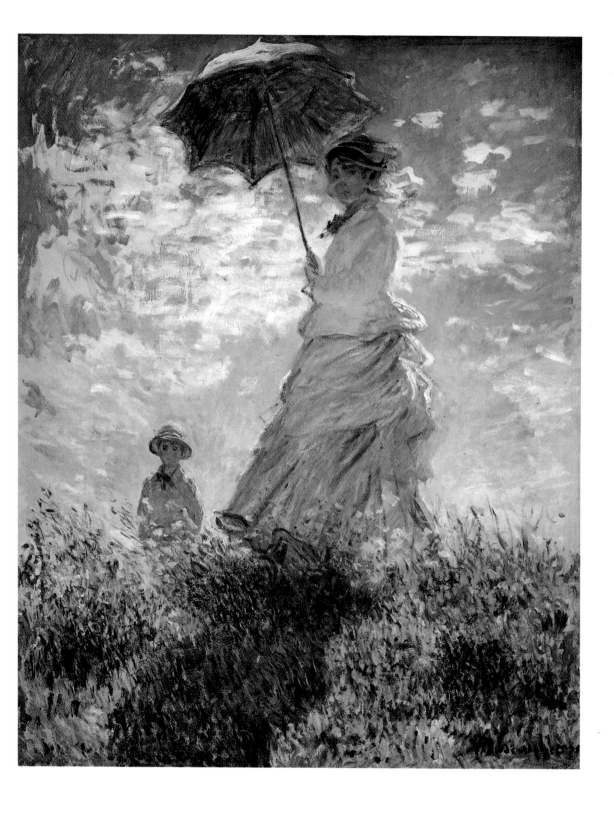

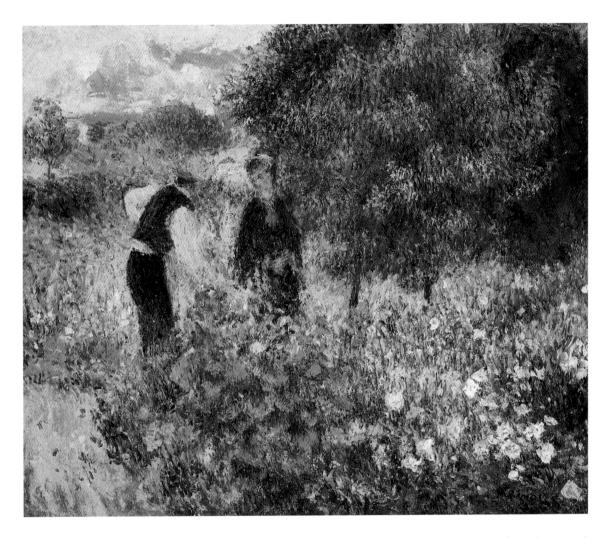

Pierre-Auguste Renoir
Conversation with the Gardener, c. 1875
La cueillette des fleurs
Oil on canvas, 51 x 63 cm
Chicago, The Art Institute of Chicago

scenes or indulging his sexual obsessions. At that period he also copied a painting by his old fellow-student Guillaumin, a scene showing workers shovelling building sand on the Quai de Bercy in Paris.[101] Guillaumin's way of working was more relaxed and dexterous than Cézanne's, and more geared to the fleeting moment.

Pissarro's achievement in terms of the artistic appropriation of given reality can be nicely seen in two views of the same subject that he curiously did not exhibit in a group show (pp. 174, 175). They are landscapes in late winter or early spring, gentle and bright, the dabs of paint evoking a veil of moist freshness, the middle ground consisting of whitish yellow and red houses and roofs positioned like crystals on a slope. In the foreground, a network of thin trees and branches stabilizes the visual surface and creates optical distance. The verticals are emphatic in the vertical-format picture, while in the other curved lines lean to the sides. Pissarro has harmonized his two concerns – to convey his powerful impression of Nature persuasively, and to establish a picture structured by human

hand as an autonomous and complementary addition to visible reality – and he has done so in exemplary fashion.

And Pissarro was at that time in serious financial need, frequently depressed and insecure about his art, despite the collectors who took an interest. One of these was a friend of Guillaumin's youth, Eugène Murer (1845–1906), who was a pâtissier in Paris. In 1876/77 he invited his artist friends to dinner at his restaurant every Wednesday; they included Renoir, Sisley, Pissarro, Monet and Cézanne, as well as critics and free-thinking friends such as Tanguy and Gachet. On one occasion he tried to help Pissarro by raffling off paintings among his customers.

Till 1878 Monet lived at Argenteuil; then for three years he moved to Vétheuil, some fifty kilometres further from Paris, also on the Seine. The river landscape at Argenteuil and then Vétheuil was his favourite motif; his paintings of that landscape are probably the first we think of when we hear the word Impressionism. From 1872 on, Monet had painted on the river bank at Argenteuil, looking either up- or downriver (p.91).

Pierre-Auguste Renoir
Country Footpath in the Summer, c. 1875
Chemin montant dans les hautes herbes
Oil on canvas, 60 x 74 cm
Paris, Musée d'Orsay

In the garden of the Moulin de la Galette:
Henri de Toulouse-Lautrec with friends

The entrance to the garden at the Moulin de la
Galette, Rue Lepic, c. 1885

Pierre-Auguste Renoir
Le Moulin de la Galette, 1876
Oil on canvas, 78.7 x 113 cm
Daulte 208. Tokyo, private collection

Pierre-Auguste Renoir
Le Moulin de la Galette, 1876
Oil on canvas, 131 x 175 cm
Daulte 209. Paris, Musée d'Orsay

According to which way he chose, the trees cluster as verticals at the left or right edge, their shadows on the path parallel horizontals. Together with the upright masts of sailing boats, and horizontal brush strokes or a bridge on the horizon (generally intersecting the visual space at a position consonant with the golden section), this Monet riverbank system evolved its own simple set of coordinates to create a firm pictorial structure. Within this structure, dabs of paint or individual brush strokes might be positioned in a more relaxed way, to recreate the motion of light on a landscape, the adumbrated figures of walkers, or the drift of white clouds across a blue sky. The two road and rail bridges rebuilt after the war were another subject Monet repeatedly painted, and here he could experiment with the spatial effects of diagonals (pp. 137, 140, 141). Engineering achievements using iron, and steaming railway trains or the flow of traffic across a road bridge, also introduced an element of modernity into Monet's landscape. On just one occasion he introduced a variation on the bridge theme, painting the Asnières road bridge in dim grey light, and in front of it workers unloading coal barges (1875; Paris, private collection). But this excursion into social realism remained "une note à part", as Monet himself later put it – a motif he did not pursue further in his artistic view of the world and creative strategy.[102]

Monet was naturally more drawn to scenes of walking in Nature (p. 147) or family bliss in a garden of flowers (p. 219). But he did not allow Paris to disappear from his view. In 1877 he decided to explore the visual attractions of a railway station filled with smoke and steam. There are amusing anecdotes describing Monet, then far from well off and harshly treated by the critics, turning up stylishly dressed and self-assured to talk the stationmaster at the Gare Saint-Lazare into having locomotives generate more steam, or even keeping trains waiting so that the pictures he, Monet, painted would be more atmospheric (pp. 170, 171). And then on 30 June 1878 a new and intoxicating mass of colour presented itself to his eyes. On that day, a further World Fair was opened in Paris, a first occasion for national celebration since the humiliation of 1871. Monet painted the flags and banners in Rue Saint-Denis (p. 177); the slogans "Vive la France" and "Vive la République" will surely have found an answering echo in his own bosom.

Renoir was especially close to Monet, both personally and in his aesthetics. For him, though, the human figure rather than landscape was always the main focus of attention. He lived in Paris and liked visiting his friend in Argenteuil. Often he would idle among the trippers and rowers at La Grenouillère, between Bougival and Croissy, or on the nearby Seine island of Chatou. There he particularly enjoyed stopping by to see Fournaise the innkeeper and his beautiful daughter. His glowing, relaxed paintings, visibly prompted by a moment actually experienced and carefully observed, recorded that world as a place where happiness and harmony were attainable. His people look contented. For his female models he always sought out girls of ampler proportions in his Montmartre neighbourhood, many of them sempstresses by trade. They liked posing, and had nothing against indulging a lover who could pay,

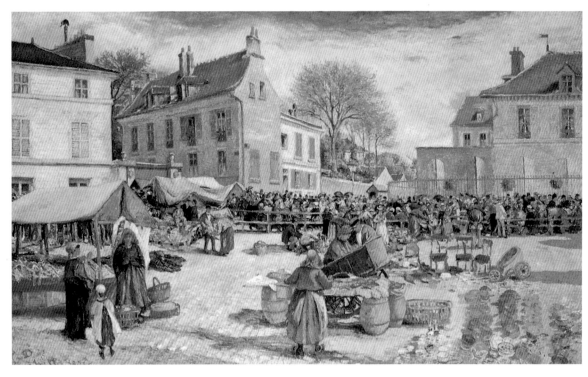

Ludovic Piette
The Market outside Pontoise Town Hall, 1876
*Place de l'hôtel de ville à Pontoise, un jour
de marché*
Oil on canvas, 111 x 186 cm
Pontoise, Musée Pissarro

either. Renoir liked them. Without troubling over questions of morality
or society, he glorified the beauty and sensuality he saw in them.

His admiration for French 18th-century masters such as Jean-Antoine
Watteau (1684–1721), François Boucher (1703–1770) and Fragonard –

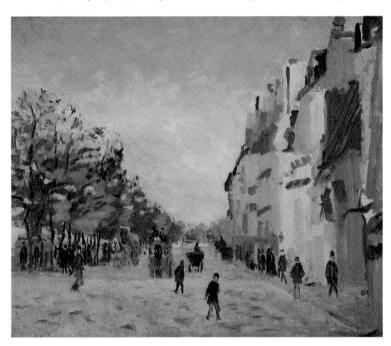

Armand Guillaumin
Quai de la Gare, Snow (Quai de Bercy), c. 1875
Quai de la Gare, effet de neige (Quai de Bercy)
Oil on canvas, 50.5 x 61.2 cm
Serret/Fabiani 29. Paris, Musée d'Orsay

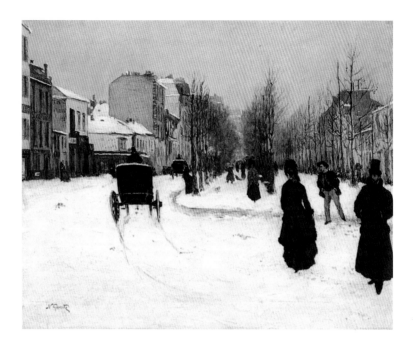

Norbert Goeneutte
The Boulevard de Clichy under Snow, 1876
Le Boulevard de Clichy sous la neige
Oil on canvas, 60 x 73.5 cm
London, The Tate Gallery

whom he had copied in his own youthful days as a porcelain painter –
lay behind erotic pictures such as *Anna* (p. 163). This nude is entirely
natural, neither coquettish, nor provocative, nor with that cool lasci-
viousness with which Gérôme invested his enamel-sleek odalisques in
oriental harem scenes at about the same time. Renoir's colourist subtlety
tenderly recorded nuanced shades in the flesh of this woman sitting on
the edge of a lilac patterned armchair in front of a sketchy background
of what seem to be white undergarments against darker plum black. The

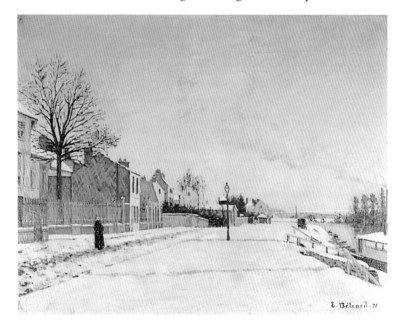

Edouard Béliard
Banks of the Oise, 1875
Bords de l'Oise
Oil on canvas, 72 x 91 cm
Etampes, Musée Municipal d'Etampes

interplay of lighter and darker areas is as important in lending the composition its baroque dynamism as are the turned and arrested position of the body or the red highlighting on the chair, lips and the corners of the eyes. In summer 1875, in his garden, Renoir had already painted the same model (who also appears in Manet's *Nana*, p. 160, as well as in pictures by other painters such as Gervex). In the earlier painting, the woman, wearing a ring and bracelet, has been enhanced aesthetically: Renoir shows her in the posture of the famed Aphrodite of Knidos. His eye was mainly concerned with the shimmering effects of light and coloured shadow falling through the foliage. This is humanity seen in harmony with Nature but simultaneously mythologized by the allusion to antiquity. For contemporaries, this style of painting was so innovatory that the influential critic Albert Wolff (1835–1891) raged in "Le Figaro" (3 April 1875) that the picture showed a piece of rotting flesh with the green and violet signs of putrefaction upon it.

That same year, in a somewhat larger canvas peopled with a large number of figures, Renoir presented the social gaiety and Parisian lifestyle that he endorsed as an artist. *Le Moulin de la Galette* (p. 153) shows a beer and dance garden in Montmartre: two disused windmills had been converted into bars, and gas lighting installed in the garden. Ordinary working people, young artists, and men down from the city to find a girl, would go there at weekends or in the evenings. Renoir's picture has all the charm of a chance impression but is in fact well composed and planned out. The figures in the space, which is marked off at the front by seat backs, form circular groups. Their gazes connect them or link us in the outside world into their world. The white lanterns mesh a grid of coordinates across the canvas. Even dabs of colour establish correspondences across the composition, and thus unity in the carefree confusion. In the blue, pink and white striped dresses of some of the girls we see a revival of 18th-century fashion – just as the entire scene is reminiscent of a *fête galante* by Watteau. In order to paint the scene as he conceived it, Renoir posed a number of his friends and models. They helped him carry his cumbersome easel and large canvas from the nearby studio to the gardens, where he then painted on the spot, in the open.

A large, unforced sketch (Copenhagen, Ordgrupsgaard Samlingen) served to fix the composition. The order in which two further versions were done is still subject to dispute.[103] A sketchier version of medium size (p. 153, top) initially belonged to Renoir's new admirer, Victor Chocquet; in 1990, it was sold at Sotheby's in New York for US$ 78, 100, 100 to the Japanese paper manufacturer Ryoei Saito – the second-highest price ever paid for a work of art at that date. In almost every detail it matches the larger version, which was quickly bought by Caillebotte and later passed to the French state with his estate. It seems unlikely that Renoir needed to paint a version in an intermediate size in order to establish the final, large painting. At that time his efforts were all directed to fixing open-air impressions, and work on the big version at a later date, in the winter, in his studio (as has been suggested), would have run counter to those endeavours. Nor would he have needed the help of

Pontoise. Postcard, c. 1890

Camille Pissarro
Harvest at Montfoucault, 1876
La moisson à Montfoucault
Oil on canvas, 65 x 92.5 cm
Pissarro/Venturi 364. Paris, Musée d'Orsay

Camille Pissarro
Rye Fields at Pontoise, Côte des Mathurins, 1877
Les seigles, Pontoise, Côte des Mathurins
Oil on canvas, 60 x 73 cm
Pissarro/Venturi 406. Japan, private collection

others to move his picture and easel (a recorded fact) if he had been engaged on the small painting. So the likeliest assumption must be that he did a repeat copy of the big painting in a sketchier format for Chocquet, in a size that was better suited to hanging in Chocquet's home. Paintings on this subject of friendly chat or lovers' talks and open-air conviviality were to recur in Renoir's work of the late 1870s (p. 144), alongside portraits for a growing circle of patrons and genre work.

 In the 1881 painting *The Luncheon of the Boating Party* (p. 220) we have the crowning work in Renoir's series on social occasions and

Alfred Sisley
Flood at Port-Marly, 1876
L'inondation à Port-Marly
Oil on canvas, 60 x 81 cm
Daulte 240. Paris, Musée d'Orsay

Alfred Sisley
Market Place at Marly, 1876
Place de marché à Marly
Oil on canvas, 50 x 65 cm
Daulte 199. Mannheim, Kunsthalle Mannheim

leisure. Renoir's old friend from military days, Baron (formerly Captain) Barbier, assembled the models for this festive scene at Fournaise's. Once again the assembly of people dressed either for sport or as city pleasure-seekers resolves into small groups, couples, or solo figures apparently lost in thought. The positioning of the figures gathers upon a diagonal line from bottom left to top right. Unconsciously, we always register this line as an active, rising thing in paintings; it is this diagonal that arrests our gaze and leads us into the picture. But Renoir wants a unified surface impression, and so he also ensures that there is a greater ease in the

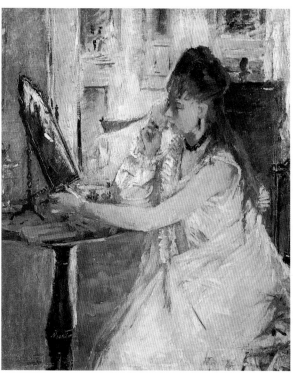

foreground figures and their postures; together with the luscious still life on the table, we feel we are in the presence of a superabundance of fine things, pleasant people and brilliant painting. The awning produces a diffused light in the picture instead of light from a single source. Renoir has forgone his dappled patchwork of sunlight and shadow. But even without the moulding possible to light effects, the two men in the foreground are solidly three-dimensional, without the sketchiness of Impressionist figures. It was the advent of a new approach in Renoir, to which we shall be returning.

In the summer of 1874, after the first Impressionist exhibition, Manet visited Monet and his family at Argenteuil. He painted the family: Monet busy gardening in the background, his wife Camille and their seven-year-old son Jean on the grass centre-picture. It is a relaxed composition, painted with the unstrained air of a sketch. Renoir was present too, and painted the same scene (Washington, National Gallery of Art). The story goes that Manet found Renoir's picture terrible and said the younger artist would never produce anything worthwhile; supposedly he even suggested to Monet that he ought to talk his friend out of painting. It is notable proof of the lack of homogeneity in the new movement, and the different qualities of personal relations among them, as well as of the mistakes artists can make when assessing each other's work.

Ironically enough, at that time Manet was entering fully into the Impressionist spirit of *plein-airisme*. He did a portrait of Monet with his wife on his blue-and-green-painted *bateau-atelier*, painting the banks of

Edouard Manet
Nana, 1877
Oil on canvas, 154 x 115 cm
Rouart/Wildenstein I,259
Hamburg, Hamburger Kunsthalle

Berthe Morisot
Young Woman Powdering Herself, 1877
Jeune femme se poudrant
Oil on canvas, 46 x 39 cm
Bataille/Wildenstein 72
Paris, Musée d'Orsay

Right:
Edgar Degas
At the Café-Concert: the Song of the Dog,
c. 1876/77
La «Chanson du Chien»
Gouache and pastel over monotype on paper,
57.5 x 45.4 cm. Lemoisne 380
New York, The Metropolitan Museum of Art

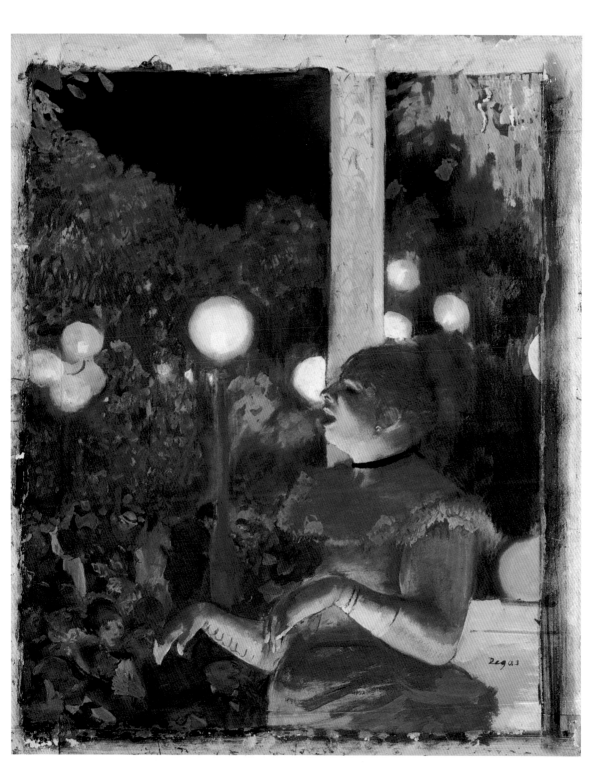

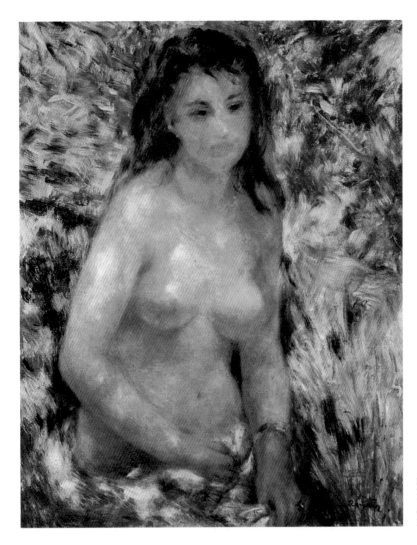

Pierre-Auguste Renoir
Nude in the Sunlight, c. 1875/76
Torse de femme au soleil
Oil on canvas, 81 x 64.5 cm
Daulte 201. Paris, Musée d'Orsay

the Seine and the boats (p. 139). The mast, slightly off the vertical, and the curves of the boat and awning convey a sense that the boat is rocking slightly in the water; the water itself, like the figures and bank, is painted in a light, open manner. Two other, larger canvases that show the figures from a closer position – open-air genre portraits rather than landscape paintings, in which the people establish eye contact with us – bring home the intense dedication Manet brought to his work that August in Argenteuil, a location that had normally (since 1869) been primarily Monet's and Renoir's domain. The vertical-format painting, the larger of the two (p. 134), is structurally the tighter thanks to its linear components, and is also the richest in motifs and forms. The sketchy horizontal-format picture (p. 138) uses large spaces of glowing colour. We do not know who the women in these paintings are; the man was either Manet's brother-in-law, the Dutch painter Rodolphe Leenhoff, or Baron Barbier, whom we have mentioned in connection with Renoir.

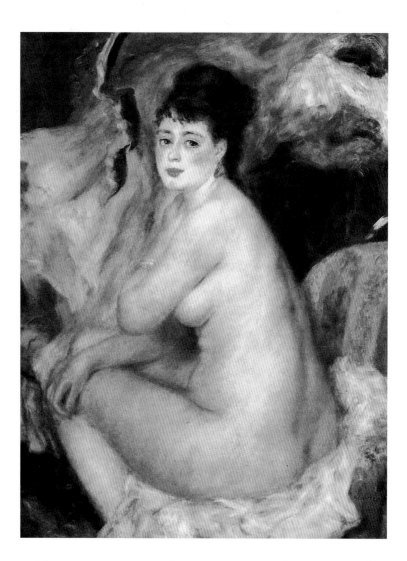

Pierre-Auguste Renoir
Female Nude (Anna), 1876
Nue (Anna)
Oil on canvas, 92 x 73 cm
Daulte 213
Moscow, Pushkin Museum of Fine Art

Manet was now committed to Impressionism and was a strong advocate of Monet in particular. In 1875, together with Duret, an art critic friend, he debated secretly buying ten or twenty of Monet's paintings without the latter knowing the identity of the purchasers; he was so short of money that he was offering his work for a mere 100 francs a canvas. It would help Monet, and might well be a profitable deal for Manet and Duret. In 1877 he tried (albeit in vain) to convince another critic, Wolff, of the value of Monet's art and that of his associates. In the course of this attempt he even painted a portrait of Wolff, though there were differences of opinion over the picture.

The following year, Manet's long-standing interest in modern city life prompted him to make a proposal for a major work of public art. He wrote to the mayor of Paris suggesting that the council chambers in the new town hall be painted with a variety of compositions "representing the belly of Paris, to use a current expression that describes my aim nicely

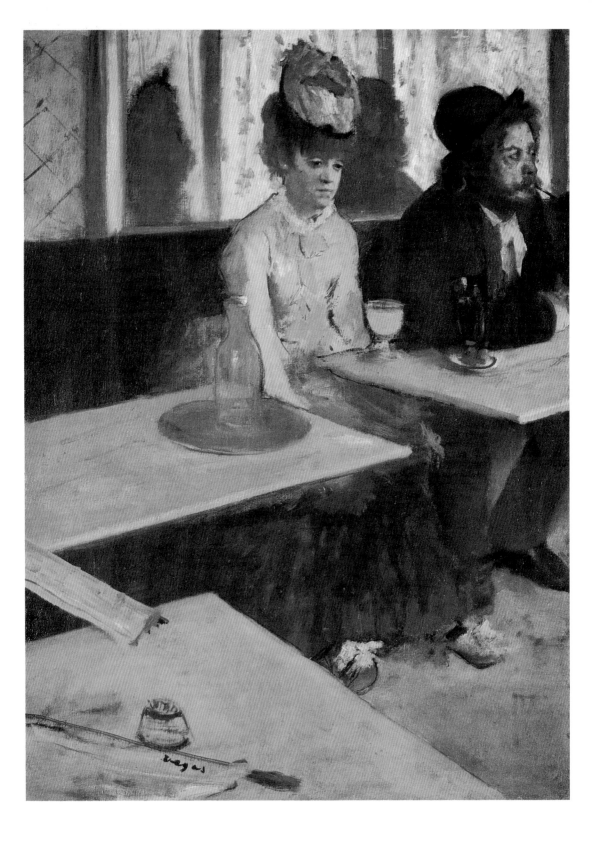

Edouard Manet
Plum Brandy, c. 1877/78
La prune
Oil on canvas, 73.6 x 50.2 cm
Rouart/Wildenstein I,282
Washington, National Gallery of Art

Eva Gonzalès
The Milliner, c. 1877
La modiste
Gouache and pastel on canvas, 45 x 37 cm
Chicago, The Art Institute of Chicago

Left:
Edgar Degas
The Absinth Drinker, 1876
L'Absinthe (Au café)
Oil on canvas, 92 x 68 cm
Lemoisne 393. Paris, Musée d'Orsay

– the various pursuits and trades that are plied here and their milieus: in brief, the public and social life of our times. I would propose Paris market halls, Parisian railways, the bridges of Paris, subterranean Paris [the sewage system], racetrack Paris, and public gardens. The ceiling could have a gallery of living dignitaries, in poses that befit their position, whose role in civilian [not military] life has contributed to the greatness and wealth of Paris."[104] Manet received no reply to his proposal.

In 1877 Manet's *Nana* (p. 160) prompted a further controversy. Turned down by the Salon, it was exhibited in the window of "a well-known shop that sold knick-knacks in the Boulevard des Capucines" – in other words, presented virtually "on the pavement" to a broad public with no interest in art (Werner Hofmann).[105] This fresh, lifesize, full-length portrait of a young woman in her underthings, making up in her boudoir while a top-hatted gentleman waits, explores the Parisian themes of lifestyle and subculture that Manet was taking a closer look at. It was an exploration that put him in Degas's company. But it also continued the subtle analysis of relations between the sexes, glimpsed in fleeting moments, that was visible in the Argenteuil boat scenes as well.[106] The rejection of the picture by the Salon was probably due to the fact that Manet's model, Henriette Hauser, was currently having an affair with the Prince of Orange[107] – and the authorities did not want to insult him. The title, as with *Olympia* merely a woman's name (but an eloquent

Jean-Paul Laurens
The Excommunication of Robert the Pious, 1875
L'excommunication de Robert le Pieux
Oil on canvas, 130 x 218 cm
Paris, Musée d'Orsay

one), establishes a literary link that has been much debated in recent scholarship.

Manet was working on his painting for weeks during the autumn and winter of 1876/77. At the same time, a new novel by his friend Zola, "L'Assommoir", was being serialized in a newspaper, "La République des lettres", and was published in book form early in 1877: that year alone it went through 38 impressions. Nana the whore, who later became the titular heroine of another novel (in 1879), made her appearance in a chapter that was printed in November 1876, when Manet was already at work on the picture. But Zola had of course outlined the subjects and main characters of his Rougon-Macquart novel cycle years before; and Manet may have been familiar with Zola's plans. Literature, at any rate, gave him a striking title that would draw even more attention to his painting. The circumstances are unusual in the annals of art; for purposes of our present assessment of the painting, though, they are of course of secondary importance. It is an enchanting work from Manet's most avowedly Impressionist phase, a precise and realistic analysis of one aspect of the social and cultural scene, and first-rate proof of Manet's skills in orchestrating visual material. Its motifs and structures bear the imprint of distance; the partnership shown is one of cool unemotionality; and the woman, though she has something of the sensual temptress, seems also unapproachable – merchandise and cultic statue at once.

Alphonse Legros
Communion, c. 1876
La communion
Oil on canvas, 36 x 30.5 cm
Oxford, Robin Burnett Harrison Collection

Manet then did a number of restaurant paintings, such as *Plum Brandy* (p. 165), which one critic recently described as disquieting on account of its unresolved mood and message. In Manet's day, the woman could only be a prostitute. At the Brasserie de Reichshoffen in the Boulevard Rochechouart – which served bock beer from Alsace and had women dancing for (and largely ignored by) its customers, a true cross-section of Parisian society – Manet hit on the idea of painting a panoramic survey of modern society. He began work on it in his studio in

1878, using models; but then cut it into separate canvases, some of which he painted further versions of (pp. 178, 179). The use of female waitresses in brewery pubs that offered music and entertainment was a new departure at the time. Manet's rapidly painted studies experimented in various kinds of eye contact between the characters, some of them people who simply happen to witness a moment; and he tried out the presentation of people who remain strangers to each other – a worker in his blue shirt, gentlemen in top hats and coats, bored girls. The graphic artist Henri Guérard, who had just married Eva Gonzalès, and the actress Ellen Andrée were among Manet's models.

The following year Manet was out in the open again, to paint *In the Garden Restaurant of Père Lathuille* (p. 195). Père Lathuille's was a suc-

Jules Bastien-Lepage
Haymaking, 1877
Les foins
Oil on canvas, 180 x 195 cm
Paris, Musée d'Orsay

Gustave Caillebotte
Le pont de l'Europe, 1877
Oil on canvas, 105 x 130 cm
Berhaut 46. Fort Worth, Kimbell Art Museum

The Pont de l'Europe in Paris

cessful restaurant in the Avenue de Clichy. In the picture, the proprietor's son is making up to a stylish lady; the eye contact is of an unusually intimate quality for Manet. This scene, thoroughly Impressionist in treatment, has a unity which has struck certain recent critics as crude, and uncomfortably kin to the mannerisms of anecdotal, narrative, academic genre painting. But then, Manet was not averse to tradition and the conventions of middle-class art. He was out to beat the opposition on their own territory, the Salon, and to prove to the public that what it expected in art could (and must) be done satisfactorily using modern painting techniques. That said, though, Manet's customary preference for detached observation, for the stance of *impassibilité* approved by Flaubert, and his aversion to unsubtly explicit narrative content in a picture, were graphically expressed in the silent couple in *In the Conservatory* (p. 195), painted at the same time.

Manet's pupil Eva Gonzalès has had little success with art lovers and critics to this day. Assuredly her modest output is uneven – though the same can be said of her more famous fellows. Her concepts and tech-

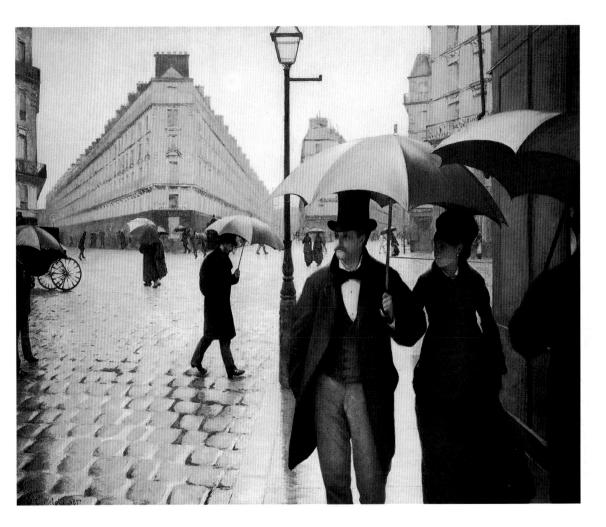

Gustave Caillebotte
Paris, the Place de l'Europe on a Rainy Day, 1877
La Place de l'Europe à Paris, temps de pluie
Oil on canvas, 212.2 x 276.2 cm
Berhaut 52. Chicago, The Art Institute of Chicago

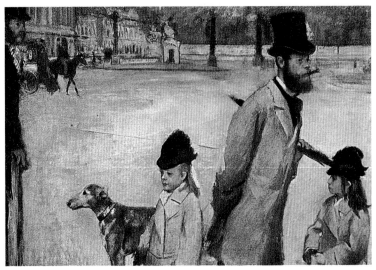

Edgar Degas
Place de la Concorde
(Comte Lepic and his Daughters), 1876
La Place de la Concorde
(Le Comte Lepic et ses filles)
Oil on canvas, 79 x 118 cm
Lemoisne 368
Formerly Berlin, Oskar Gerstenberg Collection
(presumed destroyed in the Second World War)

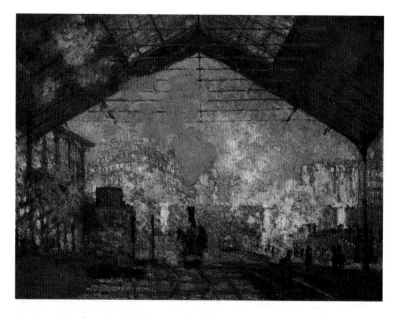

Claude Monet
Gare Saint-Lazare, Paris, 1877
Intérieur de la Gare Saint-Lazare à Paris
Oil on canvas, 75.5 x 104 cm
Wildenstein 438. Paris, Musée d'Orsay

niques were decisively influenced by Manet, whom she greatly admired; her first teacher had been the successful Salon artist Charles Chaplin (1825–1891). *A Box at the Théâtre des Italiens* (p. 132) – probably rejected by the 1874 Salon and not accepted till 1879, when it still remained unsold – suffers if compared with Renoir's painting of the same date on the same subject (p. 128), in terms of composition, colouring, and the warm, insinuating magic of the model. Nor does it have the elusive expressiveness of Manet's figural groups. The dry energy of its structure, though, perhaps appeals more to the tastes of an era after Impressionism than it did to contemporaries. By contrast, the sponta-

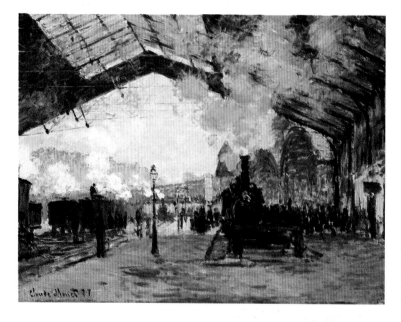

Claude Monet
Gare Saint-Lazare: the Train from Normandy, 1877
La Gare Saint-Lazare: le train de Normandie
Oil on canvas, 59.6 x 80.2 cm
Wildenstein 440
Chicago, The Art Institute of Chicago

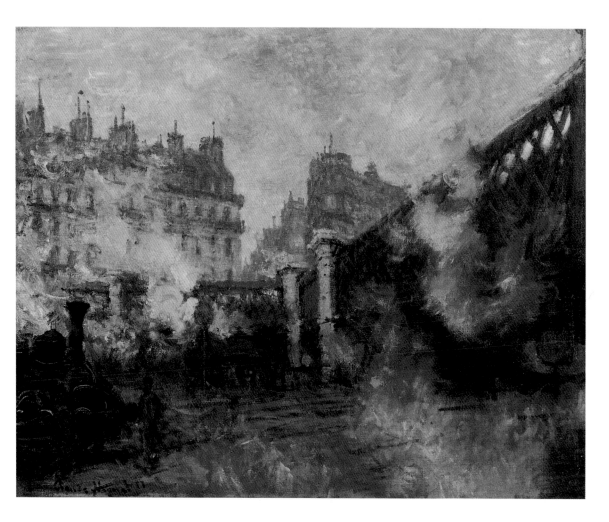

Claude Monet
Le pont de l'Europe, Gare Saint-Lazare, 1877
Oil on canvas, 64 x 81 cm
Wildenstein 442. Paris, Musée Marmottan

neity with which *Morning Awakening* (p. 133) has been seen and caught, and the sheer poetry of its sensibility, are superbly in line with Impressionism as Manet understood it at the time. Plainly Gonzalès was still hesitant to proceed wholeheartedly down the Impressionist path, no doubt partly through the influence of Guérard, whom she married at some point between 1878 and 1880 (the date is unclear). Her little study of a milliner (p. 165) has a distinct charm, though, and its psychological expressiveness is not unlike what Degas could achieve. Eva Gonzalès – herself still mourning Manet, who had died not long before – died in 1883 aged only thirty-four, shortly after giving birth to her first child.

Her rival, Berthe Morisot, enjoyed a lengthy and successful career. Free of material worries, though not of the duties of a wife and (from 1878 on) mother, she was able to paint essentially as she pleased. But she set great store on measuring up to public scrutiny. Though in artistic and social terms she had an affinity with Manet, whose younger brother Eugène she married in late 1874, she stopped submitting to the Salon (where she had scored successes) and committed herself to the Impres-

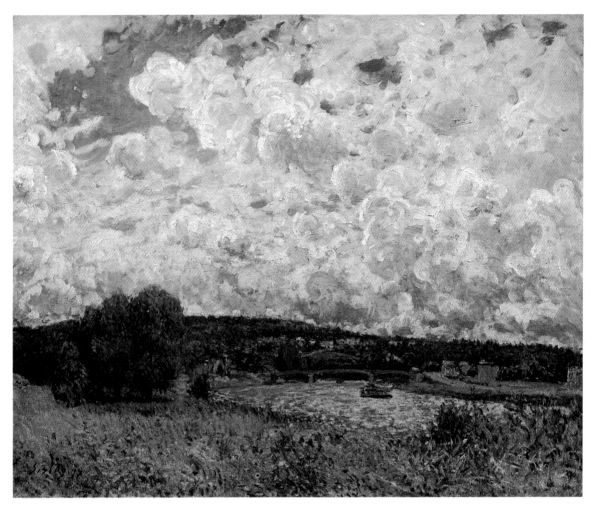

Alfred Sisley
The Seine at Suresnes, 1877
La Seine à Suresnes
Oil on canvas, 60.7 x 73.7 cm
Daulte 267. Paris, Musée d'Orsay

sionist group. She was very active on their behalf, in financial and other ways. Her paintings, which became increasingly unstrained in style, were predominantly impressions of happy family life or togetherness, or of the cultured, stylish life of her family and friends (pp. 123, 160, 192). She preferred light, tender colours, had a precise eye, and took an interest in the psychological state expressed by her models. A particularly fine use of colour distinguishes *At the Ball* (p. 151), with its slightly asymmetrical structure and the young woman's attentive sideways look. Morisot's artistic and human qualities amply account for the high regard in which she was held by fellow painters as different in character as Renoir and Degas, Monet and Puvis de Chavannes, as well as such writers as the poet Mallarmé.

Sisley's career evolved along idiosyncratic and in part tragic lines. Criticism has tended to sideline him in its presentations of Impressionism, partly through dependence on art market forces. The pictures he painted are Impressionism of an outstanding order, yet from the connoisseurs' point of view he was never more than a member of the movement

Camille Pissarro
The Mailcoach. The Road from Ennery to the
Hermitage, 1877
La diligence. Route d'Ennery à l'Ermitage
Oil on canvas, 46.5 x 55 cm
Pissarro/Venturi 411. Paris, Musée d'Orsay

who painted like Monet. He was also prey to personal misfortune; to the end of his life he never quite managed to put his financial difficulties behind him, nor did he live to see his art enjoy wider recognition. The fact is that Sisley conveys no strong sense of an artistic personality. His range of subjects is not great: he painted landscapes only, with an occasional figure. His art in total lacks subjects, techniques or qualities peculiarly his. And so, for example, the personal collection Monet left at his death included only one Sisley, but three Pissarros, five Morisots and no fewer than twelve Cézannes (though only one Degas and nothing by Manet). Yet Sisley's paintings are things of beauty and light, done with ease, the expression of a positive spirit. His unspectacular landscape work alternates between distant and closer views, like the intimate landscapes of the Barbizon school (pp. 99, 158). He painted the waters of the Seine at Bougival or Marly (p. 96) as sensitively as the nuances of snow colour in Pissarro's beloved lanes and gardens of Louveciennes (pp. 84, 183). Till 1877 he lived at Marly, where on one occasion flooding provided him with unusual and appealing subject matter (p. 159). Then he

Camille Pissarro
Path at "Le Chou", 1878
Le sente du Chou
Oil on canvas, 50 x 92 cm
Pissarro/Venturi 452
Douai, Musée des Beaux-Arts de la Chartreuse

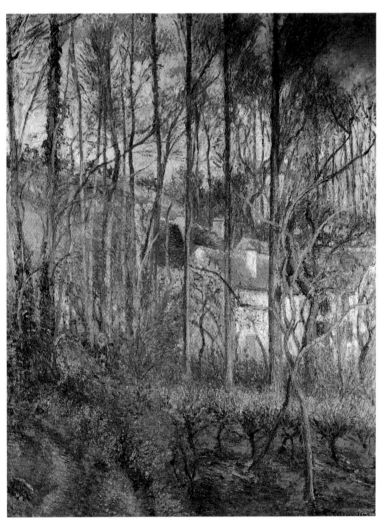

Camille Pissarro
La Côte des Bœufs at the Hermitage near Pontoise,
1877
La Côte des Bœufs à l'Ermitage près de Pontoise
Oil on canvas, 114.9 x 87.6 cm
Pissarro/Venturi 380. London, National Gallery

Right:
Camille Pissarro
Vegetable Garden and Trees in Blossom, Spring,
Pontoise, 1877
Printemps à Pontoise, potager et arbres en fleurs
Oil on canvas, 65.5 x 81 cm
Pissarro/Venturi 387. Paris, Musée d'Orsay

Camille Pissarro
The Red Roofs, 1877
Les toits rouges, coin de village, effet d'hiver
Oil on canvas, 54.5 x 65.6 cm
Pissarro/Venturi 384. Paris, Musée d'Orsay

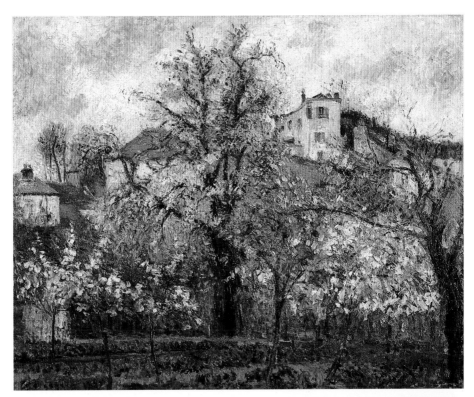

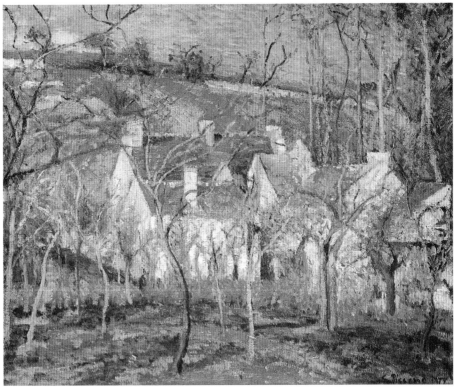

moved to Sèvres, where he got into financial difficulty with landlords and was evicted, before a patron finally came to his rescue.

Caillebotte's position was entirely different. He was financially independent, and the aesthetic lack of bias which is the advantage of the amateur inclined him to experiment. Of a well-to-do family, he studied at the Academy of Art in Paris for a short time in 1873 but then turned to marine engineering, sailing and rowing. In 1874, he met Degas, Renoir and other artists exhibiting in the Boulevard des Capucines. Degas won him over, and the following year Caillebotte bought his first paintings by his new friends and took to painting as often as he could with them, and like them. He was especially interested in light in the open, and fleeting impressions of a kind hitherto not considered proper subjects, while he was drawn thematically to human figures and aspects of urban life. His view of Impressionist realism was closest to that of Degas; however, he was also more open than the others to the world of hard physical work, and more emphatic in his willingness to take it as his subject.

He painted two versions of *The Floor Strippers* (p. 131), exhibiting both at the second Impressionist show in 1876. It was work he had seen at his parents' home. This was an aspect of Courbet's and Millet's realism – the latter's *Gleaners* comes to mind – adapted to the Impressionist idiom. He emphasized effects of light; the action presented in the painting is that of a moment; and the composition uses novel, "Japanese" perspective. Caillebotte subsequently brightened his palette considerably and relaxed his brushwork, yet never adopted fragmentary or sketchy approaches that might have dispelled the illusion of three-dimensionality or interfered with the exact definition of things in a painting. His pictures remained primarily discoveries of new aspects of contemporary reality, *tranches de vie*, unexpected slices of modern life. When Caillebotte's paintings were first publicly displayed, at the second Impressionist exhibition, the critics were taken aback by his "bizarre perspectives", the photographic character of his work, and its three-dimensionality. They were struck by his art's forceful modernity even as they registered the simultaneous use of traditional methods of representation.

Pont de l'Europe (p. 168), which crops passers-by on the bridge spanning the Gare Saint-Lazare's track approach, is interesting not least for the alert regard Caillebotte the engineer had for the new technology. He did several meticulous studies towards two versions of the painting. The lines of receding perspective in Caillebotte's work can often draw us with a disquieting violence into a picture's spatial depth: his perspective recalls the designer's drawing board. This is true of his large, atmospheric painting of the Place de l'Europe on a rainy day as well (p. 169). Renoir was to paint a similar scene some years later (p. 239), but his canvas presented a graceful throng of beautiful women and children; Caillebotte's painting, by contrast, uses wide, open spaces and figural tensions. His people straightforwardly want to get somewhere. The division of the composition into particular zones recalls Manet or Degas. The man in the foreground, so close that he is about to step out of the canvas and has had

Claude Monet
Camille Monet on her Deathbed, 1879
Camille Monet sur son lit de mort
Oil on canvas, 90 x 68 cm
Wildenstein 543. Paris, Musée d'Orsay

Claude Monet
Rue Saint-Denis, Festivities of 30 June, 1878, 1878
La rue Saint-Denis, fête du 30 juin 1878
Oil on canvas, 76 x 52 cm
Wildenstein 470. Rouen, Musée des Beaux-Arts

Gustave Caillebotte
Snow-covered Roofs in Paris, 1878
Toits sous la neige, Paris
Oil on canvas, 64 x 82 cm
Berhaut 107. Paris, Musée d'Orsay

of the show mentioned it. The picture was immediately bought, though, by Henry Hill, a tailor who had bought numerous works by Degas and lived in Brighton, where it was exhibited in September 1876 and censured by some because of its subject. In 1892/93 it rapidly changed owners, no fewer than three times.[108]

Degas used pastel with growing frequency for the many studies of singers – gesturing and fashionably tricked out – that he did in the cafés-concert. Pastel permitted fleeting impressions, a mere breath of an effect; but its granular, grainy quality had a physical presence of its own, giving the surface of a picture a sensuous interest independent of the subject and encouraging us to read this new creation as the work of a human hand. With his chemist friend Luigi Chialiva (1842–1914), Degas discovered a fixative that made pastel indelible. Degas often printed a black and white monotype first and then drew over the outline in pastel, a technique he himself had invented. At other times, he would defamiliarize and consolidate the colour texture by combining the pastel drawing with oils thinned with turpentine. The paint dried faster, which

Alfred Sisley
Snow at Louveciennes, 1878
La neige à Louveciennes
Oil on canvas, 61 x 50.5 cm
Daulte 282. Paris, Musée d'Orsay

Right:
Gustave Caillebotte
Canoeing, 1878
Les périssoires
Oil on canvas, 157 x 113 cm
Berhaut 91. Rennes, Musée des Beaux-Arts

Gustave Caillebotte
Bathers about to Dive into the Yerres, 1878
Baigneurs, s'apprêtant à plonger, bords de l'Yerres
Oil on canvas, 117 x 89 cm
Berhaut 92. Private collection

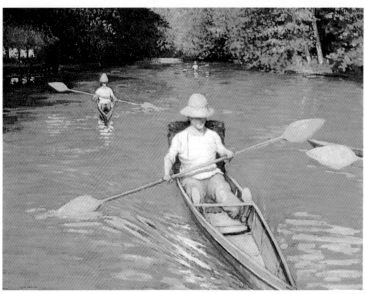

Gustave Caillebotte
Canoeing on the Yerres, 1877
Périssoires sur l'Yerres
Oil on canvas, 89 x 115.5 cm
Berhaut 95. Upperville (VA),
Mr. and Mrs. Paul Mellon Collection

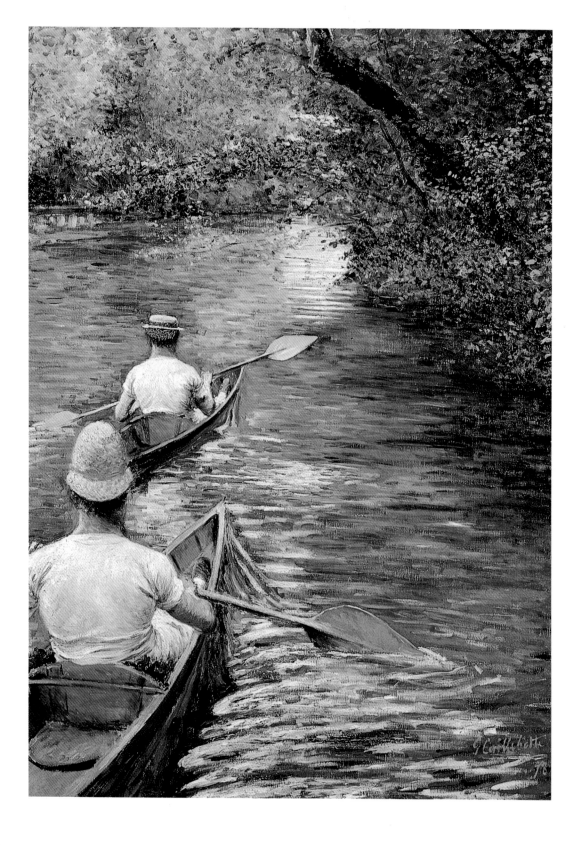

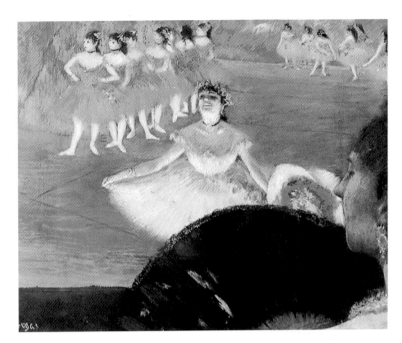

Right:
Edgar Degas
The Star or Dancer on the Stage, c. 1876–1878
L'étoile ou Danseuse sur la scène
Pastel over monotype on paper, 58 x 42 cm
Lemoisne 491. Paris, Musée d'Orsay

Edgar Degas
Dancer with Bouquet, c. 1878–1880
Danseuse au bouquet
Pastel on paper, 40 x 50 cm
Lemoisne 476
Providence (RI), Museum of Art,
Rhode Island School of Design

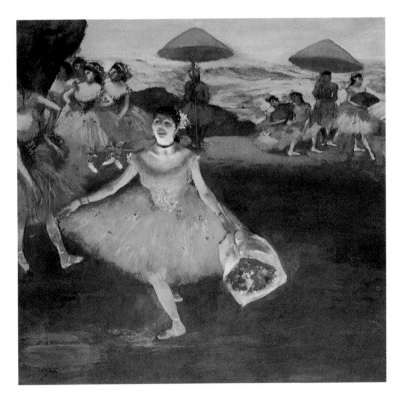

Edgar Degas
Dancer with Bouquet (Curtseying), c. 1877/78
Danseuse au bouquet saluant
Pastel on paper, 72 x 77.5 cm
Lemoisne 474. Paris, Musée d'Orsay

permitted more rapid work and produced a pastel-like effect of the fleeting moment.

Degas continued to be absorbed by unusual angles of vision. His exacting eye would isolate unusual, delicate postures that occurred during a continuum of motion. He noted colour changes produced by light or the proximity of other colours. He saw how the cold white gaslight used for stage lighting distorted the usual look of palely made-up faces when it lit them from below. His variations on a single theme, differing only slightly, repeatedly document Degas's Impressionist view of the equal appeal and value of individual moments in an infinite time sequence; they also, of course, show an artist tenaciously at work, unsatisfied by any one of the solutions he finds to his task.

An exchange of contemptuous glances between characters in a picture could be used to signal the theme of prostitution. Degas kept this in mind when observing dancers, too. The body language of singers, as he well knew, was also under intermittent police observation; singers might be examined by a psychiatrist on court orders, or even confined in an asylum for "hysteria". Degas's friend Jules Claretie once defended a woman he had drawn, Mademoiselle Bécat from the Café des Ambassadeurs, in court.[109]

William-Adolphe Bouguereau
The Birth of Venus, 1879
La naissance de Vénus
Oil on canvas, 300 x 215 cm
Paris, Musée d'Orsay

William-Adolphe Bouguereau
Bathers, 1884
Baigneuses
Oil on canvas, 200.7 x 129 cm
Chicago, The Art Institute of Chicago

Pierre Puvis de Chavannes
Young Women on the Seashore, 1879
Jeunes filles au bord de la mer
Oil on canvas, 205 x 154 cm
Paris, Musée d'Orsay

For Degas, who was plagued at an early stage in life with worries about his failing eyesight, and who ceaselessly trained his visual memory, seeing was the crucial sense, and it provided an inexhaustible supply of subjects for pictures. He came to be on close terms with the American painter Mary Cassatt (1845–1926; see vol. II), who had been living in Europe since 1868 and was rejected by the Salon in 1875 and 1877 after initial minor successes; she was a younger fellow artist willing to be inspired by his ideas, and a stylish model as well. Accompanying her through the Louvre or to the milliner's, Degas paid careful and constant attention to her unforced American self-assurance, which was founded on wealth (p. 238). He persuaded her to exhibit in the Impressionist shows, and she became one of the earliest and most important advocates of the new art in the USA.

Observation of a relatively secret nature, and the public showing of scenes normally private and unseen, played a part of growing importance

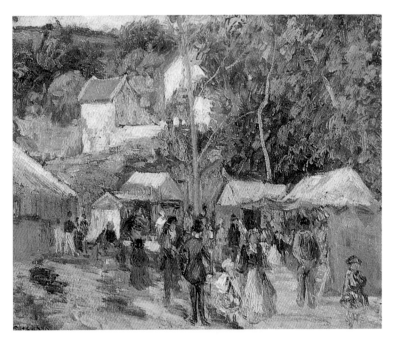

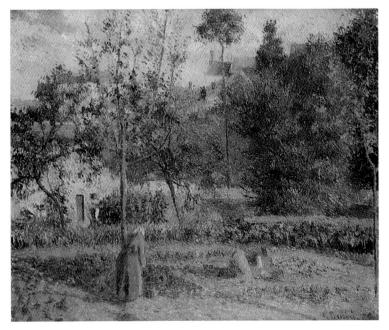

in Degas's later work from 1877 on, till this voyeurish strain became dominant. Disputes still rage over whether his female nudes washing and drying themselves in tubs and rooms should be filed under "brothel" and "prostitution". It is certain that the models Degas was able to observe, by employing them in his studio, were beyond the middle-class pale of moral normality by virtue of their willingness to pose; and we know from Renoir's models that models often sold their sexual favours. These works

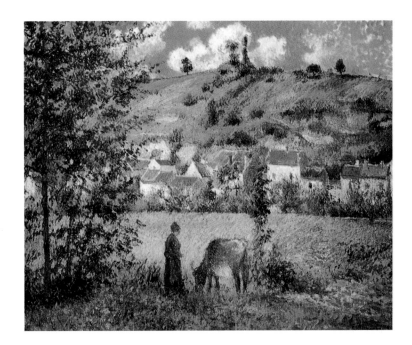

Camille Pissarro
Landscape at Chaponval, 1880
Paysage à Chaponval
Oil on canvas, 54.5 x 65 cm
Pissarro/Venturi 509. Paris, Musée d'Orsay

Camille Pissarro
The Woodcutter, 1879
Le scieur de bois
Oil on canvas, 89 x 116.2 cm
Pissarro/Venturi 499
Perth, The Robert Holmes à Court Collection

are at the heart of the unending debates over Degas's supposed misogyny, and equally over the nature of representational realism in Impressionism.

In March 1875, not long after the Société anonyme was wound up, Monet, Morisot, Renoir and Sisley had 73 works auctioned off at the Hôtel Drouot. The writer Philippe Burty (1830–1890) noted in his introduction to the catalogue that the paintings were "like small fragments of

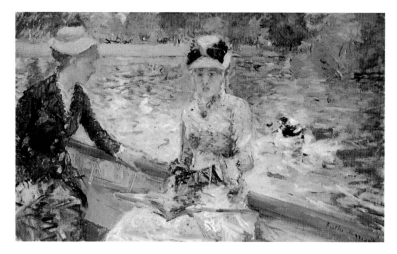

Berthe Morisot
Summer Day (Bois de Boulogne), 1879
Jour d'été (Le lac du Bois de Boulogne)
Oil on canvas, 45.7 x 75.2 cm
Bataille/Wildenstein 79
London, National Gallery

a mirror of life as as whole", reflecting "fleeting, colourful, subtle, appealing things" that merited admiration.[110] But the police were obliged to restrain an unruly public at the auction, to protect the painters and those who took their part. The prices the pictures fetched – some were sold, either back to the artists themselves or to patrons such as Duret and Caillebotte – averaged only half what they had once been. Victor Chocquet (1821–1891) made his first appearance there. He was a true lover of art, impelled by his love of beauty rather than by art-market speculation. A civil servant of modest means, he spent all he could on works of art. In 1877, despite financial troubles, he retired in order to devote his time to collecting. Chocquet was particularly susceptible to the shapes and colours of 18th-century bric-à-brac, and the continuation of a sensual approach to art in Delacroix. He bought a considerable number of Delacroix's paintings and sketches. Renoir, he felt, had an affinity with the elder painter; and Renoir led him in turn to Cézanne, Monet, Pissarro and others.

On 30 March 1876 the second Impressionist exhibition opened in three rooms of Durand-Ruel's galleries at 11, Rue Le Peletier. This time there were only nineteen exhibitors rather than thirty-one; but the catalogue ran to 252 items as against the previous 165, many of them multiple entries. Six of the artists were newcomers; Durand-Ruel's financial situation was difficult, and the show had to be financed by the group themselves once again. (This time it paid them a closing dividend, albeit of only three francs a head.) The organization of other activities was largely done by Caillebotte and the faithful Charles Tillot (1825–1895), an older landscape and flower painter who lived on the skirts of the Barbizon woods and had been recruited by Degas. His delicate floral still lifes (p. 264), which recall Fantin-Latour, cannot be described as Impressionist. Nor can the work of other acquaintances of Degas such as Desboutin (who never experienced difficulty exhibiting at the Salon). His small portrait of the baritone Jean-Baptiste Faure (p. 130) – who was a collector of Manet, Degas, Monet and Sisley and indeed funded Sisley's

Oarsmen and anglers in the Bois de Boulogne, Paris. Postcard, c. 1900

visit to England in 1874 – could just as easily have been hung in the Salon, even if it has the flavour of a study. Desboutin's picture portrays Faure in an appropriately affected pose in character for a Meyerbeer opera.

Many of the paintings in the show were already the property of collectors. Most of the Monets, for instance, belonged to Faure, and one to Chocquet. Of Renoir's 18 canvases, six were Chocquet's, and only five were still for sale. Sisley's paintings chiefly belonged to art dealer "Père" Martin (c. 1810–c. 1880). The aim of the exhibition, in other words, was partly to provide Impressionism with a platform and to legitimate its credentials with possible future collectors by demonstrating that buyers of repute already owned such works.

The show provoked a lively response from the critics. Their attention was particularly caught by two paintings that were not Impressionist in the narrower sense. Monet's *Madame Monet in Japanese Costume* (p. 150), a lifesize portrait of his wife, was a decorative *tour de force* in which the artist demonstrated his ability to handle what had long been in fashion among the middle classes. The blonde hair of his would-be Japanese subject, her exaggerated coquettishness, the grotesque gown,

Pierre-Auguste Renoir
The Seine at Asnières, c. 1879
La Seine à Asnières
Oil on canvas, 71 x 92 cm
London, National Gallery

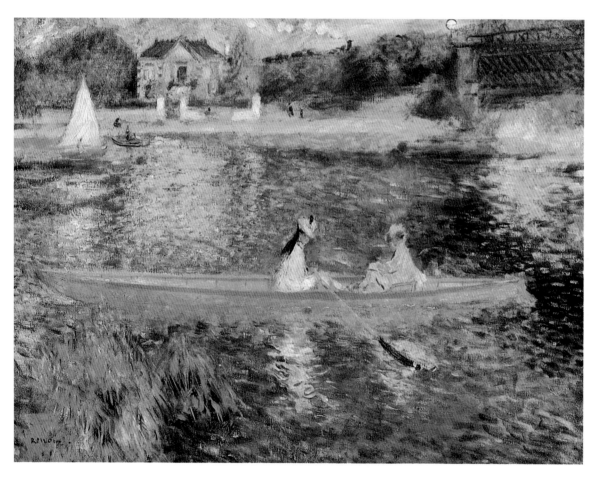

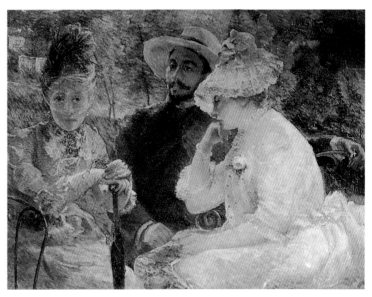

and the many fans, add up to a surfeit that may be meant ironically. Monet sold the painting to the Comte de Rossi right away, for the pleasantly high price of 2,000 francs. Degas would have liked to exhibit his *Portraits in an Office (New Orleans)* (p. 111) – thus the catalogue title – in Manchester too. "If any of the mill owners there ever needs a painter, he can try me," he wrote to his friend Tissot.[111] The painting prompted a surprising range of differing responses, demonstrating how taken aback the critics were by the subject, approach and compositional technique – and how blind critics can be. Zola found the precise draughtsmanship unclear and histrionic, and doubted whether Degas's brushwork would ever be genuinely creative.

Works painted in a manner that recorded brief impressions were the backbone of the exhibition, however. This was recognised, and influential critics such as Wolff attacked paintings such as Renoir's *Nude in the Sunlight* (p. 162) accordingly. The very headings given many of the reviews included the word "Impressionist" or "Impressionalist" – or even, in some cases, "Intransigent", a word which carried a negative political charge for conservatives. Given the prevailing censorship conditions, anti-MacMahon republican papers tended to remain vague when pointing out that artistic truthfulness, the modernity and authenticity of subject matter, the individuality of certain ways of seeing, and the unconventional nature of the aesthetic approaches adopted by the new artists, were all intrinsically connected with democratic, egalitarian ideals of freedom.

The most detailed analysis was a 38-page pamphlet by writer and art critic Louis Edmond Duranty (1833–1880), titled "La Nouvelle Peinture". A print run of 750 copies was published at the author's own expense while the exhibition was still on and probably sent to a number of newspaper editors. In 1946 it was reprinted, and in 1986 the English

Marie Bracquemond
Tea Time (Portrait of Louise Quivoron), 1880
Le goûter (Portrait de Louise Quivoron)
Oil on canvas, 81.5 x 61.5 cm
Paris, Musée du Petit Palais

Marie Bracquemond
On the Terrace at Sèvres, 1880
Sur la terrasse à Sèvres (La terrasse de la villa Brancas)
Oil on canvas, 88 x 115 cm
Geneva, Musée du Petit Palais

Right:
Edouard Manet
In the Garden Restaurant of Père Lathuille, 1879
Chez le Père Lathuille
Oil on canvas, 92 x 112 cm
Rouart/Wildenstein I,291
Tournai, Musée des Beaux-Arts

Edouard Manet
In the Conservatory, 1879
Dans la serre
Oil on canvas, 115 x 150 cm
Rouart/Wildenstein I,289
Berlin, Neue Nationalgalerie, Staatliche Museen zu Berlin, Preußischer Kulturbesitz

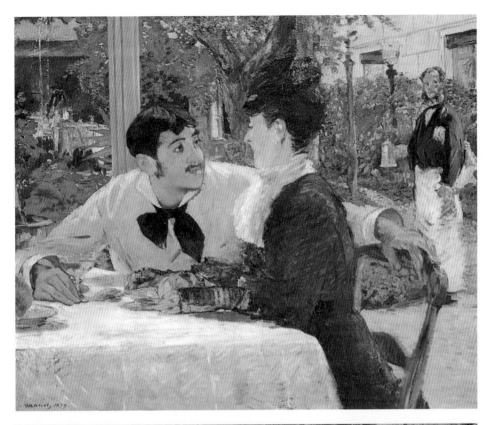

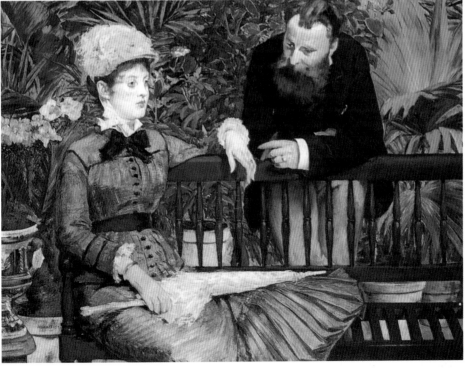

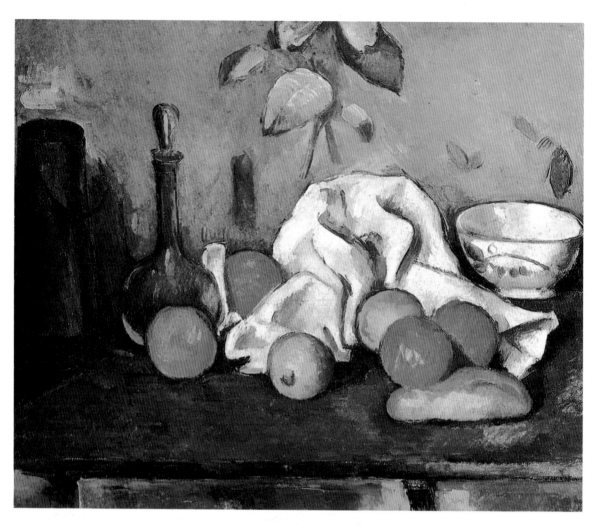

Paul Cézanne
Still Life with Fruit, 1879/80
Nature morte aux fruits
Oil on canvas, 45 x 54 cm
Venturi 337. St. Petersburg, Hermitage

translation was the centrepiece in a retrospective show and major publication.[112] Duranty had been an advocate of literary realism as a young man in 1856, and in 1877 he was to publish a novel about contemporary artistic life, "Louis Martin the Painter", heavily laced with theory. Duranty talked over "La Nouvelle Peinture" with Degas; some, indeed, supposed Degas its true author. The pamphlet took the unusual step of identifying none of the exhibiting artists or works by name (though containing references to other artists). Instead, Duranty sketched a thumbnail history of the new realism and made a programmatic call for its further development. Duranty was wholeheartedly on Degas's and Manet's side, but he was no partisan for Monet's, Sisley's or Pissarro's landscape art. Like Degas, he refused to adopt the term Impressionism, which had been widely current since 1874. Duranty would have preferred the new art to evolve along different, more realistic lines. It is only correct to consider Impressionism – or, not the same thing, the history of the eight group shows – by Duranty's lights (emphasizing

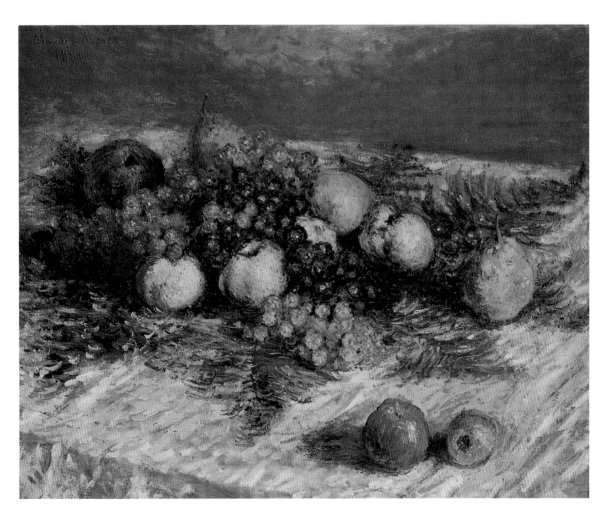

Claude Monet
Still Life with Pears and Grapes, 1880
Nature morte avec poires et raisins
Oil on canvas, 65 x 81 cm
Wildenstein 631. Hamburg, Hamburger Kunsthalle

newness) if we view Degas as an Impressionist too. Or, to put it differently: the criterion of newness was very soon to be applicable to other, non-Impressionist painting as well.

The second group exhibition left the painters dissatisfied. The French economy was not in the best of states. It is true that in the summer of 1876 Monet worked at Rottenbourg, the Montgeron residence of the collector Ernest Hoschedé (1837–1891), painting decorative open-air pictures for the home there, which Hoschedé's wife, Alice, had inherited a few years before. Manet, rejected by the Salon, was also a guest at Rottenbourg. Hoschedé, however, the director of Au Gagne Petit (a department store), was so avid a collector that he was twice compelled to sell off paintings by auction. His foolhardiness led to his dismissal from the firm, and in 1878, with debts of 82,500 francs at Durand-Ruel's and Petit's, he went bankrupt. So Monet found himself selling works for prices of 100 to 200 francs to others, such as the Paris-based Rumanian doctor Georges de Bellio (1828–1894). A homoeopath like Gachet, he

Marie Bracquemond
The Lady in White, 1880
La dame en blanc
Oil on canvas, 181 x 100 cm
Cambrai, Musée de la Ville de Cambrai

had recently started collecting Impressionist paintings, which in due course his daughter inherited; she and her husband left them to the Académie Française. Monet, acutely short of money, would even beg two or three hundred francs off rich art lovers. (This was admittedly only a financial shortage by the standards of middle-class people who expected to lead a cultural life. A sempstress would earn only one or maybe two francs for a twelve-hour day, and would be unemployed for several months a year; a milliner might earn twice that sum. Monet's earnings from the portrait of Camille would have represented three to six years' wages for working women.)

In April 1877 there was another Impressionist exhibition, organized and arranged by Caillebotte this time. Today it is viewed as the best and most homogeneous of the Impressionist shows, the pinnacle of the movement's achievement in terms of the original conception. It was Caillebotte's exhibition; he himself paid for the hire of spacious rooms on the second floor of 6, Rue Le Peletier, opposite Durand-Ruel's galleries.[113] The building was in the heart of Parisian business and cultural life, only a few paces from the Hôtel Drouot auction rooms and near the Bourse and the magnificent new opera house designed by Charles Garnier (1825–1898). Eighteen artists were involved in the exhibition. Among them was Cals, in his late seventies, who had been a participant since the first exhibition. He sent his small, tranquil, warm-hued, easily painted, plein-airist genre paintings of fishing folk and farmers from Honfleur (pp. 124, 125). The approach Cals took to art resembled that of Daubigny and Boudin. Renoir had brought in two friends, Frédéric Cordey (1854–1911) and Pierre Lamy (Franc-Lamy; 1855–1919), who were re-

Edouard Manet
Bundle of Asparagus, 1880
Une botte d'asperges
Oil on canvas, 46 x 55 cm
Rouart/Wildenstein I,357
Cologne, Wallraf-Richartz-Museum

Alfred Stevens
Family Scene, c. 1880
Scène familiale
Oil on canvas, 65.3 x 51.5 cm
Paris, Musée d'Orsay

belling against the art college and had served him as models for *Le Moulin de la Galette*. The future was to find neither of them creative, nor did they participate in further group shows. The same applied to Degas's friend Alphonse Maureau, who had a meticulously proportioned small study (p. 289) on display, revealing him to have affinities with Monet. Pissarro brought in his Pontoise friend Ludovic Piette (1826–1877; p. 154). However, the exhibition, notable for its careful hanging, was dominated by Caillebotte, Monet, Pissarro and Renoir. For the first time, works were presented in plain white frames, works such as Renoir's aforementioned masterly painting of pleasure gardens in Montmartre, or Monet's and Caillebotte's stylistically very different railway scenes of the nearby *Gare Saint-Lazare* (p. 171) and the *Pont de l'Europe* (p. 168). As critic Richard Brettell has recently stressed, Caillebotte failed, despite all his efforts, to present Manet's *Nana*, which the Salon had turned down and which Manet was displaying, as we have seen, in a shop window (p. 160).

The paintings of Cézanne constituted a special feature of the exhibition. Their subject matter, and the artist's close attention to Nature, placed him with Pissarro and Guillaumin, with whom he debated artistic creeds. But the difficulties with Nature that he told friends of, and his as yet unformed desire to create paintings that were firm structures with their own internal laws, meant that in the eyes of most contemporaries his work appeared ponderous or even unbearably crude. The portrait of his new admirer, Chocquet, turned out so grim a complex of thick paint streaks that one critic dubbed the sitter "the chocolate murderer". Cézanne's position was at an ever greater remove from mainstream Imprressionism. The critics dealt harshly with him, and the daylong efforts of Chocquet, who owned almost everything Cézanne was exhibiting, to talk people round were of no avail. Cézanne was an irritable, mistrustful, antisocial person, and easily discouraged; he never again participated in an Impressionist show, allowing his contacts with his old friends to lapse. As the 1870s closed, though, he did (somewhat later than his fellows) locate his own personal style – a style which was to play a decisive role in the visual idiom of art after Impressionism.

The hanging and the impressive number of works by each of the leading painters made the 1877 show a programmatic group exhibition. But the artists were also visibly individuals who offered points of meaningful comparison. Their aesthetic aims could be clarified in this way and the eye could be attuned to an understanding of the new art. The Salon, by

Edouard Manet
Girl in the Garden at Bellevue, 1880
Jeune fille au jardin de Bellevue
Oil on canvas, 92 x 70 cm
Rouart/Wildenstein I,347
Zurich, E.G. Bührle Collection

Edouard Manet
House at Rueil, 1882
Maison de Rueil
Oil on canvas, 92 x 73 cm
Rouart/Wildenstein I,406
Melbourne, National Gallery of Victoria

Right:
Gustave Caillebotte
Square at Argenteuil, 1883
La promenade d'Argenteuil
Oil on canvas, 60.5 x 70.5 cm
Berhaut 246
Los Angeles, The Armand Hammer Collection

Gustave Caillebotte
Farmhouse at Trouville, 1882
La chaumière, Trouville
Oil on canvas, 54 x 65 cm
Berhaut 196
Chicago, The Art Institute of Chicago

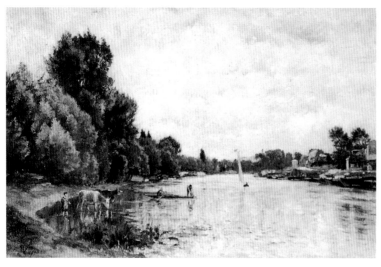

Stanislas Lépine
The Seine near Argenteuil
La Seine près d'Argenteuil
Oil on canvas, 38 x 69.3 cm
Private collection

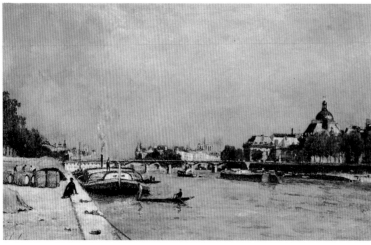

Stanislas Lépine
Paris, Pont des Arts, c. 1878–1883
Oil on canvas, 39.5 x 60 cm
Private collection

Paul-Victor Vignon
The Crossroads
La croisée des chemins
Oil on canvas, 33 x 46.5 cm
Beverly Hills (CA), Louis Stern Galleries

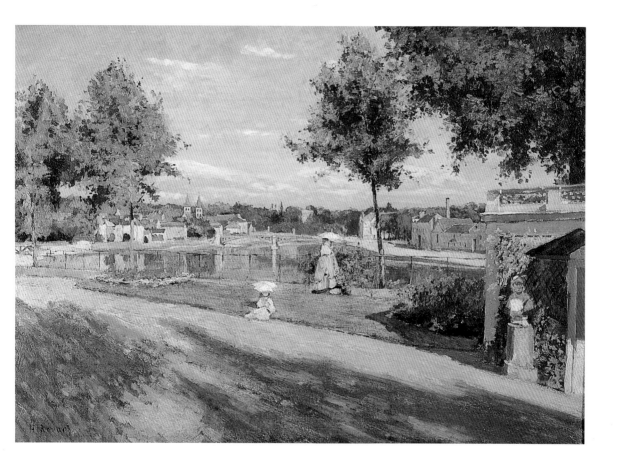

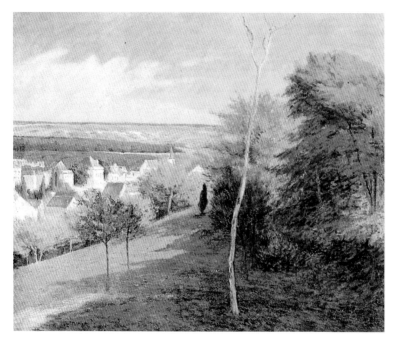

Henri Rouart
Terrace on the Banks of the Seine at Melun, c. 1880
La terrasse au bord de la Seine à Melun
Oil on canvas, 46.5 x 65.5 cm
Paris, Musée d'Orsay

Paul-Victor Vignon
The Hills at Triel, c. 1881
Les hauteurs de Triel
Oil on canvas, 46.4 x 55.4 cm
Beverly Hills (CA), Louis Stern Galleries

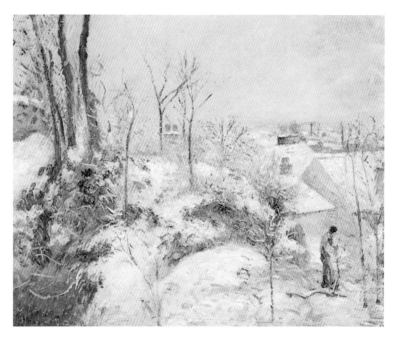

Camille Pissarro
Cottage at Pontoise in the Snow, 1879
La Garenne à Pontoise, effet de neige
Oil on canvas, 59 x 72 cm
Pissarro/Venturi 478. Chicago, The Art Institute of Chicago

Camille Pissarro
The Wheelbarrow, c. 1881
La brouette, verger
Oil on canvas, 54 x 65 cm
Pissarro/Venturi 537. Paris, Musée d'Orsay

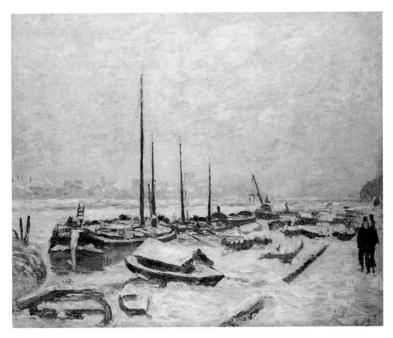

Armand Guillaumin
The Seine in Winter, 1879
La Seine pendant l'hiver
Oil on canvas, 14 x 25 cm
Private collection

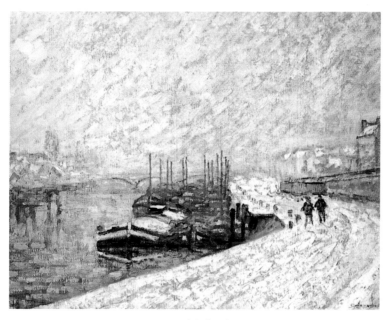

Armand Guillaumin
Barges in the Snow, 1881
Remorqueurs dans la neige
Oil on canvas. Bayonne, Musée Bonnat

Milliner. Photograph, 1861

Paul Gauguin
Study of a Nude. Suzanne Sewing, 1880
Etude de nu ou Suzanne cousant
Oil on canvas, 111.4 x 79.5 cm
Wildenstein 39
Copenhagen, Ny Carlsberg Glyptotek

contrast, only ever showed a very few submissions by any artist, and hung them insensitively. Too many works were presented in alphabetical order of artist's name, or by format, or following some other extrinsic principle, regardless of what other works might be alongside.

At Degas's insistence, the show was not described as an "Impressionist" exhibition. But Georges Rivière (1855–1943), a young tax official who was also a journalist in his spare time, published at Renoir's prompting four issues of a journal called "L'Impressionniste" while the exhibition was on, assessing the art on display. This sealed the term – though others, such as "Intentionalism", were still heard for a time, while politically charged labels such as "Intransigent" also survived for a period. (Claretie had even proposed that the technique of the Impressionists be known as the telegram style.) A year later, in 1878, when another exhibition (which did not come off) was planned, Manet's friend Duret published a monograph, "Les Peintres impressionnistes", in which he attempted an overview and history of the movement. In the same year, the term entered the Larousse encyclopaedia.

Quite apart from its name, this new phenomenon in art was a talking point of the day, as various things suggest. In far-off Basle, for instance, the historian and art historian Jacob Burckhardt (1818–1897), lecturing on Rembrandt in 1874 and 1877, brusquely dismissed any overvaluation of light and colour by "daubers and sketchers, whether of genius or not". He condemned them for subordinating the true subjects of art to the "mighty elements of light and air" and for taking them as a mere pretext for "trickery".[114] In this – and in his attack on unattractive draughtsmanship and composition and on common, unimposing figure models (an attack he aimed at Rembrandt too) – Burckhardt did not necessarily mean Manet, Monet or Degas, whose works he can hardly have been familiar with, but a broad current since Courbet and the Barbizon school which had been flowing internationally in the major exhibitions. In terms of the central art of the day, Impressionism was simply the most "intransigent", heretical, radically avant-garde option.

The critical response to the Salon exhibitions reflected an ongoing debate between historical art, still lauded by the academicians as the loftiest art, and genre, still-life and landscape art, which was increasingly being bought by well-to-do collectors for their own homes. The controversy over ways of seeing and representation, over the exemplary status given particular historical styles, over the degree to which new forms of expression were appropriate to the modern era, was part of the same debate.[115]

Talented painters schooled on the old masters, such as Jean-Paul Laurens (1838–1921), who was of the same generation as the Impressionists, were interested in seeking out the less familiar moments in mediaeval history, since they would impress a jaded public with the force of novelty. One such moment was the excommunication of Robert the Pious (p. 166). The details, and the textural, material qualities of the things we see, have been meticulously reproduced. It is like a snapshot of a single moment, with the church delegation leaving the royal couple

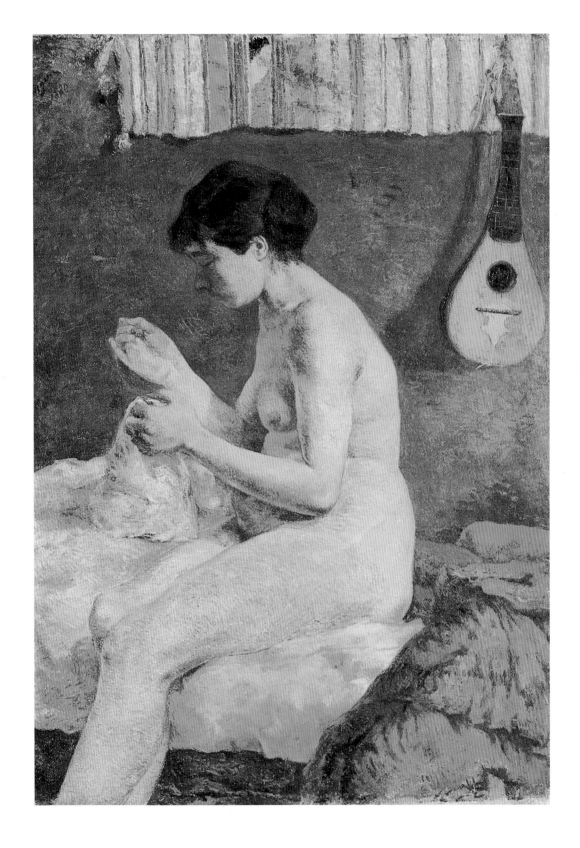

Gustave Caillebotte
Still Life: Chickens, Pheasants and Hares, 1882
Nature morte: poulets et gibiers à l'étalage
Oil on canvas, 76 x 105 cm
Berhaut 220. Private collection

staring despondently at the symbolically extinguished candle. This record of a single moment, the oblique angle on vacant space, and the candle smoke, all play a role similar to that in Degas. Later, younger history painters such as Georges-Antoine Rochegrosse (1859–1938) were to achieve even more startling shock effects in what the critic Karl Woermann has called their "art of terror". Archaeological, historical or ethnographic precision – when even fictional biblical narrative was being reconstructed (following the Pre-Raphaelites' example) – was combined with a realistic, atmospheric *plein-airisme* that introduced greater amounts of light into Salon pictures.

The most common form of historicism that reused styles of past ages, often in eclectic combinations, was the sensual, seductive, stylish portrayal of beautiful women; the supposed subject could be taken from Christianity, or from Greek or Roman myth. William-Adolphe Bouguereau (1825–1905), an Academy member since 1876, was one of the foremost artists of this kind (p. 188). A devout Catholic, he was out to oppose traditional ethical values to the materialism of the world about him, but all he managed was the frisson of superficial delights. There was an unbridgeable gap between his art and that of Renoir (p. 162) or indeed Cézanne (p. 121); the gap remained even when Bouguereau attempted a subject such as bathers, which had no ideological strings attached.

The intriguing aesthetic problem of the period lay in the relations between – on the one hand – realism, naturalism, and the new Impressionist art (widely criticized, and spurned by the Salon), and – on the other hand – similar styles of art which, though they did not escape uncriticized, earned widespread esteem and recognition by the state. Moral, political, aesthetic and technical grounds for rejection or critical dismissal were asserted in a fairly cavalier fashion. Today, in contrast, paintings will be approved unseen, so to speak, as long as the artist in question was a member of the Impressionist movement.

Félix Bracquemond
Portrait of Edmond de Goncourt, 1880
Portrait de M. Edmond de Goncourt
Charcoal on canvas, 55 x 37.9 cm
Paris, Musée du Louvre, Cabinet des Dessins

Right:
Gustave Caillebotte
In a Café, 1880
Dans un café
Oil on canvas, 155 x 115 cm
Berhaut 134. Rouen, Musée des Beaux-Arts

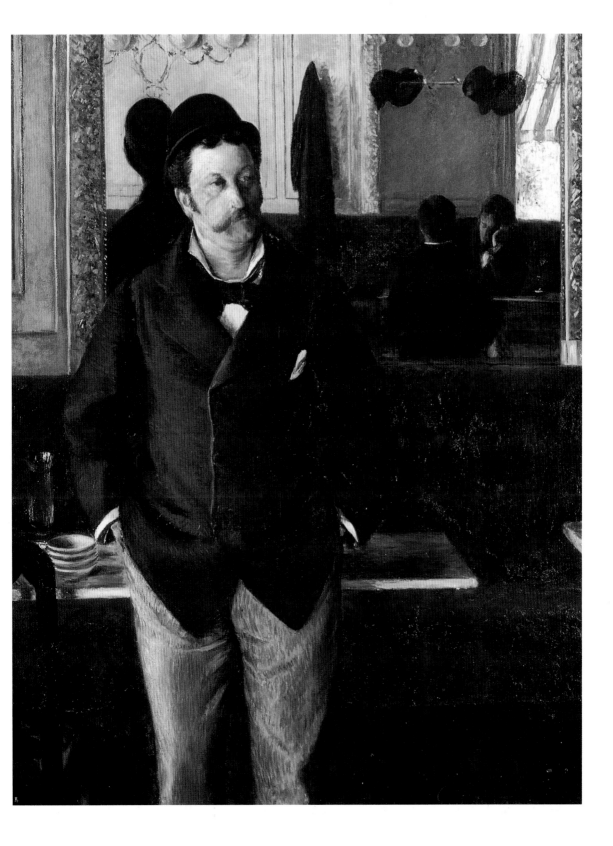

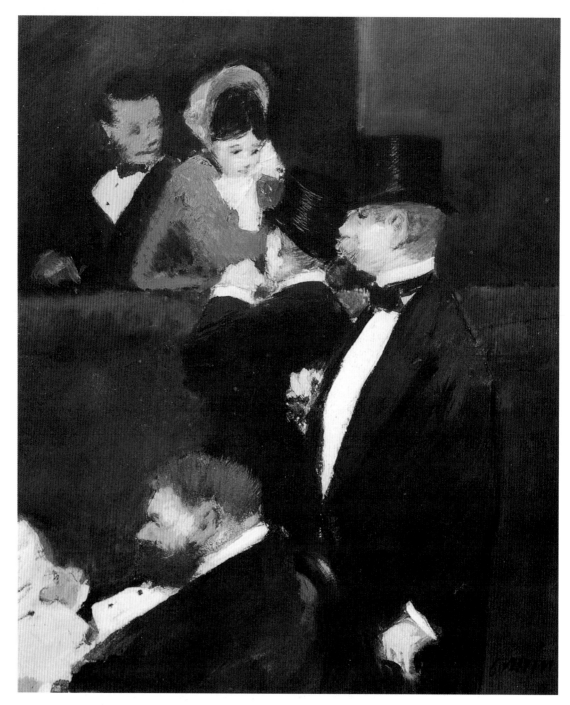

Jean-Louis Forain
A Box at the Opéra, c. 1880
Une loge à l'Opéra
Gouache and oil on card, 31.8 x 26 cm
Cambridge (MA), Fogg Art Museum,
Harvard University, Bequest of Annie Swan Coburn

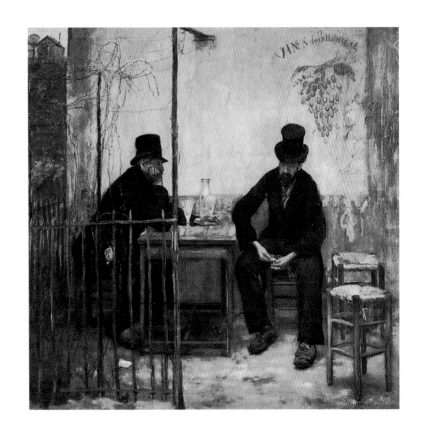

Jean-François Raffaëlli
The Absinth Drinkers, 1881
Les buveurs d'absinthe
Oil on canvas, 110.2 x 110.2 cm
Private collection

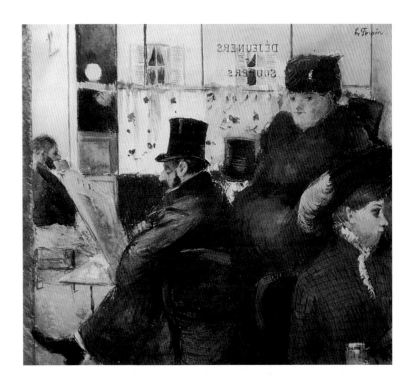

Jean-Louis Forain
In the Café de la Nouvelle Athènes, 1879
Au café de la Nouvelle Athènes
Watercolour, 35.3 x 39.1 cm
Paris, Musée du Louvre, Cabinet des Dessins

Edouard Manet
Manet's Mother in the Garden at Bellevue, 1880
La mère de Manet dans le jardin de Bellevue
Oil on canvas, 82 x 65 cm
Rouart/Wildenstein I,346. Paris, private collection

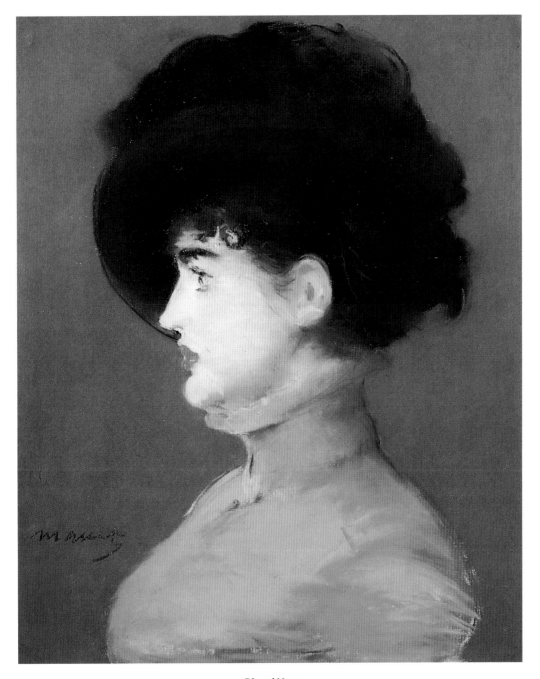

Edouard Manet
The Viennese: Portrait of Irma Brunner in a Black Hat, 1880
La Viennoise (Dame au chapeau noir: Irma Brunner)
Pastel on paper, 54 x 46 cm
Rouart/Wildenstein II,78
Paris, Musée du Louvre, Cabinet des Dessins

Jules Bastien-Lepage
Poor Fauvette, 1881
Pauvre Fauvette
Oil on canvas, 162.5 x 112.5 cm
Glasgow, Glasgow Art Gallery and Museum

Pierre-Auguste Renoir
On the Terrace, 1881
Sur la terrasse
Oil on canvas, 100.2 x 81 cm
Chicago, The Art Institute of Chicago

Naturalism was clearly gaining ground in pictures such as those of Jules Bastien-Lepage (1848–1884), a farmer's son. At the 1878 Salon his *Haymaking* (p. 167) attracted a good deal of attention. His sister modelled for the somewhat plain, dull woman in the painting. The view of agricultural labour as exhausting toil was derived from Courbet and Millet, but Bastien-Lepage brought it up to date by painting a dynamic, asymmetrical composition, in light colours, with an airy landscape in the background. In 1884 the German critic Adolf Rosenberg dismissed a similar picture as "fleeting photography". In his later historical and genre work too – which earned him Degas's sarcastic soubriquet "the Bouguereau of Naturalism"[116] – Bastien-Lepage remained stronger and more serious than other famous contemporary painters of peasant life, such as Jules Breton (1827–1906).

Landscape art at the Salon was becoming increasingly bright and sketchy, and as early as 1876 it was criticized as being too Impressionistic. Boudin's little coastal scenes (p. 35) were for many years the best of this kind of art. The rest mainly comprised views of Paris, scenes of city life, and excursions into the surrounding country, subjects which were not necessarily far removed from Impressionism. One conservative critic warned in 1879 in the "Gazette des Beaux-Arts": "Bougival is a dangerous model."

De Nittis, who briefly worked with the Impressionists in 1874 and may have been inspired by Degas to work in pastel in 1877, painted the most distinctive scenes capturing life in the boulevards and squares. His work was in great demand. The young Norbert Goeneutte (1854–1894) had a less relaxed hand than Sisley but a delicate sense of tonalities and the optical effects of snow surfaces against which figures become silhouettes. The anecdotal connections he established between figures avoided the mischievous absurdities Degas tended to like (p. 155). Much the same can be said of Jean Béraud (1849–1936) and his stylish, sometimes extremely small pictures (p. 371). They are bright, taut compositions that capture fleeting moments in everyday life. They always include brief episodes that can be retold in greater detail than, say, paintings by Renoir with similar subject matter. Painters such as Béraud did not want this thematic interest (often described as literary) vanquished by the "mighty elements of light and air" or subjected to autonomous colour structures. The representational and narrative aspect of pictures, increasingly emphasized at that time by graphic illustrations in magazines and by photographs, is always more accessible to the wider public than questions of form; and so painters were always tempted to pander to expectation, and earn the status and profit that would quickly result. The detailed and humorous *Autumn Regatta at Argenteuil*,[117] painted in 1879 by Paul Renouard (1854–1924), was highly thought of, and one critic warned against confusing this fine painter with another, a dauber called Renoir, whose name happened to sound similar.

One of the most successful painters of modern life was an associate and acquaintance of the Impressionists proper, the Belgian artist Alfred Stevens (1823–1906; p. 199). As early as 1871, the Morisots said he

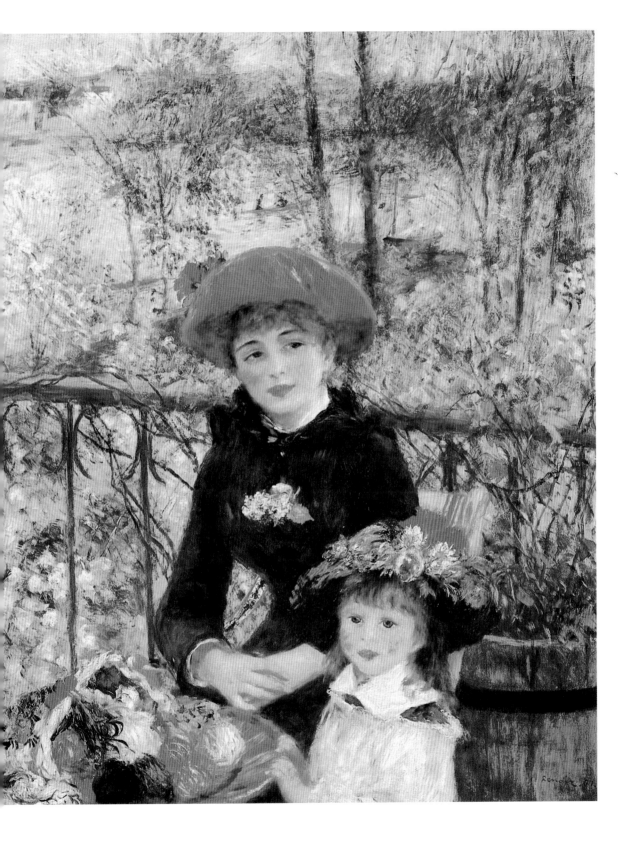

Camille Pissarro
Mère Larchevêque (the Washerwoman), 1880
La mère Larchevêque (La laveuse)
Oil on canvas, 73 x 60 cm
Pissarro/Venturi 513
New York, The Metropolitan Museum of Art

Camille Pissarro
Young Peasant Girl Wearing a Hat, 1881
Jeune paysanne au chapeau
Oil on canvas, 73.4 x 59.6 cm
Pissarro/Venturi 548
Washington, National Gallery of Art,
Ailsa Mellon Bruce Collection

Left:
Camille Pissarro
The Shepherdess, 1881
La bergère (Jeune fille à la baguette)
Oil on canvas, 81 x 64.7 cm
Pissarro/Venturi 540. Paris, Musée d'Orsay

would be earning over 100,000 francs that year with his graceful, delicately draughted and painted pictures. Jacques Tissot (1836–1902), a friend of Degas, was said by the same source to have made 300,000 francs in one sale in England in 1875. (In England he called himself James.) Since 1859 he had been exhibiting at the Salon. Because of his involvement in the Commune he spent over a decade in England, from where he travelled to Venice in 1874 to summer with the Manets. He returned to Paris in 1882. He put on a large-scale solo exhibition and embarked on a fifteen-part sequence of paintings, *Women of Paris*, which went on show in 1885. His paintings and pastels were invariably meticulously drawn, dryly painted, yet often effectively composed, and charmingly anecdotal (pp. 241, 251). Recently they have enjoyed a revival on the art market and among scholars.[118]

Debating Content and Strategies

1878, the year of the next World Fair in Paris was a year of setbacks for the Impressionists. The preceding year, France had finally consolidated its political status as a republic, and it now needed to re-establish its full international standing. This required that the cultural image be cleansed of all traces of radicalism, especially in view of revived unrest in the workers' movement. Thus in 1878 Manet was rejected by the

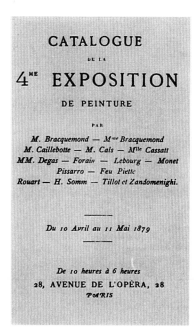

Catalogue of the fourth Impressionist exhibition, 1879

Claude Monet
Monet's Garden at Vétheuil, 1881
Le jardin de Monet à Vétheuil
Oil on canvas, 150 x 120 cm
Wildenstein 685
Washington, National Gallery of Art

Salon, and the plan for a group exhibition by the Impressionists was dropped.

The fourth exhibition was held in April/May 1879 in a flat at 28 Avenue de l'Opéra. Sixteen artists exhibited some 260 works. This time Renoir, Sisley, Morisot and Guillaumin were conspicuous by their absence, not to mention Cézanne, who did not rejoin the group. Monet never went to see the show, partly because of his difficult personal circumstances at the time. In addition to a few new paintings, he had several older works and many that had already been sold in the show. The exhibition was coordinated by Degas, who also organized the fifth, in spring 1880, which again lacked Renoir and Sisley, and this time Monet too. It was on the mezzanine of a building at 10, Rue des Pyramides which was still under construction, and the rooms were filled with noise and dust. This happened again at the sixth exhibition in April 1881, which was held at the same address as the famed first, 35 Boulevard des Capucines, though this time in a poorly lit flat at the back of the building. With thirteen artists exhibiting something over 170 works, it was the smallest of all the group shows.

In regard to the generous exhibition of 1879, which attracted over 15,400 visitors (four times as many as in 1874), a number of works were added while the show was running, with the result that the catalogue is unreliable. At the 1880 exhibition, Degas intended to exhibit his remarkable first sculpture, the coloured lifesize wax figure of a fourteen-year-old ballerina, dressed in real pieces of clothing, but in the event he left the display case empty, which must have produced a veritably surreal effect. The dancer was first seen by the public at the 1881 exhibition. The 1880 poster used the expression *Artistes Indépendants*, while the catalogue refrained from using the phrase. All of these things were symptoms of insecurity, compared with the carefully prepared and staged exhibition of 1877.

There were various causes for these symptoms. In Renoir's and then Monet's case, it is apparent that they wanted to abandon the image of rebellious outsiders, not least in order to improve their finances. Their aim was to reconcile "official" and "modern" art. This was in line with the prevailing political climate. Traumatic memories of the Commune were fading away, and, following a partial amnesty in 1879, a general amnesty was offered to Communards in prison or exile in July 1880. Three days later, 14 July was celebrated as a national holiday for the first time, recalling the fall of the Bastille in 1789. A moderate radicalism could dominate the political scene as long as it remained moderate. And finally, the media and market system afforded new opportunities which could take the place of a cooperative-style exhibition collective.

One of Renoir's new acquaintances was a diplomat, Paul Bérard (1833–1905), who repeatedly invited the painter to Wargemont, his country residence in Normandy, and commissioned portraits. Renoir had met Bérard at the home of Charpentier, who exerted a strong influence on the fate of the Impressionists at that time. Georges Charpen-

Pierre-Auguste Renoir
The Luncheon of the Boating Party, 1881
Le déjeuner des canotiers
Oil on canvas, 129.5 x 172.7 cm
Daulte 379
Washington, The Phillips Collection

The rowing club at Bougival on the Seine, setting of
"The Luncheon of the Boating Party"

tier (1846–1905), somewhat younger than Renoir, was the successful publisher of Zola, Maupassant and Daudet. Since 1875 he had been host to politicians, intellectuals and artists of every persuasion at his magnificent home. His patronage rapidly expanded to include the entire group. Renoir painted Madame Marguerite Charpentier with her daughter, son and dog in her Japanese salon; the group portrait excited considerable interest at the 1879 Salon. From that year on, at the instigation of his cultured and ambitious wife, Charpentier published a new illustrated literary and art magazine, "La Vie moderne": Armand Silvestre edited the art section. It reported in an unstrained style on contemporary art of various kinds that was relatively accessible. A special feature was the provision of rooms named after the magazine, where Renoir's younger brother Edmond (1849–1943), a journalist, had the task of organizing a monthly series of small exhibitions. This gallery was intended to afford readers and the educated public an insight into one artist's studio at a time, as it were. The second of these exhibitions, understandably successful, featured the well-known De Nittis; the fifth was devoted to Renoir, mainly his pastels. Manet, Monet (1880) and Sisley (1881) followed before very long.

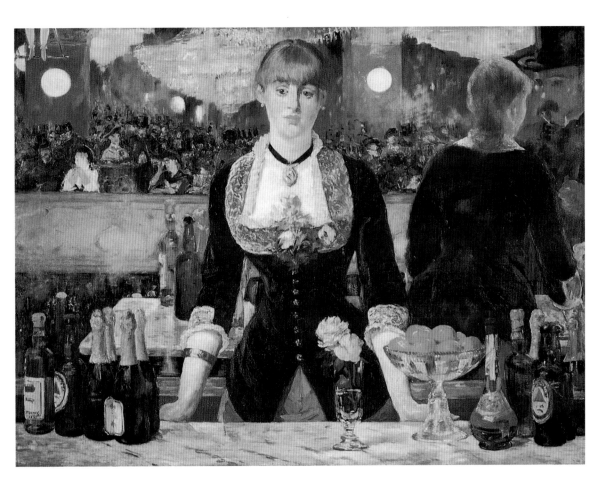

Edouard Manet
A Bar at the Folies-Bergère, c. 1881/82
Un bar aux Folies-Bergère
Oil on canvas, 96 x 130 cm
Rouart/Wildenstein I,388
London, Courtauld Institute Galleries

Renoir had successfully submitted to the Salon in 1878, and Monet followed him in 1880, though Sisley was turned down in 1879. Manet's brand of Impressionism was on view at the 1879 Salon with *Boating* (p. 138), a light, boldly cropped and strongly coloured work painted five years before. It was bought direct from the Salon by a collector. Manet's political convictions were reflected in his vigorous portrait of Georges Clemenceau (1841–1929), the new leader of the republic radicals (1879/80; Paris, Musée d'Orsay).

Degas was furious at the "renegades" who had joined the Salon. Caillebotte and the gentle-spirited Pissarro, who was already acquiring the air of an elderly patriarch, tried hard to maintain good relations. Caillebotte became resigned in 1881; Degas was pursuing other artistic goals too, and no new agreement could be reached. At the fourth exhibition, Degas had included figure painters, among them Cassatt and Marie Bracquemond (1841–1916). The latter notably had open-air work in the 1880 show that used colour in an Impressionist way and was flooded with light yet was also conspicuously exact in its draughtsmanship (pp. 194, 198). Like Degas, the youthful Jean-Louis Forain (1852–1931) had a preference for theatre and restaurant motifs (pp. 210, 211). Similar

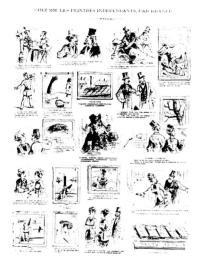

CHEZ MM. LES PEINTRES INDEPENDANTS, PAR DRANER

Cartoon by Draner (Jules Renard) on the fourth
Impressionist exhibition, from "Le Charivari",
23 April 1879

Pierre-Auguste Renoir
Two Girls, c. 1881
Deux jeunes filles
Oil on canvas, 80 x 65 cm
Moscow, Pushkin Museum of Fine Art

subjects appeared in the work of Eugène Vidal (1847–1907) and the Italian Federico Zandomeneghi (1841–1917), formerly of the Florentine pleinairist "Macchiaioli" school. There were also the moderately Impressionist landscape painters Albert Lebourg (1849–1928; pp. 313, 383) and Paul-Victor Vignon (1847–1909; pp. 202, 203) and, only once, the fairly fashionable graphic artist and painter Henry Somm, i.e. François Sommier (1844–1907; p. 263).

With Cassatt, Forain was the strongest artistic personality among Degas's followers. The son of a scenery-painter, he wanted art that was critical, satirical and committed. Under the influence of Goya and Daumier he mainly did graphic work as magazine and book illustrations or in series. As a painter he had mastered Impressionist techniques, having a precise touch for light conditions and a subtle flair for the structural division of a visual space. His small-format scenes of the entertainment world used distinctive contrasts of dark and light or of strong, glowing colour, and combined sketchy adumbrations with more substantial blocks of solid colour that had their own patchwork, asymmetrical values. This owed something to Manet. His caricatural overdrawing of figures contrasted starkly with the treatment of similar material by Renoir, Morisot or Cassatt, though, and tended to look rather superficial. The details in his works did not always possess that sense of inevitability that we associate with details in Degas before him, or Toulouse-Lautrec after.

Of comparable standing was Jean-François Raffaëlli (1850–1924), whom Degas had been trying to recruit since 1878. A former bookkeeper and singer, essentially self-taught, he essayed various thematic areas, and alternated between the Salon and other exhibition strategies. Raffaëlli was a follower of Millet, the "poet of the humble" (as Wolff, an admiring critic, put it). In 1884 he was to score so solid a financial success with a large private solo exhibition that he lost interest in the Impressionists. His contact with them in 1880 and 1881 was in any case merely loose, and consisted partly in a shared interest in social fringe groups. At first he painted Breton peasants, then urban alcoholics and rag-and-bone collectors. He also shared the Impressionists' concern with the persuasive atmospherics of sketchy pictorial spatial contexts. *The Absinth Drinkers* (p. 211), a semi-lifesize canvas exhibited in 1881 as *The Down and Outs*, would have appealed to Degas for the canvas structure and the subject of lonely outsiders, but also the delicately nuanced colouring. Raffaëlli's later *Waiting Wedding Guests* (p. 240) has an almost grotesque sense of the fleeting moment: the figures are squeezed out to the side and the setting is the dominant subject. Raffaëlli became a major figure in a Europe-wide artistic concern with the urban poor that extended well into the 20th century. This movement took only a few elements from Impressionism: the cropping, the flexible structures, and the sketchy application of paint.

Another newcomer in this very loose grouping was Paul Gauguin (1848–1903), who was to be important later. The son of a republican journalist and a Peruvian creole whose father had been a socialist, Gau-

Paul Cézanne
The Bridge at Maincy, c. 1882–1885
Le pont de Maincy
Oil on canvas, 58.5 x 72.5 cm
Venturi 396. Paris, Musée d'Orsay

guin was in the merchant navy before working as a stockbroker and painting in the manner of Corot in his spare time. In 1876 he was accepted by the Salon. Gauguin used the money he made on the stock exchange to buy paintings. Pissarro, whom he met in 1874, probably through Pissarro's patron Arosa, taught him Impressionist landscape techniques and a sense of composition. The paintings he did at this period, such as those of the Seine banks in Paris, strongly resemble those of Guillaumin, another protégé of Pissarro and the Pontoise school. In 1879 Gauguin had a sculpture in the Impressionist exhibition, submitted late and not listed in the catalogue, and again exhibited sculptural work in 1880 and 1881 but also – indeed, mainly – landscapes, painted in relatively dark colours with a great many blue shadows executed with brief, tiny brush-strokes. His striking lifesize *Study of a Nude. Suzanne Sewing* (p. 207) combined a number of technical strategies and was a major feature of the 1881 show. Huysmans likened it to Rembrandt and hailed it as the most realistic nude in contemporary painting. The heavy flesh of this big-boned pregnant woman, together with her everyday

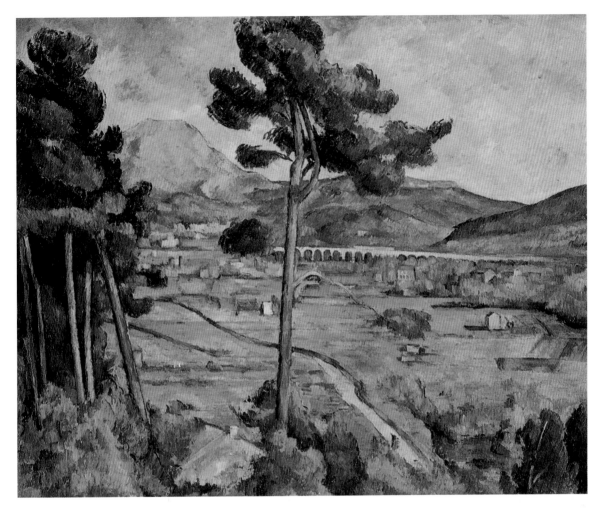

task, share the realistic eye of Degas, while the still-life quality of the setting and the overall conception of the picture suggest Manet's approach. The fine brushwork of the nuanced colouring of light, and the blue and green shadows on the woman's skin, recall Renoir and even more Pissarro, who was just beginning to paint figures. For some years, Gauguin was to move with the Impressionist current. To Impressionism he owed his independence of convention, his feel for light in the open, the glowing force of his colours, and his unstrained and flexible sense of pictorial structure.

For a long time, and in the customary academic manner, the critics accused the new artists of renouncing not only traditional values and ennobling beauty but also the more demanding subjects. As in the first half of the 19th century, the supposed decline of art was ascribed to its "industrialization", which allegedly led to mass production. Thus Claretie for instance, who had found in connection with the 1874 Salon (not the concurrent Impressionist show) that landscape artists were contenting themselves with mere impressions and, indeed, that paintings

Paul Cézanne
Mont Sainte-Victoire seen from Bellevue,
c. 1882–1885
La Montagne Sainte-Victoire, vue de Bellevue
Oil on canvas, 65.5 x 81 cm
Venturi 452. New York, The Metropolitan
Museum of Art

Mont Sainte-Victoire and the railway viaduct.
Photograph, c. 1935

were being influenced by photography.[119] Those advocating a new art were divided. Some, such as Duranty, put their weight behind a realistic or naturalistic representation of modern life;[120] others, such as Rivière, defined Impressionism as a movement that portrayed a subject not for its own sake but for the colour values which it provided an opportunity to observe.[121] Those who espoused narrative genre painting, frequently taking their bearings from literature, could be astoundingly insensitive to artistic differences in painting techniques, and to specifically painterly qualities. They often preferred more accessible semi-Impressionists such as De Nittis, Béraud, Goeneutte or Gervex.

The critical judgements made by Huysmans in reviews from 1879 to 1881 fluctuated strikingly.[122] He drew interesting parallels with contemporary architecture (such as the new railway stations and market halls), much in line with Zola's "Le Ventre de Paris" (1873). His sympathies were initially with Manet and Degas, and particularly Raffaëlli, Forain and Caillebotte; the colourist techniques of the Impressionist pleinairists, and especially their blue and purple shadows, he called hysterical. He accused the painters (as Zola increasingly did) of not achieving the aims they set themselves and leaving unfulfilled the hopes they had at first aroused. Given the political climate of France after 1870/71, it was remarkable that Huysmans chose to highlight the realistic quality of a German painter, Max Liebermann (1847–1935). He even wished that Monet's railway station scenes shared the full interest in working life that characterized the art of Adolph von Menzel (1815–1905) as seen in his

Camille Pissarro
Woman and Child at a Well, 1882
Femme et enfant au puits
Oil on canvas, 81 x 65 cm
Pissarro/Venturi 574
Chicago, The Art Institute of Chicago,
Potter Palmer Collection

Camille Pissarro
Poultry Market at Pontoise, 1882
La marché à la volaille, Pontoise
Oil on canvas, 81 x 65 cm
Pissarro/Venturi 576
Collection E.V. Thaw and Co., Inc.

Right:
Henri de Toulouse-Lautrec
Young Routy, c. 1882
Le jeune Routy
Oil on canvas, 61 x 51 cm
Dortu 149. Albi, Musée Toulouse-Lautrec

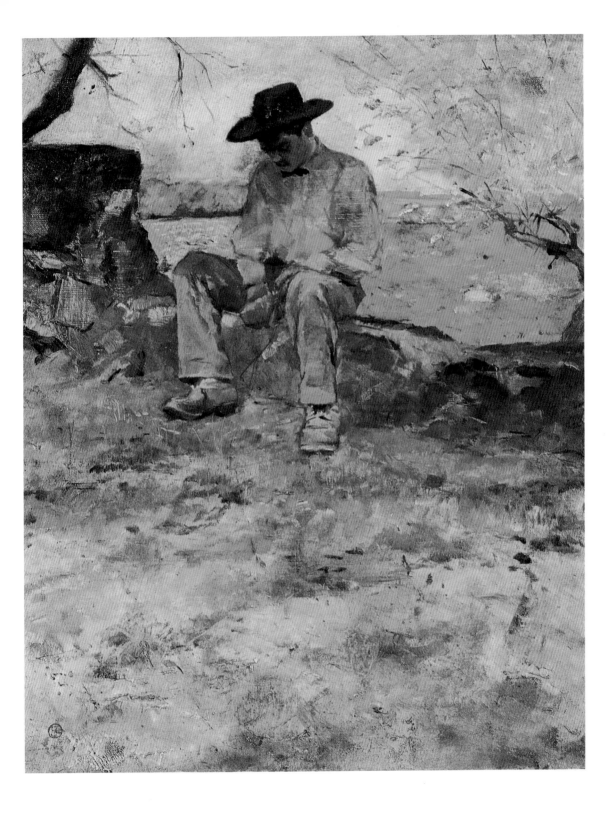

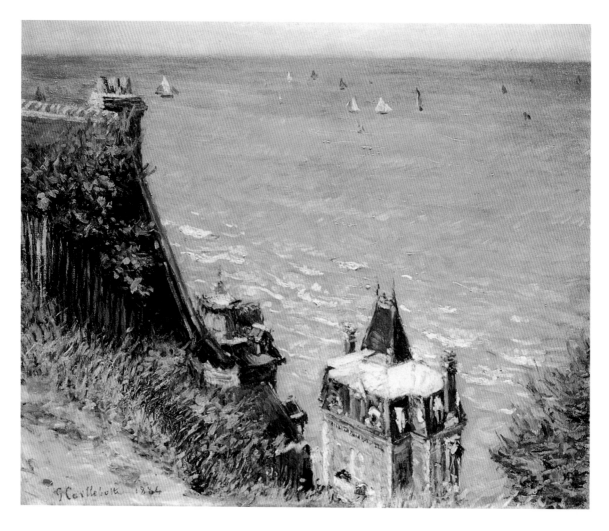

Gustave Caillebotte
The Pink Villa, Trouville, 1884
La villa rose, Trouville
Oil on canvas, 60 x 75 cm
Berhaut 271. Private collection

Yachts at La Rochelle. Photo: Atget, 1896

1875 painting *The Iron Rolling Mill*. In 1881, on the other hand, Huysmans found the Impressionism of Pissarro persuasive, and declared that he had taken that strain to maturity.

The position of one lone outsider proved controversial. Pierre Puvis de Chavannes was to play an important part in artistic movements over the next two or three decades. Largely self-taught as a painter, he had a taste for murals, and combined allegories in a classical tradition with growing brightness, sensitivity to landscape and atmosphere, and attention to the fate and dignity of "simple" people (in a manner distantly reminiscent of Millet – the more so since Puvis put his figures arrested in slow, straightforward gestural attitudes or simply froze them). In this, Puvis' art was fundamentally different from the radically naturalistic, sensation-seeking moments captured by other painters of histories. His *Young Women on the Seashore* (p. 189) had affinities with Impressionism not only through the motif and brightness; what matters in the painting is not so much the reproduction of a particular subject as the wealth of diverse sensations

the picture may prompt in us, and the sense that this is the true aim of artistic endeavour. As early as 1874, Castagnary had largely defined Impressionism through its emphasis not on landscape as such but rather on the sensations caused by it.

The 1882 Salon struck critics as more modern. The review in the "Gazette des Beaux-Arts" was written by Manet's friend Proust. The year before, the Salon had for the first time no longer been under state control, being organized instead by a committee elected by artists who had already been accepted by the Salon in the past. This committee drew up the statutes of a Société des Artistes Français, which was founded in 1882 and organized the Salon from that date on.[123] The state – and this remained true of the new society too – had been unable to solve the problem of reconciling the exhibition requirements of a growing number of artists with the ideal and qualitative demands implied in making a representative selection that would be ideologically sound and educative. In any case, since 1879 the state had been a changed thing, making greater concessions to democratic ideas, personal liberty, and a liberal interplay

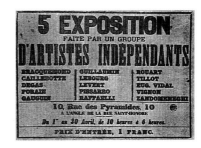

Poster for the fifth Impressionist exhibition, 1880

Gustave Caillebotte
The Harbour at Argenteuil, 1882
Le bassin d'Argenteuil
Oil on canvas, 65 x 81 cm
Berhaut 230. Private collection

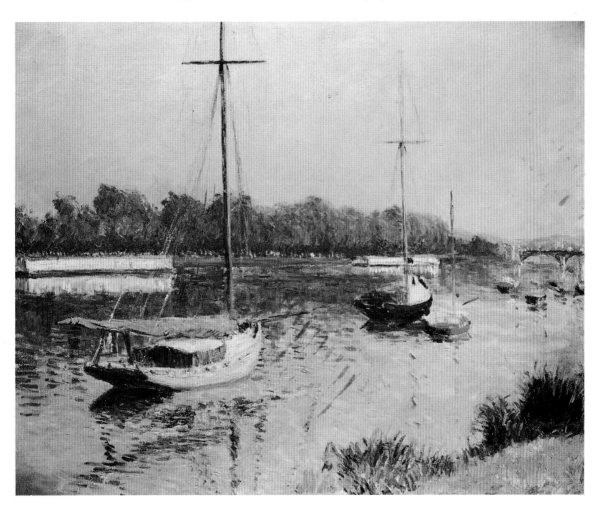

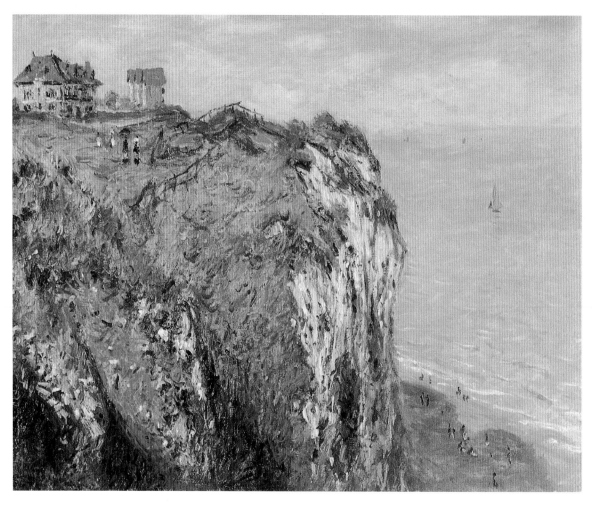

Claude Monet
Cliffs near Dieppe, 1882
La falaise à Dieppe
Oil on canvas, 65 x 81 cm
Wildenstein 759
Zurich, Kunsthaus Zürich

of competing forces. Towards the end of 1881, Antonin Proust became Minister for the Arts. The 1880 Salon included paintings with political, republican subjects, among them work by Gervex and the great *Miners' Strike* by Alfred Roll (1846–1919). The jury, chaired by Bouguereau, debated awarding Manet a medal; the award was in fact not made till 1881, under the new order.

At the same time, Durand-Ruel had weathered his financial crisis of 1880/81 and was again buying significant numbers of Impressionist paintings (though the collapse of a bank that supported him, the Union générale, brought new difficulties in 1882). In Georges Petit (c. 1835–1900) he now had a serious competitor. Petit organized appealing "expositions internationales", and from 1880 on put pressure on Monet to submit to the Salon again. In 1882, to clear his stock, Durand-Ruel organized what was billed as the seventh exhibition of independent artists, hung by Caillebotte and Pissarro and located on the top floor of 251 Rue Saint-Honoré. On the ground floor, a panoramic view of the battle of Reichshofen in Alsace (in 1870) was displayed, a detailed over-

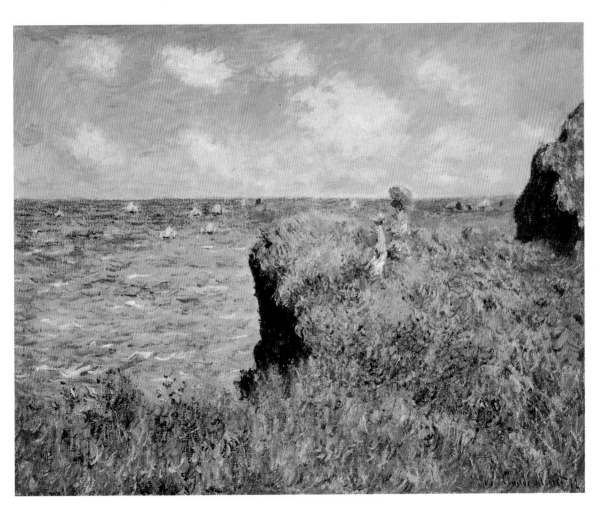

Claude Monet
Clifftop Walk at Pourville, 1882
La promenade sur la falaise, Pourville
Oil on canvas, 66.5 x 82.3 cm
Wildenstein 758
Chicago, The Art Institute of Chicago

view of the kind then popular with the public, sometimes including real objects illusionistically built in. It was a curious meeting of two fundamentally different kinds of art, both dependent on sense impact for their effect. Only one of them was popular, though – that on the ground floor. This was the more ironic since the group work upstairs was thematically harmless and thoroughly suitable for hanging on the wall at home.

Three quarters of that work consisted of landscapes. The figural work, particularly Pissarro's shepherdesses or peasant women (pp. 216, 217) or Renoir's *The Luncheon of the Boating Party* (p. 220), the exhibition's *pièce de résistance*, was thoroughly appealing too. This time Monet, Renoir and Sisley were again in the show, as was Morisot, while Degas and his followers in critical realism remained without. Cassatt and Rouart refused to participate for this reason. For Renoir, concerned to retain customers and in any case not a man inclined to controversy, Pissarro – with his friends and his anarchist leanings – represented quite enough in the way of risk. Partly for health reasons, Renoir was spending

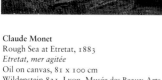

Claude Monet
Rough Sea at Etretat, 1883
Etretat, mer agitée
Oil on canvas, 81 x 100 cm
Wildenstein 821. Lyon, Musée des Beaux-Arts

La Manneporte at Etretat, c. 1910

his time in the warmer South of France, and twice indeed sojourned in Algiers; he mainly left the exhibition of his work to Durand-Ruel. Tetchy after a bout of pneumonia, he wrote to the dealer on 26 February 1882 from L'Estaque, where he was visiting Cézanne: "To exhibit with Pissarro, Gauguin and Guillaumin is like exhibiting with simply anybody. Soon we'll be having Pissarro invite Lavrov, the Russian, or some other revolutionary. The public do not like things that smell of politics, and at my age I do not want to be a revolutionary. To remain along with the Israelite Pissarro is revolution. Get rid of these people and give me people like Monet, Sisley, Morisot etc. and I'm with you, because then it is no longer a political issue, it's art pure and simple."[124] But he did wish to go on with Degas, whom he found "incomprehensible".[125] Renoir's antisemitic remark did not put an end to good working relations, though. Renoir – like Monet, who thought similarly – had only a precarious grasp of political current affairs. Their interest was in their art and their lives as artists. Many years later, Renoir, speaking of Durand-Ruel and his political views, told his son Jean: "We needed a reactionary to defend

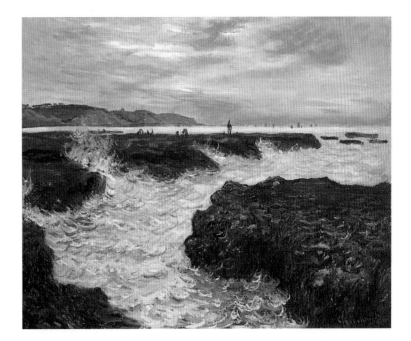

our art. The Salon people called us revolutionary, but they could scarcely shoot him as a Communard."[126]

Manet, whom the independent artists repeatedly and vainly tried to recruit for exhibition purposes, was approaching the end of his life as an artist. He spent the summer of 1880 in a rented house at Bellevue, for health reasons, and summer 1881 at Versailles. His last residence was a villa in Rueil. When a narrow majority of the Salon jury awarded him their medal (second class), he called on his fellow artists to thank them

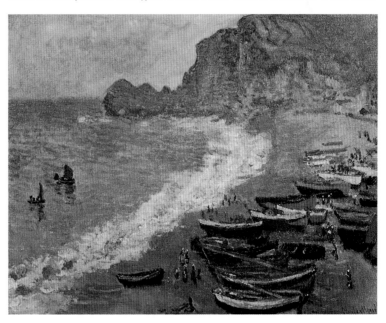

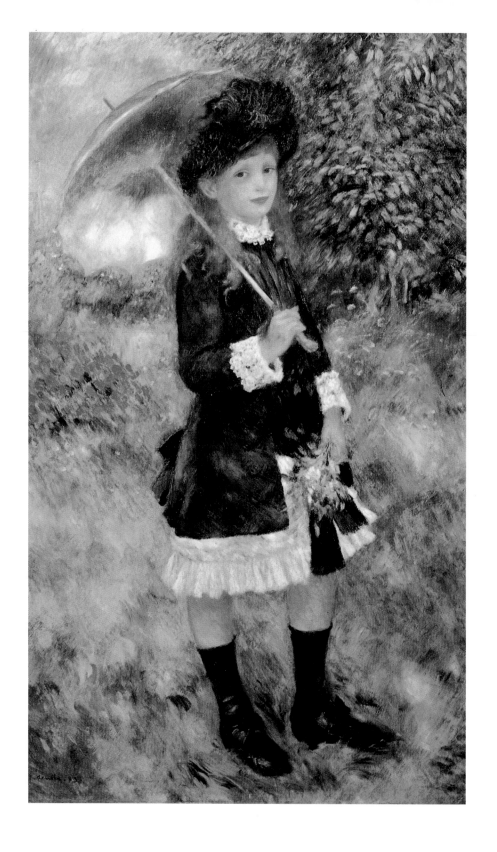

– Carolus-Duran, Cazin, Gervex, Guillemet, Roll, and others who were in no sense in his artistic league. Some months later, thanks to Minister Proust, he was awarded the cross of the Legion of Honour. When the Comte de Nieuwerkerke, formerly the imperial art panjandrum, congratulated him, Manet wrote in a surprisingly resigned tone to a friend: "He could have conferred an award on me. He would have made me very happy. Now it is too late to make up for twenty years without success."[127]

Manet was painting uneven scenes and portraits and still struggling for the uncertain recognition the art scene can grant, which in his case remained inseparable from the unhappy Salon. On the other hand, in late 1881 he was still planning to paint engine drivers and stokers in a locomotive, the "modern heroes" he admired as much as Zola (who had written a novel using this material nine years before). But primarily he was painting a series celebrating the sensual charms and challenges offered by beautiful women. These works, partly in pastel, sometimes showed ladies of the *demi-monde*. He intended four of them to make a series on the four seasons (p. 213), but this remained unfinished. As he was consumed by the disease that was to kill him, Manet also turned to the lush summer delights of gardens at Bellevue and Rueil, bringing a quality of humble observation to his work, as if the exacting delicacy of his brushwork might delay the extinction of life. The sectional views he painted were limited at every side, as if his horizon were literally becoming invisible (p. 200).

In the winter of 1881/82 Manet painted a picture that can stand as a summation of his art: *A Bar at the Folies-Bergère* (p. 221). Now exempt (as an award winner) from the jury process, he exhibited it at the 1882 Salon. The critic Julius Meier-Graefe later unfathomably called it "the weakest work Manet ever painted",[128] but most recent scholars have rightly been fascinated by the qualities of the painting and the intensity and diversity of Manet's renewed analysis of part of the society he lived in. The colours are rather subdued, it is true (which may be intended to convey the smoky somnolence of the pleasure palace), but on the other hand Manet gives us first-rate proof of his still-life talent in the foreground. The hard, cold quality of the white light globes is perfectly caught; they are like buttons on the canvas. Manet's pastose brushwork creates a unified tapestry of colour correspondences and contrasts across the various spatial levels.

Those levels themselves are intentionally confusing; most of what we see is a reflection in the bar mirror behind the woman. The laws of perspective are broken in a fashion that was a radical departure at the time. The woman's back, and the customer facing her (in whom we are invited to see ourselves), are reflected at an angle. The barwoman, whose tightly girded midriff seems wrongly drawn, seems on offer for consumption like the bottles and fruit before her, with her deep, flower-adorned decolleté. Only the roses in the wine glass seem an expression of tenderness towards her. With her weary, vacant, slightly sideways gaze, she has the inimitable Manet *impassibilité*. Only her attractive public front is participating in her work in the Parisian world of entertainment; the full

"A Visit to the Impressionists": cartoon by Draner (Jules Renard) on the seventh Impressionist exhibition, from "Le Charivari", 9 March 1882

Pierre-Auguste Renoir
Young Girl with a Parasol (Aline Nunès), 1883
Jeune fille à l'ombrelle (Aline Nunès)
Oil on canvas, 130 x 79 cm
Paris, David-Weill Collection

Pierre-Auguste Renoir
Dance in the Country, 1880
Danse à la campagne
Etching, 21.8 x 13.4 cm

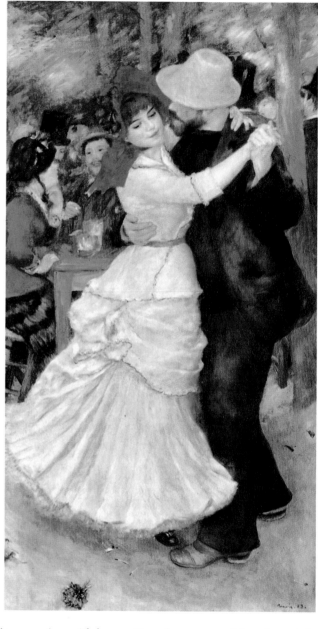

Pierre-Auguste Renoir
Dance at Bougival (Suzanne Valadon
and Paul Lhote), c. 1882/83
La danse à Bougival
Oil on canvas, 182 x 98 cm
Daulte 438. Boston (MA), Museum of Fine Arts

human being remains withdrawn. Detachment was Manet's artistic method (not to be confused with a lack of feeling in the man), and so his scene records what he saw (and pondered) impassively, levelling no grand accusations. "But for that very reason his pictures objectively constitute a more biting critique of society than any socio-critical caricature could achieve."[129]

Finally, already partly paralysed, Manet painted a number of small still lifes such as *Bundle of Asparagus* (p. 198), which became well known in Germany because Liebermann, a great admirer of Manet, once

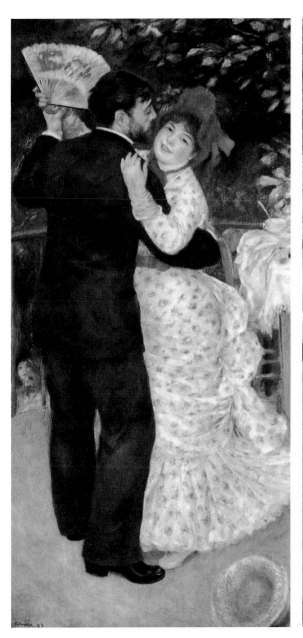

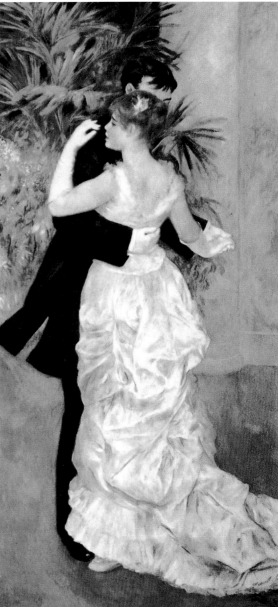

owned it. Manet also painted endless variations on the theme of flowers in vases. It is moving to look at these enchanting impressions of the loveliness of the natural world, given what we know of the advanced state of Manet's illness when he painted them. In April 1883 he had a foot amputated; a few weeks later he died in considerable pain. At his grave, Proust observed, punning in Latin: "Manet et manebit." (He remains and he will remain.)

Degas was persistent in his art, concentrating all the more intensely on ever fewer thematic areas. About 1882, with Cassatt, he discovered a

Pierre-Auguste Renoir
Dance in the Country (Aline Charigot
and Paul Lhote), c. 1882/83
La danse à la campagne
Oil on canvas, 180 x 90 cm
Daulte 441. Paris, Musée d'Orsay

Pierre-Auguste Renoir
Dance in the City (Suzanne Valadon
and Eugène-Pierre Lestringuez), 1882
La danse à la ville
Oil on canvas, 180 x 90 cm
Daulte 440. Paris, Musée d'Orsay

Edgar Degas
Mary Cassatt at the Louvre, 1879/80
Mary Cassatt au Louvre
Etching, 36.3 x 26.6 cm

new subject in milliners and their shops, finding it possible to discover the offbeat beauties of modern life through this material. His studies of jockeys and horses now tended to foreground curious patterns of brightly coloured jockeys' clothing and edgy horses. His *Women Ironing* (p. 242) reminds us why Degas wanted to recruit a painter such as Raffaëlli to the independent group. Degas's meticulous preparatory studies, and the variations he did on the theme, show how seriously he took it. The element of the grotesque in one tired woman's yawn is no more absurd, no likelier to diminish the woman's dignity, than the poses in which we see weary dancers massaging their aching feet, something Degas observed time and again. His ballet scenes, bar a few exceptions, now lost the anecdotal component introduced by ballet masters, watching gentlemen, or mothers (or procuresses) reading papers. Degas was more and more interested in individual physical gestures, the consonance of groups, and above all the colour impact of a total view, which he now made into the dominant sense appeal in pictures done for preference in grainy pastel. Another new subject area that significantly engaged him – women about their toilet – will be discussed below in connection with issues of public presentation.

Monet was also changing his subjects or emphases. Despite his disagreements with Degas over exhibition strategies or work methods, the formless, iridescent patches of colour on the ice of his winter river landscapes, say, reveal similarities with Degas's increasingly colourful pictures from the world of ballet. Monet, the leader of the true Impressionist core, left Argenteuil in 1878 and settled at Vétheuil, fifty kilometres further from Paris. At the end of 1881 he moved again, to Poissy, but failed to be inspired by any subjects there and in spring 1883 moved yet again, and finally, to Giverny, a village of 280 inhabitants, situated like the others on the Seine. Often he lived in real penury. Since his time at Vétheuil he had been living with Alice Hoschedé (and her six children), who had separated from her bankrupt art-collector husband. In 1892, following Hoschedé's death, Alice became Monet's second wife. Camille, his first, had died in 1879 after a long illness. Monet did a pale pink and blue study of her on her deathbed, the evanescent fluidity of which seems to articulate the slipping away from life of the loved one (p. 176). He later told Clemenceau that he had been struck by the various colours in his dead wife's face and had been horrified to realise how much a prisoner of his visual experience he was, impelled by instinct to paint and nothing but.[130] The loving husband had almost been supplanted by the painter. The issue of unfeeling, detached observation versus the conquest of grief by customary artistic work was one that recurred in the literature and art of the time.[131]

Vétheuil, with its church seen across the river, provided Monet with a motif he painted exhaustively in countless variations. He frequently combined it with lush poppy fields in the foreground, with Alice and her children occasionally to be seen picking flowers. More than in comparable work of the 70s, Monet would now do the red flowers as a massed agglomerate of dabs. Despite continuing financial insecurity, he

Pierre-Auguste Renoir
Les Parapluies, 1883
Oil on canvas, 180.3 x 114.9 cm
Daulte 298. London, National Gallery

Jean-François Raffaëlli
Houses on the Banks of the Oise
Petites maisons au bord de l'Oise
Oil on card, 65 x 85 cm
Paris, Musée d'Orsay

liked to go to his home parts in Normandy in summer or winter, from 1881 on; later he would join Renoir when the latter visited Cézanne in Provence, or travel to the Italian Riviera. Monet was forever questing for new landscape motifs. Every walk, as witnesses reported, afforded an opportunity to size up views and angles of vision. When confronted with paintings that are almost identical, we can now no longer say which versions were attempts at improvement, which captured different impressions, or which were copies of successful paintings.

Sisley likewise went tirelessly in search of motifs along the Seine and

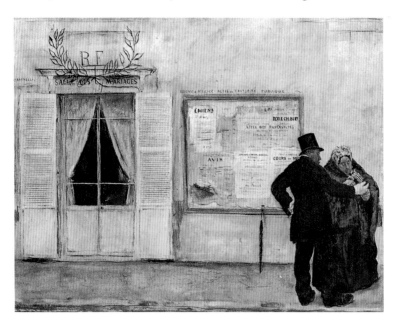

Jean-François Raffaëlli
Waiting Wedding Guests, 1884
Les invités attendant la noce
Oil on panel, 52.5 x 68.5 cm
Paris, Musée d'Orsay

James Tissot
Berthe, 1883
Pastel on paper, 73 x 59 cm
Paris, Musée du Petit Palais

James Tissot
The Newspaper, 1883
Le journal
Pastel on paper, 63 x 50 cm
Paris, Musée du Petit Palais

its tributaries; he looked no further. He abided by views of village streets or of interesting groups of buildings; he would be drawn to an old stone bridge, the kind of subject that had fascinated painters since Corot. In unprepossessing patches of gardens or meadows, landscapes on the skirts of towns or along river banks, he could often discover the most arresting colour or light effects (pp. 313, 339).

Pissarro's art entered a period of change, though he never abandoned his principle of fidelity to what the eye saw. At the end of 1882 he moved to Osny (near Pontoise), then in spring 1884 to Eragny on the River Epte, where he, his wife, and their six children remained for the rest of their lives. As well as simple landscapes, generally with an amount of additional interest (p. 275), he painted Paris street scenes for the first time, and in 1883 views of Rouen, where he visited his old patron Murer in his hotel. But these new motifs were only to bear their full fruit later. The most striking of his new departures concerned his market scenes featuring a larger number of figures (p. 226), and particularly open-air or indoor scenes in which farmers or maids are given dominant roles to play. The landscape painter had become a figure painter.

Degas, as was suspected at the time, had a hand in the diagonal or top views and the slant tensions introduced into some of the pictures. In Pissarro, though, perspectives of this kind remained notably gentler. Even if he generally looked (literally) down on his models, even on seated half-length figures, there was no sarcasm in his gaze, but rather fellow

Edgar Degas
Women Ironing, c. 1884
Les repasseuses
Oil on canvas, 76 x 81.5 cm
Lemoisne 785. Paris, Musée d'Orsay

feeling (p. 217). The large, rounded shapes of the figures and the patterning of areas they establish, as well as the lassitude expressed in movement so slow as to be barely perceptible, influenced Gauguin's idea of visual images significantly; he was in Pissarro's circle, and was a contributory factor in Pissarro's tensions with Renoir and Monet.

Pissarro generally painted very brightly, utilizing a good deal of green and yellow, and even rather sweet shades and strong contrasts that had now become distinctly removed from the subtle nuances of Corot. Above all, he employed brush-strokes that grew ever briefer, and mere dabs. A spatial structure established by houses and the sinuous curves of roads and paths was superseded by an interwoven fabric of equal parts of pigment across a visual area. Cézanne, who sometimes went to see Pissarro, was struck by this; so was Guillaumin, though for the time being he adhered to an older solution to the problem of spatial and surface qualities and of paint application (p. 205). The young artist Charles Angrand (1854–1926) painted in a style that closely resembled Pissarro's.

Morisot's life, with summers in Bougival and winters in Nice, was a carefree, happy one, even if looking after her daughter and supervising the building of a Paris house made demands on her. Her Impressionist style achieved its full bloom in this period, in light open-air or interior scenes of family contentment or domestic tasks, painted with notable ease, or portraits of lovely young people. Caillebotte chose his subjects

Right:
Henri de Toulouse-Lautrec
The Laundress, 1884–1886
La blanchisseuse
Oil on canvas, 93 x 75 cm
Dortu 346. Paris, private collection

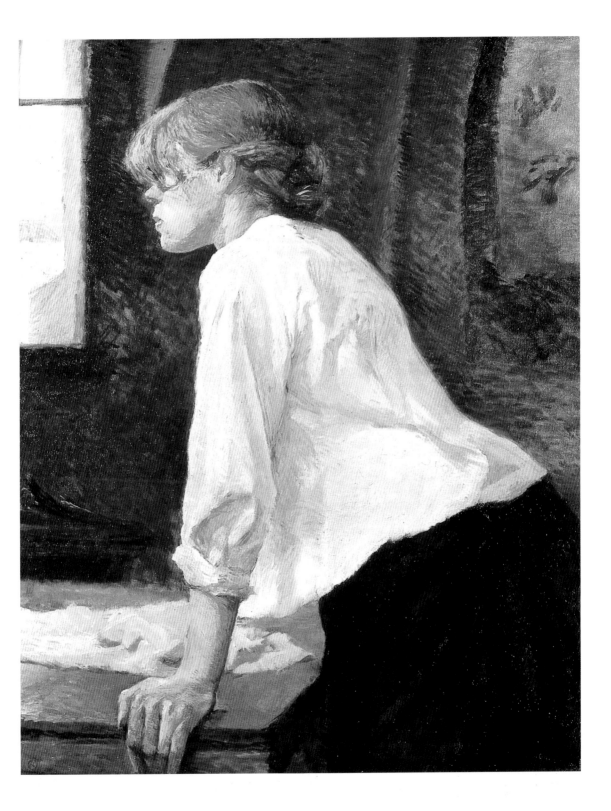

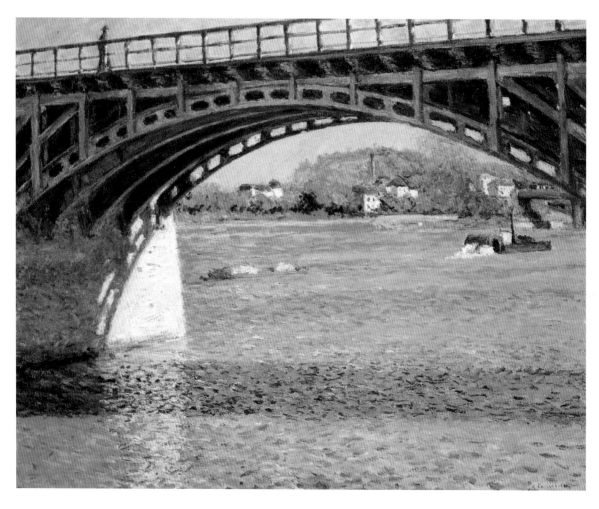

Gustave Caillebotte
The Bridge at Argenteuil and the Seine, 1885
Le pont d'Argenteuil et la Seine
Oil on canvas, 65 x 82 cm
Berhaut 310
Lausanne, Samuel Josefowitz Collection

as he pleased, painting oarsmen on the Seine, people in the country, or scenes in his home in Paris or in cafés.

Renoir was one of those artists who on the one hand were determined not to throw away their mounting success on the art scene and market but on the other hand grew insecure about their way of painting. Despite his landscapes and city scenes, Renoir was at heart a (female) figure painter, and he never lost the high regard he had for the great classical traditions. At an early stage, when his friends were damning academic classicism outright, he had "let them go on talking and had silently admired the belly of Ingres' *Source*." In old age he sardonically remarked: "I do not know if I would have become a painter if God had not created the female bosom."[132] Sales permitted him to travel to the south for the first time in 1881; in the spring he went to Algeria, in Delacroix's footsteps, as it were; in the autumn and winter to Italy; and then to L'Estaque to see Cézanne. His enthusiasm for the controversial music of Richard Wagner, an enthusiasm he shared with many modern artists positioned between realism and symbolism, prompted him to solicit a portrait

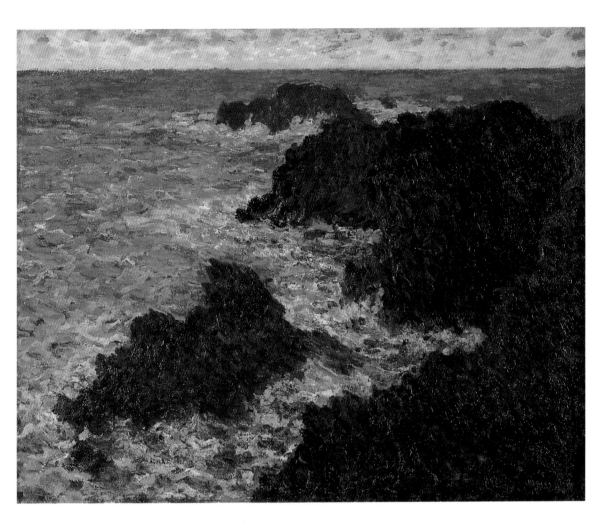

Claude Monet
The Rocks of Belle-Ile (Rough Sea), 1886
Les rochers de Belle-Ile (La côte sauvage)
Oil on canvas, 65 x 81.5 cm
Wildenstein 1100. Paris, Musée d'Orsay

session with the ungracious Saxon, who happened to be in Palermo and would spare only 35 minutes for a hasty sketch. Above all, Renoir was filled with admiration for the work of Raphael and the ancient frescoes of Pompeii, which reminded him of Corot's graceful nymphs.

Renoir was now disquieted by what he later referred to as the "traps of sunlight".[133] Never again would he resolve the three-dimensionality of flesh so fully into dabs of light and shadow and colour as in *Nude in the Sunlight* (p. 162), which had so angered the venomous Albert Wolff. First he took to carefully drawing and modelling seated female nudes in the open, all of whom he described as bathers. His eye for heavy volumes and clear outlines, for curves and smooth surfaces, could at times be sculptural, and was connected with Renoir's sense of having exhausted Impressionism and arrived in a cul de sac. Painting in the open, from Nature, merely produced momentary effects, he now felt. It was a real creative crisis accompanying three main and distinct developments. One was that Renoir, aged forty and gradually achieving success, was settling down. In 1880 he met a young sempstress from the country, Aline Cha-

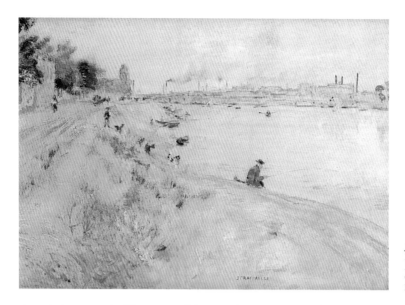

Jean-François Raffaëlli
Fisherman on the Bank of the Seine
Pêcheur sur la rive de la Seine
Oil on canvas, 25.7 x 35.6 cm
Private collection

rigot (1859–1915). They moved in together in 1882 and married in 1890, when their first son was already five. A second aspect was the changed character and climate of French society and culture. Renoir could cope, though without full consent; his enthusiasm was only for the lost values of the past. As a subject for art, contemporary reality receded, displaced by timeless idylls of undefinable location. The third factor was the arrival of the next, young generation of artists, who as always were partly continuing available lines in novel ways and partly bent on substituting something new and incomprehensible.

There were observers who lamented Renoir's changed method as the destruction of twenty years of achievement. Renoir was meticulous: he spent three years, longer than ever before, working on *The Bathers* (p. 304), completing it in 1887 and ending a dry spell in his productivity. The figures are a curious cross between momentarily glimpsed, uninhibited Paris street girls (Paul Jamot, 1923) and the creatures of a stylized, classicized composition. In contrast to Renoir's long-standing attempts to blend figures optically into their surroundings, the women seen in this work stand out clearly against the landscape. In parts the landscape is done with precision; in parts it is almost naive (and the water clumsily done). The women's bodies are modelled in fine, bright nuances of light and shadow. The restless body language of these bathers, and the additive, patchwork quality of the composition, heighten the contrariety in this picture and, though it remains fascinating, they ultimately diminish its value.

Another major painting also bore the signs of years of work and rework: *Les Parapluies* (p. 239). Changing fashions have even been identified in the clothes the people are wearing; and the changeover from a relaxed technique to tauter modelling is self-evident. Renoir's eye for female beauty, cute children and tender gazes is at work here, and the motifs are additively ranged in the Impressionist manner. Chance move-

Right:
Armand Guillaumin
The Fishermen, c. 1885
Les pêcheurs
Oil on canvas, 81 x 66 cm
Serret/Fabiani 122. Paris, Musée d'Orsay

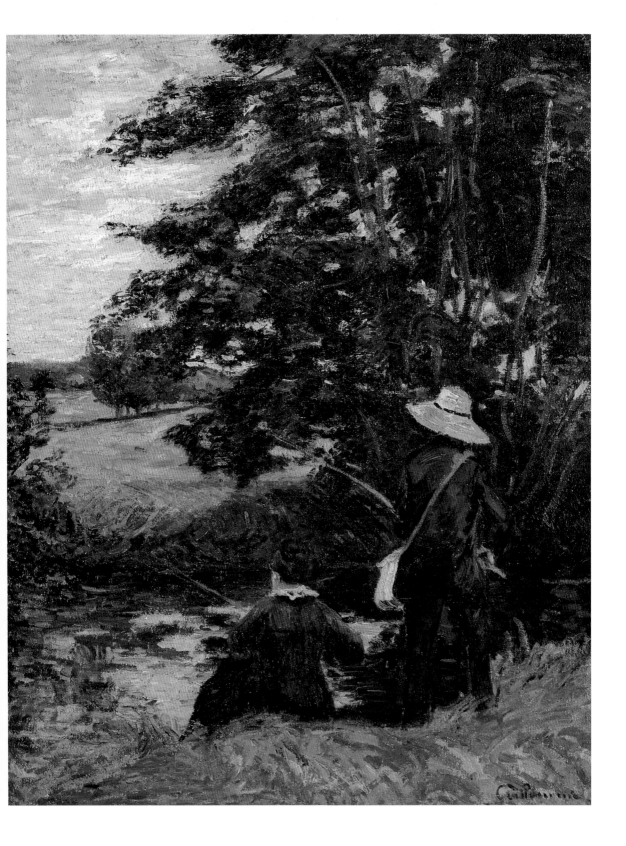

Edgar Degas
Woman Combing her Hair, c. 1885
Femme se peignant
Pastel on card, 53 x 52 cm
Lemoisne 898. St. Petersburg, Hermitage

Edgar Degas
After the Bath. Woman Drying Herself, 1885
Après le bain. Femme s'essuyant
Pastel on paper, 80 x 51.2 cm
Lemoisne, supplement 113
Washington (DC), National Gallery of Art

ments and the overlapping of figures combine with the statuesque, ancient air of the milliner with the hatbox and with the abstract three-dimensional pattern of the umbrellas that give the canvas its title. Good as this impression of street bustle is, finely as the blue-grey and silvery moist atmosphere with its dull gold patches of light has been caught, what we see is the conflict between truth to a visual experience and the linear, decorative patterning that articulates the artist's imposition of form-giving will.

Before *Les Parapluies*, Renoir completed three other scenes of Paris life (pp. 236, 237). Durand-Ruel had commissioned three high-format panels for his dining room. As with the *Moulin de la Galette*, Renoir had two fellow painters – Lhote and Lestringuez – pose for these dance paintings, as well as the model Suzanne Valadon and his beloved Aline. (Suzanne Valadon – actually Marie-Clémentine Valade, 1867–1938 – later became a gifted artist herself and the mother of the painter Maurice Utrillo, 1883–1955.) The body language, the overall visual rhythm, the materiality of the clothing and the colouring all set the more restrained city ball scene apart from the tender togetherness at a country inn or the conviviality of a boating party at Bougival. The happy, appealing smile of Aline in one painting is the nucleus of the composition.

At that time, Cézanne sought close contact with his associates of the early years, and in his art he approached very close to one fundamental Impressionist tenet: to concentrate entirely on what was seen. But at the same time he moved on from Impressionism, in order "to make of it

Edgar Degas
The Tub, 1885/86
Le tub
Pastel on paper, 70 x 70 cm
Lemoisne 876
Farmington (CT), The Hill-Stead Museum

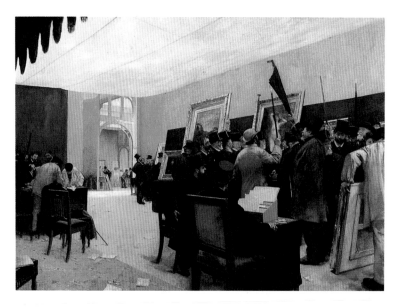

Henri Gervex
The Salon Jury, 1885
Une séance du jury de peinture, Salon des artistes français
Oil on canvas, 299 x 419 cm
Paris, Musée d'Orsay

something as solid and lasting as the art in the museums" and not remain content with the mere recording of an impression.[134] He was living mostly in Aix and the vicinity, but between 1879 and 1885 he paid several visits to the friend of his youth, Zola, in Médan (not far from Paris), as well as to Pissarro at Pontoise. In 1882 and 1883 (the second time with Monet), Renoir was his guest in Provence and painted with him at La Roche-Guyon, on the Seine near Giverny, in 1883. In 1882, just once, he succeeded in placing a painting in the Salon. Rejected once more in 1884, he finally abandoned the "battle for Paris".

The Bridge at Maincy (p. 224), near Melun, surrounded by slender trees in glowing emerald depths, was one of the first masterpieces of a mature personal style that was to have implications of great consequence for future art. There is an inner dynamic and a dimension of time to the painting, as if it expressed a process of becoming. This derives from the unstrained and unfinished brushwork and from the gently swaying lines that demarcate colour boundaries. Adjoining patches of colour are always balanced, however delicately. The interwoven overall *gestalt* invariably meant more to Cézanne than the unambiguous representation of details. He created that *gestalt* through an idiosyncratically tentative approach, continually comparing the impression of the natural scene with the organic pictorial image and trying to bring the two into line.

In addition to portraits or studies of his partner Hortense Fiquet (1850–1918), and still lifes, Cézanne also tackled one of Impressionist art's main subjects, the human figure, and specifically open-air nudes (usually described as bathers). In Cézanne, nudes could always assume another character – romantically literary, or dramatically related to the psychology of sex. Cézanne was a shy person, and Aix a prudish, philistine town, so that painting naked women in the open was quite out of the question. He therefore sketched copies of paintings he admired by

old masters such as Titian or Rubens when he was in the Louvre in Paris. He also used reproductions or photographs of paintings at home, and nude photographs that were available to artists. He only ever drew single figures in complicated poses, though, and never entire compositions. Again, in this work he would dissect the subject into fragments and sectionalize movement. His whole life long, dissatisfied and often aware of failure, his aim was to put the pieces back together in a meaningful overall structure.

Cézanne's main work was done in landscapes. He painted the river valleys of the Ile-de-France and, above all, his beloved hard, bright, sun-baked Provence. His dream was that someone who looked at his paintings might smell the characteristic scents of the region and feel the mistral blowing. Over the course of decades he never tired of walking the hills in order to paint the majestic profile of Mont Sainte-Victoire, often with the valley of the Arc in the foreground and the impressive intrusion of a lengthy new railway viaduct (p. 225). Later he was to define his method by saying, "I merely try to convey perspective by means of colour."

Albert Besnard
Portrait of Madame Roger Jourdain, 1886
Portrait de Mme Roger Jourdain
Oil on canvas, 200 x 155 cm
Paris, Musée des Arts Décoratifs

James Tissot
The Painters and their Wives, c. 1885
Les peintres et leurs femmes
Oil on canvas, 146 x 101.7 cm
Norfolk (VA), The Crysler Museum

À l'ami Cordier
P. Signac.
Montmartre 84

7 Neo-Impressionism and Post-Impressionism

While Pissarro, Renoir and Cézanne were painting the pictures we have just been discussing, the arts in France were witnessing events that changed the parameters for the Impressionists. By the time of the eighth and last group exhibition in May/June 1886, which reviews almost unanimously labelled Impressionist, the front line where new or controversial aesthetics were fought out had moved. (Of course such controversies were always only the concern of an avant-garde minority on the fringe of the mainstream art perceived and wanted by the majority of people with any interest at all in such matters – not to mention the many who took no interest at all.)

Despite its new circumstances, under the guidance of the Société des Artistes Français, the Salon continued its policy of exclusion. Since the jury was elected by artists who had previously been honoured with a Salon medal, it retained its distrust of new rivals. For this reason, 1884 saw the establishment of a second annual Salon by some 400 dissatisfied members of the Société des Artistes Indépendants. There was to be no jury assessment of artists' work. The idea was Albert Dubois-Pillet's (1846–1890); an amateur artist and freemason who was a gendarme by profession, he became the secretary and vice-president of the association. Odilon Redon (1840–1916) chaired the debates on the society's statutes. He was a friend of Corot and Fantin-Latour who had become known primarily for his drawings and graphics in the years since 1879. His easeful, sometimes asymmetrical, enigmatic and even fantastic little works had already been showcased in Charpentier's "La Vie moderne" and elsewhere. Guillaumin was actively involved. The young Georges Seurat (1859–1891), who had been so disenchanted with his studies at the Ecole des Beaux-Arts that he broke them off in 1879, preferring to paint in the manner of Renoir, met Paul Signac (1863–1935) through the debates; Signac shared his views. In December 1884 the first unjuried show by the Indépendants was then held.

The foundation of this group of Indépendants inaugurated the era of what came to be known as secessions. At the turn of the century, secessional offshoots and splinter groups were time and again to prove the main innovatory force in art throughout Europe, America and even Japan. The Indépendants mounted a second exhibition in 1886. By 1890/91 they were experiencing the usual fate of dissatisfied groups who

The mills of Montmartre, with the Moulin de la Galette on the right, c. 1840

Paul Signac
Rue Caulaincourt: Mills on Montmartre, 1884
Rue Caulaincourt: Moulins à Montmartre
Oil on canvas, 35 x 27 cm
Paris, Musée Carnavalet

Georges Seurat
Horses in the Seine
(Study for "Bathing at Asnières"),
c. 1883/84
Cheval blanc et cheval noir dans l'eau
Oil on canvas, 15.2 x 24.8 cm
Dorra/Rewald 88; De Hauke 86
London, Courtauld Institute Galleries

Georges Seurat
Bather (Study for "Bathing at Asnières"), c. 1883/84
Baigneur assis
Oil on canvas, 17.5 x 26.4 cm
Dorra/Rewald 96; De Hauke 84
Kansas City (MO), Nelson-Atkins Museum of Art

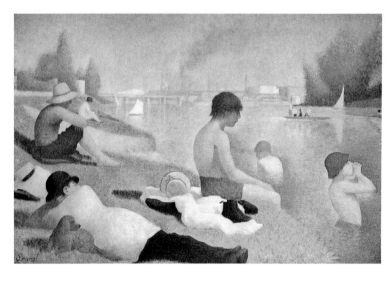

Georges Seurat
Bathers at Asnières, 1883/84
Une baignade à Asnières
Oil on canvas, 201 x 300 cm
Dorra/Rewald 98; De Hauke 92
London, National Gallery

take things into their own hands: under the guidance of Meissonier, now an old man, they set up the Société Nationale des Beaux-Arts (known as the Nationale) and re-introduced a jury system. Unassessed exhibitions certainly guaranteed the freedom of the artist; unfortunately, though, they afforded no protection against self-important people with not an ounce of talent. This proved counterproductive in terms of the needs of genuinely innovatory art.

But the confrontation of official and secessional Salons was no longer the only problem. The official Salon still held the promise of a reputation and distinction, improved prospects of public commissions, or professorial chairs. The difficulty was that people were already drawing a distinction between traditional "academic" art and a stylistically more plural "official" art. Mainstream artists who borrowed from realism and Impressionism could now achieve fame and good sales, as Gervex, De Nittis, Raffaëlli and others demonstrated.[135] The Salon, and public commissions, were becoming more important for art in ideal terms and for the financial conditions of artists' lives. Now, artists tended rather to need to define their position in the face of a new cultural power: the dealers.[136]

Durand-Ruel had been the most important dealer for the Impressionists, and was to be even more important in the years ahead. He had organized the seventh group exhibition in 1882, and smaller shows for Boudin, Monet, Renoir, Pissarro and Sisley in 1883. That year he also exhibited modest collections of their works at associated commercial galleries in London, Boston, Rotterdam and Berlin. The Berlin show was at Fritz Gurlitt's gallery, which he had opened in 1880. Menzel annihilatingly found the paintings "terrible". In 1886, Durand-Ruel and his American colleague James Fountain Sutton embarked on an ambitious measure to conquer a market which was indeed soon to prove decisive in the future fortunes of Impressionism but which was problematic because of drastic customs duty increases in 1882: they mounted a huge sales exhibition in the US, under the auspices of the American Art Association.

His most successful and wideawake rival was Georges Petit, not least with his *expositions internationales*, held annually from 1882 on, where the work of academicians, leading genre painters, realists and pleinairists was as thoroughly mixed as in Charpentier's "Vie moderne" shows. In 1885, Monet exhibited ten landscapes at Petit's alongside work by Albert Besnard (1849–1934), Cazin, Gervex, Raffaëlli, Stevens, Liebermann and others. In 1886 he, Renoir and Raffaëlli were again in the show; and in 1887 he, Renoir, Raffaëlli, and his coeval, the sculptor Auguste Rodin (1840–1917), who was soon to become a good friend, joined the hanging committee, selecting Morisot, Pissarro and Sisley, among others. Monet placed his influence with his friends behind his belief that dealers were the decisive factor in making reputations and success. The Impressionists, he felt, ought not to seem Durand-Ruel's pet group, but should occupy a variety of positions. It was some years before Durand-Ruel felt able to accept this view.

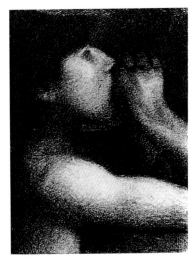

Georges Seurat
Echo (*L'écho*)
Study for "Bathers at Asnières", 1883/84
Conté crayon on paper, 32 x 24 cm
De Hauke 591. Private collection

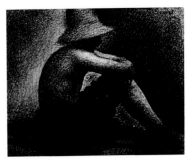

Georges Seurat
Seated Youth with Straw Hat
Study for "Bathers at Asnières", 1883/84
Homme au chapeau de paille, assis sur l'herbe
Conté crayon on paper, 24.2 x 31.5 cm
De Hauke 595
New Haven (CT), Yale University Art Gallery

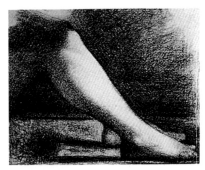

Georges Seurat
The leg (*La jambe*)
Study for "Bathers at Asnières", 1883/84
Black crayon on paper, 23 x 30 cm
De Hauke 594. Stockholm, private collection

In the mid–1880s, one of the most successful dealers in paintings and graphics, who already had an international presence, began to take an interest in the Impressionists. Adolphe Goupil (1806–1893) had established the firm with a partner in 1827; from 1875, as a result of his grand-daughter's marriage (she was a daughter of Gérôme the painter) to a Monsieur Valadon, the firm traded as Goupil, Boussod et Valadon. One of the partners was the uncle of Vincent van Gogh (1853–1890), and the employee who started acquiring Pissarros for the gallery from 1884 on, and then Sisleys, Monets and Renoirs, was the Dutch painter's younger brother, Theo (1857–1891). Ten years later, the enterprising dealer and publisher Ambroise Vollard (1867–1939) was also to play a part in spreading the fame of the Impressionists, though he came to be interested primarily in the Post-Impressionists.

In 1886, following protracted discussion, the eighth Impressionist exhibition was held not at Durand-Ruel's but in five rooms rented by the artists at 1 Rue Lafitte, above the Maison Dorée, a chic restaurant. It was a five-minute walk from either Durand-Ruel's gallery or his rival's,

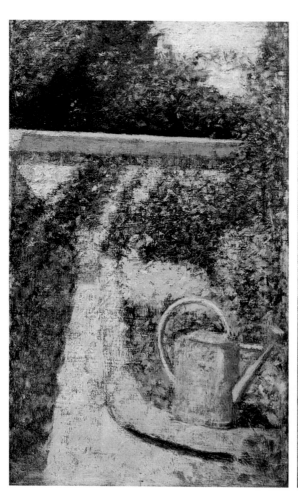

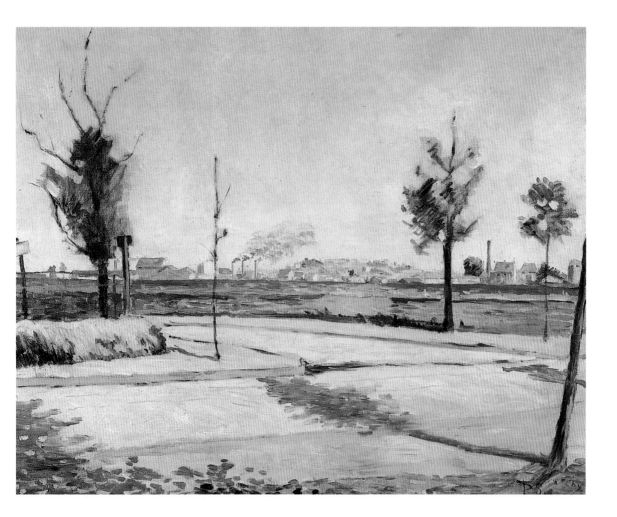

Petit's, and was in a district frequented by well-to-do people with an interest in art.[137] Seventeen artists were in the show; the catalogue listed 246 items. Five of the artists had been in the first show twelve years earlier, and six others had participated at least three times. But Monet, Renoir, Sisley and Caillebotte refused to exhibit because Degas had again smuggled in "his" associates – Bracquemond, Cassatt, Forain and Zandomeneghi – and Pissarro was also introducing protégés they did not care for.

Among other things, Forain displayed irreverent pastels, modishly chic *demi-monde* scenes. Degas perplexed the public partly with his milliner's shop scenes but mainly with ten pastels that carried the curiously meticulous, archivist title, *Series of Female Nudes, bathing, washing, drying, cleansing, combing their hair or having it combed.* The level detachment Degas brought to his pictures of women at their toilet, some of them seemingly coarse or plump, in postures at times awkward or even grotesque as they went about intimate business in which they would normally be unobserved, was interpreted as an iconoclastic attack on the

Poster for the eighth Impressionist exhibition, 1886

19th century's sacrosanct idol of female beauty, and an expression of the unmarried Degas's personal misogyny. With the possibility of legal consequences under the obscenity laws in mind, the critics refrained from suggesting that women who consented to be drawn in bath tubs and the like, in tiny rooms with floral-pattern furniture, must surely be prostitutes in cheap brothels.

In addition to Guillaumin (who exhibited village landscapes from Damiette in the Ile-de-France) and Gauguin, Pissarro introduced one of the latter's acquaintances, the bank clerk and amateur artist Emile Schuffenecker (1851–1934), as well as Seurat and Signac. The "fantastic visions" (as one critic put it) of Redon, mainly drawings, were stylistically odd ones out at the show. No one could detect any link with the Impressionists at all. Doubtless it was because Redon was one of the leaders of the Indépendants that he was invited to exhibit (and accepted). Seurat's *Bathers at Asnières* (p. 254), begun in autumn 1882 and the product of numerous preparatory studies, had been refused by the 1884 official Salon and shown at the first Indépendants exhibition. There it was seen by Signac, who introduced Pissarro and Seurat the following year, when the latter had almost completed *A Sunday Afternoon at the Ile de la Grande Jatte* (pp. 260/261). Pissarro was so impressed that he immediately adopted the dot method, a technique later labelled Neo-Impressionist. He also gave the younger painter welcome advice. Pissarro's son Lucien, who mainly worked in graphics, joined them, and the four exhibited together in one room. Their techniques were so similar that visitors to the show reputedly could not tell them apart. The *Grande Jatte* painting was the most striking in the Maison Dorée show. Signac exhibited *Two Milliners, Rue du Caire* (p. 266). That August, he and Seurat

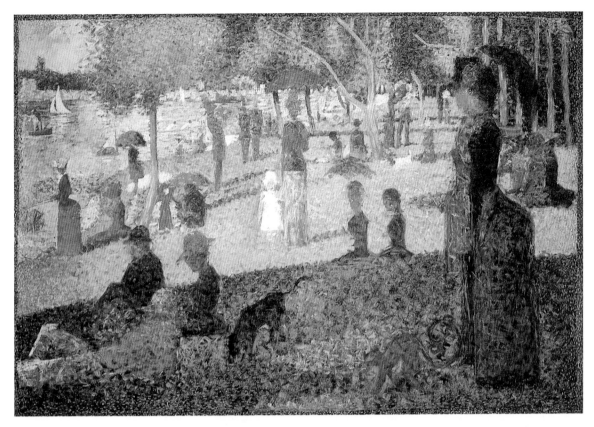

Georges Seurat
Angler (Study for "A Sunday Afternoon at the
Ile de la Grande Jatte"), 1884–1886
Oil on panel, 24 x 15 cm
Dorra/Rewald 132; De Hauke 115
London, Courtauld Institute Galleries

Georges Seurat
Couple (Study for "A Sunday Afternoon at the
Ile de la Grande Jatte"), 1884–1886
Oil on canvas, 81 x 65 cm
Dorra/Rewald 136; De Hauke 138
England, private collection

Georges Seurat
Woman with Parasol (Study for "A Sunday
Afternoon at the Ile de la Grande Jatte"), 1884
Oil on canvas, 25 x 15.5 cm
Dorra/Rewald 133; De Hauke 153
Zurich, E.G. Bührle Collection

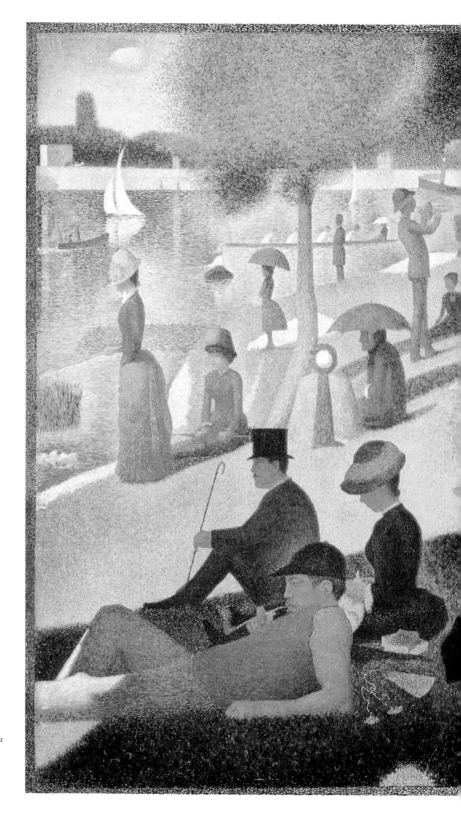

Georges Seurat
A Sunday Afternoon at the Ile de la
Grande Jatte, 1884–1886
*Un dimanche après-midi à l'Ile de la
Grande Jatte*
Oil on canvas, 206.4 x 305.4 cm
Dorra/Rewald 139; De Hauke 162
Chicago (IL), The Art Institute
of Chicago

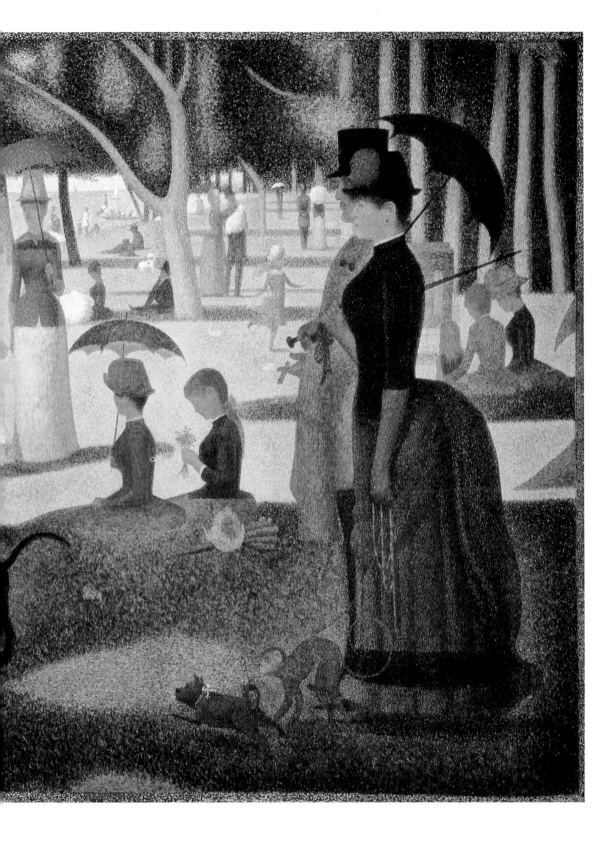

again showed their main works at the Indépendants. The use of dots won over other painters too, among them the jolly Norman Louis Anquetin (1861–1932), while Vincent van Gogh and Henri de Toulouse-Lautrec (1864–1901) used the brief and even brush-strokes Pissarro and Cézanne had employed before them.

Van Gogh, son of a Dutch vicar, was familiar with French and English art through his work for branches of Goupil & Cie. in The Hague and London and at the Paris head office of the dealership from 1869 to 1876. He had also been a lay preacher in England and Belgium before finally deciding in 1880, after years of drawing, to be a painter. In spring 1886 he went to Paris to study in the independent atelier of naturalist history painter Fernand Cormon (1845–1924). There he met Anquetin, Toulouse-Lautrec and Emile Bernard (1868–1941), among others. His brother Theo, being in art dealing, quickly put Vincent in touch with Pissarro and the other Impressionists. This, and the new exhibitions he saw that year, prompted van Gogh to abandon the melancholy, darkly brooding scenes of toilsome peasant and weaver life, and landscapes whose sketchiness and colour range placed them in the company of the Barbizon painters. He took to brighter work using strong, pure colours and more relaxed brushwork. City scenes, still lifes and portraits replaced his earlier subject matter. As early as 1887, though, he was telling his friends that he had to go beyond Impressionism. He took a close

Jean-Louis Forain
Ball at the Paris Opera, c. 1885
Un bal à l'Opéra
Oil on canvas, 74 x 61 cm
Moscow, Pushkin Museum of Fine Art

Edgar Degas
Six Friends of the Artist, 1885
Six amis de l'artiste
Pastel on paper, 113 x 70 cm
Lemoisne 824
Providence (RI), Museum of Art,
Rhode Island School of Design

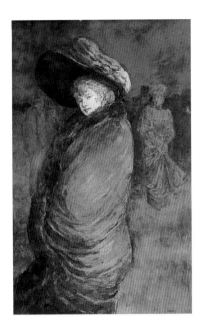

Henry Somm
The Red Overcoat
Le manteau rouge
Watercolour on paper
Rouen, Musée des Beaux-Arts

Henry Somm
Stylish Ladies in the Street
Elégantes dans la rue
Watercolour and ink on paper on card,
48.3 x 62.3 cm. Private collection

interest in Japanese coloured woodcuts, and together with Anquetin, Bernard, Gauguin and Toulouse-Lautrec (calling themselves the Painters of the Little Boulevard, as opposed to Monet, Pissarro and company of the Great Boulevard) he exhibited a large number of pictures at La Fourche, a restaurant in the Avenue de Clichy. In February 1888, after two fertile years in Paris, van Gogh went south, moving to Arles in Provence. His attitude to colours and their expressive potential had been transformed, and he was thirsting for stronger colours in brighter light.

Henri Marie Raymond de Toulouse-Lautrec-Monfa to give him his full name) came of ancient aristocratic stock in south-west France. He had painted and drawn skilfully at an early age; in Paris, he first took private tuition, then lessons with Bonnat and then (1882 to 1886) Cormon. His health was poor and broken legs had not healed, so that he was already a dwarfish cripple with short legs, unable to participate in riding, hunting, dancing or the love affairs of high society. He had no financial worries, though, and was able to take an independent, bitingly sarcastic view of the world around him. He was a hedonist given to alcoholic over-indulgence; his physical state doubtless drove him to this, as it did to mental deterioration. Forain strongly encouraged him at first, and from the early 1880s on his art had the brightness and the brief, easy brushwork of Impressionism (p. 227). For him, a generation junior to Degas, Impressionist technical and structural approaches were already part of the available repertoire from which to proceed onward.

The extent to which Impressionism could already be considered a finished chapter in art history, open to criticism from various points of view, can be gauged from Zola's novel "L'Œuvre", published in that fateful year of 1886. The novel was part of Zola's Rougon-Macquart series, and its hero was an artist to whom Zola gave the features of his

Charles Tillot
Still Life with Flowers
Nature morte aux fleurs
Oil on canvas, 81.5 x 65 cm
New York, private collection

friend Cézanne, together with aspects of Manet's career (such as the scandal concerning *Le Déjeuner sur l'Herbe*) and that of Monet (his penury, and his portrait of his dead wife). This hero painted in an Impressionist style – and was a failure. Zola, the good Naturalist, believed Impressionism was incapable of making a powerful creative response to modern social realities. Cézanne, deeply hurt, broke off their friendship.

Simultaneously a new aesthetic confrontation hit the art scene. On 18 September 1886, Jean Moréas (originally Papadiamantopoulos, 1856–1910), a writer of Greek extraction, published his Symbolist manifesto in the much-read "Figaro littéraire". This gave a name to a movement that had been palpable for some years in literature, the visual arts, music and theatre. In contrast to the naming of Impressionism, this time there was no ridicule involved; it was a positive, programmatic term. Of course it was open to varying interpretation. Symbolism was also to become a rallying-point for various new trends that played an important role in the next few years. One major literary Symbolist was the poet Stéphane Mallarmé (1842–1898), who had taken Manet's part in 1874 and had

his portrait painted by him in 1876 – a wonderful portrait, nervy, wary, at odds with intimacy. He was now particularly close to Morisot. Redon was a typical example of a Symbolist artist.

Behind the new aesthetics lay the shift from positivist, materialist theories of the exact scientific knowability and governability of Nature and society to various brands of idealism, a broad range that included a revival of religious belief. Scepticism concerning technological and scientific progress and its consequences for civilization undermined optimistic emphasis on progress and the belief in an earthly paradise.

The existence of an objective reality was being questioned – or at least its epistemological verifiability and the possibility that it could be represented. Perceptions registered on the senses, it was felt, provided no information on anything that really existed. One could be content – impressionistically – with recording the diversity of those perceptions. Otherwise, the only alternative (now considered the better option) was to see the evidence of the senses, or the image conveyed by the subject, as a symbol that pointed the way, so to speak, to the thing meant, however circuitously – the way to a reality that ultimately retained its mys-

Paul Gauguin
The Four Breton Girls, c. 1886
La danse des quatre Bretonnes
Oil on canvas, 72 x 91 cm
Wildenstein 201
Munich, Bayerische Staatsgemäldesammlungen,
Neue Pinakothek

tery. Many of the typical terms appeared in an 1888 essay: "In painting and literature, representation of Nature is sheer delusion... on the contrary, painting and literature aim to convey an apprehension of things using the means specific to painting and literature. What ought to be expressed is not a representational image [of the subject] but its character. Whyever should one pursue the thousand insignificant details registered by the eye? One ought to seek out the essence and reproduce that, or rather: produce it... Using the smallest possible number of characteristic lines and colours, the painter will capture the essence of the chosen object and thus escape the charge of photographic imitation. Primitive and folk art are symbolist in this sense, as is Japanese art... To confuse line and colour implies that one is unable to grasp their peculiarities as expressive means: the line expresses what abides, colour what is of the passing moment. The line is an almost abstract symbol and conveys the character of the object, while the unity of colour conditions

Paul Signac
Two Milliners, Rue du Caire, c. 1885/86
Apprêteuse et garnisseuse, rue du Caire
Oil on canvas, 111.8 x 89 cm
Zurich, E.G. Bührle Collection

the overall atmosphere and the emotional realm..."[138] This makes clear
the points of disagreement with the Impressionist emphasis on what the
eye saw and on momentary colour phenomena, on the prior value of
colour dabs over the line, on the part played by chance, and (in Degas's
case, at least) on the possibilities opened up by photography. While the
Impressionists were still fighting the academic wing, they were now being
attacked on a new front as well.

Little magazines, often short-lived and publishing poetry, prose,
graphics, and essays on aesthetics, art, culture theory and politics, were
increasingly playing a part in the making of art history. The critics tended
to be young men who wrote alongside other jobs, men such as Félix
Fénéon (1861–1944), Gustave Kahn (1859–1936), Roger Marx (1859–
1913), Octave Mirbeau (1848–1917) and the novelist Gustave Geffroy
(1855–1926), who worked for Clemenceau's newspaper "La Justice"
and was made director of the famous state-run tapestry manufactory
under Clemenceau's government.

In 1884, when the Indépendants were forming their society, the
"Revue Indépendante" was also started, a magazine first edited by Fé-
néon and responsible after 1887 for small-scale exhibitions too. Politi-

Paul Signac
Breakfast (The Dining Room), c. 1886/87
Le petit déjeuner ou La salle à manger
Oil on canvas, 89 x 115 cm
Otterlo, Rijksmuseum Kröller-Müller

cally it was anarchist. The dream of a society free of rule was an old one. Modern artists – of necessity individualists – were particularly prone to dream it. Courbet's friend Pierre-Joseph Proudhon (1809–1865) coined the term. Another friend, the Russian nobleman Mikhail Bakunin (1814–1876), stood alongside Richard Wagner in the revolution in Dresden in 1849. His successor as leader of the anarchists in western Europe was the Russian aristocrat Petr Kropotkin (1842–1921). Pissarro read the latter's books, much to Renoir's dismay, as we have seen. A magazine he edited from Geneva, "La Révolte", was continued from 1887 in Paris by his former secretary Jean Grave (1854–1939). Pissarro did illustrative work for this and similar publications from 1889 on.

On 1 May 1885, under the pseudonym Trublot, Paul Alexis, a friend of Zola, Renoir, Pissarro and Seurat, wrote in the popular left-wing paper "Le Cri du Peuple", edited by the ex-Communard Jules Vallès (1832–1885): "The Impressionists stand for the same thing in painting as the Naturalists in literature and the socialists in politics... Following the overall movement of the century, alert to the natural sciences and to truth, they share a concern to unsettle privilege, deference and pedantry, to unseat those who cling to establishment opinions, and to startle the stupidity of the bourgeoisie."[139]

The "Revue Wagnérienne", which began in 1885, not only celebrated Wagner as the creator of a new, sensuous, nervy music, and as the founder of a new artistic synthesis of poetry, music, drama, decor and festival theatre, but also dealt with "Wagnerian painting". This supposedly included Puvis de Chavannes and Redon, as well as Monet, Cézanne and Degas, because their pictures offered an enigmatic evocation of reality rather than merely representing it.

"Le Décadent" was published for a short period in 1886. The authors and readers valued an individual blend of cultured address, luxurious extravagance, inactive and meditative solitude, exquisite pleasures and vices, sadism, and the longing for death. This blend, they averred, was only possible in the closing phase of a long cultural history; it had been thus with the decay and decadence of ancient Rome. Sophisticated art, they claimed, was a response to universal collapse and the spiritual shallowness of the times. One of the most thorough presentations of the decadent attitude and its aesthetics appeared in Huysmans' novel "A rebours" (Against Nature, 1884). In that work, Huysmans turned away from his previous enthusiasm for realistic portrayals of modern life; his art criticism was consistent with his new position.

Only a few decades earlier, the widely-touted goal had been to champion modern life, rejecting the classical, academic legacy of the past. Now, however, capitalism was beginning to cause concern. Many felt a certain abhorrence at the phenomena and processes that left the imprint of modernity on the times. As a result, there was a tendency to seek ways of escape. The vague hope of some future paradise was sustained mainly by the quest for other, lost paradises; and, as in the Romantic era, there were those who supposed they could find them among peoples who lived in simpler, pre-technological and pre-societal conditions.

Paul Signac
The Railway at Bois-Colombes, 1886
L'embranchement de Bois-Colombes
Oil on canvas, 33 x 47 cm
Leeds, Leeds City Art Gallery

Paul Signac
Gasometers at Clichy, 1886
Les gazomètres à Clichy
Oil on canvas, 64.8 x 81 cm
Melbourne, National Gallery of Victoria

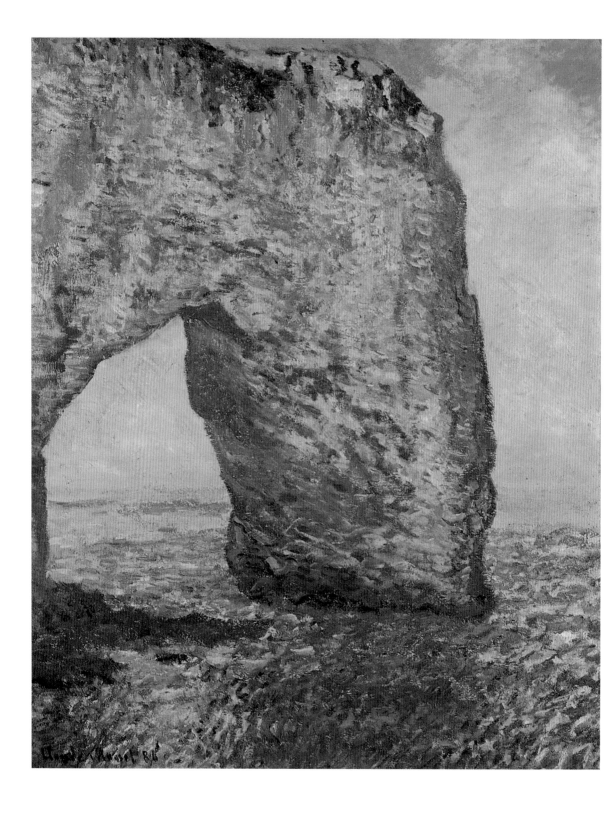

Georges Seurat
The Beach at Bas-Butin near Honfleur, 1886
La plage de Bas-Butin, Honfleur
Oil on canvas, 67 x 78 cm
Dorra/Rewald 165; De Hauke 169
Tournai, Musée des Beaux-Arts

Georges Seurat
Bec du Hoc, Grandcamp, 1885
Le Bec du Hoc, Grandcamp
Oil on canvas, 66 x 82.5 cm
Dorra/Rewald 153; De Hauke 159
London, The Tate Gallery

Left:
Claude Monet
La Manneporte near Etretat, 1886
La Manneporte près d'Etretat
Oil on canvas, 81 x 65 cm
Wildenstein 1052
New York, The Metropolitan Museum of Art

Georges Seurat
The Lighthouse at Honfleur, 1886
L'hospice et le phare à Honfleur
Oil on canvas, 66.7 x 81.9 cm
Dorra/Rewald 168; De Hauke 173
Washington (DC), National Gallery of Art,
Mr. and Mrs. Paul Mellon Collection

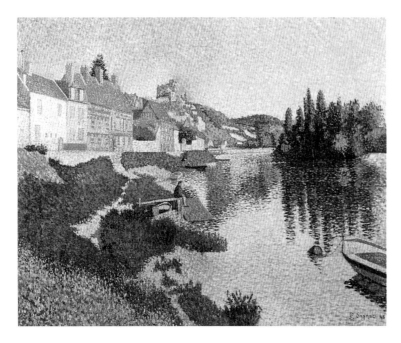

Paul Signac
The River Bank, Petit-Andely, 1886
La berge, Petit-Andely
Oil on canvas, 65 x 81 cm
Paris, private collection

Georges Seurat
The "Maria", Honfleur, 1886
La Maria, Honfleur
Oil on canvas, 53 x 63.5 cm
Dorra/Rewald 169; De Hauke 164
Prague, Národní Gallery

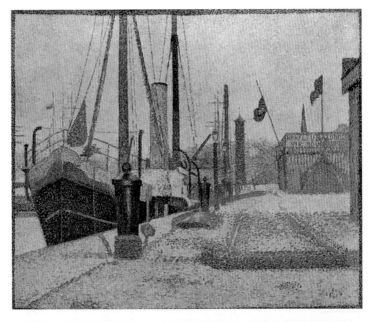

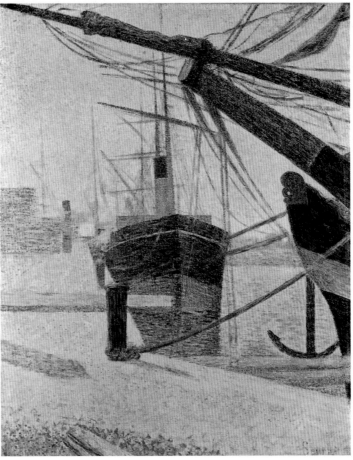

Georges Seurat
The Harbour at Honfleur, 1886
Le port d'Honfleur
Oil on canvas, 79.5 x 63 cm
Dorra/Rewald 166; De Hauke 163
Otterlo, Rijksmuseum Kröller-Müller

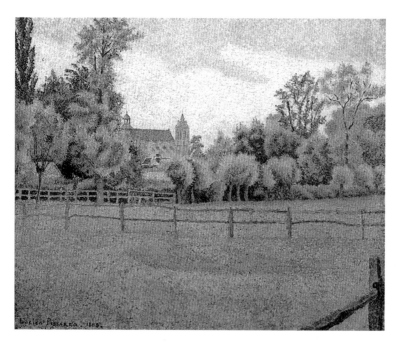

Camille Pissarro
Woman in an Orchard. Spring Sunshine
in a Field, Eragny, 1887
Femme dans un clos. Soleil de printemps
dans le pré à Eragny
Oil on canvas, 54 x 65 cm
Pissarro/Venturi 709. Paris, Musée d'Orsay

Camille Pissarro
Apple Picking, 1886
La cueillette des pommes
Oil on canvas, 128 x 128 cm
Pissarro/Venturi 695
Kurashiki, Okayama (Japan),
Ohara Museum of Art

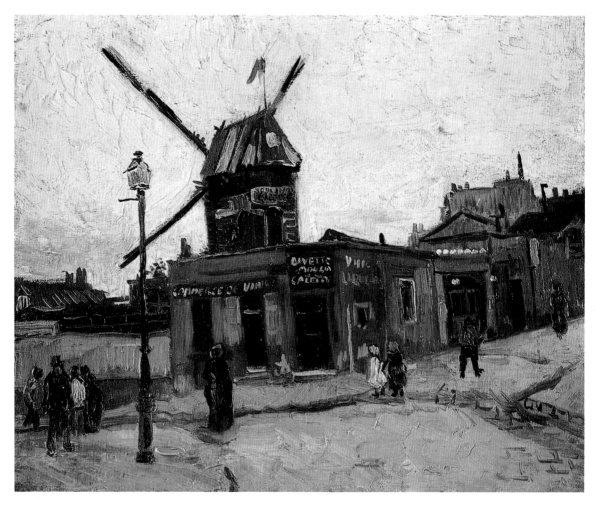

Vincent van Gogh
Le Moulin de la Galette, 1886
Oil on canvas, 38.5 x 46 cm
F 227, JH 1170, Walther 189
Otterlo, Rijksmuseum Kröller-Müller

The Moulin de la Galette, Montmartre

In summer 1886, after the eighth Impressionist exhibition, Gauguin went for the first time to the Breton fishing village of Pont-Aven, on the Atlantic coast, to paint the landscape and people. At the same time, at nearby Kervilahouen, Monet found a new subject in the "wild" and "terrible" cliffs and spray of Belle-Ile. The following year, Gauguin ventured into the tropics, to the French Caribbean colony of Martinique. In spring 1888, though, he returned to Pont-Aven, where he was presently a member of the new Pont-Aven School of artists. There had been occasional groups of this kind decades earlier; even so, the Pont-Aven painters were one of the first and most famous rural artists' colonies. The phenomenon quickly spread throughout Europe; one well-known colony was at Worpswede in Germany. In summer 1888 Emile Bernard went to Pont-Aven, introducing an idea he and Anquetin had had for a new, decorative style highlighting contained colour spaces, which he called cloisonnism. The name and method came from the time-honoured technique of *émail cloisonné*, in which a very fine metal partition separated the colour zones. Gauguin used the approach in 1888 for his *Vision after*

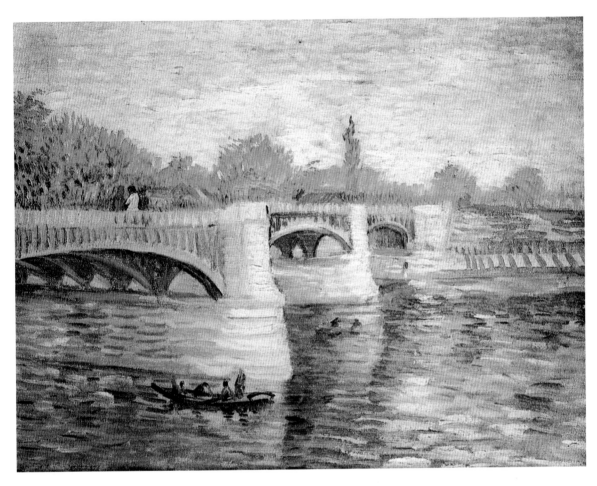

Vincent van Gogh
Pont de la Grande Jatte, 1887
Oil on canvas, 32 x 40.5 cm
F 304, JH 1326, Walther 273
Amsterdam, Rijksmuseum Vincent van Gogh,
Vincent van Gogh Foundation

the Sermon (p. 303), his first attempt to introduce a purely imaginary scene into a visual world which, since Courbet, had been exclusively governed by the evidence of the painter's own eyes.

Another young painter who was still studying in Paris at the Académie Julian was Paul Sérusier (1864–1927). Under Gauguin's guidance he painted a small wooden panel (p. 320) at the Bois d'Amour near Pont-Aven, using strong, luminous strokes. The representational character of the brushwork had almost disappeared; instead, the strokes produced a strong, wild colour accord such as the Fauves and the Expressionists were to use routinely twenty years later. The young symbolist and decorative painters who organized an exhibition of "synthetic" painting, with Gauguin, at the Café Volpini in Paris in 1889 saw Sérusier's picture as their talisman. Synthesis, and unified totality of effect, were the new watchwords, instead of the Impressionist analysis of light and dissection of colour. The Café Volpini was opposite the entrance to the art pavilion at the Paris World Fair – bigger than ever – which marked the centenary of the French Revolution. The exhibition of "A Century of French Art"

included Manet and Monet; Renoir had expressly refused to be included since he did not want his paintings hung alongside conventional work. Now it was the turn of the next generation to stake their claims.

The Colour of Light: Pointillism

While the idealist, symbolist line in thought was producing critical reservations concerning exact explanations and rules, "scientific Impressionism" (Camille Pissarro) was simultaneously being conceived. If the two lines were at odds, that fact did not prevent the sharing of certain things, nor did it stop painters from being friends and exhibiting together. After all, it was still fashionable to link art with the exact sciences. A few years before, in 1879, Zola had coined the term "experimental novel" for his objective, naturalist analyses of social and mental states.

Seurat's aim was to found his art on an incontestable system. Studying under a pupil of Ingres, he had conducted a careful examination of pictures by Delacroix which struck him as being not altogether consistent in their use of colour. He also read a great deal. He happened upon a publication from 1839 by a chemist, one Eugène Chevreul (1786–1889) – "De la Loi du contraste simultané des couleurs et de l'assortiment des objets colorés" – together with a later study by the same author, "Des Couleurs et de leur application aux arts industriels à l'aide des cercles chromatiques" (1864). There were also more modern investigations of complementary colours and the optical laws governing their perception. "Modern Chromatics" (1879), by the New York physicist Ogden Nicholas Rood (1831–1902), was published in French translation in 1881. In 1880 David Sutter (1811–1880) published a series of articles on phenomena of vision in the magazine "L'Art". And from 1886 on, Seurat found his views conclusively endorsed by Charles Henry (1859–1926), who was working as a librarian at the Sorbonne. Henry was a man familiar with many disciplines – mathematics, biology, literature, music and psychology – and gave popular evening lectures. In 1885 he had published an "Introduction to Scientific Aesthetics". In colours and in the directions of lines, Henry proposed a distinction between the "dynamogenic" (i.e. creating momentum and pleasure) and the "inhibiting" (i.e. retarding, and causing pain). Seurat and Signac drew their own circular colour scheme in order to clarify the spiritual relations of colours in their own minds.

In a letter written to Durand-Ruel in 1886, Pissarro gave an economical description of the technique Seurat had been the first to use after thorough study of the scientific theories: "The aim is to substitute optical mixing for the mixing of pigments, or, to put it differently, to analyse colour tonalities into their fundamental components."[140] Science had found that colours reached the eye in the form of light of differing wavelengths, and were mixed in the eye to establish the colour that corresponded to the object seen. If a painter juxtaposed tiny dots of unmixed

Chromatic triangle by Ogden N. Rood. From: "Modern Chromatics", 1879

Chromatic diagram by Charles Blanc (1813–1882)

Henri de Toulouse-Lautrec
Portrait of Vincent van Gogh, 1887
Portrait de Vincent van Gogh
Pastel on card, 54 x 45 cm
Dortu 278
Amsterdam, Rijksmuseum Vincent van Gogh,
Vincent van Gogh Foundation

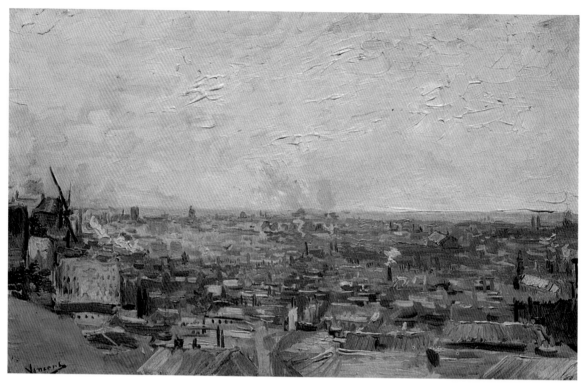

Vincent van Gogh
View of Paris from Montmartre, 1886
Oil on canvas, 38.5 x 61.5 cm
F 262, JH 1102, Walther 182
Basle, Öffentliche Kunstsammlung Basel,
Kunstmuseum

primary colours in the right way, the eye would perceive them as the desired colour tone when looking from a certain distance; and that tone would appear lighter than if it had been mixed in the conventional way, on the palette or the canvas. For instance, blue and yellow dots juxtaposed would produce green. Furthermore, the intensity of colours would be greater if the eye perceived them through simultaneous contrast, together with a context of a different colour. Seurat had called this procedure "chromoluminarism" but then settled on "divisionism". The term that gained currency, though, and by which the technique is still known today, was Signac's "pointillism". Fénéon came up with the more historically coloured term Neo-Impressionism, which Signac subsequently accepted.

In 1881 and 1882, Seurat concentrated on drawing. Indeed, capturing nuances of light and dark was always to be of great significance for him. He almost invariably used Conté chalk on Michallet paper, the surface of which is so grainy that the white still glimmers through even the deepest black (p. 255). In his tiny oils too, done in sketchy brush-strokes on wood panels, he strikingly often used dark figures silhouetted against light backgrounds, and linear elements to structure his space (p. 259). Seurat's subjects were chosen preponderantly from the work and leisure of ordinary people in the outer suburbs of Paris, where the social changes and construction created by industrialization were at their most noticeable. The English art critic Richard Thomson has pointed out that Seurat, like the intellectual anarchists in whose circles he moved, registered

Paris and the Seine bridges seen from Saint-Gervais
church tower

these socio-cultural phenomena with a clear critical awareness, and deliberately took them as his themes.[141]

Bathers at Asnières (p. 254), at two by three metres a demonstratively large work, was his first programmatic picture. The location was not far out, like Argenteuil or Bougival, but close to newly built factories. There was no restaurant, and those who bathed there went because the rail fare to Argenteuil was too expensive. Fourteen surviving oil studies and a number of drawings show how meticulously Seurat prepared the painting (p. 254). The atmosphere is one of hazy brightness; the sky and water almost constitute a single colour continuum, which powerfully diminishes the spatiality of the work. The figures look exhausted; their three-dimensionality has an inflated look, and the outlines of the colour zones are sharp. These outlines are not marked by actual lines, though, but solely by the different colours of the tiny brush-strokes or by an aura of light. The boy at right who has entered the water is tooting a call into the silence through his cupped hands much like the conch-blowing Tritons in roughly contemporaneous symbolist art by Arnold Böcklin (1827–1901). The scientifically precise rendering of the colours of this carefree genre scene and sunny landscape admittedly introduces a disquieting note of ornamentality, involving as it does the uncompromising use of a technique that has no time for unimportant details.

The Place de Clichy in the Batignolles quarter. Photograph, 1900

Paul Signac
The Boulevard de Clichy under Snow, 1886
Le Boulevard de Clichy, la neige
Oil on canvas, 46.5 x 65.5 cm
Minneapolis (MN), The Minneapolis Institute of Arts

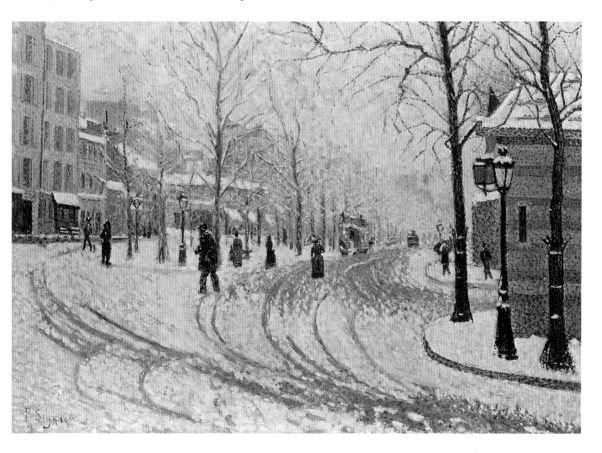

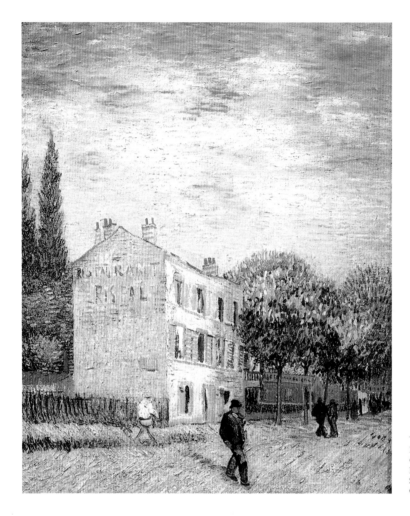

Vincent van Gogh
Restaurant Rispal at Asnières, 1887
Oil on canvas, 72 x 60 cm
F 355, JH 1266, Walther 240
Shawnee Mission (KS), Henry W. Bloch
Collection

The urge to establish a specific form that obeyed strict internal laws won out over faithful reproduction of what the eye saw – as became more apparent in the painting Seurat shortly began work on, *A Sunday Afternoon at the Ile de la Grande Jatte* (pp. 260/261). These people are enjoying their sunny leisure on an island in the Seine near the Neuilly Bridge to Courbevoie, a place convenient for the city and not far from the modern quarter of La Défense. The picture continues Seurat's analysis of the new encounters of different social strata. Symbolic motifs such as the monkey on a lead – in Parisian slang, a monkey was a prostitute – and the formal allusions to dolls and tin soldiers introduce a grotesque note. While he was working on this large canvas, Seurat practised painting landscapes drenched in light by doing form and colour studies of fields of flowers near Paris and curious cliff formations on the coast of Normandy, such as the *Bec du Hoc* (p. 271). Above all, he used oil studies of segments of the work, and of the total composition, to establish the overall harmony of the painting. The picture is done entirely in tiny dots, including the strip around the painting proper.

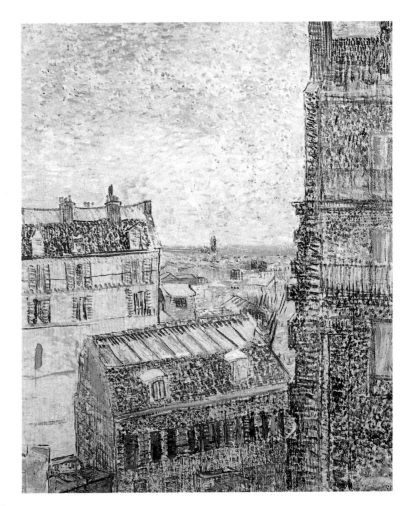

Vincent van Gogh
Paris Seen from Vincent's Room in the Rue Lepic,
1887
Oil on canvas, 46 x 38 cm
F 341, JH 1242, Walther 222
Amsterdam, Rijksmuseum Vincent van Gogh,
Vincent van Gogh Foundation

54 Rue Lepic, where Vincent van Gogh lived in
1886 as a subtenant of his brother Theo

Contemporaries have left accounts of the concentration and stamina
Seurat brought to his work, on a ladder before the huge canvas, scruti-
nizing the various subjects in light or shade and patiently selecting his
colour dots. He worked in his studio every afternoon and evening, com-
pleting a small section every day, like a fresco painter or mosaic artist.
Impressionist analysis of the passing moment, the slice of life in motion,
had become an artificial, synthetic *gestalt*. It was to prove as enduring –
like the quite different style Cézanne evolved – as the art already in the
museums. Seurat wanted the modern people in his paintings to move
with the same free, ceremonial grace as Phidias's figures on the Parthe-
non frieze from the Acropolis in Athens.[142] He paid close attention to
work that Puvis de Chavannes was painting at the same time, and found
the neo-classical symbolist confirmed him in his approach. And indeed,
the first critics to applaud Seurat described him as a "materialist" or
"modernized" Puvis.

After the *Grande Jatte* painting, *Bec du Hoc* and various others had
been exhibited, Seurat only had five years to live; he died of diphtheria

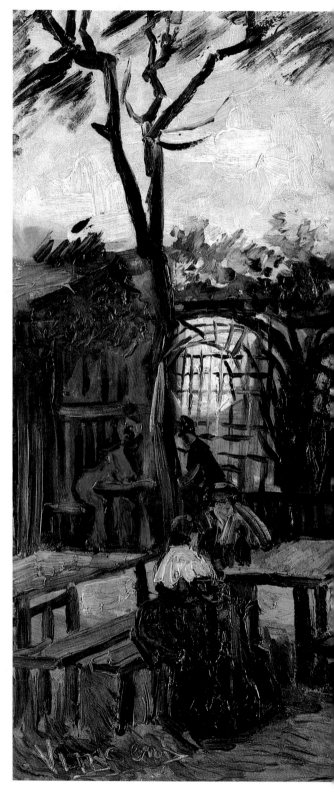

Vincent van Gogh
Terrace of a Café on Montmartre,
1886
Oil on canvas, 49.5 x 64.5 cm
F 238, JH 1178, Walther 190/191
Paris, Musée d'Orsay

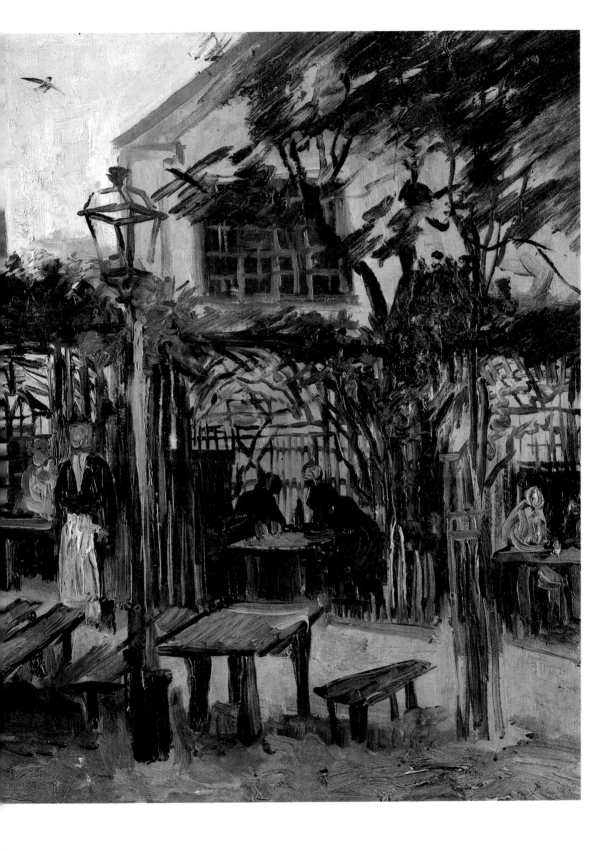

in March 1891.[143] During that time he largely abandoned painting in the open. He was trying to make his system even more exact; in 1890 he wrote it down. He became self-importantly proud, and went into voluntary isolation from his hordes of imitators. The *Grande Jatte* was exhibited at the 1886 Impressionist show, then with the Indépendants, and again in 1887 in Brussels with Les Vingt, a prominent artists' association founded in 1884. Les Vingt, with their lawyer and art-critic leader Octave Maus (1856–1919), played a very important part in the international dissemination of Impressionism, but particularly in that of Neo-Impressionism, Symbolism and Post-Impressionism.

In *The Models* (pp. 298, 299, 301) Seurat affords a glimpse of his studio and the artist's work. Waiting amidst discarded clothing, or dressing, these lean and altogether unerotic nudes are related to the completed *Grande Jatte*, which is partly to be seen on the studio wall. The situation, quite free of the anecdotal, has a quality of chance that recalls Manet; it is monumentalized into lifesize and has the air of a relief. It might be seen as an ironic paraphrase of the classic motif of the Three Graces. It is also a totally serious attempt to establish normal postures of standing or sitting, using frontal, profile and rear views, as Puvis and the German painter Hans von Marées (1837–1887) had been doing at the same time. Seurat was struggling to assert a new classicism outside the tired conventions of the academic variety. Time and again he embarked on studies recording impressions and then developed them using his systematic "divisionism".

At the same time Seurat was working on *The Circus Parade* (p. 300), followed by *Le Chahut* (p. 318) and the not quite finished *Circus* (p. 329). He also painted a buxom young woman powdering herself (p. 319) – his lover, Madeleine Knobloch, of whose existence only his closest friends were aware. It was a Degas world, but quite differently handled. The effects of stage lighting, overlapping and cropped foreground figures, and a certain malice in the grotesque way types of people or posture were presented, were certainly not unrelated to Degas, but the differences were greater: a sense of ceremony accompanied by distortions and grimaces, motion arrested in mechanical parallel attitudes, a strict patterning of spaces, and an emphatically enigmatic flavour despite the seemingly straightforward attention-getting. The core note is struck by display, by the noisy, colourful, made-up and costumed world of tinsel illusion. Revue theatre provided Seurat with a means of criticizing a society engrossed in mean, witless gaping (the figure at bottom right in *Le Chahut*) and becoming steadily desensitized. The skill of the circus artiste in animated suspension, like that of the dancers and musicians, obeys the whip of a ringmaster or conductor or impresario – always the same suave moustached character. The clown in the foreground of *The Circus* is yelling out, revealing the truth, as the court jesters and fools used to do and artists now do. This late work gives us the full disquieting, emblematic legacy of a painter who had set out to find a scientific method of reproducing colour.

Signac was the most devoted follower and propagandist of Seurat's

Agostina Segatori modelling for Corot's painting "Agostina", c. 1866

Vincent van Gogh
Agostina Segatori in the Café du Tambourin, 1887
Oil on canvas, 55.5 x 46.5 cm
F 370, JH 1208, Walther 206
Amsterdam, Rijksmuseum Vincent van Gogh, Vincent van Gogh Foundation

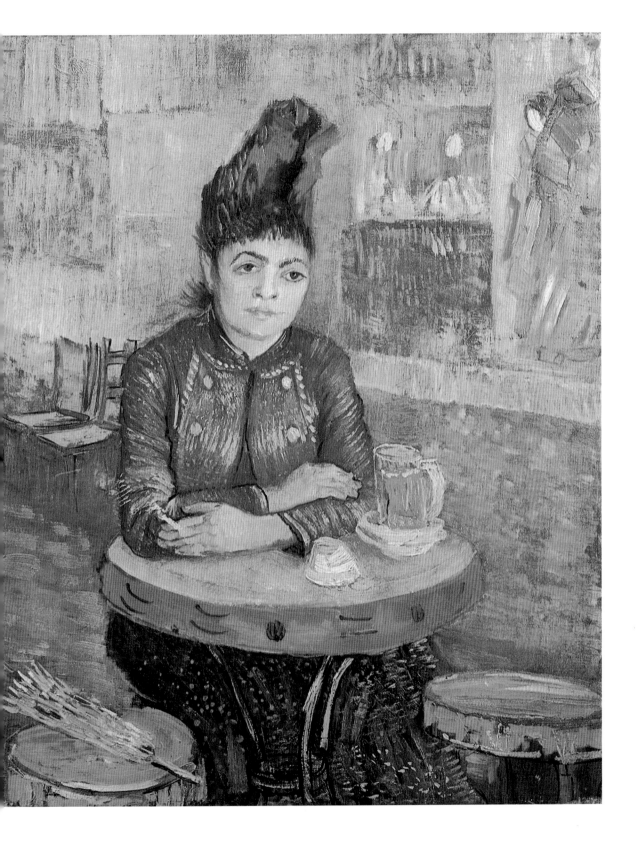

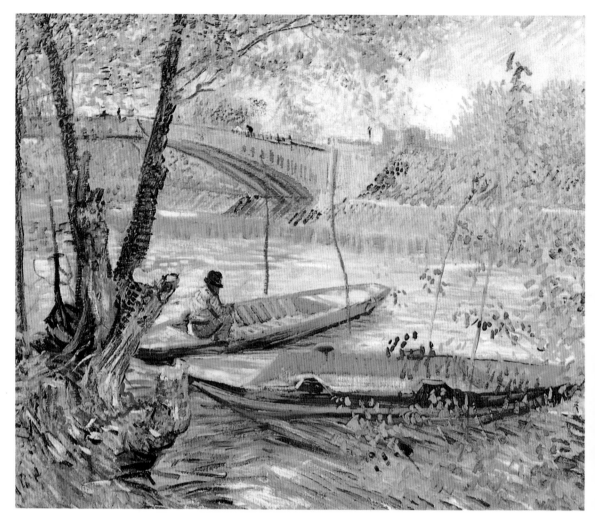

Vincent van Gogh
Fishing in Spring, Pont de Clichy, 1887
Oil on canvas, 49 x 58 cm
F 354, JH 1270, Walther 237
Chicago, The Art Institute of Chicago

Boats on the Marne. Photo: Atget, 1903

method. In various interior genre scenes he tried his hand at a new pres-
entation of physical volume and striking gestures (p. 267). If a milliner
bent to pick up the scissors she had dropped, it became a loaded dramatic
gesture eloquent of weary toil. Influenced by his friend Guillaumin, Sig-
nac began painting suburban and industrial landscapes (pp. 257, 269).
From 1882 – a keen yachtsman himself – he repeatedly painted sunny
seaside landscapes and harbours bobbing with boats. From 1892 he was
a regular visitor to Saint-Tropez. His watercolours in particular had an
airy verve; but in his oils, too, his pointillism was always fresher, more
generous and radiant, than in the increasingly austere and sombre Seu-
rat. He dabbed his strong though oddly sickly-sweet colours onto his
canvases in rectangular patches of equal size.

His most distinctive blend of scientific Impressionism, Symbolism and
Japanese decorative spatial approaches came in his Uncle Sam portrait
of Fénéon, the Neo-Impressionists' energetic spokesman, who always
made a rather droll impression (p. 321). The picture – ironic, theatrical,

Vincent van Gogh
On the Outskirts of Paris, 1887
Oil on canvas, 38 x 46 cm
F 351, JH 1255, Walther 252
USA, private collection

Vincent van Gogh
In the Jardin du Luxembourg, 1886
Oil on canvas, 27.5 x 46 cm
F 223, JH 1111, Walther 157
Williamstown (MA), Sterling and Francine
Clark Art Institute

Alphonse Maureau
Banks of the Seine, c. 1877
Bords de la Seine
Oil on panel, 14.5 x 24 cm
Florence, Galleria d'Arte Moderna

Emile Bernard
Portrait of Père Tanguy, 1887
Portrait du Père Tanguy
Oil on canvas, 36 x 31 cm
Luthi 72. Basle, Öffentliche
Kunstsammlung Basel, Kunstmuseum

poster-like – was exhibited with the Indépendants in 1891. Signac gave it the cumbersome but exact title *Portrait of Félix Fénéon in Front of an Enamel of a Rhythmic Background of Measures and Angles, Shades and Colours.* At that time, in 1890, he was working closely with Henry, illustrating his theoretical writings. He was convinced that, using Henry's aesthetic tables, one could compute the measures and angles in a picture and check shapes for harmony. This struck him as being "of great social importance" for the aesthetic education of those active in the applied arts. Fénéon, painted pointillistically, is holding a cyclamen in fingers of a neo-Gothic delicacy that was presently to be a hallmark of certain Symbolists (such as the Swiss artist Ferdinand Hodler, 1853–1918). The "enamel" background, based on the design on a Japanese kimono, emphasizes dynamic curves in a way that looks forward to another style soon to break – Art Nouveau.

Pointillism or divisionism did not permit strong personal styles. Thus the artists have to be assessed primarily through the slight differences in their subject matter, the degree to which they blended their aesthetic aims

Vincent van Gogh
Self-Portrait in a Grey Felt Hat, 1887
Oil on card, 41 x 32 cm
F 295, JH 1211, Walther 211
Amsterdam, Stedelijk Museum
(on loan from the Rijksmuseum)

with realistic or Impressionist or indeed Symbolist leanings, and, of course, the energy they brought to visual structures of their own and the work of creating persuasive images with them.

Dubois-Pillet, an active Indépendant, died young in 1890. He painted atmospheric landscapes and city scenes (p. 311). Angrand, one of Seurat's first followers, moved on from vigorous and spontaneous brushwork (p. 295) to a dense fabric of points. His working-class couple out walking (p. 307) have their own simple dignity, and are well established in the light ochres of the clearly structured street scene. In the 1890s, linear styles and Symbolism prevailed over pointillism, and Angrand eventually moved on once more. Anquetin's tie with divisionism was of even briefer duration. As early as 1888, Bernard's friend (and rival) had begun to seem the quintessential new Symbolist (p. 306). Towards the end of 1891, interviewed on the occasion of an "Impressionists and Symbolists" exhibition at Le Barc de Boutteville galleries, he stressed that he espoused neither ism. Mirbeau had recently criticized him tartly for his traditionalist horrors.

Vincent van Gogh
Portrait of Père Tanguy, 1887
Pencil on paper, 21.5 x 13.5 cm
Amsterdam, Rijksmuseum Vincent van Gogh,
Vincent van Gogh Foundation

Henri-Edmond Cross (1856–1910), whose actual name was Delacroix, had exhibited in the Salon before turning to Impressionism via Monet. Then in 1884 he joined Seurat and Signac, and adhered till his death to a radiantly bright pointillism. He was most attracted to subjects in the south of France, in Venice, and elsewhere in Italy. Cross did not solely use unmixed prime colours for his pictures, which aspired to use spatial areas decoratively. The poetically titled *The Golden Isles* (p. 323), painted in 1891/92 and showing the Mediterranean islands of Hyères, suggests with particular vividness where the potential of Neo-Impressionism lay. From this point, the path led either to the decorative Symbolism and sophisticated opulence of the Vienna Secession artist Gustav Klimt (1862–1918) or to non-representational, abstract art dependent on colour accords alone.

Maximilien Luce (1858–1941), just beginning a long life and a tremendous output of paintings, drawings and posters, was a close friend of the anarchist leader Grave from 1887 on, and the friendship played a decisive part in his outlook. In style a pointillist from that year, he frequently painted streets and buildings in his home city of Paris (pp. 295, 374, 375). In figure work he retained a realistic approach to social actuality. Neo-Impressionist technique later constituted only one of the visual options he combined with his exact draughtsmanship.[144]

The young Lucien Pissarro (1863–1944) had a flair for brief brushstrokes combined with very light, dustily pale points. He used his technique to paint humanized landscapes of a kind his father liked to do (p. 274). He counterbalanced spatial depth with a tendency to emphasize surfaces which went hand in hand with his preference for graphic and illustrative work. After 1883 he went repeatedly to England, settling there for good in 1890; he married a Jewish Englishwoman and became a British citizen in 1916. His Eragny Press (established 1894), named for his home village, became one of the most highly respected small publishers in the new European movement of printed book art. In 1919, with the Belgian Théo van Rysselberghe (1892–1926) and the Englishman James Bolivar Manson, later director of the Tate Gallery in London, he founded the short-lived Monarro Group to promote the influence of the French Impressionists on English art. Pissarro was well regarded by various points on the art spectrum. For some years he alternated between pointillism and old-style Impressionism. His whole life long he painted attractive, if not especially inspired, English and French landscapes, the views always free of tension and sometimes seeming a little clumsy.

In his divisionist work, his father, Camille Pissarro, retained his scenes of land under cultivation, mostly tranquil farm or garden work or river landscapes, almost all near his new home at Eragny-sur-Epte or in Paris. He preferred minimal strokes to Seurat's dots. Whenever he pictured buildings, fields and trees together, as in the view from his window (p. 312) or his intriguing misty scene at Rouen harbour (p. 312), his old penchant for firm linearity and cubic compositional components became apparent. Pissarro preferred a constructive visual structure, even if the light was flickering and the section chosen seemingly random.

Vincent van Gogh
Portrait of Père Tanguy, 1887
Oil on canvas, 92 x 75 cm
F 363, JH 1351, Walther 282
Paris, Musée Rodin

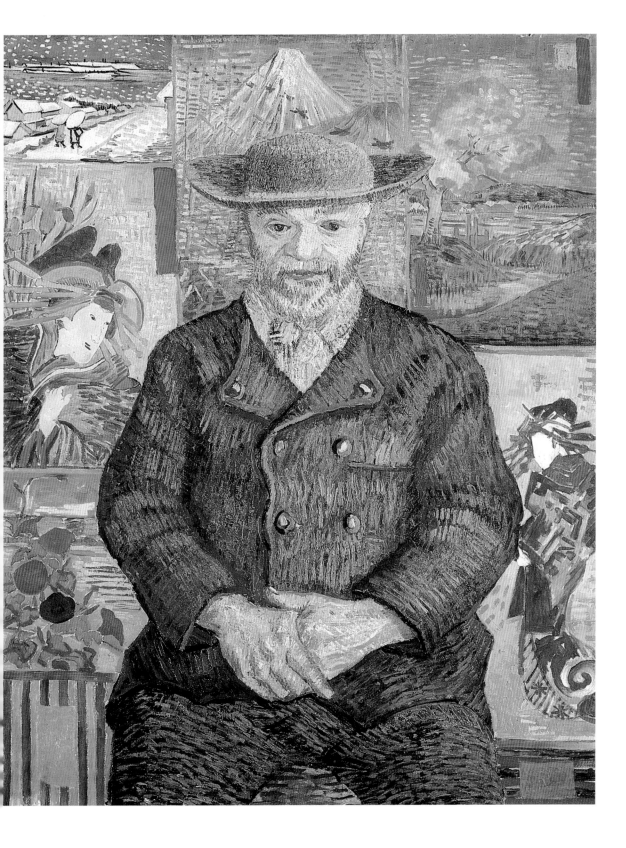

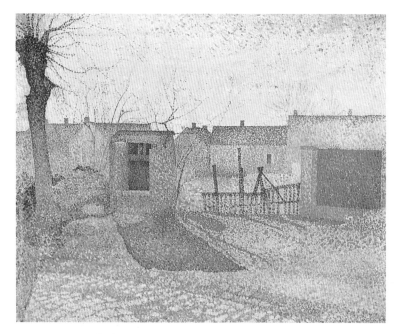

In 1890 – with the impressions of a visit to England fresh in his mind, and prepared by a visit to Holland in 1889 which had reawoken his love of Nature and his admiration of Monet, Degas, Renoir and Sisley[145] – Pissarro put the "systematic divisionism of our friend Seurat" behind him. Looking back in 1896, he wrote to the Belgian architect, painter and designer Henry van de Velde (1863–1957) that the "so-called scientific theory" of Seurat was "an aesthetic diametrically opposed" to life and movement. It had made it impossible for a man of his temperament to remain true to what he felt: that is, "to convey life and movement, or

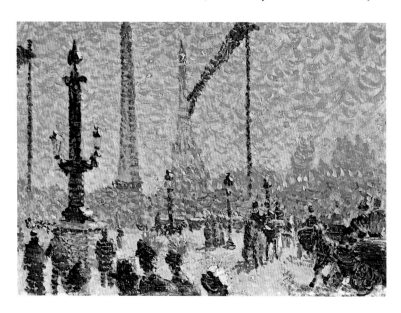

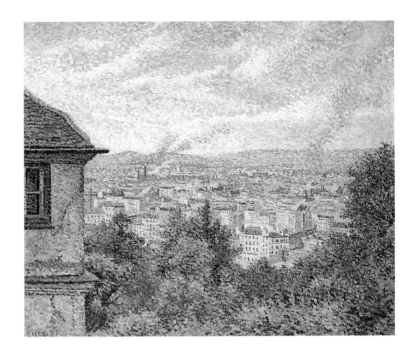

the wonderful way Nature simply happens to look... Fortunately, it turned out that I was not the man for this kind of art, which makes an impression of deadly monotony on me."[146]

Pointillism remained central for only a few painters. As a style in its own right, it was a brief transitional phase in the history of art, yet releasing the hitherto unknown luminous force of pure colours by "dividing" them optically was to prove important for much that followed.

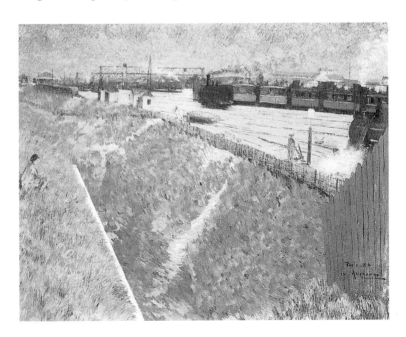

Claude Monet
Young Girls in a Boat, 1887
Jeunes filles en barque
Oil on canvas, 145 x 132 cm
Wildenstein 1152
Tokyo, National Museum of Western Art,
Matsukata Collection

Claude Monet
Boating on the River Epte, 1890
En canot sur l'Epte
Oil on canvas, 133 x 145 cm
Wildenstein 1250
São Paulo, Museu de Arte de São Paulo

Claude Monet
The Boat, 1887
La barque
Oil on canvas, 146 x 133 cm
Wildenstein 1154
Paris, Musée Marmottan

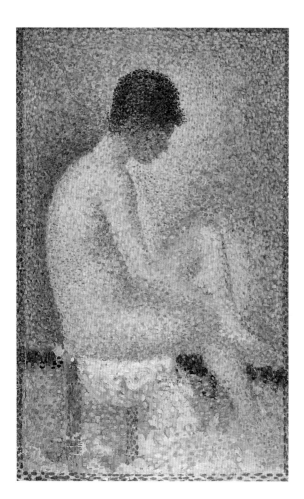
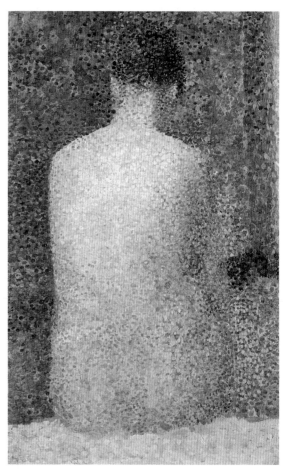

Georges Seurat
Seated Female Nude
(Study for "The Models"), c. 1886/87
Poseuse de profil
Oil on panel, 25.4 x 16.2 cm
Dorra/Rewald 175; De Hauke 182
Paris, Musée d'Orsay

Georges Seurat
Model from Behind
(Study for "The Models"), c. 1886/87
Poseuse de dos
Oil on panel, 24.5 x 15.5 cm
Dorra/Rewald 176; De Hauke 181
Paris, Musée d'Orsay

Despite the overall monotony of the exacting system, stripping artists of their individuality, the personal achievement of Seurat remains. The tenacious consistency with which he structured his visual ideas was arresting, as was the unflinching intensity he brought to his labours.

The Synthetist Moment

In the late 1880s, a number of young artists rejected Impressionism and Neo-Impressionism alike after first being fellow travellers for a time. Certain characteristics of Impressionism remained in their techniques, which may be called Post-Impressionist. One formal feature was a stronger emphasis on two-dimensional surface spaces, and greater freedom with colour and line. Representation of what the eye saw was displaced by the tonal harmonies inherent in the picture itself.

This principle of space had already interested Manet, and was apparent in Monet's loose brushwork and especially the uniform dots of Seu-

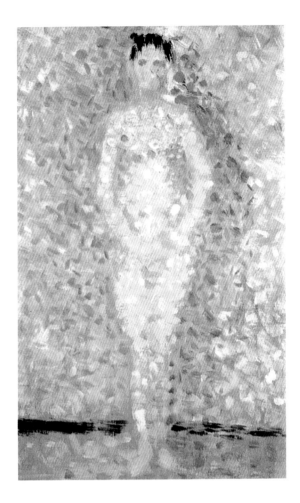

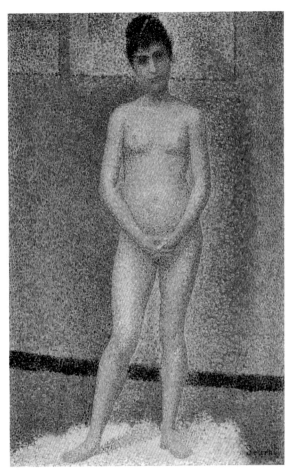

rat. But now the new artists were interested in larger, homogeneously coloured zones enclosed in their own contours (the *cloisons*). The picture was to be a synthesis, a coherent and autonomous entity, and not an analysis of reality, motion and phenomena of colour and light. Accordingly, the subjective establishment and interpretation of subjects was rated higher than looking at Nature through an individual temperament.

Every new movement finds it *de rigueur* to appeal to a historical tradition. In this case, the line was traced back to the very beginnings, to the primitive. The endeavour was comparable with the responses of Rousseau and the Romantics to the decline of absolutism and the startling beginnings of the industrial revolution in the later 18th century, and it took its place in a varied current of Neo-Romanticism. The new artists struck a distinctive note in the high value they placed upon the decorative, and their openness to the applied arts. They admired the way older cultures, where the makers of art had been craftsmen, took it for granted that utility objects could be decorated. A decorative pattern of shapes and colours could possess an autonomous beauty all its own, they felt – a beauty that was aesthetically perfect and sensuously enhanced the

Georges Seurat
Standing Female Nude
(Study for "The Models"), 1887
Poseuse de face, debout
Oil on panel, 25.4 x 16.2 cm
Dorra/Rewald 173; De Hauke 179
Paris, private collection

Georges Seurat
Standing Female Nude
(Study for "The Models"), 1887
Poseuse de face, debout
Oil on panel, 25 x 16 cm
Dorra/Rewald 174; De Hauke 183
Paris, Musée d'Orsay

quality of life. In other words, these artists too were rebelling against the academic hierarchies.

Gauguin became the central figure in this movement, even if certain other painters practised its preachings more doggedly, and his work alone came to be accorded the highest place in the history of Post-Impressionist art. In early 1891, the critic G.-Albert Aurier (1865–1892) took Gauguin's work as his point of reference for an account of Symbolist aesthetics, writing a second article on the subject shortly before his early death. The new art, he declared, "aims not to picture objects, as even Impressionism did (which was merely a variant of realism)... but rather to articulate ideas by putting them into a particular idiom." Objects were no more than "signs" for artists, who then recorded them in simplified form. The work of art should instead be "ideational", since its sole ideal was to express ideas; "symbolic", because it expressed them through shapes; and "synthetist", because the object was not grasped *qua* object but as a sign standing for an idea. And for these reasons it should also be "decorative", since truly decorative painting – as with the Egyptians, and probably the Greeks and primitive painters too – was an artistic creation at once subjective, synthetist, symbolic and ideational. To this tautological position Aurier added his assessment of Gauguin as

Georges Seurat
The Circus Parade, c. 1887/88
La parade de cirque
Oil on canvas, 99.7 x 150 cm
Dorra/Rewald 181; De Hauke 187
New York, The Metropolitan Museum of Art

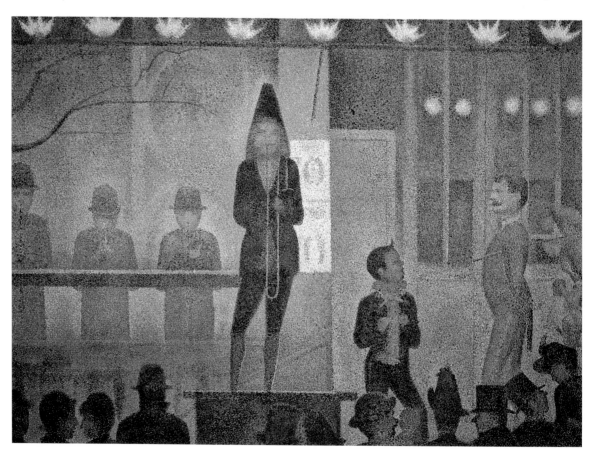

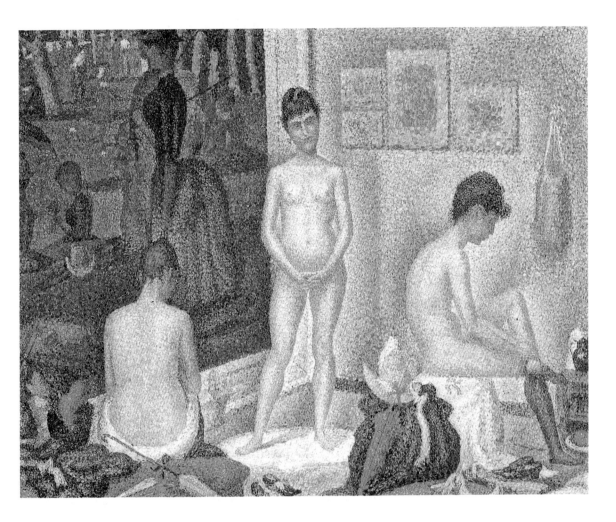

a savage (recalling the "noble savage" of 18th-century utopias). He concluded with the demand that the walls of public buildings be placed at the disposal of this artist of genius, Gauguin, for the painting of enormous decorative murals.[147] (Cézanne too hankered after commissions for mural work some time later, but his wishes were similarly in vain.)

Gauguin esteemed Cézanne's art but rejected Seurat's pointillism. Till his first stay at Pont-Aven in 1886 he painted similarly to his mentor, Pissarro, and afterwards too he continued to use Impressionist techniques intermittently. Even his motifs – rural genre scenes, landscapes, animals and even still lifes – tended to remain within the traditional Impressionist compass. *The Four Breton Girls* (p. 265), though, heralded a decorative spatial rhythm that evoked movement and song in a way that went beyond representation. There is a radical distinction to be drawn between this veritably ceremonial presentation of unfamiliar gestures and old-style folklorish art.[148] Gauguin's aim was to return, through learning, to roots that he felt to be of greater value.

A key painting was the 1888 *Vision after the Sermon: Jacob Wrestling*

Georges Seurat
The Models (small version), 1888
Les poseuses
Oil on canvas, 39.4 x 48.7 cm
Dorra/Rewald 179; De Hauke 184
Paris, Heinz Berggruen Collection
(On loan from the National Gallery, London)

Paul Gauguin
L'Arlesienne (Madame Ginoux), 1888
Crayon and charcoal on paper, 56.1 x 49.2 cm
San Francisco, The Fine Arts Museum,
Achenbach Foundation

with the Angel (p. 303). The Breton women returning home from church, and the priest, are foreground onlookers as in Degas's theatre paintings. What they are witnessing is about as far away from them as Degas's dancers would be from a theatre box, and the two spatial levels are as uncompromisingly juxtaposed. But here what they see – the vision recorded in Genesis 32, 24–29 – appears to their mind's eye alone. The biblical scene is kept apart from them by a tree trunk (the diagonal clearly influenced by Japanese art), the spatial position of which remains unclear, and the ground is an unreal and overwhelming glow of red.

This painting, which was too innovative to be accepted by many contemporaries, broke new stylistic ground, along with Sérusier's talisman painting *The River Aven at Bois d'Amour* (p. 320) and the work of Anquetin (p. 306). In fact it was Anquetin (who later lapsed into a traditionalism of no interest) who reconciled Impressionism and an almost surreal use of spatial decorativeness in his grand painting *A Gust of Wind on the Seine Bridge* (1889; Bremen, Kunsthalle Bremen). Gauguin was expressly seeking after stylized rather than mirror images. "This year I have sacrificed everything, technique, colour, to style," he observed – meaning

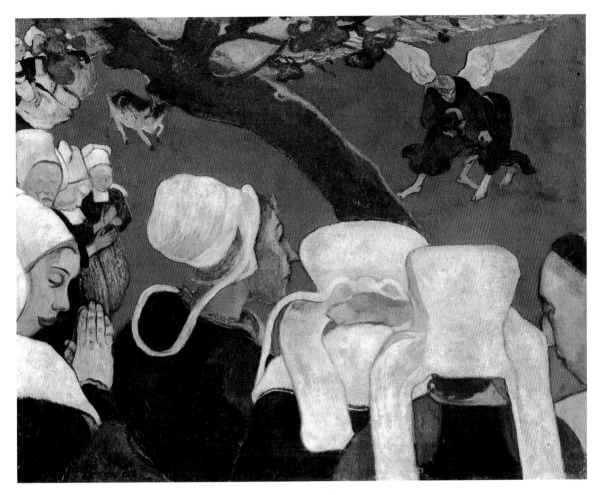

an autonomous uniform order of shapes. The emphasis on style was a core feature of Symbolism.

In late 1888, Gauguin and van Gogh made their famous attempt to work together in Arles and learn from each other (p. 302). The Dutch painter was the more committed to the enterprise, which foundered on differences of temperament and aesthetics. In 1891 Gauguin set out for the South Seas, to Tahiti (a French colony). The artistic fruits of that journey, exhibited during his return stay in France from 1893 to 1895, did not bring him the success he hoped for. Till his death in 1903 he then remained first on Tahiti and then finally on Hiva-Oa (Dominique), one of the Marquesas Islands. Full of inner contradictions, complicated in his behaviour, fighting for fame and against the colonial authorities, and a victim of syphilis in the end, he made a genuine attempt to understand the world-view and mythology of the native peoples. In his poeticized autobiographical account, *Noa Noa*, first published in the *Revue blanche* in 1897, he sought to bring his alien realm closer to a Europe that was not without a taste for the exotic. But his utopian notion that he could become a child of Nature like the indigenous women he lived

Left:
Paul Gauguin
Night Café in Arles (Madame Ginoux), 1888
Au café (Mme Ginoux)
Oil on canvas, 72 x 92 cm
Wildenstein 305
Moscow, Pushkin Museum of Fine Art

Paul Gauguin
Vision after the Sermon: Jacob Wrestling with the Angel, 1888
La vision après le sermon ou La lutte de Jacob avec l'ange
Oil on canvas, 73 x 92 cm
Wildenstein 245
Edinburgh, National Gallery of Scotland

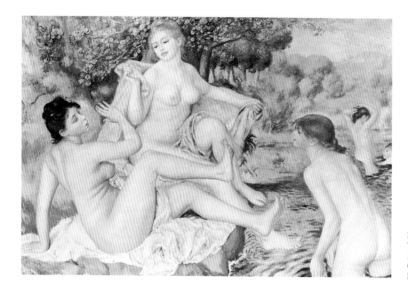

Pierre-Auguste Renoir
The Bathers, 1887
Les grandes baigneuses
Oil on canvas, 118 x 170 cm
Philadelphia (PA), Philadelphia Museum of Art

with was a delusion as long as he continued to draw money transfers from the Paris agent who handled his art (ranting all the while against capitalism and bourgeois culture).

His paintings, though, brought honest integrity and a real appreciation to bear on the beautiful "golden bodies" of the indigenous people and on the resplendent colours of Nature in the tropics (pp. 334/335). The Polynesian titles he gave his paintings were intended (in line with his Symbolist views) to deepen their mysterious allure. The poses in which we see his nude or semi-nude people – relaxed, about their everyday business, pictured realistically – are eloquent of peace and tranquillity; it is, however, a peace that is often examined psychologically, and clouded by sadness or the fear of demons. These people harmoniously occupy an environment that is rendered in flat, ornamental terms. The outlines, proportions and details are all subject to the simplification and some-what awkward coarseness characteristic of primitive art. Gauguin also quoted the hallmarks of ancient Egyptian art (p. 333). The gravity and enigmatic otherness of certain attitudes transform commonplace poses into cultic images of magical force (pp. 332, 352). Gauguin's simple brushwork and intensely contrastive colours largely retain the Impressionist approach to three-dimensionality through shadow, patches of light and an extensive use of green.

Gauguin hoped that Bernard would accompany him to the South Seas. Bernard's work included a vigorous, concentrated portrait of Père Tanguy (p. 290), the indefatigable supporter of innovatory artists. But the two artists fell out. Bernard was shortly to return to a traditional, historical technique. So too was Sérusier, who had enrolled at the independent Académie Julian with several others in 1888. A group of friends was established who were ardent adherents of synthetism, sought the symbolist advice of Redon, and revered both Puvis and Cézanne. The group of young artists were semi-seriously seized by religious and mys-

Right:
Pierre-Auguste Renoir
After the Bath, 1888
Après le bain
Oil on canvas, 65 x 54 cm
Tokyo, private collection

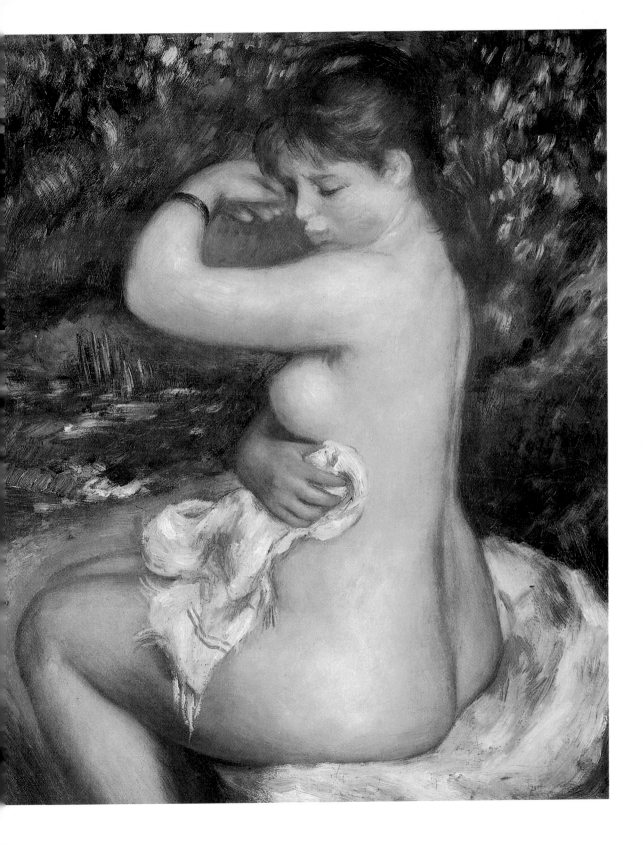

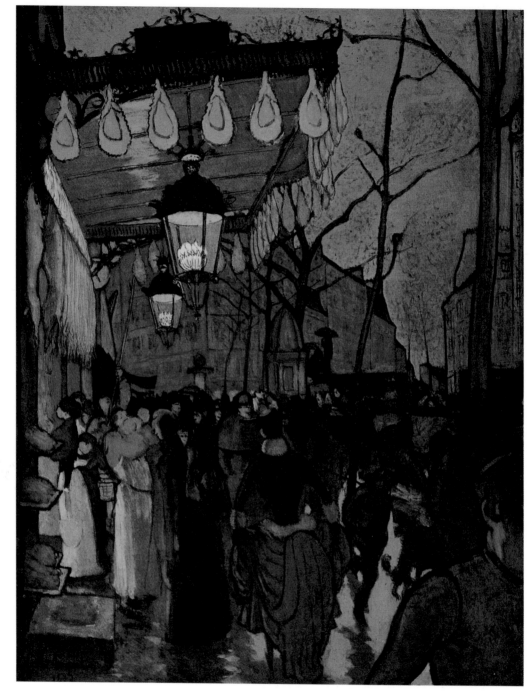

Louis Anquetin
Avenue de Clichy – Five O'Clock in the Evening, 1887
Avenue de Clichy – cinq heures du soir
Oil on canvas, 69 x 53.5 cm
Hartford (CT), Wadsworth Atheneum

Charles Angrand
Man and Woman in the Street, 1887
Couple dans la rue
Oil on canvas on card, 38.5 x 33 cm
Paris, Musée d'Orsay

Paul Cézanne
Boy in a Red Waistcoat, c. 1888–1890
Garçon au gilet rouge
Oil on canvas, 79.5 x 64 cm
Venturi 681
Zurich, E.G. Bührle Collection

Paul Cézanne
Still Life with Flowers and Fruit, 1888–1890
Nature morte aux fleurs et fruits
Oil on canvas, 65 x 81 cm. Venturi 610
Berlin, Alte Nationalgalerie, Staatliche Museen
zu Berlin – Preußischer Kulturbesitz

tical feeling, but were equally intent on provocative media impact; Sérusier gave them the Hebraic name Nabis (prophets), and indeed their regular meeting place in the home of one member was declared a temple. One of their number, the Dutchman Jan Verkade (1868–1946), took monastic orders not long after. From 1891 the Nabis exhibited at Le Barc de Boutteville, the gallery which had previously promoted the Neo-Impressionists and Symbolists. Several of the artists attempted to meet Aurier's demand for an all-embracing synthesis of art forms by designing stage sets for small avant-garde theatres, posters, and tapestries.

One of their leading theorists was Maurice Denis (1870–1943), who was influenced by Gauguin and subsequently played an important part in religious art. *The Muses* or *In the Park* (1893; p. 341) is a good example of how an open-air Impressionist genre scene can be transformed into a rhythmic, decorative tapestry. The ethereally slender, sensitive, ivory-pale figures are established in soft, flowing lines; their manner has a ceremonial remoteness, so that they seem supernatural beings in some mysterious sacred grove. This, certainly, was a triumph of style,

Léo Gausson
Undergrowth, 1888
Sous-bois
Oil on panel, 31.7 x 26.7 cm
Michigan, private collection

Armand Guillaumin
Outskirts of Paris, c. 1890
Environs de Paris
Oil on canvas, 74 x 93 cm
Serret/Fabiani 210
USA, Mrs. Lyndon Baines
Johnson Collection

Albert Dubois-Pillet
The Marne at Dawn, 1888
La Marne à l'aube
Oil on canvas, 32 x 46 cm
Paris, Musée d'Orsay

overlaid on the legacy of the preceding generation. Denis did later use a sprightly, pallid, bright Impressionist technique of dabs, though.

In 1890, aged just twenty, he had published an article in a little magazine which dealt with "Neo-Traditionalism", it is true, but in its preamble calmly stated what was to be a central creed of Modernism: "One must bear in mind that before a painting is a warhorse, a naked woman or an anecdote, it is essentially a flat surface covered with colours arranged in a particular way."[150]

Light for the World

In 1888 Gauguin, van Gogh and Bernard painted portraits of each other, and self-portraits, to seal their artistic brotherhood.[151] It was for this group that van Gogh hoped the yellow house in Arles (p. 315) – which he had used a modest legacy to fit out and paint – would serve as home and studio; he proposed to hang pictures of sunflowers there in such a

Camille Pissarro
View from the Artist's Window at Eragny,
c. 1886–1888
Vue de ma fenêtre, Eragny sur Epte
Oil on canvas, 65 x 81 cm
Pissarro/Venturi 721
Oxford, The Visitors of the Ashmolean Museum

Camille Pissarro
Lacroix Island, Rouen, in Fog
L'Ile Lacroix, Rouen, effet de brouillard
Oil on canvas, 46.4 x 55.6 cm
Pissarro/Venturi 719
Philadelphia (PA), Philadelphia Museum of Art,
John G. Johnson Collection

Albert-Charles Lebourg
Road on the Banks of the Seine at Neuilly in
Winter, c. 1888
Route au bord de la Seine, à Neuilly, en hiver
Oil on canvas, 50 x 73 cm
Bénédite 963. Paris, Musée d'Orsay

Alfred Sisley
Moret-sur-Loing in Morning Sun, 1888
Vue de Moret-sur-Loing, soleil du matin
Oil on canvas, 60.5 x 73.5 cm
Daulte 678. Private collection

Vincent van Gogh
The Sower, 1888
Oil on canvas, 32 x 40 cm
F 451, JH 1629, Walther 453
Amsterdam, Rijksmuseum Vincent van Gogh,
Vincent van Gogh Foundation

way as to recall an altar.[152] Many things met in this hope: a realistic appropriation of visible reality; a wish to use art for democratic, Christian or missionary, and anarcho-socialist ends; decorative beautifying of the place one lived in; and a Symbolist approach to the deeper significance of things and the emotional impact of colour and form harmonies.

Van Gogh adopted these views, and particularly the Impressionist and pointillist techniques, from 1886 to 1888 in Paris. He devoured the Impressionists' subjects. He schooled his sense of colour by painting countless floral still lifes, and did at least fifteen paintings of the old Moulin de la Galette (p.276), which may have reminded him of Holland – though he had never painted a windmill when he was there. His views of the city, of walkers in the park, the Seine, or avenues (pp.277, 280, 289) were among the best that Impressionism produced – even if an undisciplined brushwork or a confrontational approach to objects and forms could sometimes mar the effect. *Fishing in Spring, Pont de Clichy* (p.288) affords an instructive comparison with Monet's tranquil *The River* (p.76) painted twenty years earlier. Van Gogh painted countless

self-portraits, and in his portraits of ordinary people his fellow feeling led him to emphasize their sadness, dignity and kindness. The *Portrait of Père Tanguy* (p. 293) is a good example.

In February 1888 he moved to Arles, where the light was brighter and the colours more luminous. He was tireless in his quest for subjects that would provide the happiest accord between things seen and his own sensations. He changed his colours, made them more robust, and composed in contrasts. Van Gogh wanted his pictures to serve humankind, to bring them light; at the same time, he was determined to make no concessions where his artistic aim of honest self-expression was concerned, despite the fact that his brother, Theo, was unable to sell his work in Paris. In material terms, Vincent was totally dependent on Theo, who believed in his brother's artistic vision. Van Gogh quoted revered realists such as Millet in works like *The Sower* (p. 314). Hours on end spent painting in the open almost gave him sunstroke. He wanted to sow light for the world; painting had become identical with life itself.

At Christmas 1888 the failure of his venture with Gauguin (who

Vincent van Gogh
Vincent's House in Arles (The Yellow House), 1888
Oil on canvas, 72 x 91.5 cm
F 464, JH 1589, Walther 423
Amsterdam, Rijksmuseum Vincent van Gogh,
Vincent van Gogh Foundation

Van Gogh's "yellow house" in Arles, where he lived from May 1888 till April 1889

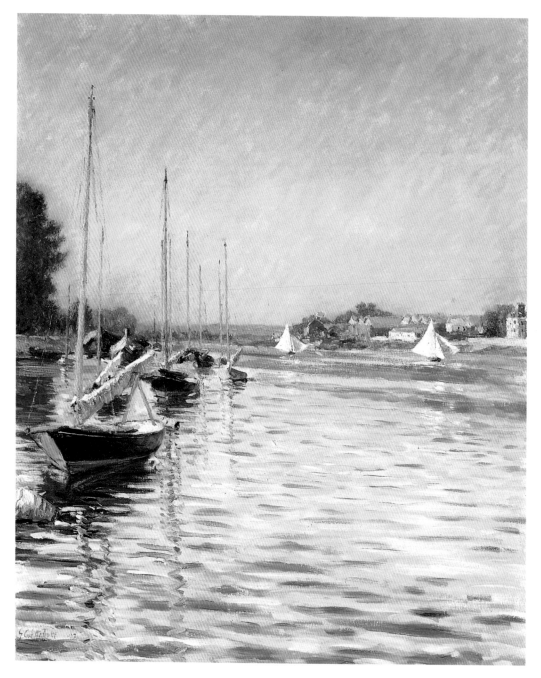

Gustave Caillebotte
Boats on the Seine at Argenteuil, 1892
Bateaux sur la Seine à Argenteuil
Oil on canvas, 73 x 60 cm
Berhaut 413
London, Richard Green Gallery

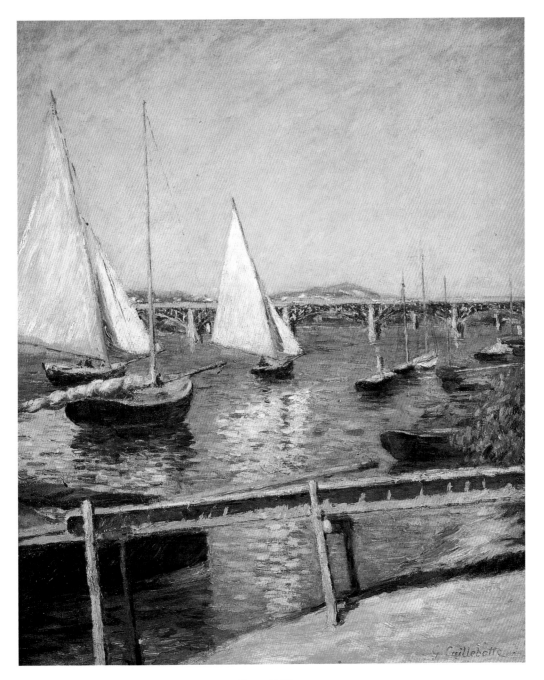

Gustave Caillebotte
Sailing Boats at Argenteuil, c. 1888
Voiliers à Argenteuil
Oil on canvas, 65 x 55.5 cm
Berhaut 359. Paris, Musée d'Orsay

thought in more businesslike ways) prompted van Gogh's symbolic act of self-mutilation: he cut off an earlobe. In dedicating his act to a prostitute, the marginalized and humiliated artist (who could still be used for pleasure) was associating himself with her in his own philosophy. At that point van Gogh had nineteen months to live, and spent some of that time under psychiatric treatment. When finally Dr. Gachet at Auvers, the old friend of the Impressionists, decided to look after him, Vincent shot himself in the very fields he had so often painted. In those nineteen months he had painted about 255 further pictures, the subjects, angles, colours and free brushwork of which went notably beyond Impressionism. Indeed, the intense colours and the dramatic shapes (as in his flamelike cypress trees and swirling stars) anticipated Expressionism. But it is fair to assume that the pleasure the Impressionists took in the things of the world, their accessibility, and the beauty of their colours, played a significant part in putting paintings by the impoverished van Gogh at the top of today's art price range.[153]

The Pain of Pleasure

Toulouse-Lautrec was not yet twenty when in 1882, already in full command of Impressionist techniques and ways of seeing, he painted his port-

Georges Seurat
Le Chahut, c. 1889/90
Oil on canvas, 171.5 x 140.5 cm
Dorra/Rewald 199; De Hauke 199
Otterlo, Rijksmuseum Kröller-Müller

Georges Seurat
Dancers on Stage (Study for "Le Chahut"), 1889
Danseuses sur la scène (Etude pour «Le Chahut»)
Oil on panel, 21.8 x 15.8 cm
Dorra/Rewald 197; De Hauke 197
London, Courtauld Institute Galleries

Georges Seurat
Young Woman Powdering Herself, c. 1889/90
Jeune femme se poudrant
Oil on canvas, 95.5 x 79.5 cm
Dorra/Rewald 195; De Hauke 200
London, Courtauld Institute Galleries

Paul Signac
Woman Taking up Her Hair, 1892
Femme se coiffant
Oil on canvas, 59 x 70 cm
Paris, Collection Mme Gachin-Signac

Paul Sérusier
The River Aven at Bois d'Amour (The Talisman), 1888
L'Aven au Bois d'Amour (Le talisman)
Oil on panel, 27 x 21.5 cm
Guicheteau 2. Paris, Musée d'Orsay

Georges Seurat
Portrait of Paul Signac, 1890
Conté crayon on paper, 34.5 x 28 cm
De Hauke 694. Private collection

rait *Young Routy* (p.227). At Cormon's studio he met the Post-Impressionists, subsequently exhibiting with them at the Indépendants and the Brussels exhibitions of Les Vingt. But he was not the man for binding group ties. He wanted companions to talk to or drink with, and that was all. He was quick to adopt the cloisonnists' large, strong colour spaces with their defined linear boundaries in his own formal idiom. For Toulouse-Lautrec, though, an expressive, swinging line like a whiplash (such as soon became the hallmark of Art Nouveau) was more important than it would ever be for his friend Anquetin or for Gauguin. Above all, he retained to the end a light, nervy sketchiness in his painting technique; a delight in capturing grotesque movement and the effects of artificial light; and an interest in unusual sectional views and plunging depth perspective of a kind he had admired in Forain and especially Degas. He did an airy but firmly structured pastel portrait of van Gogh, whom he had met at Cormon's (p.278), showing him at the Café du Tambourin, run by Agostina Segatori (cf. van Gogh's portrait of her, p.287). The grainy paper had much the same effect of loosening up the pastel as it had had when Seurat tried the same approach.

Paul Signac
Portrait of Félix Fénéon in Front of an Enamel of a
Rhythmic Background of Measures and Angles,
Shades and Colours, 1890
*Portrait de Félix Fénéon sur l'émail d'un fond ryth-
mique de mesures et d'angles, de tons et de teintes*
Oil on canvas, 73.5 x 92.5 cm
New York, The Museum of Modern Art

Van Gogh doubtless liked the interest in people and their fates that Toulouse-Lautrec attested in his outstanding portraits and genre scenes from those years. Toulouse-Lautrec was a skilful draughtsman, far better able than van Gogh to capture character, temperament and the momentary mood of a person in facial expression, gestures and – most of all – body language, and, through these, that person's social situation. The realism of Courbet or Zola survived in Toulouse-Lautrec with an intensity alien to his Symbolist contemporaries. He painted Carmen Gaudin, a blonde working woman who often modelled for him, as a tired laundress (p. 243) gazing with longing out of her top floor window at the wide world without. We see her very slightly from below, so that the woman, propped firmly on her arms, shoulders and back tensed, makes a more rebellious impression than any similar figure between Degas and the young Picasso, or any of the other figures at windows that had been a 19th-century visual stock in trade ever since the Romantics.[154]

As a wealthy aristocrat, Toulouse-Lautrec was hardly destined by birth to be alert to the social issues that were growing more acute in his

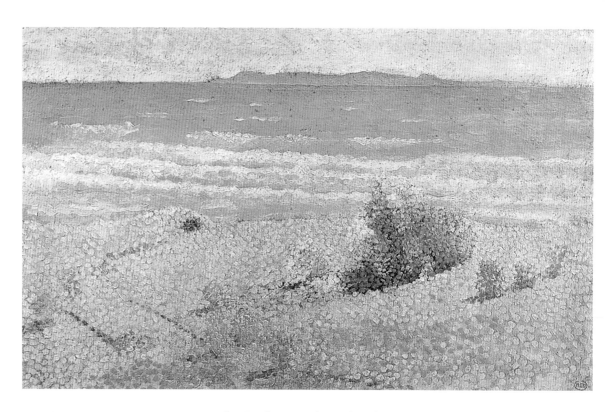

Henri-Edmond Cross
Beach on the Mediterranean, c. 1891/92
La plage en Méditerranée
Oil on card, 38 x 61 cm
France, private collection

day. But his own physical misfortune had made him more sensitive to the lot of others. Of course he was a rich man going to the theatres and revues and cafés-concert[155] in quest of entertainment; but his dwarfish stature meant the cost was twice as high for him. He developed an acute sense of the polarity between the professional life of dancers and prostitutes, and the simple humanity they preserved in what private life remained to them. He did psychologically penetrating *plein-air* portraits of some of them in the garden of Père Forest's Montmartre inn, where he was living from 1884.

Toulouse-Lautrec's subject matter, including most of his situation portraits, was drawn from the theatre, variety shows and the circus, from restaurants, horse racing and brothels. Some of his best work showed the Moulin Rouge (pp. 324, 325) in the Boulevard de Clichy, which had been opened in late 1889, the year of the World Fair. Those who went there were doubtless upright middle-class citizens, but the dancing was eccentric and challenging, of a kind associated with robuster folk entertainment. One of the establishment's stars was the temperamental La Goulue (Louise Weber, 1870–1929), another the lean Valentin (Jules Renaudin), nicknamed Le Désossé (boneless) for his agility. The sectional views, spatial sense, alternation of light and dark and of colours and lighting effects, as well as his sketchy technique, all reveal Toulouse-Lautrec's debt to the Impressionists in these works; the contour lines that define his almost silhouetted figures, on the other hand, are synthetist.

Henri-Edmond Cross
The Golden Isles, 1891/92
Les Iles d'Or
Oil on canvas, 59 x 54 cm
Compin 36. Paris, Musée d'Orsay

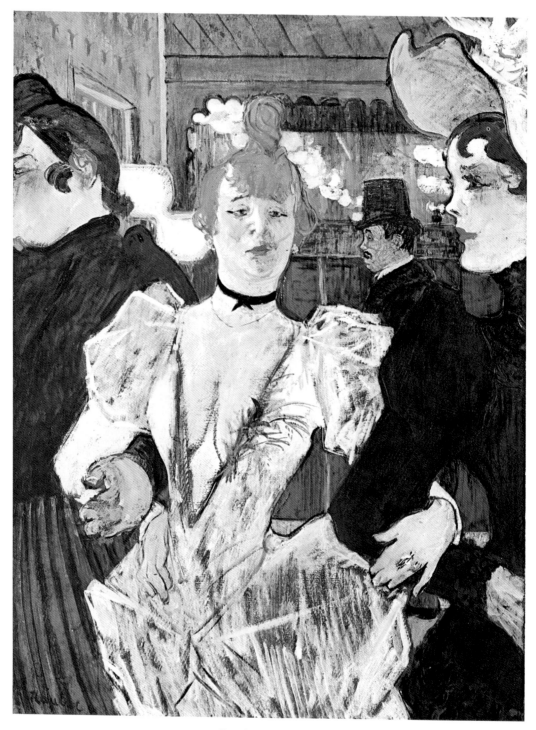

Henri de Toulouse-Lautrec
La Goulue Entering the Moulin Rouge, 1892
La Goulue entrant au Moulin Rouge, accompagnée de deux femmes
Oil on card, 79.4 x 59 cm. Dortu 423
New York, The Museum of Modern Art, Gift of Mrs. David M. Levy

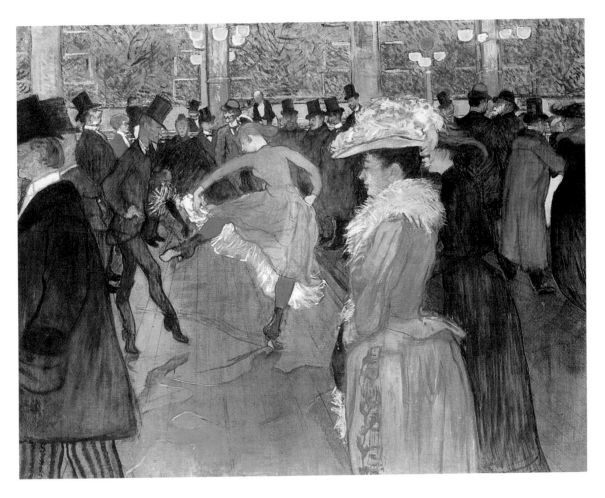

Henri de Toulouse-Lautrec
A Dance at the Moulin Rouge, 1889/90
La danse au «Moulin Rouge»
Oil on canvas, 115.5 x 150 cm
Dortu 361
Philadelphia (PA), Philadelphia Museum of Art

The owner of the Moulin Rouge realised that this new customer who could hold his drink had a novel, provocative style in art that could make attractive advertising for the establishment – better, certainly, than the sickly-sweet small posters done hitherto by Jules Chéret (1836–1933). In October 1891 Toulouse-Lautrec's first poster was on the walls of Paris, a large colour lithograph that emphasized blocks of space. Along with the France-Champagne poster by the young Pierre Bonnard (1867–1947), a member of the Nabis, this inaugurated a new era in poster graphics. Thanks to its openness to applied arts conceived as a mass product for a mass audience, advertising henceforth became a medium well suited to daring graphic experiment. Toulouse-Lautrec did another thirty lithographic posters for literary cabarets, chanson singers and publishers. On several occasions (including superlative portraits) his subject was the dancer Jane Avril (1868–1943), who performed on a variety of stages. The structure of the picture showing her at the Jardin de Paris (p. 327) is clearly a variation on themes by Degas. The bold elegance of the singer Aristide Bruant (p. 327), or the almost demonic idiosyncrasy perceived in a violinist in another poster, went beyond Impressionism.

At the Moulin Rouge. La Goulue is on the floor

Jane Avril. Photograph

Louis Anquetin
Girl Reading a Newspaper, 1890
Jeune femme lisant un journal
Pastel on paper on card, 54 x 43.5 cm
London, The Tate Gallery

Louis Anquetin
In the Theatre Foyer, 1892 *(Au foyer du théâtre)*
Oil on canvas. Private collection

The self-assurance and charisma of La Goulue fascinated Toulouse-Lautrec. In 1895, when she had put on so much weight (her nickname meant "glutton") that she only appeared in a dive of her own, he painted wall drapes of coarse canvas showing her in several of her famous numbers, for the premises. He had already painted her provocative if nervous entry into the Moulin Rouge, with her sister and a fellow performer (p. 324), and had conveyed something of the psychological pressure show business exerts on its stars. In all his work, men – including his friend and cousin, Dr. Gabriel Tapié de Céleyran (1869–1930) – tended to be subject to spiteful caricaturist swipes; prostitutes in brothels, on the other hand, though shown in unbeautiful coarseness, prompted a warm fellow feeling in him. He was interested in the way they behaved to each other outside their work, and in their lesbian relations, a private emotional realm which they opposed to their business world of sex (pp. 344, 345). In fact Toulouse-Lautrec sometimes even lived in brothels. His economical, assured, "unfinished" studies recorded the movements of models who were altogether uninhibited. To his painter's eye, hungry for form, they seemed more natural and thus lovelier than professional models with their polished poses.

Toulouse-Lautrec was increasingly indifferent to the offence his family took at his descent into a nether world of vice. From 1893 on he also chose not to enter works for any juried exhibition. His old school friend Maurice Joyant (1864–1930) was working for Goupil's as Theo van Gogh's successor, then partner, and finally sole proprietor of the gallery. It was he who set up the first solo exhibition for Toulouse-Lautrec in

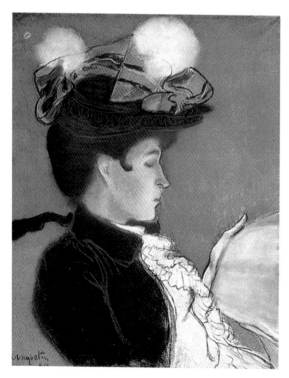

1893, which brought the artist a certain recognition from Degas. Joyant it was as well who received the rights to Toulouse-Lautrec's artistic estate from the artist's father, now a stranger to his wayward son. Alcohol, syphilis contracted in 1888, and sheer disgust at life, were driving Toulouse-Lautrec increasingly to distraction. In February 1899 he collapsed in the Rue des Moulins brothel and was taken to an asylum. Before long he was able to make the escorted journey to Bordeaux, where he set up in a studio and painted his relentlessly forceful final theatre pictures, such as *Messalina with Two Extras* (Zurich, Collection E. G. Bührle). For the last three weeks of his life he was tended by his beloved mother at Château Malromé, where he died two months before his thirty-seventh birthday. Through this idiosyncratic offshoot, something of the Impressionist heart had continued to beat into the 20th century.

Henri de Toulouse-Lautrec
Jane Avril at the Jardin de Paris, 1893
Jane Avril au «Jardin de Paris»
Lithograph, 124.5 x 89.5 cm
Wittrock 11. Private collection

Henri de Toulouse-Lautrec
Aristide Bruant at his Cabaret, 1892
Aristide Bruant dans son cabaret
Lithograph, 137 x 96.5 cm
Wittrock 6. Private collection

8 The Fruits of Persistence

Georges Seurat
Study for "The Circus", 1891
Etude pour «Le cirque»
Oil on canvas, 55 x 46 cm
Dorra/Rewald 210; De Hauke 212
Paris, Musée d'Orsay

Georges Seurat
The Circus, 1891
Le cirque
Oil on canvas, 185.5 x 152.5 cm
Dorra/Rewald 211; De Hauke 213
Paris, Musée d'Orsay

By the late 1880s and early 1890s, Impressionism was a firmly established feature of the art landscape, familiar even outside France, and was continually attracting new followers. Its fate was that of every modern creative concept: on the one hand, traditionalists continued to combat the movement, accusing it of abandoning aesthetic norms and, in the broadest of political terms, of undermining the existing order; on the other hand, Impressionism had itself become the target of newer movements with their own new scales of values. Any style is necessarily one-sided and will offer opponents a purchase if they choose to highlight its shortcomings. The Impressionists no longer saw any point in compromising with academic views in order to gain entry to the Salon. Indeed, certain aspects of the Impressionist programme had meanwhile influenced the art that was given official support.

The "reflex responses made by Impressionism"[156] to the alternative aesthetics of younger artists were a quite different matter. The major Impressionist masters never held academic positions and had no pupils worth mentioning, with the exception of Pissarro, who gave advice and encouragement to his juniors over many years. But they did take a close look at whatever tempting innovations the younger artists might have hit upon after first trying to paint in the usual Impressionist ways. And the *zeitgeist* had in any case changed; the aesthetic climate had been transformed. Symbolist and decorative approaches modified the late phase of Impressionism. For that reason, the movement offered no resistance to interpretations of its original intentions made under the influence of Post-Impressionism by well-meaning young critics.

Impressionist art was no longer the domain of a group (and anyway, the group had never been entirely unified or homogeneous from the outset). Rather, the individual artists – even if they were linked by friendships or often exhibited together – were now concerned to conquer the upper reaches of the market and assure their positions in art history. Their exhibitions at commercial galleries in and outside France were of greater importance than the Salons, where they might go unnoticed in the crowd. Changes in prices occasioned by auctions of private collections (generally when the collector died) affected the prices the artists' new works fetched. And they continued the struggle to have the Impressionist contribution to the glorious annals of French art recognised. In

this struggle, their old collective spirit, friendship and mutual esteem stood firm.

The inclusion of 15 Manets in the 1889 World Fair boosted the fame of the artist. His widow, who was in financial straits, still owned important works, such as the epoch-making *Olympia*. When it seemed likely that the painting would be sold to an American, Monet organized a collection to keep the picture in France, for the Louvre. A great many art lovers, intellectuals and artists contributed. Some were too poor to do so. Manet's old friend Zola refused, on the rather strange grounds (for him) that he did not want to be involved in pushing prices up, for the sake of the owners of other Impressionist pictures. Yet the proposed 20,000 francs for *Olympia* were nothing to the 336,000 francs that had

Claude Monet
Poplars on the Banks of the Epte, 1891
Peupliers au bord de l'Epte
Oil on canvas, 88 x 93 cm
Wildenstein 1312. USA, private collection

Right:
Claude Monet
Haystack in the Snow, Morning, 1890
Meule, effet de neige, le matin
Oil on canvas, 65.4 x 92.3 cm
Wildenstein 1280. Boston (MA), Museum of Fine Arts

Claude Monet
Haystack in the Snow, Overcast Weather, 1891
Meule, effet de neige, temps couvert
Oil on canvas, 66 x 93 cm. Wildenstein 1281
Chicago (IL), The Art Institute of Chicago

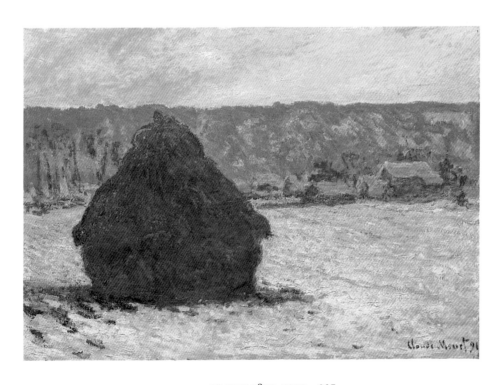

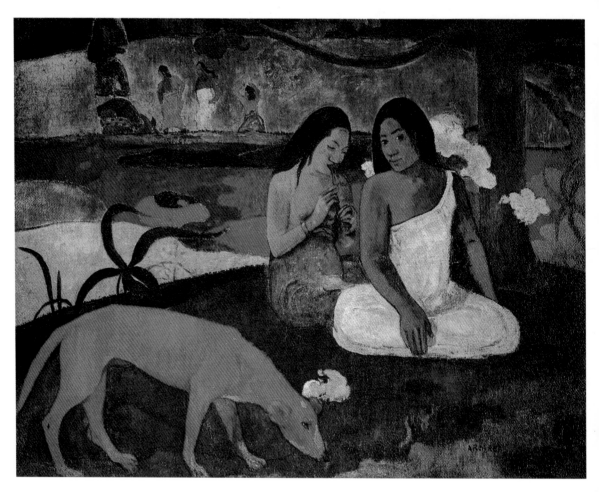

Paul Gauguin
Pastime ("Arearea"), 1892
Joyeusetés
Oil on canvas, 75 x 94 cm
Wildenstein 468. Paris, Musée d'Orsay

been paid in New York in 1887 for a Meissonier, for instance. At the beginning of 1890, *Olympia* was bought for 19,114 francs and donated to the nation. It was placed not in the Louvre, in the event, but in the Palais de Luxembourg, where contemporary art was exhibited.

Individual works by Renoir and Morisot acquired by the state were also added to the Luxembourg's holdings, in particular the legacy of Caillebotte. The controversy is notorious, and was in fact the last hurdle that had to be cleared before the triumph of Impressionism was finally assured.[157] Caillebotte, who died in 1894, had appointed Renoir the executor of his will. On the advice of Léonce Bénédite (1859–1925), director of the Luxembourg, the museum's committee and the Minister of the Arts accepted Caillebotte's bequest of 67 paintings by Manet, Monet, Renoir, Pissarro, Sisley, Degas and Cézanne, and Caillebotte's own *The Floor Strippers*. But then the press intervened, at a delicate political moment. Anarchist unrest had peaked on 24 June 1894 with the assassination of President Sadi Carnot. Following this, anarchist intellectuals such as Luce and Fénéon were arrested, and Pissarro thought it prudent to spend a few months in Belgium. The Dreyfus affair also began in 1894

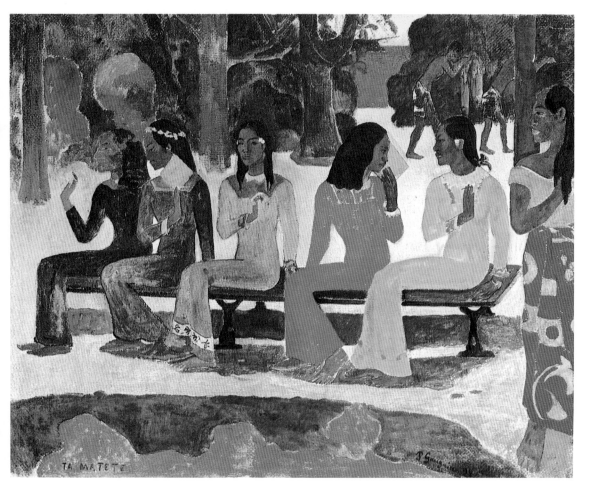

Paul Gauguin
We Shall not Go to Market Today
("Ta matete"), 1892
Le marché
Oil on canvas, 73 x 91.5 cm
Wildenstein 476. Basle, Öffentliche
Kunstsammlung Basel, Kunstmuseum

(October), when the Jewish Captain Alfred Dreyfus was wrongly court-martialled for treason, prompting a wave of anti-semitism (which directly affected Pissarro) and deeply dividing French society, including the Impressionists. Degas broke off his contacts with Jewish friends.

The ministry now considered that the Luxembourg's bulk accession of works by controversial painters posed a problem. Tough negotiations resulted in the rejection of 29 of the pictures in the legacy, among them 11 by Pissarro alone, though none by Degas. This spoke volumes about government tactics; but the controversy became really fierce when the Caillebotte collection was exhibited in early 1897. The Academy of Fine Arts, on a majority of 18 to 10, passed a protest against the insult to French painting. The aged Gérôme gave an interview in which he sounded off against the state for supporting such "rubbish". When a self-important, stupid senator raised the issue in the National Assembly, Henri Roujon (1853–1914), head of the fine-art section of the ministry, replied with calm aptness: "Though most of us will not consider Impressionism to have said the last word on art, we nonetheless agree that it is a viable form of art... and that the evolution of Impressionism, which

Old photograph which, together with an ancient Egyptian bas-relief, inspired "We Shall not Go to Market Today"

Paul Gauguin
Two Women on the Beach, 1891
Femmes de Tahiti ou Sur la plage
Oil on canvas, 69 x 91.5 cm
Wildenstein 434. Paris, Musée d'Orsay

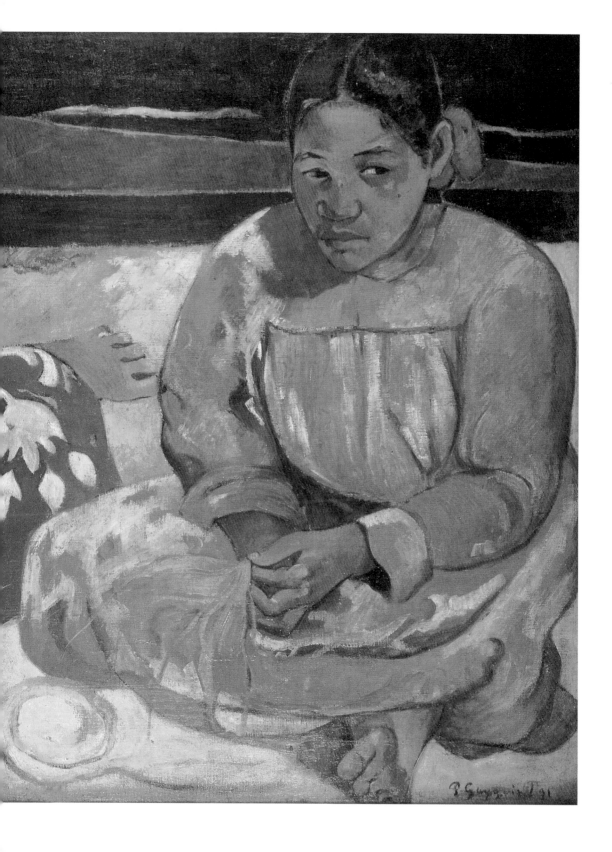

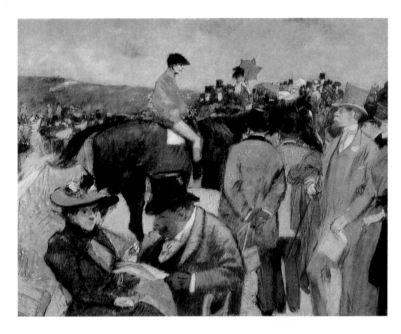

Jean-Louis Forain
At the Races, c. 1890
Aux courses de chevaux
Oil on canvas, 38 x 45 cm
Moscow, Pushkin Museum of Fine Art

does interest some people, constitutes a chapter in the history of contemporary art which we are in duty bound to exhibit on the walls of our museums."

At the 1900 World Fair in Paris, which marked the dawn of the new century, the Impressionists were crammed into a side room; but at the Centennale, the retrospective exhibition of a century of French art, they could not be denied space, especially since the critic Roger Marx (1859–1913) – who had written on Bernard, Gauguin and others and was now responsible for provincial museums – was hanging the show.

Impressionist approaches had spread to the works of other landscape, genre and portrait painters in various ways. Renouard, a painter and graphic artist prized for his fashionable, skilful, inventive city and theatre scenes and portraits, was perceived together with Forain, Chéret and "the great master, Degas".[158] Lebourg – recruited by Degas for the Impressionist exhibitions in 1879 and 1880 – was a member of the Société Nationale who now painted French landscapes in which he chose typical Impressionist motifs and deployed their atmospheric effects (pp. 313, 383). Much the same can be said of the younger Gustave Loiseau (1865–1935), a self-taught painter who experimented with pointillism around 1884, sojourned in Pont-Aven, and then, on his many travels, painted landscapes, mainly featuring rivers and the coast (pp. 378, 379). He was dubbed "the historian of the Seine" because he was adept at what Impressionism was best suited to: recording and celebrating shifting conditions of light and the changes made in a landscape by human hand. He was contracted to Durand-Ruel in 1897. Charles Durand-Ruel, the young boss, saw Loiseau as the most gifted of the second-generation Impressionists.[159]

There were also older painters, such as Louis-Hilaire Carrand (1821–1899) from Lyons, who were tempted into adopting Impressionist viewpoints and techniques. In the mid-80s, Roll, who had caused a furore in 1880 with his *Miners' Strike*, was painting very fine, sensitive, lifesize open-air portraits. A founder member of the Nationale, in 1905 he became its president. That position was previously occupied by Albert Besnard (1849–1934), who had won the Prix de Rome in 1874 and subsequently in London absorbed Pre-Raphaelite influences and tightened the precision of his draughtsmanship. From 1884 on he made skilful use of the Impressionist eye for light, for bright colours, for the presentation of motion, and for motifs happened upon by chance. From 1887, his decorative talent brought him major commissions for ceiling and mural paintings. As the 20th century began he was being seen by some as the finest French painter since Delacroix.[160] When in 1905 he was asked his opinion on the situation of art, he stressed the role of Nature, and particularly of its rhythm; he criticized Impressionism for lacking concentration and thought, but assessed the movement – thanks to Monet, Renoir and Pissarro – as a "glorious period of the past".[161]

Camille Pissarro
The Chat, 1892
La causette
Oil on canvas, 89 x 165 cm
Pissarro/Venturi 792
New York, The Metropolitan Museum of Art

Success and Disappointment at the End of the Century

Renoir had tried to discipline his work by aiming at a classical note. In this he was the first to respond to the anti-sensuous Neo-Traditionalism of the *zeitgeist* as the century ended, and of younger artists' endeavours. Towards 1890, after his dry spell, he returned to colour in full bloom, light brushwork, and, above all, unconditional commitment to what the eye experienced. He was commissioned to paint portraits, which he did in amiable styles with an occasional touch of dramatic life, overlapping with genre work. He frequently stayed at Essoyes in Burgundy, the home town of Aline, whom he married in 1890. The way of life and the people there appealed to him. It was not only because they cost less than professional Parisian models that he liked to paint the young women of Essoyes as laundresses. He had a strong intuitive sense of their healthy physical rapport with the natural surroundings and their time-honoured task, and it was that harmony that he was painting. Criticism of the toilsomeness of their labour, such as we find in the laundresses and women ironing by Degas and Toulouse-Lautrec (pp. 242, 243), was not at all Renoir's purpose. He travelled widely, visited friends, and liked to go to the sea. In 1897 in Essoyes he broke his right arm in a bicycle accident, as he had done once before, in 1880. This produced rheumatoid arthritis, which, together with the partial atrophy of a nerve in his left eye, confined him to a wheelchair from 1902 to 1905.

Since the late 1880s, Renoir had enjoyed the company of Morisot (Madame Eugène Manet). She in turn frequently visited Monet and Sisley, and often included Mallarmé among her own guests. Her first solo exhibition in 1892, at Galerie Boussod & Valadon (run by Toulouse-

Maxim Maufra
Ile de Bréhat, 1892
Oil on canvas, 60 x 72 cm
Private collection

Alfred Sisley
The Bridge at Moret, 1893
Pont de Moret
Oil on canvas, 73.5 x 92.5 cm
Daulte 817. Paris, Musée d'Orsay

Lautrec's friend Joyant) and with a catalogue introduction by Geffroy, was a success – one clouded, however, by her husband's death not long before. The following year she also lost her sister, Yves Gobillard (1838–1893). She was especially fond of Yves' daughter Jeanne (Nini) and frequently painted her, at times together with her own daughter, Julie. In 1900 Jeanne Gobillard married the poet Paul Valéry, and Julie Manet married the painter Ernest Rouart (1874–1942), son of Henri Rouart, who had exhibited at seven of the Impressionist shows (p. 203). In 1894, through the offices of Mallarmé, the state acquired its first Morisot, *Young Girl in a Ball Gown* (Paris, Musée d'Orsay), from the collection which Duret was then having to sell. The intelligent, sensitive, highly gifted Morisot died of pneumonia in 1895, aged just 54.

Her art, to which she always referred in modest and highly self-critical terms, was exclusively an art of personal happiness at the grace and beauty of those who were close to her, particularly girls, seen in the available light of gardens or drawing rooms. "She painted only what her eye actually saw, and not what her reason told her she saw," her grand-

son Denis Rouart observed.[162] Her style underwent a change around 1889. Instead of short brush-strokes she now tended to use lengthy strokes in sweeping arabesques. Together with her concentration on essentials. this produced a gently melodic, atmospheric overall effect. Her elegiac feel for the past happiness of youth and the dangers to traditional civilized values now outweighed the physiognomic scruple, and the precision with which she recorded the passing moment, that had characterized her earlier paintings.

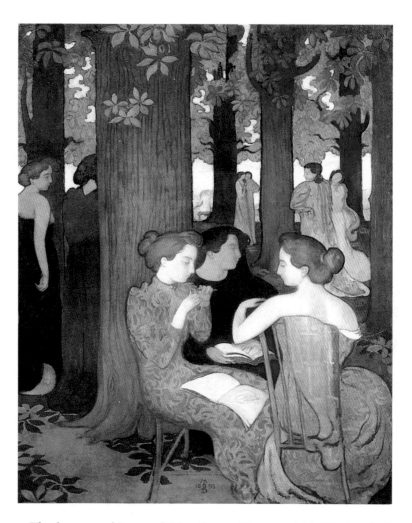

Maurice Denis
The Muses or In the Park, 1893
Les Muses ou Dans le Parc
Oil on canvas, 171.5 x 137.5 cm
Paris, Musée d'Orsay

The baroque château of Mesnil near Nantes, which Morisot had bought in 1892, and the little house near the church at Moret-sur-Loing which Sisley rented in 1889 as the last but one of his many homes, were separated by a distance not only geographical but also social. Sisley never succeeded in putting his straitened financial circumstances behind him. The few times he travelled were made possible by individual patrons such as François Depeaux, a Rouen ship owner. Sisley became embittered and withdrawn, preferring not to see even his old fellows. He did, however, ask Monet to his deathbed, in order to take his farewell before he died a painful death of cancer in his sixtieth year. From 1890 he regularly exhibited with the Société Nationale des Beaux-Arts, which he had joined at Roll's prompting. Durand-Ruel and Boussod & Valadon both represented his work, and in 1897 Petit organized a large exhibition of his finest work. But the press ignored the show almost completely, and nothing at all was sold. Sisley, who was already ill but had recently revisited his English homeland in quest of motifs, was exhausted.

That his light, peaceful landscapes and many views of the houses, old

Claude Monet
Rouen Cathedral in the Morning, 1894
*La cathédrale de Rouen. Le portail et la tour
Saint-Romain à l'aube*
Oil on canvas, 106.1 x 73.9 cm
Wildenstein 1348. Boston (MA), Museum
of Fine Arts

Claude Monet
Rouen Cathedral in the Morning Sun.
Harmony in Blue, 1894
*La cathédrale de Rouen. Le portail,
soleil matinale. Harmonie bleue*
Oil on canvas, 91 x 63 cm
Wildenstein 1355. Paris, Musée d'Orsay

Claude Monet
Rouen Cathedral in the Morning. Harmony in
White, 1894
*La cathédrale de Rouen. Le portail et la tour Saint-
Romain, effet du matin. Harmonie blanche*
Oil on canvas, 106 x 73 cm
Wildenstein 1346. Paris, Musée d'Orsay

Claude Monet
Rouen Cathedral in Bright Sunlight. Harmony in
Blue and Gold, 1894
*La cathédrale de Rouen. Le portail et la tour Saint-
Romain, plein soleil. Harmonie bleue et or*
Oil on canvas, 107 x 73 cm
Wildenstein 1360. Paris, Musée d'Orsay

Claude Monet
Rouen Cathedral in Overcast Weather.
Harmony in Grey, 1894
*La cathédrale de Rouen. Le portail, temps gris.
Harmonie grise*
Oil on canvas, 100 x 65 cm
Wildenstein 1321. Paris, Musée d'Orsay

Claude Monet
Rouen Cathedral. Frontal View. Harmony in
Brown, 1894
*La cathédrale de Rouen. Le portail vu de face.
Harmonie brune*
Oil on canvas, 107 x 73 cm
Wildenstein 1319. Paris, Musée d'Orsay

Right: cf. caption bottom left this page

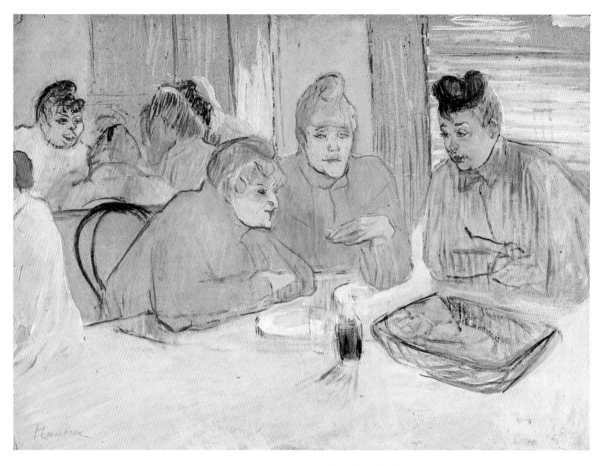

Henri de Toulouse-Lautrec
Women in a Brothel, c. 1893/94
Ces dames au réfectoire
Oil on card, 60.3 x 80.5 cm
Dortu 499. Budapest, Szépművészeti Múzeum

The Knight's Room in the Rue des Moulins brothel

stone bridge and Gothic church of Moret (p. 339) met with so poor a response, and that the prices for them did not rise until after his death (though they then rose steeply), is not altogether difficult to understand. Sisley never attempted to bring his style into line with the taste for symbolist or synthetist work. His motifs and view of Nature placed him too plainly as an emulator of Monet; and he had no material distinctly his own that could have asserted his own individuality. This became most apparent when in 1893/94, parallel to Monet's Rouen cathedral series (pp. 342, 343), he painted about 15 views of the church at Moret, twelve of which we now have knowledge of.[163] Like all Sisley's later works, they are firmly painted, and evidently aim to give a rather ordinary sense of the appearance of the building instead of the veils of light and colour impressions Monet registered when looking at his cathedral. Sisley's work focussed on the thing seen; but art was evolving towards a more subjective emphasis on configurations of colours and shapes. Monet's cathedrals were already fetching 15,000 francs at that time, while in 1896, when one of Sisley's church views was resold, it was for a mere 305 francs.

Guillaumin, in their mutual friend Murer's judgement, did not paint

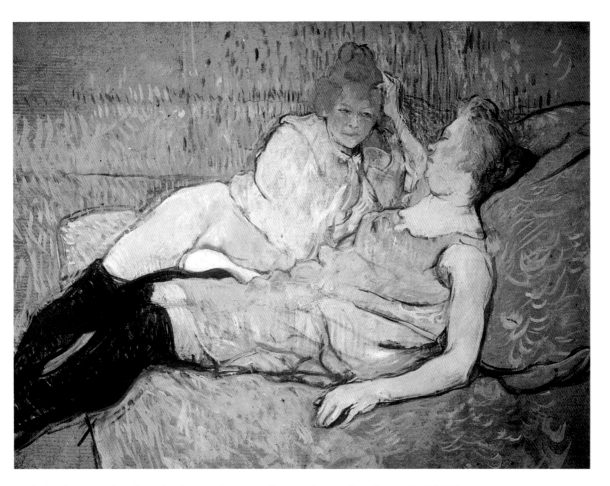

with the finesse and agility of Sisley. In the 1890s he was slower than the rest to abandon views of the Paris Seine docks with barges. He lived long, till 1927, and on his travels around France and its coasts he painted characteristically Impressionist motifs. He used a rather violent, brusque brush-stroke that already, in the 1890s, anticipated Fauvism. His colours were vigorously contrasted and luminous, and sometimes became decoratively, almost camply patterned (p. 351). In 1891 he won 100,000 francs in the Loterie Nationale, which enabled him to give up his job with the road and canal building department and devote his time to painting. In 1894 Durand-Ruel mounted Guillaumin's first solo exhibition, which was quite successful.

Pissarro, who had played a key role in Guillaumin's early development, highlighted the problems of Impressionism anew in his late period. He had given up pointillism, though to the very end he still used small dots of colour. The pleasure he took in landscape painting remained, and he went on repeated short journeys around the Ile-de-France and Normandy looking for new subjects. He painted farm women at work, talking (pp. 216, 217, 226) or, in 1894/95, bathing and washing their feet in a woodland stream.

Henri de Toulouse-Lautrec
The sofa, 1895
Le sofa
Oil on card, 63 x 81 cm
Dortu 601
New York, The Metropolitan Museum of Art

The ladies of the Rue des Moulins

Pierre-Auguste Renoir
Portrait of Paul Cézanne, 1880
Portrait de Paul Cézanne
Pastel on paper, 53.5 x 44.4 cm
Private collection

Pissarro's health and an eye complaint obliged him to paint less in the open, where it was windy, and more indoors, from the window. But this was only one of the reasons why, after his short-lived attempts in 1883, he now developed an interest in the city that only Monet and Caillebotte had shared to the same extent. In Paris (1893, 1897/98, 1902), Rouen (1896 and 1898), Dieppe (1901) and Le Havre (1903) he rented rooms from which he enjoyed dynamic perspectives of squares and boulevards (pp. 356, 357), the city and the river or harbour and bridges (p. 355). He painted variations and repeated views in order to capture various atmospheric moods and also to have something to offer to as many buyers as possible. His old skills in spatial structure were visibly still with him, even if a certain tiredness or lack of tension are sometimes apparent. Doubtless this return to city material was prompted by the wish to record the new contemporary realities, which had always been a plank in the Impressionist platform. "The revolting, brand new, glittering station, a number of chimneys... with swathes of smoke... the working-class district, as far as the iron Pont Boieldieu, in the morning, in gentle sunshot mist," was not, he felt, banal, as some critics had claimed, but "as beautiful as Venice, of an extraordinary character... It is art, seen with my own innermost feelings."[164]

That the revolting or ugly was beautiful was a paradoxical, provocative, defiantly anti-academic article of Naturalist faith, one echoed in the aesthetics of the Primitivists and the Fauves. In Pissarro, it was a view that went hand in hand with social and political convictions that set him apart from his fellow Impressionists. Unlike Renoir, who lamented the decline of beauty in the industrial age, Pissarro criticized society with an eye to the future. In his letters he raged at neo-Gothic historicism and "religious Symbolists, religious Socialism, ideational art, occultism, Buddhism" – all of which he saw as the devious reactionary ploys of the bourgeoisie. Alas, he even went so far as to detect this aberration in *Vision after the Sermon* (p. 303) by his former protégé Gauguin, and in Gauguin's circle generally.[165] By contrast, what he admired in genuine Gothic, such as the statues at Rouen Cathedral, was the harmony of Nature and decorative values.

There is a plunging spatial depth in his cityscapes. They pulsate with the flow of traffic along tree-lined avenues amidst a solid architectural frame. Their structures use cubic, towering buildings or draw our gaze disquietingly into a restless throng. The light is usually leaden and muted, a wintry light, or indeed we see the gleam of gaslight on wet roads at night. "All I see," wrote the 73-year-old Pissarro in 1903, the year of his death, "is dabs [*taches*] of colour. When I begin a painting, the first thing I try to fix is the accord... The great problem that has to be solved is... to bring everything into line with the overall harmony, with that accord I have spoken of."[166]

Pissarro's situation was at once typical and an exception. He was no longer very short of money, but he still had no sense of financial security and occasionally had to trim his children's allowances. Sometimes, though, Monet (who earned more) would borrow money from him to

Paul Cézanne
The Smoker, 1895–1900
Le fumeur
Oil on canvas, 91 x 72 cm
Venturi 686. St. Petersburg, Hermitage

Paul Cézanne
Still Life with Onions, 1895–1900
Nature morte aux oignons
Oil on canvas, 66 x 82 cm. Venturi 730
Paris, Musée d'Orsay

bridge a financial crisis. In 1892 Durand-Ruel became Pissarro's sole gallery agent, arranging a large and successful solo show followed by a number of smaller exhibitions in the next few years. With Durand-Ruel's approval, Pissarro also sent small batches of work to dealers abroad – in 1894 to Berlin, for instance, where he was a member of the Secession, and to Dresden. It angered him if it was only by chance that he heard of a museum acquisition of one of his paintings, as was the case with the Berlin National Gallery; and he had a fundamental distrust of dealers, who thought in terms of storehouse space and market forces and agreed among themselves to keep his prices below Monet's. His rivalry with Monet played a part in an exhibition at Durand-Ruel's in 1898, where he showed series of works, including twelve Paris avenue scenes and seven or eight of avenues and boulevards. Pissarro believed he was being disadvantaged because of his political views; but it was probably his fidelity to realistic principles of vision that the public no longer felt comfortable with. It was this that made him and Sisley – as he pithily put it in a letter of 24 February 1895, somewhat resigned but faithful to his artistic stance – "the rearguard of Impressionism".

Paul Cézanne
Still Life with Apples and Oranges, c. 1895–1900
Nature morte aux pommes et oranges
Oil on canvas, 74 x 93 cm
Venturi 732. Paris, Musée d'Orsay

And what of Monet, the vanguard of the movement, one of whose paintings had given Impressionism its name? With great consistency he continued to develop a response to reality which was anchored in Impressionism: in order fully to capture changing conditions, he painted entire series of pictures, transforming (as the titles of studies recently published have it) Nature into art.[167]

Monet had enough self-confidence to act independently of the dealers. He played Petit and Durand-Ruel off against each other, but worked mainly with the latter; and he sold his large output via a number of galleries, especially Bernheim's. Monet too had to put up with Durand-Ruel's urging him to keep painting the sun rather than stormy seas; and the dealer would push him to paint more of the subjects that sold well, and paint them faster. Only with misgivings did Monet go along with these wishes.

At Argenteuil, Vétheuil and the Gare Saint-Lazare, Monet had already probed the various aspects of a single subject, and had exploited effective views by painting them more than once. In the mid–80s he began a systematic analysis of the effects of changing light. This work ran paral-

Odilon Redon
Peyrelebade, c. 1896/97
Oil on canvas, 36.5 x 45 cm
Paris, Musée d'Orsay

lel, in his own way, to that of Seurat. In 1885, Guy de Maupassant observed him at the coast, at Etretat: "Often I would follow Monet as he searched for impressions. The truth is that he was no longer a painter; he was a hunter. He would set out followed by children carrying his canvases, five or six canvases showing the same motif at different times of day and in different conditions. He would take one after another, set it up for work and put it aside, depending on how the sky changed."[168] Others observed the same working habits in later years. At Etretat in Normandy, where in 1869 Courbet had already painted a number of coastal landscapes (p. 31), Monet was fascinated by the sheer cliffs and the bizarre shape of the Manneporte, an arch of rock (p. 270). He returned to the subject over several years, and to the jagged crags and stormy Atlantic at Belle-Ile-en-Mer in Britanny (p. 245). Using Impressionist dabs to establish an irregular pattern was almost as important in such work as recording a striking view.

The same essentially applies to Monet's last figural work worth mentioning. The three pictures of a woman with a parasol (pp. 146, 147) do of course record an impression on a walk with his stepdaughter-to-be, Suzanne Hoschedé, whose face is obscured by her fluttering scarf. The pictures showing the two Hoschedé girls in a boat (p. 296) are also scenes of that everyday life which the Impressionists had made a fit subject for art. But these works were doubtless painted primarily because Monet's eye was captivated by particular colour accords, effects of reflection, and the "Japanese" angle of vision from above.

It was in Giverny in 1884 that Monet was first struck by the haystacks. In 1890/91 he painted a series of 18 pictures (p. 331), 15 of which he exhibited at Durand-Ruel's; every one was immediately sold for prices

Armand Guillaumin
Landscape in Normandy: Apple Trees, c. 1887
Paysage en Normandie: Les pommiers
Oil on canvas, 60.5 x 100 cm
Paris, Musée d'Orsay

Armand Guillaumin
View of Agay, 1895
Vue d'Agay. Pointe du Dramont
Oil on canvas, 73 x 92 cm
Serret/Fabiani 340. Paris, Musée d'Orsay

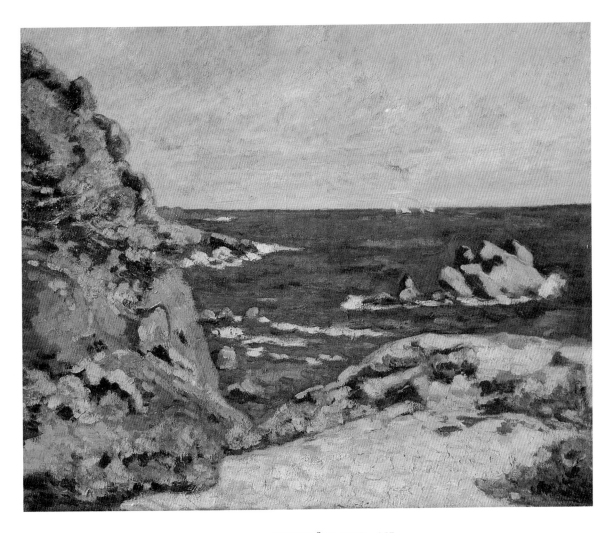

Paul Gauguin
The Dug-Out ("Te vaa"), 1896
La pirogue
Oil on canvas, 96 x 130 cm
Wildenstein 544. St. Petersburg, Hermitage

from 3,000 to 4,000 francs. Morning and evening, in late summer and in winter, in sunny or overcast conditions, he stood at the selfsame spot, watching how the light changed the world. His brushwork was energetic and dense. The irregular *taches*, not standing for any specific detail, glowed in contrasted juxtaposition, so pastose that the thickness had a rough, relief-like impact. The crusts of thick paint gleamed in the light or even cast tiny shadows of their own. People had meanwhile acquired a more practised eye for such effects (and therefore came to value it where they had previously overlooked it, in late Titian or Rembrandt).

When one of Monet's haystacks was exhibited in Moscow in 1895, it was seen by Wassily Kandinsky (1866–1944). Kandinsky had completed law studies, and the following year began to study art in Munich. He later wrote: "The catalogue told me that it was a haystack. I could not recognise it as such myself... I vaguely felt that the subject was missing from the picture... But what was completely clear to me was the un-dreamt-of power of the palette, which I had previously known nothing of... I had a sense that painting itself was the subject."[169] For Kandinsky, this encounter was a decisive impulse on his own way forward to abstract, "absolute" painting some 15 years later. Monet, though, is said to have laughed aloud when he heard of Kandinsky's reaction. He him-

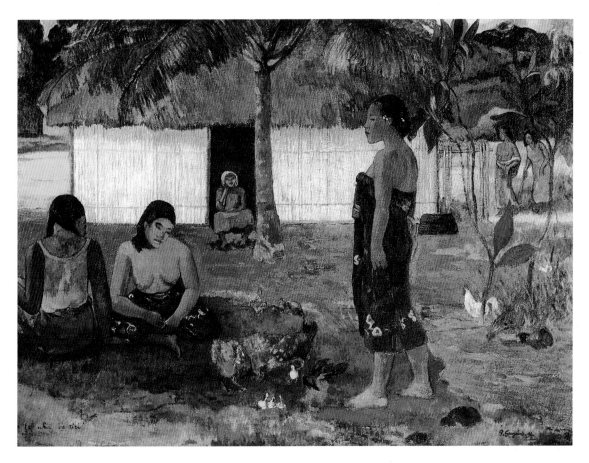

Paul Gauguin
"Why are you angry?" ("No te aha oe riri?"), 1896
«Pourquoi es-tu fâchée?»
Oil on canvas, 95.3 x 130.5 cm
Wildenstein 550
Chicago (IL), The Art Institute of Chicago

self was still primarily interested in impressions made on him by something he had actually seen.

In 1892 he exhibited about 15 pictures of poplars, and in 1895 twenty views of Rouen Cathedral. These were the finest and most unified of his series. Subsequently he did 24 pictures of the cliff coastline at Varengeville in Normandy (1896), 18 morning scenes by the Seine (1897), over 37 views of the Thames in London (1899–1904) and 29 paintings of Venice (1908/09). The poplars, on the banks of the Epte near Giverny, Monet painted from spring to autumn 1891. He paid a wood merchant (who had just bought them for timber) not to fell them till he had painted them from his boat (p. 330). The freshness of his rendering of an easeful natural scene, and the delicacy of his colours, are such that we imagine we can sense the breeze soughing in the trees. The trees, the sky, and the reflections in the water, form a unified whole. The surface structure is linear and harmoniously proportioned. These qualities make Monet's poplars supremely subtle blends of impressions, poetry and decorative values with lithe structure, the manifest traces of the artist's work, and the overflow of feeling.

The cathedral series is more dramatic, radical and charged with mystery (pp. 342, 343). Monet visited Rouen in 1893 at the expense of the

Eugène-Louis Boudin
Sailing Ships at Deauville, c. 1895/96
Deauville. Le bassin
Oil on panel, 45.8 x 37.1 cm
Washington (DC), National Gallery of Art,
Ailsa Mellon Bruce Collection

collector Félix Depeaux (who also supported Sisley), and painted the intricate Gothic façade from his hotel window. The given date of 1894 indicates that, as with other paintings, Monet continued work on the canvases at home, making the interrelations exact. His son Michel swore that his father only ever worked straight from the subject; of course Monet's practice is in fact simply a responsible artist's perfectly understandable desire to arrive at the best possible visual form. The series abides by the old Impressionist principle of the sectional view dictated by chance. It offers fragmented views of the façade rather than a conventionally informative architectural overview. The details are lost in a total impression of colour, light and shadow playing upon an intricate surface. The subject is not explained; it is rendered mysterious, a thing of wonder. The fact that the subject is a venerable cultural legacy of the Middle Ages only heightens its symbolic appeal. Monet emphasized the browns and reddish golds that he saw in the shadows and the morning light, at noon and in the dusk.

The general drift of the series was in line with prevailing philosophical

Camille Pissarro
Morning, Overcast Weather, Rouen, 1896
Matin, temps gris, Rouen
Oil on canvas, 54 x 65 cm
Pissarro/Venturi 964
New York, The Metropolitan Museum of Art

Camille Pissarro
Pont Boieldieu in Rouen in a Drizzle, 1896
Le Pont Boieldieu à Rouen, temps mouillé
Oil on canvas, 73.3 x 91.4 cm
Pissarro/Venturi 948
Toronto, Art Gallery of Ontario

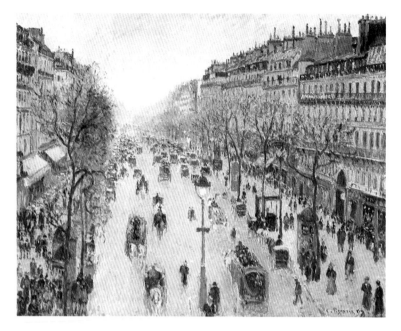

Camille Pissarro
The Boulevard Montmartre on a Cloudy Morning,
1897
Boulevard Montmartre, matin, temps gris
Oil on canvas, 73 x 92 cm
Pissarro/Venturi 992
Melbourne, National Gallery of Victoria

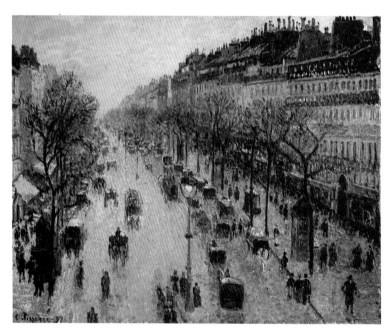

Camille Pissarro
The Boulevard Montmartre on a Winter Morning,
1897
Boulevard Montmartre, matin d'hiver
Oil on canvas, 65 x 81 cm
Pissarro/Venturi 987
New York, The Metropolitan Museum of Art

currents of the time, especially the empirio-criticism of Ernst Mach
(1838–1916). According to Mach, it was not things but colours and
other sensations that constituted the "true elements of the world".
Monet's paintings state that Rouen Cathedral cannot be said to *be* a
particular colour. Rather, it appears to us in various, changing colours,
all of them legitimate in their way. This represented a quite extraordinary
licence for artistic subjectivity, and gave it a task. The total meaning of

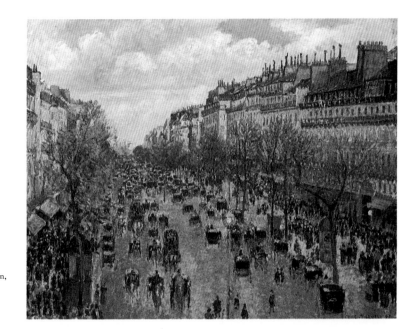

Camille Pissarro
The Boulevard Montmartre on a Sunny Afternoon,
1897
Boulevard Montmartre, après-midi, soleil
Oil on canvas, 74 x 92.8 cm
Pissarro/Venturi 993. St. Petersburg, Hermitage

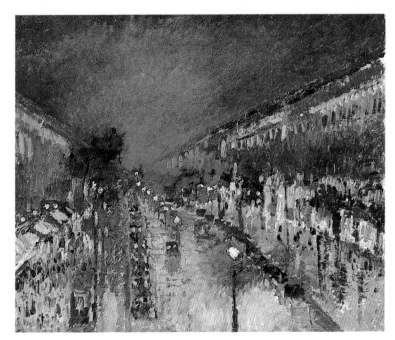

Camille Pissarro
The Boulevard Montmartre at Night,
1897
Boulevard Montmartre, effet de nuit
Oil on canvas, 53.3 x 64.8 cm
Pissarro/Venturi 994. London, National Gallery

these works, though, was only apparent on the one unique occasion
when they were all exhibited together. They were then sold to individual
collectors, and it was not till long after that smaller groups could be
assembled by certain museums.

Left: The Boulevard Montmartre.
Photograph, c. 1900

A Harmony Parallel to Nature

Monet and Cézanne respected each other, and ultimately there was more shared ground in their art than is commonly realised. The two painters, of course, led quite different lives. In 1886 Cézanne inherited about 400,000 francs after his father's death, which made him financially independent, indeed affluent. Only a few months before he had married Hortense Fiquet, by whom he already had a 14-year-old son; Cézanne had concealed both from his father for fear of having his allowance (a man in his forties!) cut. He was unable to live on the proceeds of his art, but now he was his own man. On the rare occasions when he had exhibited in Paris he had reaped only ridicule. A few of his paintings remained on show in Père Tanguy's famous back rooms. Young painters who saw them there were not quite sure if the artist was even still alive – despite the fact that every year till 1899 Cézanne spent some time in Paris, painting, studying old paintings and sculptures in the Louvre, and drawing copies of them. Mainly he lived at Aix, where the provincial eye saw him as an odd-man-out and a failure. An irascible man, mistrustful even of his friends, he became increasingly wary of contact with people. Even his wife, who did not understand his art, became a stranger to him. For all this, Cézanne would have liked to lead a conventional middle-class life. In 1894, when he met Clemenceau, Geffroy and Rodin at the home of Monet (who was now an established figure with contacts), Cézanne was deeply moved when Rodin, whose sculpture had earned numerous awards, shook his hand. Even at a later date he was still wishing he would be commissioned to paint murals in order to reach "ordinary people" rather than simply painting "some rubbish or other" for rich Americans.

Sales had picked up ever since Vollard, newly established in Paris galleries, put on Cézanne's first major solo show in 1895. Further small exhibitions followed, and in 1899 Vollard bought everything that was available in Cézanne's studio. In 1900 Roger Marx included three Cézannes in the Centennale at the World Fair. Cézanne's final recognition came through repeated exhibition with the Indépendants, and subsequently in the new autumn salon (where the Fauves were concentrating their forces), and through exhibitions abroad. Cézanne's extraordinary impact on younger artists became clear with the memorial retrospective in 1907, the year after his death. In 1901 Denis had exhibited a large *Homage to Cézanne* (1900; Paris, Musée d'Orsay, Gift of André Gide) at the Indépendants – though the dark and indiscriminately spaced painting had little in common with Cézanne's approach. It shows a lifesize group, Denis and nine other painters dressed in black, and Vollard, solemnly contemplating a Cézanne still life.

Cézanne had direct contact with some of his young admirers following the 1895 exhibition. The writer Joachim Gasquet (1873–1921), son of one of the painter's schoolfriends, familiarized himself with Cézanne's views from 1896 to 1900 and then wrote them up in 1912/13 in the form of three imaginary conversations (published 1921). Gasquet partly drew

Rouen Cathedral. Photograph, c. 1900

Camille Pissarro
The Old Market-Place in Rouen and the Rue de l'Epicerie, 1898
Les anciennes halles à Rouen et la rue de l'Epicerie
Oil on canvas, 81 x 65 cm
Pissarro/Venturi 1036
New York, The Metropolitan Museum of Art

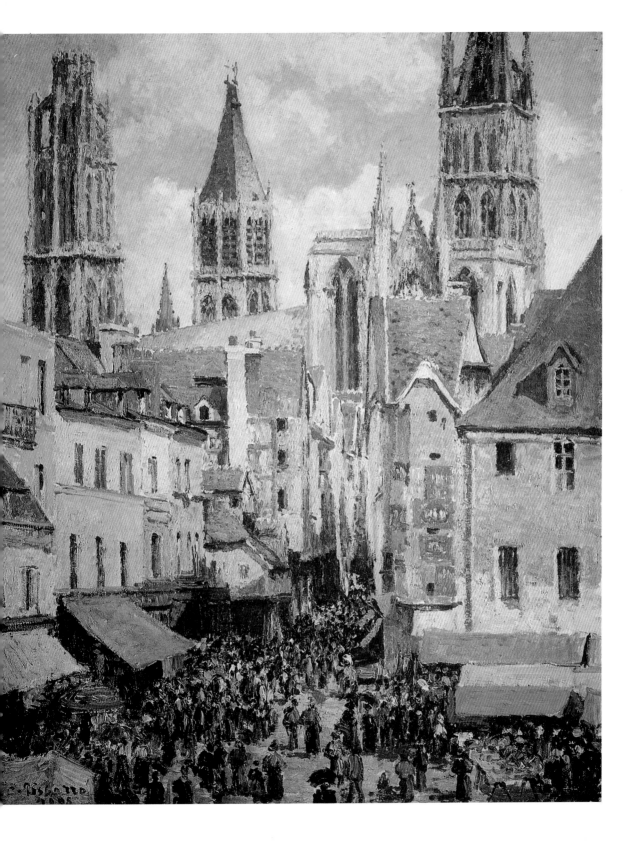

Manzana (Georges Pissarro)
The Harbour at Rouen, 1898
Le port de Rouen
Oil on canvas, 55 x 65 cm
Paris, Galerie Etienne Sassi

on Cézanne's letters and on published memoirs by others. Some of the statements put into Cézanne's mouth seem coloured by the symbolist philosophy of Gasquet, but the gist is corroborated by the letters, and helps gain a purchase on understanding Cézanne's bulky but magnificent late work.

He concentrated on portraits and figure paintings of family, friends, and ordinary people he could persuade to sit for him; and on landscapes, still lifes, and open-air nudes that were labelled, in the customary way, "bathers". These subjects may not seem entirely promising, but for Cézanne they were laden with philosophical significance, and contained messages related to the improvement of life and the world. These messages, though, were immanent in the works, a specific function of painting, distinct from anything that might have been known or said previously. And they made their impact quite independently of the brouhaha of the market place, of opinion-mongering and art dealing, and without concurrent political positions being adopted as Cézanne's mentor Pissarro did.

Cézanne wanted to create images of the subjects he took, images that would become a subordinate part of Nature, images which (as Courbet and the Impressionists had both preached and practised) were drawn from careful observation. In this respect Cézanne, like Monet and Renoir, likened himself to children who see with eyes free of the distortions caused by education and conditioning, or to a camera fixing the image of reality and nothing but. The individual temperament, he felt (contrary to Zola's definition), should not be interposed like a prism splitting up rays. On the other hand, Cézanne always referred to powerful feelings, especially for his home parts, which he hoped would be communicated

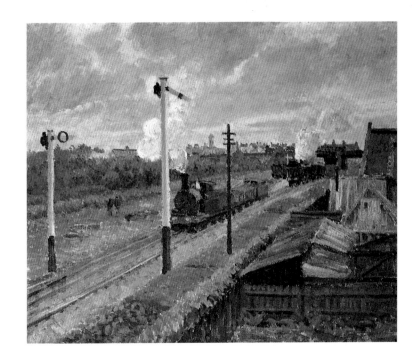

by his paintings. This twofold truth, both objective and subjective, could only be established if the appearance of phenomena was not reproduced but represented – by colour equivalents. Spatial distances, and three-dimensionality, had to be suggested by perspectives of colour in Cézanne's creed – by the sense of spatiality conveyed by various colour values which appear to the eye either to advance or to recede. The use of shadow for three-dimensionality was wrong; the colours had to be modulated. The work of art (thought Cézanne) was an autonomous product created in contact with reality by looking, by theory, and by an

Claude Monet
Monet's Garden, the Irises, 1900
Le jardin de Monet, les iris
Oil on canvas, 81 x 92 cm
Wildenstein 1624. Paris, Musée d'Orsay

assured craftsmanly hand. He saw it as a "harmony parallel to Nature". For Cézanne, Nature – including all its contrary movements of growth and death, structure and decay, inertia and motion – was a cosmos, and thus had its own order. To record this in the microcosm of a painting required the hardest of work. The fruits of that toil almost never satisfied Cézanne. And so it was that friends would witness the artist in old age weeping as he stamped on unfinished canvases, dissatisfied with the way he had recorded his perceptions.

An exact dating of Cézanne's paintings is very difficult. He never considered his works finished, and many indeed show clear signs of being more unfinished than even a high Impressionist regard for sketchiness would permit; so he signed only a very few, and then at the request of the buyer. At times, mementoes or wallpaper that Cézanne's biographers

Claude Monet
The Houses of Parliament, London, c. 1900/01
Le parlement, ciel orageux
Oil on canvas, 81.6 x 92.1 cm
Wildenstein 1605. Lille, Musée des Beaux-Arts

have traced to one of his homes can provide a clue. Thus, for instance, if the *Boy in a Red Waistcoat* (p. 308) – a young Italian Cézanne painted four times in relaxed poses – was done in a Paris flat on the Quai d'Anjou, the date must have been between 1888 and early 1890. But arguments have been advanced for a date in the early Nineties too. What does seem incontestable is that Cézanne's sitter was at ease in the world, as his pose suggests. For purposes of compositional balance, Cézanne felt justified in making the youth's right arm unnaturally long.

Still lifes provided him an opportunity to paint things in accordance with his conception of form, and he could subject them to lengthier scrutiny than he could human sitters. In still lifes he could explore ways of establishing visual harmony and three-dimensionality more thoroughly. It is clear to the attentive eye that he used colours both to signal

Right:
Claude Monet
The Japanese Bridge, 1899
Le bassin aux nymphéas
Oil on canvas, 92.7 x 73.7 cm
Wildenstein 1518
New York, The Metropolitan Museum of Art

Claude Monet
The Japanese Bridge, Harmony in Green, 1899
Le bassin aux nymphéas, harmonie verte
Oil on canvas, 89 x 93.5 cm
Wildenstein 1515
Paris, Musée d'Orsay

Claude Monet
The Japanese Bridge, 1900
Le bassin aux nymphéas
Oil on canvas, 89.2 x 92.8 cm
Wildenstein 1630
Boston (MA), Museum of Fine Arts

Paul Signac
The Papal Palace at Avignon, 1900
Le château des Papes à Avignon
Oil on canvas, 73.5 x 92.5 cm
Paris, Musée d'Orsay

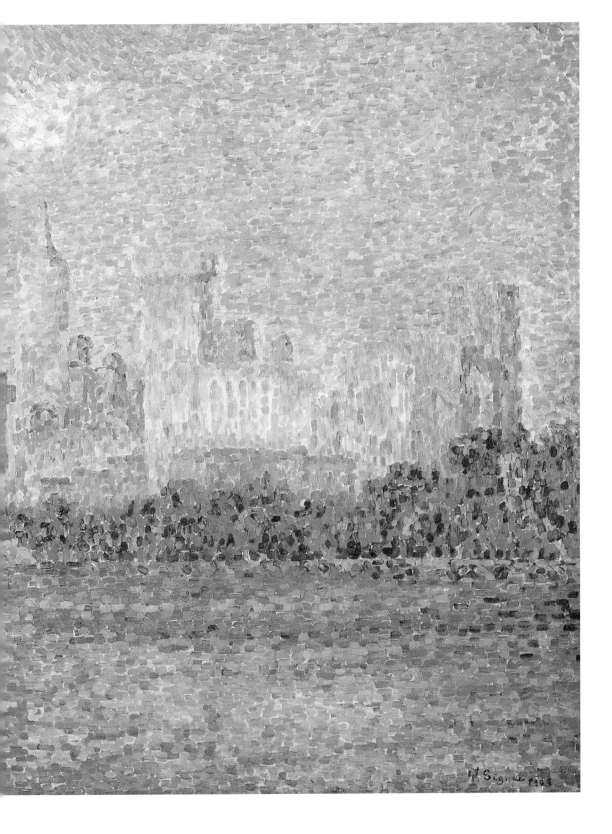

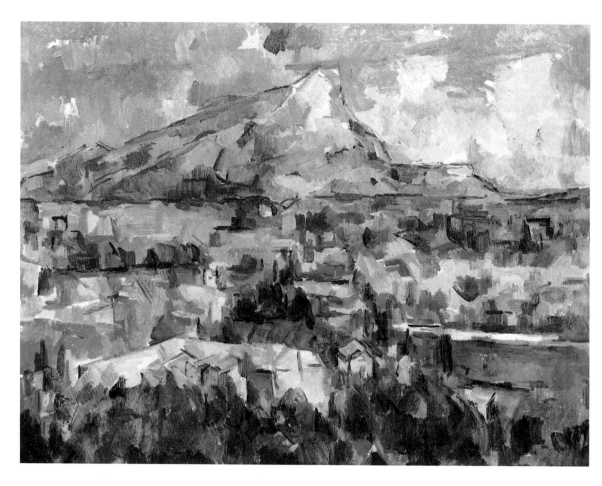

Paul Cézanne
Mont Sainte-Victoire, 1904–1906
La Montagne Sainte-Victoire
Oil on canvas, 73 x 91 cm
Venturi 798. Philadelphia (PA),
Philadelphia Museum of Art

View of Mont Sainte-Victoire
from Bellevue

the boundaries of different objects and to establish an overall visual continuum, to convey three-dimensionality even as they remained parts of a surface pattern. Cézanne never outlined subjects as the cloisonnists did. In the latter half of the Nineties, after his successful exhibition at Vollard's, he increasingly did more opulent, spatially more dynamic, indeed baroque compositions (pp. 348, 349). These pictures are far removed from the straight representation of a laid table. No one would pile crockery, fruit, a brocade drape and a crumpled tablecloth on a chest in this way (p. 349). This is painting for its own sake, with its own rules.

In old age, Cézanne still tirelessly walked the country around Aix in order to paint the ensemble effect of earth, vegetation and ordinary houses, in a manner at once organic and crystalline. He was particularly fond of painting his revered Mont Sainte-Victoire, towering over the valley as in a vision (p. 368). In October 1906, out painting, he contracted pneumonia, from which he then died. Almost all of his late works have that distinctive, generous formal assurance which we associate with the late periods of the masters; yet Cézanne, whose principle it was only to work *sur le motif*, would pause for a long time over a brush-stroke if he was not absolutely certain of the colour, even preferring to leave the

space blank. This gives his paintings the appearance of work in progress, in the process of becoming – an inner dimension of time that had originated in the Impressionist alertness to movement and change but had led to a new conception of the relativity of visual statements.

From the outset, Cézanne had painted oils and watercolours and done drawings of nudes in the open. There has recently been a major exhibition and publication on this area of his work.[170] From 1895 Cézanne's attention to this theme, which doubtless touched on psychological problems within himself, was summed up in three large-format groups of bathers that were to occupy him till he died (p. 369). The throng of female nudes, altogether unerotic, are caught in attitudes which are partly unclear and seem to have cultic rather than bathing or games-playing significance. Some of the poses, despite the heaviness, can be traced to ancient sculpture or to Renaissance or baroque painting. The shapes are crudely simplified. They have a primitive expressive power, which meant more to the artist than accuracy or beauty. Away beyond, Nature glows a "sacred blue". This tense vision, which was incapable of completion, provided a point of departure for Matisse, Picasso, the Expressionist painters of the Brücke, and generations of artists down to the present day.

Cézanne's art was and remains of such extraordinary consequence

Cézanne setting out to paint

Paul Cézanne
The Bathers, 1900–1905
Les grandes baigneuses
Oil on canvas, 126 x 196 cm
Venturi 721. London, National Gallery

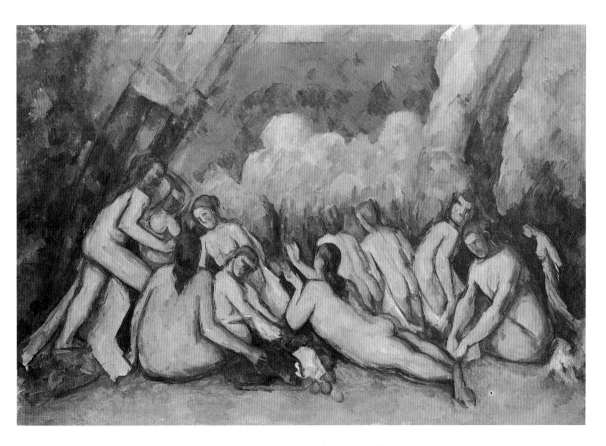

because it doggedly confronted a paradox. It aimed to be both representational image and invention, objective and subjective, a moment and all eternity, and all this in harmonious equilibrium. At the turn of the century, Cézanne's art was doing a balancing act, so to speak, with the dominant aesthetic fundaments of the 19th and the 20th centuries.

The Wisdom of Age

When Cézanne died in 1906, the last of the founding fathers of 20th-century art, who took Impressionism and transformed it into something new, was gone. These four founding fathers, according to the influential Austrian critic Werner Hofmann,[171] were Seurat, who systematically took colour apart (died 1891); van Gogh, who heightened expressiveness (died 1890); Gauguin, who established a new synthesis of colour and formal tonalities (died 1903); and Cézanne, who persistently based everything on the accuracy with which phenomena were observed. In 1905, the year before Cézanne died, a number of young artists exhibited work at the Paris autumn salon (a further splinter system that had been in operation for two years) in which they already went beyond these founding fathers. The critic Louis Vauxcelles labelled these painters – who included Henri Matisse (1869–1954) and Georges Braque (1882–1963) – "Fauves" (savages). At the same time in Dresden, four architecture students established an artists' group (soon to include other members) known as the Brücke (bridge). The style of these painters rapidly attracted the label Expressionist.

But three of the artists who created Impressionism continued to paint for a decade or even two beyond that time (not counting Guillaumin, their fellow traveller since the start, or the American Cassatt, who had joined at an early stage). These three were Degas, Renoir and Monet, and they continued to create masterpieces despite the onset of old age and infirmity.

Degas was hit earliest and hardest. In various ways he remained a special case. He had fought for independent exhibition space for himself and others, but latterly proved indifferent to showing his work. He was rich, which meant that access to the art market meant nothing to him. But this did not prevent him from making scathing comments on the profits dealers or collectors made by reselling his works, comparing them to stable owners growing rich by selling horses they had merely fed a little hay to. In 1912 he was present when a picture by his friend Rouart, painted in 1876/77, fetched the staggering price of 430,000 francs. From 1886 he himself sold solely through Durand-Ruel, who in 1893 organized Degas's only solo exhibition in France in his lifetime.

Degas remained with his favourite subjects: situation portraits, jockeys, ballet dancers, and above all women (prostitutes) at their toilet, works such as he had shown as a series at the last Impressionist exhibition in 1886. He gave up painting in oils (not, as recent scholarship has found, in 1890 but much later) in favour of his preferred pastels, and

Franc-Lamy
An Exotic Beauty
Une beauté exotique
Oil on canvas, 73.5 x 61 cm
Private collection

Jean Béraud
On the Boulevard, 1895
Sur le boulevard
Oil on canvas, 33 x 25 cm
Paris, Musée Carnavalet

Jean Béraud
Waiting, Paris, Rue de Chateaubriand, c. 1900
L'attente. Rue de Chateaubriand, Paris
Oil on canvas, 56 x 39.5 cm
Paris, Musée d'Orsay

charcoal drawings. A major reason for this change was the failure of his sight. We cannot say quite how blind he was. His friend Halévy said in 1894 that he was nearly blind,[172] but Degas went on drawing till about 1910. He was also a keen photographer. He photographed nude women washing, as preliminary and complementary studies for his drawings and pastels. These photographs include some of the finest in the history of nude photography.[173] When arranging group photos he could be a bully to his friends if they were slow to adopt the poses he wanted them in. His failing eyesight did not prevent him from buying pictures by Delacroix, Gauguin, van Gogh, Cézanne and others at auctions. "I buy, I buy, I can't help myself," he told Halévy in 1895[174]. He also went to exhibitions, dispensing his characteristic sarcasm: Monet's landscapes, he said,

with their light and agitated atmosphere, made him feel there must be a draught in the exhibition room – he felt like putting up his collar.

His late bathers and dancers were mainly large-format. The charcoal sketches in particular were largely simplified and at times coarsely drawn variations on unusual, expressive poses he had hit upon. His pastel and mixed techniques produced a rough, relief-like texture reminiscent of the pigmented dust (and vulnerability) of a butterfly's wings. It is as if there were space between the individual particles of colour for light or darkness. There is an unfinished, vibrant sense of movement in these works that destabilizes them, as in Cézanne or Monet. Towards the end, as Degas's blindness deepened, all he could record were shapes and colours from a remembered repertoire, much as the deaf Beethoven worked with remembered chords. He would now draw thicker outlines to structure the turbulence of the colours. His eyes could no longer see delicate lines.

André Devambez
The Charge, 1902
La charge
Oil on canvas, 127 x 162 cm
Paris, Musée d'Orsay

He took to using tracings to repeat and adapt figures, in variable groupings. He was drawing on a lifetime's store of observation and draughtsmanship. Obsessed with a concept of form that had become quite detached from subject, persisting in his experiments, he left 20th-century artists a legacy that pointed the way forward for many. "With absolute consistency he had investigated whatever was unfinished, rudimentary and fragmentary in his world of forms, and his radical simplifications of form; and brusque, disruptive material idiom, had effectively countered the triumphant style of the times with its melodic lines, Art Nouveau."[175]

From the 1880s, Degas also sculpted dancers and bathers in wax and clay. In the 20th century, sculpture done by painters was to become a significant branch of artistic endeavour. For Degas, so preoccupied with

Notre-Dame, Paris. Photograph, c. 1900

forms in motion and their spatial relations, it was an unsurprising field of further experiment. The audacious sketchiness and delicacy of his sculptures even went beyond that of his drawings. Once blindness no longer permitted drawing, all that was left was to work with his fingers. After his death in 1917, some 150 partially wax or clay figures were found in his studio, some of them damaged or broken. Hebrard later cast 74 of them in bronze.

Renoir too turned to sculpture in old age, though the few pieces he made remained more traditional. They were done between 1913 and 1917 at a time when a young pupil of Aristide Maillol's (1861–1944), the Catalan Richard Guino (1890–1973), placed his hands at Renoir's disposal; for, if Degas could no longer see, Renoir's hands could no longer grip. They were so gnarled by arthritis that his brush had to be jammed between his fingers for him. Guino modelled the sculptures following Renoir's instructions or his indications with a cane.

Since 1905, Renoir had been living at Cagnes-sur-Mer, where he built a house on the Les Colettes estate, moving into it in 1908. On occasion he also stayed at Essoyes. He lost a good deal of weight and from 1910 was confined to a wheelchair, in continous pain. Even in bed he needed wire guards to keep the covers off his twisted and hypersensitive body. At the very opening of the First World War, his sons Pierre (1885–1952) and Jean (1894–1979) were seriously wounded. Their mother, Aline, selflessly tended by Jean, died in 1915. After the war ended in 1918, Renoir, now 78, was honoured with a visit to the Louvre, to see the paintings he loved best; a small one of his own had temporarily been hung beside a magnificent Veronese. His art had earned its place in Eu-

Maximilien Luce
La Sainte-Chapelle, Paris, 1901
Oil on canvas, 63 x 53 cm
Bazetoux 265
San Francisco (CA), Montgomery Gallery

Hippolyte Petitjean
Notre-Dame, c. 1895
Oil on canvas, 54.3 x 70.8 cm
Private collection

Odilon Redon
Beatrice, c. 1905
Pastel on paper, 63.5 x 48 cm
Zurich, Kunsthaus Zürich

Odilon Redon
Paul Gauguin, c. 1903–1905
Oil on canvas, 66 x 54.5 cm
Paris, Musée d'Orsay

ropean culture, in the continuation of which he defiantly believed. Five months later he was buried beside his wife in Essoyes.

To an almost incredible extent, Renoir's late work remained a celebration of beauty, healthful vigour, and *joie de vivre*. His unflagging desire to paint erected a protective barrier of hundreds of paintings, against pain, against the woes of reality. Working in his house, his garden, and the glassed studio he had built in 1915 in order to paint as if in the open, he recorded his impressions of trees, shrubs, flowers and people in large-format and smaller pictures using light brushwork and dabs. The colours became less real, sometimes indeed cloyingly bright. An unnatural brightness of light irradiated his canvases. Painting was life for Renoir. To repeat the pleasure he had taken in some unanticipated use of colour struck him as perfectly in order; and thus the paintings which collectors now hungered after were sometimes without real vigour or critical self-discipline, and might not be valued very highly today were it not that they bear Renoir's signature.

Renoir's most powerful inspiration was still derived from the sensual, rosy, fleshy bodies of young women. To his son Jean (later a film director of the first water), to young artists who visited and later wrote on him, such as Albert André (1869–1954) and the American Walter Pach, to his old friend Rivière or the art dealer Vollard, he expressed his unchanged views time and again. Ultimately he assessed his women models purely according to how well their skin took the light. Any intellectual capacities they might possess left him cold. When he was occasionally talked

into doing portraits, he was generally unsuccessful at conveying mental qualities, and his presentation of sophisticated style could likewise easily become mere accessories and a vacant facial expression.

But when he painted the maid, Gabrielle, transforming her into the very epitome of female youth, bloom and happiness, the full magic of his art came into its own (p. 390). We see her in a flimsy négligée at an 18th-century dressing table, pleased to see how jewellery and a rose in her hair enhance her own beauty. Such works were "a feast for the eyes" (as Delacroix once said art should be) – and also, quite simply, celebrations of the sensual beauty of women. Gabrielle Renard (1879–1959) was a cousin of Aline's who joined the household in 1894 as Jean's nanny and did not leave till she married an American painter in 1914. Possibly she did not really possess the grace we see in her. Perhaps Renoir was following his own ideal rather than visible fact. The inner rhythm of these paintings was now calmer and less capricious. In Matisse, who visited him in 1917 and whose paintings he respected, Renoir saw a worthy successor, one who would adopt in his own changed way Renoir's view of the visual image and his dream of harmony.

Paul Gauguin
Sunflowers on a Chair, 1901
Tournesols dans un fauteuil
Oil on canvas, 73 x 91 cm
Wildenstein 603. St. Petersburg, Hermitage

Gustave Loiseau
Orchard in Spring, c. 1899–1900
Le verger au printemps
Oil on canvas, 38.4 x 46 cm
Private collection

Gustave Loiseau
Banks of the Seine, 1902
Bords de la Seine
Oil on canvas, 65 x 81.5 cm
Private collection

In 1883 Monet had moved into a house at Giverny which he subsequently bought. That home became the centre of his existence, from which he rarely went on forays for new subjects. Instead he preferred to invite old friends, new admirers, and dealers who were awaiting paintings, to visit. At the turn of the century he travelled once again to London, where from his hotel window he painted the Thames, the bridges and the Houses of Parliament in the autumn and winter mists (p. 363).

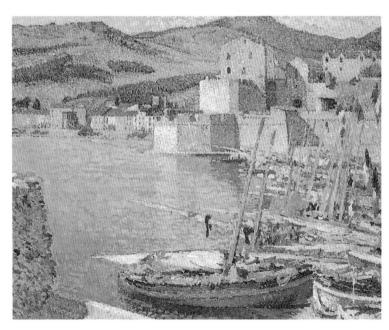

Scholars today are divided as to whether this concentration on the amorphous was prompted by new thinking and aesthetic concepts or by the old Impressionist delight in specific atmospheric effects.[176] The sole reason Monet gave for travelling to London was the fog. His paintings are tightly-woven fabrics of short brush-strokes. The palpably material texture of oils and canvas is greater than that of the subjects, which seem insubstantial in the haze. Monet subsequently attuned the colours of the

Henri-Edmond Cross
The Clearing, c. 1906/07
La clairière
Oil on canvas, 162 x 130 cm
France, private collection

various pictures in his studio, and exhibited them as a series at Durand-Ruel's in 1904.

But ultimately Giverny sufficed Monet. It gave him all he needed in order to demonstrate his concept – and mastery – of painting. It also afforded him the pleasure of gardening: not merely painting Nature, but shaping it with his own hands. "All I can do is gardening and painting," he told the art critic Maurice Kahn in 1904, who reported the observation in the large-circulation paper "Le Temps".[177] In 1893 Monet had bought an adjoining plot of land and received permission to dam the Ru, a tributary stream of the Epte, in order to create a pool. Across this he had a "Japanese" wooden bridge built. It was hard to convince neighbouring farmers that neither the altered course of the stream nor the waterlilies he planted in the pool would be harmful to agriculture. Using a troop of gardeners, he laid out and tended his famous garden over the next thirty years. There were two garden studios in it.

The death of his wife Alice in 1911 was such a blow that for three years he did not paint. And in 1914 his son Jean died. But Monet's friend

Charles Camoin
Girl with a Cat, c. 1904
La fille au chat
Oil on canvas, 65 x 54 cm
Private collection

Clemenceau succeeded in persuading the 74-year-old to return to his art. Jean's widow, Blanche, née Hoschedé (1865–1947), at once Monet's daughter-in-law and step-daughter and herself starting to paint, became his housekeeper. The day after the First World War ended, Monet's patriotic feelings prompted him to offer Clemenceau, then Prime Minister, two paintings as a gift to the nation. Six days later, Clemenceau visited Monet, with Geffroy, and seized upon an ambitious idea Monet himself had long had for a building devoted to Monet's *paysages d'eau* - as the first *Nymphéas* (waterlilies) series had been titled when exhibited at Durand-Ruel's in 1900.[178] When the Tiger (as Clemenceau was nicknamed) was defeated at the polls in 1920, and retired from political life, it seemed this plan would come to nothing. But a journalist, François Thiébault-Sisson, made the proposal public, and the state took it up. A contract signed in 1922 envisaged the Orangerie of the Tuileries as a site for Monet's art, over 100 square metres of which (much still to be completed) he gifted to the nation in return for the state's assurance of a permanent exhibition professionally handled.

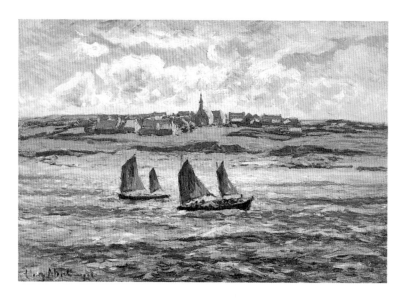

Henry Moret
The Village of Paulgoazec, 1906
Village de Paulgoazec
Oil on canvas, 38.2 x 55 cm
Paris, Galerie Bruno Meissner

Henry Moret
Ouessant, Calm Seas, 1905
Ouessant, jour de calme
Oil on canvas, 93 x 74 cm
Private collection

What was so special about this "Sistine Chapel of Impressionism" – as the artist André Masson (1896–1987) termed it – was that it involved neither the decoration of a space used (like the Pope's chapel) for non-artistic purposes, nor a patriotic or historical national Pantheon, nor the representation of modern life such as Manet had in mind for the Paris city hall or Cézanne for other public spaces. Rather, the Orangerie became a temple of pure vision, where we look at art in which an aged painter has expressed his responses to plants, water and light. Till the age of 86, Monet performed demanding physical work in order to master the vast areas involved, also painting countless large and small variations on his themes on the side, in order to assess and structure his visions. From 1912 he had cataracts in both eyes, and in 1923 had to have an operation on the right eye. It was some time before he could be provided with genuinely helpful spectacles, and he had to rely on his own knowledge of paint and the effects of mixed colours, and of consonance and contrast, when placing colours on his surface according to the label on the tube or their position on his palette. He was no longer able to judge with his own eyes the relation of details to the whole. Thus some of the results were blurred and streaky pictures, disappointing in their colours; art historians are still reluctant to pronounce their opinions on these works. Monet did not live to see the opening of the Orangerie permanent exhibition in May 1927, having been buried by

Albert-Charles Lebourg
Barges at Rouen, 1903
Remorqueurs à Rouen
Oil on canvas, 50 x 73.5 cm
Bénédite 1371. Paris, Musée d'Orsay

Frédéric Cordey
Track at Auvers-sur-Oise
Ruelle à Auvers-sur-Oise
Oil on canvas, 28.5 x 35.5 cm
Louveciennes, Collection Paul Bequaert

his closest friends five months before; at his own wish it was not a state funeral.

The roughly square *paysages d'eau* showing the Japanese bridge, among the very first pictures Monet had painted of his earthly paradise a quarter century before (pp. 364, 365), are exemplary variations on a theme in different conditions of light. The Japanese influence survives in them. Monet's brushwork at that date was still more intent on capturing

Henri-Edmond Cross
Undergrowth, 1906/07
Sous-bois
Oil on canvas, 58 x 70 cm
France, private collection

form than Cézanne's. The water, waterlilies, grasses, trees and bridge give structure and spatial differentiation to the visual space. The way waterlily stems moved below the water's surface, and the reflections of trees, fascinated Monet.

Elsewhere in his garden he painted the lush opulence of flowers, shrubs, overhanging trees and patchwork light (p. 362). There is no horizon to our field of vision, and this, with the tapestry of dabs and *taches*,

Henri le Sidaner
Table beneath Lanterns, Gerberoy, 1924
La table aux lanternes, Gerberoy
Oil on canvas, 125 x 150 cm
Farinaux-Le Sidaner 535
Chicago (IL), M. Sternberg Gallery

Henri Le Sidaner
14 July, Gerberoy, 1910
Le 14 juillet, Gerberoy
Oil on canvas, 82 x 100 cm
Farinaux-Le Sidaner 201
Private collection

Henri Le Sidaner
House by the Sea at Dusk, 1927
La maison de la mer au crépuscule
Oil on canvas, 46.3 x 56 cm
Farinaux-Le Sidaner 620
Private collection

Charles Camoin
The Market Place, Toulon, c. 1908
La Place du Marché, Toulon
Oil on canvas, 65 x 81 cm
Private collection

Paul Signac
Pine Tree at Saint-Tropez, 1909
Pin à Saint-Tropez
Oil on canvas, 72 x 92 cm
Moscow, Pushkin Museum of Fine Art

perpetuates the abiding Impressionist ambition to harmonize spatial depth and surface. Versions of the same subject painted twenty years later, though, emphasized the surface patterning almost exclusively. The *Nymphéas* pictures done from 1904 on, entering a second stage of development around 1916, were mainly what Monet termed "landscapes of reflection". Their vitality derives from the poetic spell which the moist, succulent, sexually symbolic open calyxes of the waterlily blossoms – adrift on the dangerous dark depths of the marshy waters – cast on Symbolist poets and their public alike. The vigorous, pastose curls of paint that sketch the flowers fall into tenderly spatial arabesques reminiscent of Art Nouveau. The floating islands of colour are intermingled with sky colour and the hanging weeping willows and their reflections, in like intensity of colour.

These tantalizing images of motifs with reflections become hypertrophied in the large essays and variations Monet did in the early 1920s for the Orangerie walls (p. 393). Against a blue in which the pink and yellow

reflections of clouds gleam we see the floating carmine flowers, with willow depending from above and irises entering the field of vision from below. The relish Monet brought to his lavish, sometimes impurely coloured work remains permanently evidenced: this spontaneous record of impressions has become a gestural, absolute kind of painting such as was to be rediscovered in the Tachism and action painting of the Twenties. Wistaria hanging down above the water (pp. 394/395) becomes an almost completely non-representational exercise in colour accords, authoritatively reversing traditional views of visual priorities in composition. Impressionism had come a long way since the youthful artists retorted to their furious teachers: "I paint what I see the way I see it."

Henri-Edmond Cross
Cypresses at Cagnes, 1908
Les cyprès à Cagnes
Oil on canvas, 81 x 100 cm
Compin 212. Paris, Musée d'Orsay

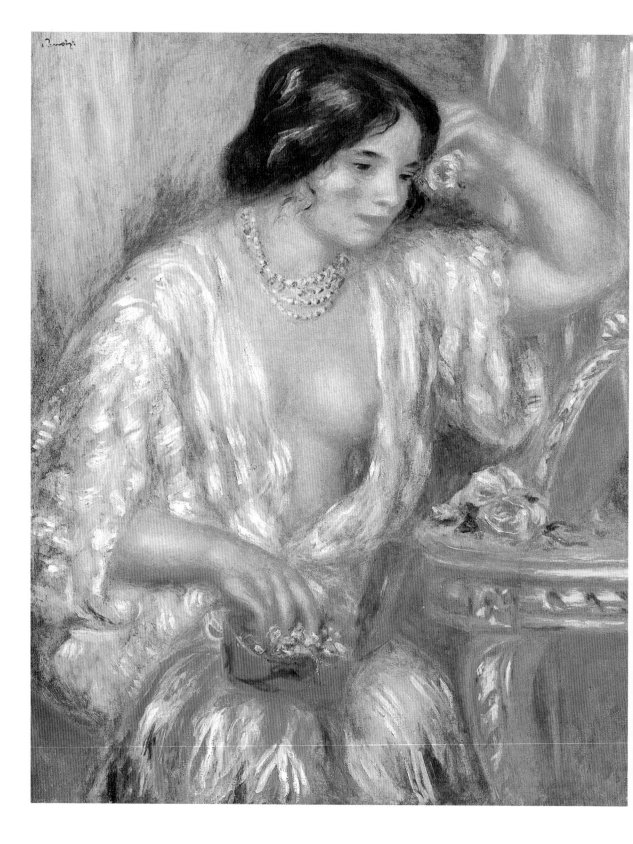

9 "The Masters will last"

Since the end of the 19th century, Impressionism had become established worldwide, not only in France, among artists and in terms of public expectation. Slowly but surely, the number of those who saw Impressionism as a genuine and notably contemporary way of registering experience of the world grew. It is true that in 1905 Durand-Ruel offered 315 first-rate paintings by all the main Impressionists at Grafton Galleries in London – the best and biggest overview anywhere before 1945 – only to have not a single work sold.[179] However, more and more painters were availing themselves of the structural and formal approaches Manet, Monet, Degas and the others had evolved in the 1860s.

Some used them for subjects the founding Impressionists had avoided. Thus André Devambez (1867–1944) painted the gendarmerie breaking up a demonstration in the Boulevard Montmartre at night (p. 373). The slant angle from above of the street and the crowds, the rapid movement, the dramatic spaces, the unusual lighting, all drew on the Impressionist idiom, though the detail was exacter than in comparable street scenes done not long before by Pissarro (pp. 356, 357). Whenever a precision image of actuality was the aim, later artists tended to use Impressionist methods only with reservations. But when artists and the public want a life-asserting, beautiful, light and energetic version of the visible world, Impressionism has stood its ground worldwide to this day, even if many subsequent movements have long since superseded its claim to be avant-garde.

Two painters who moved back from Post-Impressionist, decorative, symbolist styles to Impressionism, and are sometimes referred to as Intimists for their subjects and for the exquisite delicacy of their colour harmonies, afford attractive proof of the vitality of Impressionism.

As a student, Bonnard had designed a poster that impressed Toulouse-Lautrec, and displayed a sensitive touch for decorative effects in paintings exhibited with the Indépendants (p. 340). Bonnard painted his father, sister and brother-in-law playing croquet in the grounds of the family home in south-east France – an old favourite among Impressionist subjects. The overall effect, though, is of a decorative tapestry using Art Nouveau shapes and an elegiac evening mood. Around 1900 Impressionism gained the upper hand in his work, bringing him more into line with Renoir, Monet and Signac; later he was to alternate between Fauvist

Pierre-Auguste Renoir
Study for "Bathers", c. 1884
Etude pour «Les Baigneuses»
Red, black and white chalk, 98.5 x 64 cm
Chicago (IL), The Art Institute of Chicago

Pierre-Auguste Renoir
Gabrielle with Jewels, c. 1910
Gabrielle aux bijoux
Oil on canvas, 82 x 65.5 cm
Private collection

intensity and a rather trite representational copying of views. Bonnard was best at interior nudes drenched in light, or festive family scenes in the open, when he could celebrate the beauty of things and the pleasure of seeing them in bright, lightly dabbed brushwork.

Edouard Vuillard (1868–1940) was in agreement with him in his love of detail, or rather of a luxurious copiousness, and in his concentration on everyday life, portraits of friends, interiors and landscapes – in a word, a typically Impressionist range of subject matter. Vuillard too had a taste and talent for the decorative, and among his early work were stage-set designs. He was closely associated with the magazine "Revue blanche", which was of such importance for the Post-Impressionists and was edited from 1889 to 1903 by Thadée Natanson. Natanson and his beautiful, capricious Franco-Polish wife Marie (Misia), née Godebska – who was portrayed by Toulouse-Lautrec, Vuillard, Renoir and Bonnard, among others – were the heart of an active circle. Vuillard was captivated by the atmosphere. Till the end of his days, elected to the Académie des Beaux-Arts, he retained a highly sensual but cultured approach to seeing and painting. A small early study (p. 340) is a good example, with its dynamic structure, balanced asymmetry and enjoyment of a world that offers beautiful things.

How does Impressionism weigh in the balance of critical, historical and aesthetic judgement? What do people feel on leaving the galleries throughout the world that cherish their French Impressionist holdings as particularly popular and costly treasures? A number of painters, endowed with an intuitive sense many years ahead of most of their contemporaries, discovered important aspects of life and reality in middle- and lower-class circles in highly civilized, modern industrial society, and made art of what they saw. They expressed what they saw in apt and innovatory artistic form, producing among the public, in the course of time, attitudes and ways of seeing to match. Building on realism that was true to appearances and using open-air techniques, the artists painted pictures which many people to this day feel to be images of a world where they themselves would like to live. Unlike various contemporaries and successors, the Impressionists thought nothing of work that dwelt on problematic, distressing or depressing aspects of reality; they painted only the sides of life, and the moments, that asserted pleasure, *joie de vivre*, a feast of the senses. This was in line with their temperaments and convictions, which they adhered to even in the most difficult of personal circumstances, and also accorded with a rather naive optimism concerning the society they lived in. To various, individually differing degrees they were intelligent and sensitive enough to acquire greater critical detachment from the world about them as the years went by. Thus many of their pictures recorded reservations they felt, or inner tension, or offered alternative visions by appealing to the past or to timeless utopias. Though this meant their paintings ran the overall risk of too complaisantly striving for harmony, the works thus had an inner consistency and truthfulness. And this alone can assure works of art a long-term validity and relevance; this alone can make them moving masterpieces.

The waterlily pond in Monet's garden at Giverny, c. 1933

The Impressionists set great store by their craft, and by new and attractive styles of form. In this they were audacious, and their work bore fruit in the further evolution of art too. The claim that subject matter was unimportant in assessing artistic quality was of course first and foremost a youthful protest against tired old subjects. Of graver consequence was their rejection of the philosophical or literary. However, their belief (one they held with regret) was that their culture as a whole was losing the great ideas and traditions it had lived by. Other artistic movements that were philosophically, religiously or politically motivated to connect with

Claude Monet
Waterlilies, 1914
Nymphéas
Oil on canvas, 200 x 200 cm
Wildenstein 1800
Tokyo, National Museum of Western Art

those traditions enjoyed only limited success. The resignation with which a Degas would concentrate on what was pragmatically possible was expressed in his dry remark: "Two hundred years ago I would have painted Susannah and the Elders, the biblical subject, but now what I paint is women washing in bathtubs."[180] Like many others, he realised that modern praxis was incompatible with mythology, with the "unconscious artistic processing" of reality in a folk imagination, which is so much more favourable to artistic creativity than modern rationality.[181]

Impressionist technique significantly enriched the repertoire of art. The Impressionists introduced ways of suggesting motion through sketchy, open composition and brushwork; used evocatively unusual sectional views taken from a spatial and chronological continuum; discovered how dependent colour was on light, and established a hitherto unknown brightness, purity and vigour in colours; found new ways of relating painted surface, spatial illusion and three-dimensionality in visual structures; and asserted a new autonomous value for both the materials out of which art is made and for the visible traces of the artist's own work. All of this proved a fertile legacy for 20th-century artists of various persuasions. Sometimes this circumstance has meant that Impressionist art is automatically seen as more diverse in its aesthetic ap-

proach to visible reality, and intellectually richer, than what came later. Hofmann has summed up the historical significance and fertility of Impressionism by seeing it as the "watershed" of the 19th and 20th centuries – which implies the reaching of a peak.[182]

Zola was a shrewd judge, though his opinions were controversial. Writing in "Le Figaro" in 1896 on the Salon, he recalled his own beginning and that of his friends thirty years earlier.[183] He had hoped that their art would go in a different, more critical and realistic direction. He was appalled at the way light had become a modish and superficial component in art, and horrified at the Symbolism prevalent in the mid–90s. His contemporaries who were still painting took offence at his view of them as pioneers of a better future art who in their own achievement remained imperfect. Like many a later art historian, they failed to note that he still approved wholeheartedly of their audacious beginnings. Writing of Manet, Monet and Pissarro, he declared: "The masters will last."

Claude Monet
Wistaria, 1919/20
Glycines
Oil on canvas, 100 x 300 cm
Wildenstein 1904. Paris, Musée Marmottan

Monet's waterlily pond at Giverny, c. 1933

Notes

1 W. Hofmann: Das irdische Paradies. Kunst im neunzehnten Jahrhundert. Munich 1960; R. Zeitler: Die Kunst des 19. Jahrhunderts (Propyläen Kunstgeschichte, II). Berlin 1966; H.G. Evers: Vom Historismus zum Funktionalismus (Kunst der Welt. Die Kulturen des Abendlandes, 21). Baden-Baden 1967; R. Rosenblum, H.W. Janson: 19th Century Art. Painting and Sculpture. New York and London 1984.

2 J. Rewald. In: Camille Pissarro. Hayward Gallery, London; Grand Palais, Paris; Museum of Fine Arts, Boston. London et al. 1981, pp. 9–12 (exhibition catalogue).

3 R. Hamann: Der Impressionismus in Leben und Kunst. Cologne 1907.

4 W. Weisbach: Impressionismus. Ein Problem der Malerei in der Antike und Neuzeit. 2 volumes. Berlin 1910/11.

5 A. Boime: Thomas Couture and the Eclectic Vision. New Haven and London 1980; T. J. Clark: The Painting of Modern Life. Paris in the Art of Manet and His Followers. London 1985; R.L. Herbert: Impressionism. Art, Leisure and Parisian Society. New Haven and London 1988.

6 C.S. Moffett (ed.): The New Painting. Impressionism 1874–1886. The Fine Art Museum of San Francisco et al. Oxford and Geneva 1986 (exhibition catalogue).

7 F. Novotny: Cézanne und das Ende der wissenschaftlichen Perspektive. Vienna 1938.

8 The following contains lists of works and selected monographs, together with those important for recent research. – D. Rouart and D. Wildenstein: Edouard Manet. Catalogue raisonné. 2 volumes. Lausanne and Paris 1975; A.C. Hanson: Manet and the Modern Tradition. New Haven and London 1977; K. Adler: Manet. Oxford 1986.

9 P.A. Lemoisne: Degas et son œuvre. 4 volumes. Paris 1946–1949; P. Cabanne: Edgar Degas. Munich 1958; Degas. Grand Palais, Paris; Metropolitan Museum, New York; Musée des Beaux-Arts, Ottawa. Paris et al. 1988 (exhibition catalogue).

10 D. Wildenstein: Claude Monet. Biographie et catalogue raisonné. 4 volumes. Lausanne and Paris 1974–1985; Hommage à Claude Monet. Grand Palais, Paris 1981 (exhibition catalogue); R. Gordon and A. Forge: Claude Monet. Paris 1984; J. House: Monet. Nature into Art. New Haven and London 1986; K. Sagner-Düchting: Claude Monet, 1840–1926. A Feast for the Eyes. Cologne 1992.

11 F. Daulte: Renoir. Catalogue raisonné de l'œuvre peint, volume 1: Figures 1860–1890. Lausanne and Paris 1971; W. Pach: Pierre-Auguste Renoir. Cologne 1958; Renoir. Hayward Gallery, London; Grand Palais, Paris; Museum of Fine Arts, Boston. Paris et al. 1985 (exhibition catalogue); P.H. Feist: Pierre-Auguste Renoir, 1841–1919. A Dream of Harmony. Cologne 1991.

12 L.R. Pissarro and L. Venturi: Camille Pissarro. Son art, son œuvre. 2 volumes. Paris 1939; Pissarro. Hayward Gallery, London; Grand Palais, Paris; Museum of Fine Arts, Boston. London et al. 1981 (exhibition catalogue); C. Lloyd: Camille Pissarro. Geneva 1981; R.R. Bretell: Pissarro and Pontoise. The Painter in a Landscape. New Haven and London 1990.

13 F. Daulte: Alfred Sisley. Catalogue raisonné de l'œuvre peint. Lausanne and Paris 1959.

14 F. Daulte: Frédéric Bazille et son temps. Geneva 1952.

15 G. Wildenstein and M.-L. Bataille: Berthe Morisot. Catalogue des peintures, dessins, aquarelles. Paris 1960; D. Rouart (ed.): Correspondance de Berthe Morisot avec sa famille et ses amis Manet, Puvis de Chavannes, Degas, Monet, Renoir et Mallarmé. Paris 1950.

16 L. Venturi: Les Archives de L'Impressionnisme. 2 volumes. Paris and New York 1939; J. Rewald: Die Geschichte des Impressionismus, Cologne 1965; L. Venturi: De Manet à Lautrec. Paris 1953; O. Reuterswärd: Impressionisterna inför publik och kritik. Stockholm 1952; J. Leymarie: Impressionismus. 2 volumes. Geneva 1955; P. Pool: Die Kunst des Impressionismus. Berlin 1970; M. and G. Blunden: Der Impressionismus in Wort und Bild. Geneva 1978; A. Bellony-Rewald: Le monde retrouvé des impressionnistes. Paris 1977; S. Monneret: L'Impressionnisme et son époque. Dictionnaire international illustré. 4 volumes. Paris 1978–1981; D. Kelder: Die Großen Impressionisten. Munich 1981; Französische Impressionisten und ihre Wegbegleiter. Neue Pinakothek, Munich 1990 (exhibition catalogue).

17 G. Serret and D. Fabiani: Armand Guillaumin, 1841–1927. Catalogue raisonné de l'œuvre peint. Paris 1971.

18 M. Berhaut: Caillebotte, sa vie et son œuvre. Catalogue raisonné des peintures et pastels. Paris 1978; K. Varnedoe: Gustave Caillebotte. New Haven and London 1987.

19 C. Roger-Marx: Eva Gonzalès. Saint-Germain-en-Laye 1950.

20 L. Venturi: Cézanne. Son art, son œuvre. 2 volumes. Paris 1936; K. Badt: Die Kunst Cézannes. Munich 1956; W. Rubin (ed.): Cézanne. The Late Work. The Museum of Modern Art, New York et al. New York 1977 (exhibition catalogue); L. Gowing (ed.): Cézanne. The Early Years, 1859–1872. Royal Academy of Arts, London et al. London 1988 (exhibition catalogue); J. Rewald: Cézanne. Biographie. Cologne 1986; H. Düchting: Paul Cézanne, Biographie. 1839–1906. Nature into Art. Cologne 1991.

21 H. Dorra and J. Rewald: Seurat. L'œuvre peint. Biographie et catalogue critique. Paris 1959; C.M. de Hauke: Seurat et son œuvre. 2 volumes. Paris 1961; R. Thomson: Seurat. Oxford 1985.

22 Signac. Musée du Louvre, Paris 1963/64 (exhibition catalogue); Paul Signac, 1863–1935. Paintings, Watercolors, Drawings and Prints. New York 1977 (exhibition catalogue).

23 J. Rewald: Le post-impressionnisme. De van Gogh à Gauguin. Paris 1961; J. Sutter: Die Neoimpressionisten. Berlin 1970.

24 G. Wildenstein and R. Cogniat: Gauguin. Catalogue des tableaux. Volume 1, Paris 1964; G.M. Sugana: L'opera completa di Gauguin. Milan 1972; W. Jaworska: Gauguin et l'école de Pont-Aven. Paris 1971; F. Cachin: Gauguin. Paris 1988; I.F. Walther: Paul Gauguin, 1848–1903. The Primitive Sophisticate. Cologne 1992; Paul Gauguin. Grand Palais, Paris 1989 (exhibition catalogue).

25 J.-B. de la Faille: The Works of Vincent van Gogh. Amsterdam and New York 1970; J. Hulsker: Van Gogh en zijn weg. Het complete werk. Amsterdam 1977; I.F. Walther and R. Metzger: Vincent van Gogh. The Complete Paintings, 2 volumes. Cologne 1990.

26 M. Joyant: Henri de Toulouse-Lautrec, 1864–1901. 2 volumes. Paris 1926/27; M.G. Dortu: Toulouse-Lautrec et son œuvre. 6 volumes. New York 1971; M. Arnold: Henri de Toulouse-Lautrec, 1864–1901. The Theatre of Life. Cologne 1992.

27 J. and H. Dauberville: Bonnard. Catalogue raisonné de l'œuvre peint. 4 volumes. Paris 1965; Pierre Bonnard. Städelsches Kunstinstitut, Frankfurt am Main 1985 (exhibition catalogue).

28 J. Russel (ed.): Edouard Vuillard, 1868–1940. Toronto and London 1971 (exhibition catalogue).

29 N. Broude (ed.): Impressionismus. Eine internationale Kunstbewegung 1860–1920. Cologne 1990; cf. Landschaft im Licht. Impressionistische Malerei in Europa und Nordamerika 1860–1910. Wallraf-Richartz-Museum, Cologne 1990 (exhibition catalogue).

30 A. Boime: The Academy and French Painting in the Nineteenth Century. London 1971; N. Pevsner: Academies of Art. Past and Present. New York 1973; P. Grunchec and J. Thuillier (eds.): La peinture à l'Ecole des Beaux-Arts. Les concours des Prix de Rome, 1797–1863. 2 volumes. New York 1984/85 (exhibition catalogue).

31 G. Wildenstein: Ingres. London 1954; G. Picon: Ingres. Geneva 1980.

32 R. Huyghe: Delacroix. Munich 1967; P. Georgel and L. Rossi-Bortolatte: Tout l'œuvre peint de Delacroix. Paris 1975; Eugène Delacroix. Gemälde. Zurich and Frankfurt am Main 1987/88 (exhibition catalogue).

33 M. Rosenthal: Constable. The Painter and His Landscape. New Haven and London 1983; G. Reynolds: The Later Paintings and Drawings of John Constable. 2 volumes. New Haven and London 1984.

34 J.D. Hunt and P. Willis (eds.): The Genius of the Place. The English Landscape Garden 1620–1820. London 1975; A. v. Buttlar: Der Landschaftsgarten. Munich 1980.

35 W. Hofmann (ed.): William Turner und die Landschaft seiner Zeit. Kunsthalle Hamburg, Munich 1976 (exhibition catalogue); A. Wilton: J.M. Turner. Leben und Werk. Munich 1979; M. Butlin and E. Joll: The Paintings of J. M. W. Turner. 2 volumes. New Haven and London 1984.

36 J. Ingamells: Richard Parkes Bonington. London 1979; C. Peacock: Richard Parkes Bonington. London 1979.

37 M. Pointon: The Bonington Circle. English Watercolor and Anglo-French Landscape 1790–1855. Brighton 1985, p. 80.

38 Cf. "Équivoques". Peintures françaises du XIXᵉ siècle. Musée des Arts décoratifs, Paris 1973 (exhibition catalogue); A. Celebonovic: Peinture kitsch ou réalisme bourgeois. Paris 1975; Un autre XIXᵉ siècle. Peintures et sculptures de la collection de M. et Mme Joseph M. Tanenbaum. Galerie Nationale du Canada, Ottawa 1978 (exhibition catalogue); C. Ritzenthaler: L'Ecole des Beaux-Arts du 19ᵉ siècle. Les pompiers. Paris 1987.

39 J.C. Sloane: French Painting between the Past and the Present. Artists, Critics and Traditions from 1848 to 1870. Princeton 1951; L. Nochlin: Realism. Harmondsworth 1971 (Style and Civilization, edited by J. Fleming and H. Honour); G.P. Weisberg (ed.): The European Realist Tradition. Bloomington 1982; W. Klein: Der nüchterne Blick. Programmatischer Realismus in Frankreich nach 1848. Berlin and Weimar 1989.

40 R.L. Herbert: Barbizon revisited. Essay and Catalogue. New York 1962; J. Bouret: L'Ecole de Barbizon et le paysage français au XIXᵉ siècle. Neuchâtel 1972; Zurück zur Natur. Die Künstlerkolonie von Barbizon, ihre Vorgeschichte und Auswirkung. Kunsthalle Bremen, Bremen 1977/78 (exhibition catalogue); H.-P. Bühler: Die Schule von Barbizon. Französische Landschaftsmalerei im 19. Jahrhundert. Munich 1979; L'Ecole de Barbizon. Maîtres français du XIXᵉ siècle. Ghent, The Hague, Paris 1985/86 (exhibition catalogue).

41 J. Castagnary: Salons 1857–1870. Paris 1892, p. 17.

42 A. Robaut: L'œuvre de Corot. Catalogue raisonné et illustré. 5 volumes. Paris 1904–1906; A. Schoeller and J. Dieterle: Corot. Supplément au catalogue de l'œuvre par Robaut et Moreau-Nélaton. Paris 1948; J. Selz: Camille Corot. Courbevoie 1988.

43 A. Fermigier: Jean-François Millet. Geneva 1977.

44 R. Fernier: La Vie et l'œuvre de Gustave Courbet. Catalogue raisonné. 2 volumes. Lausanne 1977/78; T.J. Clark: Image of the People. Gustave Courbet and the Second French Republic 1848–1851. London 1973; L. Nochlin: Gustave Courbet. A Study of Style and Society. New York 1976; Gustave Courbet (1819–1877), Grand Palais, Paris 1977/78 (exhibition catalogue; cf. H. Toussaint: Le dossier de "L'Atelier" de Courbet, pp. 241–272); K. Herding (ed.): Realismus als Widerspruch. Die Wirklichkeit in Courbets Malerei. Frankfurt am Main 1978; S. Faunce and L. Nochlin: Courbet Reconsidered. New Haven and London 1988; M. Fried: Courbet's Realism. Chicago 1989.

45 Kunstverhältnisse. Ein Paradigma kunstwissenschaftlicher Forschung. Wissenschaftliches Kolloquium, Institut für Ästhetik und Kunstwissenschaften der Akademie der Wissenschaften der DDR. Berlin 1988. – The expresssion "Kunstverhältnisse", used in the German text and translated here as "the conditions that prevailed in the art world", was formed by the author following R. Rosenberg's use of the expression "Literaturverhältnisse" ("prevailing literary conditions") in the title of his work: Literaturverhältnisse im deutschen Vormärz. Berlin 1975.

46 J. Allwood: The Great Exhibitions. London 1977; W. Friebe: Vom Kristallpalast zum Sonnenturm. Eine Kulturgeschichte der Weltausstellungen. Leipzig 1983; G. Maag: Kunst und Industrie im Zeitalter der ersten Weltausstellungen. Munich 1986; P. Mainardi: Arts and Politics of the Second Empire: The Universal Exhibitions of 1855 and 1867. New Haven and London 1987.

47 From K.W. Luckhurst: The Story of Exhibitions. London and New York 1951, p. 55, in 1781, the "one-picture-shows" began in London with "The Death of Chatham" by J.S. Copley. In France J.L. David exhibited his "Sabine Women" from 1799 to 1804, reaping considerable financial award. It was the contemporary relevance and sensational quality of the subject matter on view which proved the decisive factor in this and other, later cases. Short-term exhibitions free of admission held in the respective artist's studio were coming in at this time. The artist's studio as exhibition and sales gallery was to be encountered particularly in the second half of the century.

48 W. Leibl: Letter to his mother from 18ᵗʰ March, 1879. In: J. Mayr: Wilhelm Leibl. Sein Leben und Schaffen. Munich 1935, p. 78.

49 A. Boime: Thomas Couture and the Eclectic Vision. New Haven and London 1980.

50 P. Vaisse: Thomas Couture ou le bourgeois malgré lui. In: "Romantisme. Revue du dix-neuvième siècle" 17/18 (1977), pp. 103–122.

51 E. Moreau-Nélaton: Manet, raconté par lui-même. Volume 1. Paris 1926, p. 26.

52 A. Proust: Edouard Manet. Souvenirs. In: "La Revue Blanche" 8 (1897), No.88–93. – In 1897, Degas disputed Daniel Halévy's claim that Manet had already used pleinairist impressions in the 1860s.

53 J. Mayne (ed.): Art in Paris 1845–1862. Salons and other Exhibitions reviewed by Charles Baudelaire. London 1965; C. Baudelaire: Le peintre de la vie moderne. Essais, "Salons", journaux intimes.

54 First edition in 1921. Cf. J. Rewald: see note 16, p. 116

55 Eadweard James Muybridge (1830–1904) had been experimenting since 1872 with – among others – photographs of galloping horses taken using twelve cameras, so-called "chronophotography". His photographs were published in 1878 in "La Nature". It is highly probable that Degas attended a slide show given by Muybridge in Paris in 1881. Cf. Degas. Grand Palais, Paris; Musée des Beaux-Arts, Ottawa; The Metropolitan Museum, New York. Paris 1988, p. 459 (exhibition catalogue).

56 R. Schmit: Catalogue raisonné de l'œuvre peint d'Eugène Boudin. 2 volumes. Paris 1973; J.Selz: Boudin. Paris and New York 1982.

57 Note from a sketchbook of Boudin; J. Rewald: see note 16, p. 30.

58 Monet in an interview. F. Thiébault-Sisson: Claude Monet. Un entretien. In: "Le Temps". Paris, 27ᵗʰ November, 1900. J. Rewald: see note 16, p. 30; K. Sagner-Düchting: Claude Monet. Cologne 1992, p. 11.

59 From the same interview. Rewald, ibid. p. 47; Sagner-Düchting, ibid. p. 16. For Jongkind cf. V. Hefting: Jongkind. Sa vie, son œuvre, son époque. Paris 1975.

60 Charles Gleyre ou les illusions perdues. Winterthur, Lausanne, Aarau, Marseilles, Munich, Kiel 1974/75 (exhibition catalogue).

61 Cézanne et Zola. Paris 1936. Rewald's dissertation marked the beginning of his studies of Impressionism. – E. Zola: Salons. Recueillis, annotés et présentés par F. W. J. Hemmings and R.J. Niess. Geneva and Paris 1959; E. Zola: Œuvres critiques, III. Préfaces de G. Besson, H. Mitterand and G. Picon, notices et notes de H. Mitterand (Œuvres complètes. Edition établie sous la direction de H. Mitterand, 12). Paris 1969; E. Zola: L'œuvre; P.H. Feist: Zolas Kritik am Impressionismus in der Malerei. In: Realismus und literarische Kommunikation (Sitzungsberichte der Akademie der Wissenschaften der DDR, Gesellschaftswissenschaften, no.8/G). Berlin 1984, pp. 45–51.

62 Fantin-Latour. Grand Palais, Paris; Galerie Nationale du Canada, Ottawa; Fine Arts Museum, San Francisco. Paris et al. 1982 (exhibition catalogue).

63 J.-P. Bouillon (ed.): Félix and Marie Bracquemond. Mortagne-Chartres 1972.

64 No comprehensive history of the Paris "Salon" and its later splitting-up exists; all that is available is a multitude of individual studies and references in the literature. Cf. P. Vaisse: Salons, Expositions et Sociétés d'artistes en France 1871–1914. In: Saloni, gallerie, musei e loro influenza sullo sviluppo dell'arte dei secoli XIX e XX. (edited by F. Haskell) Bologna n.d., pp. 141–155, and further contributions in this title. – Cf. K.W. Luckhurst: The Story of Exhibitions. London and New York 1951; E. Mai: Expositionen. Geschichte und Kritik des Ausstellungswesens. Munich 1986.

65 J. Rewald: see note 16, p. 16.

66 W. Hofmann. In: Courbet und Deutschland. Kunsthalle, Hamburg, and Städelsches Kunstinstitut, Frankfurt am Main 1978/79, p. 603 for no. 779 (exhibition catalogue).

67 M. Osborn. In: A. Springer: Handbuch der Kunstgeschichte. Volume 5, Leipzig ⁹ 1925, p. 175.

68 See note 61. – In detail: P. Brady: "L'Œuvre" de Emile Zola. Roman sur les arts, manifeste, autobiographie, roman à clef. Geneva 1967; R.J. Niess: Zola, Cézanne, and Manet. A Study of "L'Œuvre". Ann Arbor 1968.

69 J.L. Vaudoyer: Edouard Manet. Paris 1955.

70 W. Klein: Der nüchterne Blick. Programmatischer Realismus in Frankreich nach 1848. Berlin and Weimar 1989, p. 240.

71 E. Zola: Mes haines. Paris 1867.

72 An extensive study of the work's history may be found in N.G. Sandblad: Manet. Three Studies in Artistic Conception. Lund 1954. Manet had the final version of the picture exhibited as a one-work show in Philadelphia, New York and Boston in 1879 through the mediation of travelling friends; inevitably, this proved unsuccessful.

73 Previously working for a publishing house, Zola became a freelance writer and critic in 1866. In 1867, he published a large-scale study on Manet, in whom he saw an ally in the fight for a modern realism.

74 G.P. Weisberg et al. (eds.): Japonisme. Japanese Influence on French Art 1854–1910. Museum of Art, Cleveland 1975; S. Wichmann: Japonismus. Ostasien – Europa. Begegnungen in der Kunst des 19. und 20. Jahrhunderts. Herrsching 1980; K. Berger: Japonismus in der westlichen Malerei 1860–1920. Munich 1980.

75 D. Rouart and D. Wildenstein: Edouard Manet. Catalogue raisonné. Lausanne and Paris 1975, Volume 1, p. 5.

76 P. Jamot in: "Gazette des Beaux-Arts" 1918, p. 152.

77 E. Lipton: The Laundress in Late Nineteenth-Century French Culture. Imagery, Ideology and Edgar Degas. In: "Art History" 3 (1980), pp. 295–313.

78 Edmond de Goncourt, 13th February, 1874. Journal des Goncourt, 5, 1891, p. 111 f.

79 F. Daulte: Frédéric Bazille et son temps. Geneva 1952, p. 135.

80 F. Daulte wrote, back in 1957 in the catalogue to the Pissarro exhibition organized by the Berne Kunstmuseum, of the need for a new consideration of the artist's output. This has now been achieved, above all through C. Lloyd, R.R. Bretell (see note 12), R.E. Shikes and P. Harper: Pissarro. His Life and Work. London 1980; R. Thomson: Camille Pissarro. Impressionism, Landscape, and Rural Labour. Birmingham and Glasgow 1990 (exhibition catalogue). Cf. C. Lloyd (ed.): Studies on Camille Pissarro. London 1986.

81 Z. Astruc quoted from L. Venturi: Les archives de l'Impressionnisme. Volume 1. Paris and New York 1939, p. 31.

82 T. Thoré: Salons. Volume 2. Paris 1870, p. 531.

83 K. Adler: Wiederentdeckte Impressionisten. Oxford 1988, p. 95.

84 Ibid. p. 96.

85 D. Rouart (ed.): The Correspondence of Berthe Morisot. London² 1959, p. 63. (5th June, 1871). Cf. recently J. Baas: Edouard Manet and "Civil War". In: "Art Journal" 44 (1985), pp. 36–42.

86 J. Rewald: Cézanne and His Father. In: J. Rewald: Studies in Impressionism. London 1985, pp. 69–101, especially pp. 78–89.

87 For J. Gasquet cf. P. Cézanne: Über die Kunst. Reinbek 1957, p. 98.

88 In: "L'Avenir National", Paris 5th May, 1873; J. Rewald: Histoire de l'Impressionnisme. Paris 1955, p. 187.

89 Degas to Mrs. Havemeyer. In: D.C. Rich: Degas. Cologne 1959, p. 19.

90 J.-K. Huysmans: Certains. Paris³ 1898, p. 23.

91 P. Cabanne: Degas. Munich 1957, p. 29.

92 Cf. R.R. Bretell: Pissarro and Pontoise. The Painter in a Landscape. Thesis (unpublished) Yale University, New Haven 1977.

93 C. Lloyd: Camille Pissarro. Geneva 1981, p. 72.

94 E.R. Curtius: Die französische Kultur. In: E.R. Curtius and A. Bergsträsser: Frankreich. Volume 1. Stuttgart 1930, p. 165.

95 E. Zola: La Curée. Paris 1986, p. 256.

96 A. Bellony-Rewald: Die verlorene Welt der Impressionisten. Berlin 1978, p. 132 f.

97 The details concerning the exhibition and its past history are to be found in many reminiscences and publications, among them J. Rewald: Histoire de l'Impressionnisme; D. Wildenstein: Claude Monet. Biographie et catalogue raisonné. Volume 1. Lausanne 1974, as well as in the exhibition catalogues for Centenaire de l'Impressionnisme, Grand Palais, Paris 1974, and C.S. Moffett (eds.): The New Painting. Impressionism 1874–1886. Washington and San Francisco, Geneva 1986 (see note 6).

98 J. Rewald: see note 16, pp. 201 and 358, note 35.

99 Henri Rouart had studied painting under Millet, and previously under Edouard Brandon (1831–1897) and Jean-Baptiste-Léopold Levert (b. 1828), among others; it is possible that, through his mediation, they took part at least in the 1874 exhibition.

100 Most of the relevant articles were reprinted in the exhibition catalogue Centenaire de l'Impressionnisme. Paris 1974, with the curious exception of Manet. An analysis was undertaken by O. Reuterswärd in his Swedish thesis: Impressionisterna inför publik och kritik, Stockholm 1952. The language barrier would appear to be the reason why this thorough work is so seldom mentioned. The most recent relevant study may be found in P. Tucker and S.F. Eisenman in: C.S. Moffett (ed.): The New Painting. Geneva 1986.

101 J. Rewald: Cézanne and Guillaumin (first published in 1975). In: Studies in Impressionism. London 1985, pp. 103–119, especially pp. 106–109.

102 D. Wildenstein's localization of the motif and dating of the picture, refuting earlier suppositions: Claude Monet. Catalogue raisonné. Volume 1. Lausanne and Paris 1974, no. 364. Cf. for the critique T.J. Clark: The Painting of Modern Life. London 1985, p. 190 f. and colour plates XVIII and XIX.

103 J. Rewald: John Hay Whitney Collection. New York; Tate Gallery, London 1960/61, no. 47; F. Daulte: Auguste Renoir. Catalogue raisonné de l'œuvre peint. Volume 1. Lausanne 1971, no. 207–209.

104 D. Rouart and D. Wildenstein: Edouard Manet. Catalogue raisonné. Volume 1. Lausanne and Paris 1975, p. 20 f. Cf. M.L. Bataille: Briefe Edouard Manets. In: "Kunst und Künstler" 32 (1933) pp. 10–20.

105 W. Hofmann: Nana. Mythos und Wirklichkeit. Cologne 1973.

106 Ibid. p. 42.

107 Ibid. p. 17. Other authors are of the opinion that the model is identical with Renoir's "Anna", despite the differing bodily posture and colour of hair.

108 R. Pickvance: "L'Absinthe" in England. In: "Apollo" (London), May 1963, pp. 395–398; D. Cooper: The Courtauld Collection. London 1954, p. 42, note 3 and p. 60 f.; C.S. Moffett (ed.): The New Painting. Geneva 1986, p. 161.

109 H. Dawkins: Degas and the Psychogenesis of Modernism (Critique to C. Bernheimer: Figures of Ill Repute, Representing Prostitution in Nineteenth-Century France. Cambridge (MA) 1989). In: "Art History" 13 (1990), pp. 580–585, especially pp. 583 and 585, note 13.

110 J. Rewald: see note 16, p. 209.

111 T. Reff: Degas. The Artist's Mind. New York 1976, p. 182.

112 Duranty: La nouvelle peinture. A propos du groupe d'artistes qui expose dans les galeries Durand-Ruel. Paris 1876 (new edition by M. Guérin, Paris 1946); C.S. Moffett: The New Painting, Impressionism 1874–1886. Geneva 1986.

113 R.R. Bretell: The "First" Exhibition of Impressionist Painters. In: C.S. Moffett: The New Painting. Geneva 1986, pp. 189–202, especially p. 190.

114 J. Burckhardt: Kulturgeschichtliche Vorträge. Edited by R. Marx. Stuttgart 1941, pp. 60 and 112 f.

115 About the predominant painting see among others P. Vogt: Was sie liebten… Salonmalerei im XIX. Jahrhundert. Cologne 1969, and also the studies mentioned in note 38.

116 K. McConkey: The Bouguereau of the Naturalists: Bastien-Lepage and British Art. In: "Art History" 1 (1978), pp. 371–382.

117 Reproduced in a wood engraving and commented upon in T.J. Clark: The Painting of Modern Life. London 1985, repr. 96, p. 199.

118 M. Wentworth: James Tissot. Oxford 1984. His rediscovery began with an exhibition in Providence (RI) and Toronto in 1968.

119 J. Claretie: L'Art et les artistes français contemporains. Paris 1876, pp. 207–209.

120 Duranty: Réflexions d'un bourgeois sur le Salon de peinture. In: "Gazette des Beaux-Arts" 19 (1877). Cf. Duranty's novel, "Le peintre Louis Martin", published at the same time, the portrait of a painter marked by the impression that modern Parisian life makes upon him.

121 G. Rivière. In: "L'Impressionniste", Paris, 6th April, 1877, p. 4, quoted from J. Rewald: see note 16, p. 204 and C.S. Moffett: The New Painting. Geneva 1986, p. 201.

122 J.-K. Huysmans: L'Art moderne. Paris 1883.

123 P. Vaisse in the title mentioned in note 64.

124 L. Venturi: Les Archives de l'Impressionnisme. Volume 1. Paris 1939, p. 122.

125 Ibid. p. 120 (letter from 24th February).

126 J. Renoir: Mein Vater Auguste Renoir. Frankfurt am Main 1965, p. 136.

127 D. Rouart and D. Wildenstein: Edouard Manet: Catalogue raisonné. Volume 1. Lausanne 1975, p. 23.

128 J. Meier-Graefe: Edouard Manet. Munich 1912; reprint in W. Tenzler (ed.): Meier-Graefe: Das Fest der Farben. Berlin 1986, p. 208.

129 K.H. Usener: Edouard Manet und die Vie

Moderne. In: "Marburger Jahrbuch für Kunstwissenschaft" 19 (1974) pp. 9–32, quotation p. 32 (Paper from 1959).

130 G. Clemenceau: Claude Monet. Paris 1928, p. 19 f. .J Rewald: see note 16, p. 248.

131 E. de Goncourt: La Faustin. Paris 1882; E. Zola: L'Œuvre. Paris 1886. Alexandre Robert (1817–1891) had painted "Luca Signorelli Painting His Dead Small Son" back in 1848.

132 According to the reminiscences of A. André: Renoir, Paris 1923, and J.-E. Blanche: Propos de peintre. De David à Degas. Paris 1919.

133 J. Renoir: Mein Vater Auguste Renoir. Frankfurt am Main 1965, p. 99.

134 Passed on as a remark made by Cézanne to Maurice Denis in March 1905. M. Denis: Cézanne. In: "L'Occident" (Paris), September 1907; P.M. Doran (ed.): Conversations avec Cézanne. Paris 1978, p. 170.

135 For the distinction between academic and official art, see the sociological study on the art of M.-C. Genet-Delacroix: Vie d'artistes: art académique, art officiel et art libre en France à la fin du XIXe siècle. In: "Revue d'histoire moderne et contemporaine" 33 (1986), pp. 40–73.

136 H.C. and C.A. White: Canvases and Careers. Institutional Change in the French Painting World. New York 1965. Also M. Ward: The Rhetoric of Independence and Innovation. In: C.S. Moffett: The New Painting. Geneva 1986, pp. 421–442.

137 Cf. M. Ward: see note 136.

138 E. Dujardin: Le Cloisonisme. In: "Revue indépendante", 19th May, 1888, quoted following J. Rewald: Le Post-impressionnisme. De van Gogh à Gauguin. Paris 1961, p. 98. This is the most comprehensive work to deal with the problems raised here.

139 According to R. Thomson: Seurat. Oxford 1985, p. 95.

140 M. and G. Blunden: see note 16, p. 177.

141 See note 139, also J. Sutter and R.L. Herbert: Die Neoimpressionisten. Berlin 1970; A. Boime: George Seurat's "Un Dimanche après-midi à la Grande Jatte" and the Scientific Approach to History Painting. In: E. Mai and A. Repp-Eckert (eds.): Historienmalerei in Europa. Mainz 1990, pp. 303–333.

142 According to G. Kahn in the discussion of an exhibition by Puvis de Chavannes at Durand-Ruel's in late 1887. R. Thomson: see note 139, p. 116.

143 The 100th anniversary of his death was celebrated in Paris and New York by the most comprehensive exhibition to date of those works which, while less well known, are most significant within the history of art. Cf.: The Grande Jatte at 100. In: "The Art Institute of Chicago. Museum Studies" 14 (1989) no.2.

144 The artist, anticapitalist and with an ongoing commitment against war, was always interested in a realistic manner in the particular character of localities, working processes, and movements of the body, for example those performed by bathers or wrestlers. He exhibited regularly from 1889 on at the Société des Artistes Indépendants, whose president he became in 1935. Cf. D. Bazetoux and J. Bouin-Luce: Maximilien Luce. Catalogue de l'œuvre peint. 2 volumes. Paris 1986.

145 Cf. letter to his son Lucien, November 1889.

146 J. Rewald: Le Post-impressionnisme. De van Gogh à Gauguin, Paris 1961, p. 254.

147 Ibid. pp. 482 f. and 518 f. The articles by Aurier were published in the "Mercure de France", March 1891, and in the "Revue Encyclopédique" 1st April, 1892. Cf. W. Rasch: Fläche, Welle, Ornament. Zur Deutung der nachimpressionistischen Malerei und des Jugendstils. In: Festschrift Werner Hager. Recklinghausen 1966, pp. 136–160, especially p. 144.

148 For example Adolphe Leleux (1812–1891) "Un Mariage en Bretagne", 1863, Musée des Beaux-Arts, Quimper. In: Le Musée du Luxembourg en 1874. Paris 1974, no. 157 (exhibition catalogue).

149 R. Hamann and J. Hermand: Stilkunst um 1900. Berlin 1967.

150 Reprint in M. Denis: Théories, 1890–1910. Du Symbolisme et de Gauguin vers un nouvel ordre classique. Paris 1912.

151 J. Rewald: Le Post-impressionnisme. De van Gogh à Gauguin, Paris 1961, pp. 113 ff. with reproductions.

152 K. Hoffmann: Zu van Goghs Sonnenblumenbildern. In: "Zeitschrift für Kunstgeschichte" 31 (1968) p. 27 ff. – For van Gogh in general, see the extensive study by I.F. Walther and R. Metzger: Vincent van Gogh. The Complete Paintings. 2 volumes. Cologne 1990.

153 In 1987, one version of the "Sunflowers" was sold for 250 million francs; in the same year, "The Irises" went for 300 million francs and in 1990 a version of the "Portrait of Doctor Gachet" for 450 million francs.

154 J.A. Schmol called Eisenwerth: Fensterbilder. Motivketten in der europäischen Malerei. In: Beiträge zur Motivkunde des 19. Jahrhunderts. Munich 1970, pp. 13–165.

155 M. Arnold: Henri de Toulouse-Lautrec in Selbstzeugnissen und Bilddokumenten. Reinbek 1982, pp. 37 ff. For greater detail, see W. Barthelmess: Das Café-Concert als Thema der französischen Malerei und Graphik des ausgehenden 19. Jahrhunderts. Thesis Berlin 1987.

156 W. Haftmann: Malerei im 20. Jahrhundert. Munich 1954, p. 46 f. – The book was seminal for the concept of modernist art in the German-speaking sphere of art history.

157 The process, while impossible to authenticate in every detail, is described in the light of research conducted by M. Berhaut in G. Bazin: Les Trésors de l'Impressionnisme. Paris 1958.

158 A. Dayot: Exposition des œuvres de Paul Renouard aux Galeries du Théâtre d'Application. Paris n.d., p. 13.

159 Gustave Loiseau. Didier Imbert Fine Art. A la mémoire de Durand-Ruel. Paris 1985 (exhibition catalogue). A catalogue raisonné is in preparation.

160 Thus the article by F. Monod in Thieme-Becker: Allgemeines Künstlerlexikon. Volume 3. Leipzig 1909, pp. 528–530.

161 G. Mourey: Albert Besnard. Paris 1906, pp. 123–125 (reprint of an interview by C. Morice in "Mercure de France", 1st September, 1905).

162 D. Rouart, preface to: Berthe Morisot. Zeichnungen, Pastelle, Aquarelle, Gemälde (edited by I. Moskowitz). Hamburg 1961.

163 O. Reuterswärd: Sisley's "Cathedrals". A Study of the "Church at Moret" Series. In: "Gazette des Beaux-Arts" 94, 6. per. 39 (1952) pp. 193–202, and the catalogue raisonné by F. Daulte, Lausanne and Paris 1959.

164 J. Rewald (ed.): Camille Pissarro. Letters to his son Lucien. Paris 1953 (Letter from Rouen, 2nd October, 1896).

165 Letters of the 20th April and 13th May, 1891, ibid. pp. 197 and 208 f.

166 L.R. Pissarro and L. Venturi: Camille Pissarro. Son art, son œuvre. Volume 1. Paris 1939, p. 69.

167 J. House: Monet. Nature into Art. New Haven and London 1986; H. Keller: Ein Garten wird Malerei. Monets Jahre in Giverny. Cologne 1982.

168 G. de Maupassant: La Vie d'un paysagiste. In: "Le Gil Blas", Paris 28th September, 18

169 W. Kandinsky: Rückblick 1901–1913. Berl 1913.

170 M.L. Krumrine (ed.): Paul Cézanne. Die Badenden. Kunstmuseum, Basle 1989 (exhibition catalogue).

171 W. Hofmann: Grundlagen der modernen Kunst. Eine Einführung in ihre symbolischen Formen. Stuttgart 1966, pp. 190–229.

172 D. Halévy: Degas parle. Paris 1960, p. 77.

173 B. Bernard (ed.): The Impressionist Revolution, London 1986, p. 85 for a photograph from c. 1896 (Malibu, J. Paul Getty Museum), which I believe to have been utilized in this year for several paintings and pastels; Degas. Grand Palais, Paris; Musée des Beaux-Arts, Ottawa; The Metropolitan Museum of Art, New York. Paris et al. 1988, no. 340, p. 549 (exhibition catalogue).

174 See note 172, p. 86.

175 G. Adriani: Edgar Degas. Pastelle, Ölskizzen, Zeichnungen. Cologne 1984, p. 96.

176 P. Tucker: Monet in the '90s. The Series Paintings. Museum of Fine Arts, Boston et al. New Haven and London 1989 (exhibition catalogue). Cf. the review of this exhibition by E. Parry Janis in: "Burlington Magazine" 132 (1990), no. 1053, pp. 887–889.

177 D. Wildenstein: Claude Monet. Catalogue raisonné et biographie. Volume 4. Paris 1985, p. 41.

178 K.H. Usener: Claude Monets Seerosen-Wandbilder in der Orangerie. In: Wallraf-Richartz-Jahrbuch 14 (1952), pp. 216–225.

179 J. Rewald: Depressionist Days of the Impressionists. In: J. Rewald: Studies in Impressionism. London 1985, pp. 203 ff.

180 Passed on by P. Borel in his edition of J. Fèvre's reminiscences: Mon oncle Degas. Geneva 1949, p. 52.

181 K. Marx in his manuscript in preparation of an introduction to the "Grundrisse der Kritik der politischen Ökonomie" from 1857. K. Marx and F. Engels: Werke. Volume 42. Berlin 1983, p. 44.

182 W. Hofmann: Grundlagen der modernen Kunst, Stuttgart 1966, p. 181.

183 E. Zola: Peinture (Le Salon de 1896). In: "Le Figaro", 2nd May, 1896. In: H. Mitterand (ed.): E. Zola: Œuvres complètes; Œuvres critiques, III, Paris 1969, pp. 1047–1052.

Degas

Seura

manet

P. Cézan

Sisley

Berthe